STUDIES IN BRITISH ART

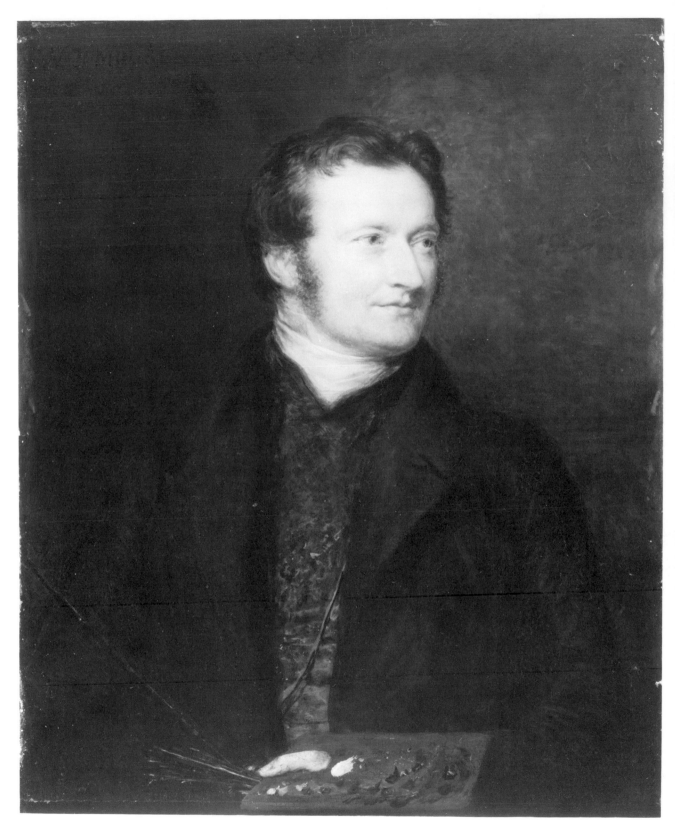

John Linnell, Sr *William Mulready* 1833. Oil on canvas, 12¼ × 10. National Portrait Gallery, London

WILLIAM MULREADY

Kathryn Moore Heleniak

Published for the Paul Mellon Centre
for Studies in British Art
by Yale University Press
New Haven and London 1980

To David

Designed by Caroline Williamson
and set in Monophoto Ehrhardt
Filmset and printed in Great Britain by BAS Printers Limited, Over Wallop, Hampshire.
Colour Plates printed in Great Britain by Penshurst Press Limited, Tunbridge Wells, Kent.

Published in Great Britain, Europe, Africa, and Asia (except Japan) by Yale University
Press, Ltd., London. Distributed in Australia and New Zealand by Book & Film Services,
Artarmon, N.S.W., Australia; and in Japan by Harper and Row, Publishers, Tokyo Office.

Library of Congress Cataloging in Publication Data
 Heleniak, Kathryn Moore, 1945–
 William Mulready.

 (Studies in British art)
 A revision of the author's thesis, New York
University.
 Bibliography: p.
 Includes index.
 1. Mulready, William 1786–1863.
I. Paul Mellon Centre for Studies in British Art.
II. Series.
 ND497.M9A4 1979 759.2 79-21775
 ISBN 0-300-02311-1

Preface and Acknowledgements

William Mulready, R. A. (1786–1863) was an important figure in the development of nineteenth-century British art and yet he has been unduly neglected in the modern period. This study was undertaken to redress this situation, to bring Mulready the attention and appreciation which he deserves.

Mulready was the subject of two monographs in the nineteenth century: Frederic G. Stephens' *Masterpieces of Mulready*, London, 1867, revised and enlarged as *Memorials of William Mulready, R. A.*, London, 1890; and James Dafforne's *Pictures by William Mulready, R. A.*, London, (1872). The latter is in essence a compilation of Dafforne's remarks originally published as Royal Academy reviews in the *Art Journal*, with the addition of rather lavish borrowings from Richard and Samuel Redgrave's important discussion of Mulready's work in *A Century of Painters of the English School*, 2 vols., London, 1866. On the whole, Dafforne's book is an ephemeral production scarcely worthy of consultation save for its occasional description of lost paintings by the artist. However, F. G. Stephens' monograph is an excellent source. Written soon after Mulready's death with the cooperation of Mulready's family, friends, associates and students, it is a thoughtful, thorough and generally reliable examination of Mulready's life and art, including a list of his important paintings and a record of his exhibited works, by a very good, nearly contemporary art historian. It is an admirable starting point for any modern discussion of the artist. But it is by no means the final word.

Stephens treats Mulready's career in a narrow context with only a limited discussion of his works in relation to the paintings of his contemporaries. Moreover, his nineteenth-century eyes were incapable of seeing or perhaps of recording the suggestive content found in Mulready's childhood and courtship scenes–the meaningful undercurrents which are so fascinating to us today. Lastly, Mulready's Account Book, his Sketchbook with its illuminating comments on

Mulready's own credo, his personal papers and his correspondence with patrons, students and friends were not available for Stephens' perusal. They are now held for the most part in the Victoria and Albert Museum Library and the Tate Gallery. Mulready, who once complained to his friend Henry Cole "of keeping Papers in order & not using them with regret at the want of occasion . . . like regret at not having y[ou]r house burnt after paying a long insurance", would I hope be pleased at this occasion for using this "insurance", for delving into these invaluable records for the sake of the welcome light which they shed on Mulready's private life and public career.

Two modern exhibitions have underlined the need for a new assessment of Mulready's importance. Andrew Wilson mounted a small exhibition of Mulready's paintings and drawings at the Bristol Art Gallery in 1964, which fell nearly on the centennial of Mulready's death. The catalogue contained a brief introduction recounting the development of Mulready's career and served as a reminder that his work deserved the appreciation of a modern audience. In 1972 Anne Rorimer prepared an important exhibition of the extensive collection of Mulready's drawings (numbering over 475) in the Victoria and Albert Museum. These drawings, along with thirty-three oil paintings by Mulready (principally given to the museum in 1857 by Mulready's close friend and patron John Sheepshanks, or purchased at the Artist's Sale in 1864), constitute the largest single holding of the artist's work and present a vast and instructive array of Mulready's artistic means. The exhibition of these magnificent drawings was the initial stimulus for my own study of the artist.

As the first substantial modern reassessment of Mulready's painting career, this book attempts to chronicle his life, art and times in view of the impact of contemporary social attitudes on his work. A catalogue of paintings follows the text.

A study of this nature, written as a Ph.D. thesis (now revised) under the generous and astute guidance of Professor Robert Rosenblum at the Institute of Fine Arts, New York University, could only have been accomplished with the cooperation of many people. I would like to thank in particular the staffs of the following institutions for their indispensable assistance: the Victoria and Albert Museum and Library (the site of an incomparable collection of Mulready's paintings, drawings, correspondence, and private papers), especially C. M. Kauffmann, John Murdoch and Joyce I. Whalley; the Tate Gallery (which holds an important collection of Mulready manuscript material as well as a number of paintings by the artist), especially Leslie Parris; the National Gallery of Ireland, especially John K. Hutchinson; the Whitworth Art Gallery, University of Manchester (which holds a large body of Mulready's drawings, once the property of John E. Taylor); the

British Museum and the British Library; the Witt Library; the Royal Academy of Arts, especially Constance-Anne Parker; the Paul Mellon Centre for Studies in British Art; the Metropolitan Museum of Art Library; the National Gallery of Art Library, Washington, D.C.; the New York Public Library; the Frick Art Reference Library; and the Yale Center for British Art, especially Susan P. Casteras. Sir Oliver Millar, Surveyor of the Queen's Pictures, was also very helpful.

I should also like to express my appreciation for the kind generosity of so many private owners, and in particular Mulready's descendant Mr John Harrison. Mrs Joan Browne-Swinburne, Mr John Browne-Swinburne, Mrs Thomas Bodkin, Mrs Joan Linnell Burton, Lord Dartmouth, Mr C. B. J. Gledhill, Mrs Brigid Hardwick, Lord Northbrook and Mr Wellington Sloane were all very generous with their time and help.

A number of art galleries and auction houses also helped me enormously with my research. In particular I would like to thank Thomas Agnew & Son Ltd, especially Miss Gabriel Naughton, P. & D. Colnaghi & Co. Ltd, William Drummond of Covent Garden Gallery, Peyton F. Skipwith at the Fine Art Society, J. S. Maas and M. A. Ford of J. S. Maas & Co. Ltd, Stephen Somerville of Somerville & Simpson, Ltd, Anthony Spink of Spink & Son Ltd, and Sotheby's and Christie's, especially Lady Dorothy Lygon and Miss Margy Christian.

The welcome advice and encouragement of friends and colleagues Christopher Allen, Matthew Ancketill, David Bindman, P. Campbell, Frances Carey, James Cole, Diana Dethloff, Josephine Gear, Deborah Langer, Miranda McClintic, Edward Nygren, Marcia Pointon, William Pressly, Miklos Rajnai and Allen Staley made this undertaking much more valuable and enjoyable. I would also like to express my gratitude to Katherine Lilleskov and Zohreh Sabet for their essential assistance at home. To my mother for her warm support, to my daughter for her forbearance, and especially to my husband David, to whom this book is dedicated, I am deeply indebted.

Lastly I should like to express my sincere appreciation to Professor Robert Rosenblum, and to Professor Gert Schiff, both of whom gave valuable advice along the way, to my editor John Nicoll, who was a wise and patient guide through the maze of publication, and to Caroline Williamson of Yale University Press.

Financial support for this research was generously provided by a Robert Lehman Fellowship and a Walter S. Cook Travel Fellowship, through the Institute of Fine Arts, New York University.

Contents

List of Illustrations

xiii

Photographs were supplied by the owners, except in the following cases:

Thomas Agnew & Son, 60; P. Campbell, 75; Liverpool City Libraries, 111; J. S. Maas & Co Ltd., 38; Medici Society Ltd., 83; Paul Mellon Centre for Studies in British Art, 14, 28, 40, 41, 43, 66, 85, 95, 96, 97, 105, 109, 135, 136, 141, 157, 161, 162, 163, 169; National Gallery of Ireland, Dublin, 148; National Postal Museum, London, 17; Phillips Fine Art Auctioneers, 107; Royal Academy of Arts, 101, 137; Peyton Skipwith, 104; Wellington Sloane, 179; Sotheby's, 44; Sotheby's Belgravia, 194; Spink & Sons, Ltd., 53; Tate Gallery (Archives), 178, 183; Witt Library, Courtauld Institute of Art, University of London, 16, 31, 72, 73, 82, 84, 113, 123, 124, 185.

Introduction

William Mulready was one of the giants of English painting in his own day, rivalling and perhaps surpassing David Wilkie in the field of domestic genre, a branch of painting which later came to epitomize nineteenth-century British art. His scenes of childhood life, of young love, of literary themes carried him to the very pinnacle of contemporary popularity. His consummate skill as a draughtsman and painter engendered frequent and fervently phrased comparisons of his work to that of the old masters, especially to Ostade, De Hooch, and the Teniers, but also (and perhaps to us more surprisingly) to Masaccio, Dürer, Van Eyck, Veronese and Michelangelo.

In fact, this list of disparate old masters suggests the scope of Mulready's painting style, for although his production was limited in quantity it was decidedly varied. His early panels with their humble scenes and subtle manipulation of tonal colors look to Dutch seventeenth-century models; his later, meticulously wrought paintings recall the masterly draughtsmanship of Dürer; his strong compositions can bring to mind the designs of Masaccio or Michelangelo; his brilliant, eye-searing palette the panels of Van Eyck or the rich lustrous canvases of the Venetians.

Yet despite such exalted comparisons, Mulready slipped from public favor in the early twentieth century. Modern viewers tended to agree with Ruskin's assessment that "while Mulready . . . always produced exquisite pieces of painting, he . . . failed in doing anything which can be of true or extensive use".[1] Mulready's own devotion to "Story Character Expression Beauty", the four goals starkly set forth in his Sketchbook (Victoria and Albert Museum Library), spoiled his delightful scenes for sophisticated twentieth-century viewers, who found the little happenings in his paintings, whether sweet, humorous, or instructive—so much appreciated by contemporary viewers who loved Goldsmith and lionized Dickens—too sentimental for their taste. Yet these very scenes deserve our renewed attention. Not only do they display fine painting

I

methods, sometimes brilliant almost luminous color, and interesting compositions finely honed by numerous preparatory studies, they also illuminate disturbing aspects of British society, which are disclosed in both conscious and unconscious layers of meaning. In these seemingly benign scenes, undertones of social repression, aggression, xenophobia and eroticism emerge.

Mulready deserves additional attention for his frequently neglected early landscapes, works confined to the first decade of his career and subsequently abandoned in favor of anecdotal subjects. These open-air oils, these cottage scenes and village streets, embody a fresh and direct view of nature comparable to the best examples of English landscape painting.

Lastly, Mulready should be recognized for his extraordinary draughtsmanship. His preparatory drawings, from rough scratches with the pen or pencil to highly finished and refined chalk cartoons, are very beautiful works of art in their own right: drawings which, when transferred to the canvas or panel, Mulready showed understandable reluctance to obliterate, often allowing them to remain as visible, spirited skeletons behind his thinly painted oil surfaces. Mulready also produced some of the most exquisite academic nudes of the nineteenth century through his attendance both as pupil and teacher at the Academy's Life School. While this study is essentially an examination of Mulready the painter, his drawings will be introduced whenever possible to reveal his working methods and to emphasize his remarkable ability in this area.

Today Mulready is known, if at all, as a precursor of the Pre-Raphaelites, who like Mulready gloried in brilliant, often violent color and precisely rendered detail. Certainly his role as a formative influence upon the rebellious young brethren should be noted; but his importance for nineteenth-century English painting goes far beyond that. His paintings are seminal examples of that pre-eminent nineteenth-century British production, anecdotal genre painting. While expressing his own distinctive and personal vision, the pictures also reflect the ideals, secret passions, foibles and fears of an aggressive yet vulnerable society in transition, a society that left an indelible impression upon the content of Mulready's paintings.

I. Biography

Mulready's early life was rescued from obscurity by the publication in 1805 of a small volume written by the philosopher and libertarian William Godwin for the edification of children, impressively entitled *The Looking Glass a True History of the Early Years of an Artist; Calculated to awaken the Emulation of Young Persons of both Sexes, in the Pursuit of every laudable Attainment: particularly in the cultivation of the Fine Arts.*[1] As a young student at the Royal Academy in the early years of the nineteenth century, Mulready helped support himself by illustrating children's books published by Godwin, to whom he divulged his life story. Godwin, judging it to be an excellent model for children, published an account of Mulready's youth under the pseudonym Theophilus Marcliffe.

Written when Mulready was just nineteen years old, long before he was recognized as an artist of stature, this biography is not the history of his ultimate success but rather the inspirational tale of an anonymous young man who began "under every disadvantage of a humble situation", and who through his own merit and industry achieved financial independence and professional esteem. It is written in praise of hard work and its just reward—self-sufficiency. Mulready, the hero of this story, was never identified, but the details of his life were readily recognizable, and in later years Mulready acknowledged its veracity to his good friend Sir Henry Cole.[2] Godwin takes us to 1801 when Mulready entered the Royal Academy Schools. Our knowledge of Mulready's family background is supplemented by the artist's own manuscript notes and a rather bare family tree assembled by him late in his life.[3]

William Mulready was born into a Roman Catholic family in Ennis, County Clare, Ireland on 1 April, 1786.[4] His father, Michael Mulready, a leather-breeches master, was evidently a hot-tempered, vigorous man, who indulged in amateur drawing and boxing, inspiring his son in both.[5] He appeared in a number of paintings, including John Linnell's

3

Removing Timber, Autumn of 1808[6] and David Wilkie's *Duncan Gray* of 1814, as well as in several of Mulready's own works. He is believed to have served as the model for the schoolmaster in both *Idle Boys*, R.A. 1815 (Plate 84) and *The Fight Interrupted*, R.A. 1816 (Plate 90).[7] The same elderly gentleman with strong rugged features appears in one of his earlier landscapes, the 1810 version of *Horses Baiting* (Plate 59) and in *The Village Buffoon* of 1815–16 (Plate 121).[8]

Little is known concerning the history of the Mulready family. The artist retained memories of his grandfather, James Mulready, who died before 1792, and an uncle, William, his father's brother, who died without children in 1822. The family of another uncle, James Mulready of Limerick (died 1797), was brought to Mulready's attention in 1815, when the first of several of his children approached their successful cousin for assistance. An aunt, Mary (Mulready) Brady, died without issue.[9]

Mulready's mother is an elusive figure. Nothing is known concerning her family—not even her maiden name. She too appeared in a Linnell painting, *A Woman at a Table Drinking* (now lost) of 1811, and it has been suggested recently that a drawing traditionally identified as Linnell's mother is in fact Mrs Mulready, and a study for the above-mentioned work.[10] From an anecdote recorded in John Linnell's unpublished Journal (31 August 1811), Mrs Mulready emerges as a kind, charitable person, who insisted upon helping Linnell when he established his own home and studio in 1811.[11] In other references she appears as an idealized mother figure, always encouraging her son's artistic pursuits.[12]

The number of Mulready's siblings is uncertain. In his family tree he is listed as an only child. But on another occasion he mentioned the circumstances surrounding the birth of a sister.[13] In addition, Godwin reported the deaths of an infant brother and sister from "the plague" (probably smallpox) in about 1791, which, he claims, Mulready barely survived himself. Without evidence of adult brothers and sisters in his later notes and correspondence, one must presume that William was the only child in his family to reach maturity.

When Mulready was one and a half years old his family moved to Dublin, and approximately four years later they moved on to London. No explanations have been offered for these moves. Presumably they were undertaken for economic or political reasons. Godwin noted that Mulready's father served as a private soldier in the volunteer army of Ireland, an organization which sprang up during the American Revolutionary period and agitated for Irish independence while remaining loyal to Great Britain. Since the political situation in Ireland was decidedly unstable at the time, one might imagine that England presented a more serene and secure setting for the Mulready family.

4

Nevertheless, the resultant demotion of the father to mere journeyman in London surely proved a severe financial setback to the immigrants.

As an oppressed religious minority Irish Roman Catholics were subject to severe disadvantages.[14] As late as the 1820s, there were only some 60,000 Catholics in England. Although the Toleration Act of 1689 had given Dissenters some measure of freedom for religious worship, the Catholics had none. They were excluded from ministerial or administrative office, from commissions in the armed services, from universities, and from the House of Commons. Popular feeling ran so high that "Papists" were frequently subject to mob violence for practising their religion. The Catholics (including Mulready, who professed his faith throughout his life) remained in this unequal state until the Roman Catholic Relief Act of 1829, which provided political equality while continuing to deny university education; this was not granted until much later in the century.[15] Irish Catholics engendered exceptional suspicion and animosity among the English population, especially during the Napoleonic Wars. Sharing the French religion, and considered rebellious as well, they were regarded as a susceptible and traitorous chink in the otherwise formidable English defense.

Despite the presumably precarious social position of the Mulready family, funds were forthcoming for young William's education. He attended a number of day-schools and by the age of ten his father was encouraging his reading of such classics as Homer (Pope's translation), Shakespeare, Cervantes' *Don Quixote*, and Goldsmith's *Vicar of Wakefield* (which would one day be the source for some of his best paintings). The bookstalls in St Paul's churchyard provided additional literary material for the voracious young reader. In fact, for a boy of "humble origins" Mulready received a substantial formal education including three and a half years of Latin and a smattering of French—though lacking that essential ingredient and crowning accomplishment of a true gentleman's instruction, a knowledge of Greek, a deficiency which he attempted to rectify in his adult years. One finds evidence of this pursuit in the Greek scribblings that border several of his drawings and in the little Greek grammar, once in the possession of his aristocratic patrons the Swinburnes, found among his effects at death.[16]

In later life, he also attempted to learn German. A letter of 1812 from one of his students, a Mr Heine, suggests that Mulready gave drawing lessons in exchange for German instruction. Mr Heine wrote enthusiastically (if stiltedly): "we can make a proper beginning now, in the German (a Language so much in fashion now) & I will do my utmost to make Mr. M perfect in, in a short time, as Mr. M has a very good pronunciation, & therefore will find it very easy."[17] As one never hears reference to this possible accomplishment again, it is rather doubtful that he ever achieved proficiency in this fashionable language. Yet, with

his smattering of French and German, his Latin, his elementary Greek, and his reading of the classics, Mulready acquired at least a veneer of gentlemanly knowledge to accompany his artistic achievements.

The history of Mulready's early artistic training, like that of so many other successful artists, is replete with stories of his precocious ability. Godwin tells of his drawing in chalk on floors and walls at three years of age, at seven drawing objects from nature, and at nine, foreshadowing the subject matter of his later career, composing "little groups of boys at hoops or at marbles, and girls about the same size, with infants in their arms, looking on and observing the sport. . ."

At about this time Mulready had his first encounter with a professional painter. John Graham (1754–1817), the Scottish artist, came across Mulready in the streets near Leicester Square, and invited him to pose for the figure of David in his painting *King David Instructing Solomon* (R.A. 1797, 146). Graham noted Mulready's budding artistic ability and provided prints for copying. He advised Mulready's parents to encourage their son to prepare for a professional career. Graham returned to Scotland soon after (1798), where he took a position at the Trustees Academy, Edinburgh, providing instruction for the young David Wilkie—later Mulready's great friend and fellow painter of genre scenes.[18]

After receiving additional advice and encouragement from several little-known artists, Mulready was urged to apply for entrance to the Royal Academy Schools.[19] Since Thomas Banks, the neo-classical sculptor, headed the alphabetical list of Royal Academicians, he was approached by Mulready's parents to inspect their son's drawing after the cast of Apollo. According to Godwin, Mulready was just "13 years & 1 month old" (May 1799) when he presented his drawing to Banks. The sculptor criticized this particular example but suggested that he continue with his efforts. He was more enthusiastic when Mulready returned a month later with an improved version.[20] Banks then agreed to supervise Mulready's instruction in preparation for his admission to the Royal Academy Schools.[21] He began by sending Mulready to a formal drawing school in Furnival's Inn Court, Holborn—perhaps the same drawing school that Mulready's later teacher and friend John Varley attended.[22] After six weeks Mulready returned to Banks' workroom and studied directly under the sculptor for several months, the only drawing student ever to do so. Here he drew after antique casts and, more surprisingly, from Banks' rather unusual collection of Gothic foliage fragments.[23] His studies under Banks successfully concluded with his admission to the Royal Academy Schools on 23 October 1800.[24]

Although Mulready only left one drawing (Plate 1) as direct evidence of his involvement with Banks, the sculptor's personal beliefs and habits influenced the young artist long after their formal association. Banks'

6

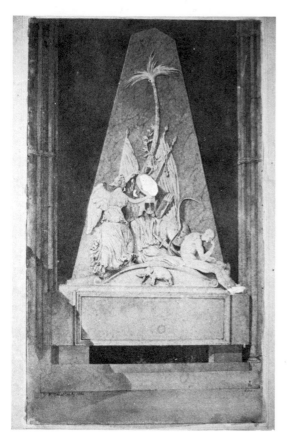

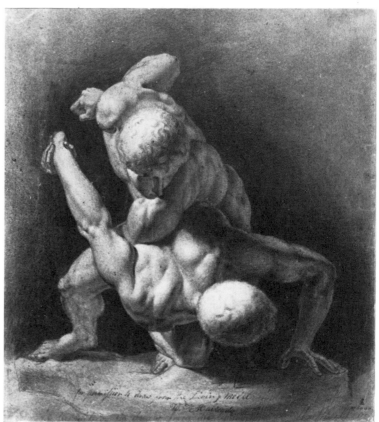

dedication to hard work,[25] his insistence on the importance of drawing as the basis for any significant artistic production, and his steadfast attachment to the classical heritage undoubtedly inspired his impressionable student. Throughout his career Mulready had a profound respect for the antique and a deep and abiding devotion to drawing. Perhaps the classicizing order that informs even his most lowly genre productions can be linked to his youthful study under this sculptor.

Mulready soon achieved fame as a draughtsman in the Academy Schools. He appears to have made unusually rapid progress into the Life School if, as it has been asserted, his drawing after the *Pancrastinae* (Plate 2), inscribed "for permission to draw from the Living model", can be dated 1800.[26] In 1801 he was awarded the Greater Silver Pallet by the Society of Arts for an outline drawing (now lost),[27] and in 1806 his draughtsmanship earned the silver medal at the Royal Academy.[28] A comment in Joseph Farington's Diary (16 November 1807) confirms Mulready's reputation, though casting an aspersion on his character: "Mulready a young man twenty one or two years of age is reckoned to draw the best, but gets Himself high upon it as if He had done His business."[29]

While attending the Academy Schools Mulready fell under the influence of the watercolorist John Varley (1778–1842). He became his

1. Drawing after Thomas Banks' *Monument in Honor of Sir Eyre Coote*, Westminster 1804. Varnished pencil drawing, 15½ × 9. Victoria and Albert Museum, London (Crown Copyright)

2. *Pancrastinae* 1800. Black and white chalk, 14½ × 13. Victoria and Albert Museum, London (Crown Copyright)

7

pupil and was shortly promoted to being his assistant. John Varley was just eight years older than Mulready, but was well established in his professional career by the early years of the nineteenth century, when he had gathered a number of pupils to his studio, including William Henry Hunt, Joshua Cristal, Copley V. Fielding, John Linnell, William Turner of Oxford, and David Cox. Contemporary accounts suggest that his studio/home was a lively meeting place both socially and artistically. Both elements were extremely important for Mulready; artistically, Varley was influential in the development of his early landscape style and socially, Varley was instrumental in introducing Mulready to his future wife, Elizabeth Varley (1784–1864), John's eldest sister.

In 1803 when barely seventeen Mulready married Elizabeth Robinson Varley, his senior by a year and a half and an artist herself.[30] As a member of an illustrious family with an impressive ancestry[31] and the sister of his own tutor, Elizabeth Varley must have represented a socially successful match for the Irish-born immigrant, although their subsequent marriage proved to be disastrous.

There are no surely identified portraits of Elizabeth Varley, although she may be the slight figure in a small oil sketch (Plate 168) in the possession of one of her descendants.[32] An early miniature by Mulready, reportedly depicting her as an attractive tawny-haired young girl with a turned-up nose and a piquantly expressive face, has since disappeared.[33] She is thought to have posed for the mother in Mulready's painting *A Carpenter's Shop and Kitchen* in 1808 (Plate 72), where her appearance as a rather buxom young woman with regular, almost noble features seems somewhat at variance with the above description.[34] This identification is considerably strengthened by the appearance of Mulready himself as the father or carpenter; undoubtedly their own sons supplied the models for the two children. Unfortunately this portrait of domestic felicity was far from being an accurate depiction of their own family life. They were formally separated in 1810 (though they parted earlier) after seven years of marriage and four sons produced in quick succession: Paul Augustus (1804–64), William, Jr (1805–78), Michael (1807–89), and John (*c.* 1809–92).[35]

F. G. Stephens, Mulready's nineteenth-century biographer, remained inexplicably mute on the reasons for their separation, evidently in accordance with his professed belief that "it is not just to pry into the inner life of any person".[36] But perhaps his exceptional reticence on this and other delicate family matters can be more readily explained by his deference to the wishes of the Mulready family. Stephens conferred with Michael Mulready following his father's death[37] and contemporary sources suggest that Michael was anxious to shield the Mulready name from any scandalous associations.[38] Stephens probably assured the Mulready family that he would refrain from commenting on private matters in return for their cooperation.

Some writers did allude to their separation. Most simply cited their mutual incompatibility; others produced specific causes, often quite amusing. Alfred Story, John Varley's nineteenth-century biographer, claimed that Elizabeth Mulready habitually altered Mulready's paintings when he was away. Piqued at her husband's notoriously slow painting methods, she sought to accelerate the completion of his works herself—or if angry would attack them by painting out the eyes.[39] Naturally such action was thought to provoke her husband. Without any documentation and in the light of more substantial causes stated below this lively account of their dissension must be relegated to mere speculation—gossip quite naturally produced following the mysterious marital separation of two artists.

Richard Redgrave, painter, historian and Mulready's friend in later years, cites a more plausible cause in his memoirs: "His wife said Mulready's violent temper made her finally determine to quit him."[40] Mulready's temper, which according to Stephens he constantly sought to control, was undoubtedly a factor in their separation. But by far the most illuminating material on their problematic marriage has recently come to light in the form of two separate manuscripts in which each party sets forth their own accusatory explanations: Elizabeth's sensational letter to her husband, and Mulready's own statement absolving himself of responsibility for the dissolution of their marriage. Both documents are undated but were written a long time after their separation, probably about 1828–30.[41]

Mulready's own statement places the blame squarely on the "bad conduct" of his wife. Although never specifying the nature of her misconduct (which is obliquely confirmed as adultery in her own letter), he concerns himself primarily with relating the nature of his own generous behavior in allowing the articles of separation to be drawn up on less serious grounds than his wife's conduct supposedly warranted. He did this in deference to "the very great contrition that she seem'd to feel" and his fear that "exposure . . . might plunge her into fresh infamy or hurry her into some violence against herself". The remainder of his statement is devoted to recounting his wife's allegedly rash and often violent attempts to regain custody of their children, then left in his care.

Mulready's rather guarded comments justifying his own behavior were undoubtedly a response to the explosive charges contained in his wife's letter written approximately twenty years after their initial separation. Elizabeth's letter is couched in the full-blown rhetoric of post-Byronic Romanticism. In a touchingly clichéd manner she describes her sad plight. "Repeated calamities have rendered my feelings acute to agony . . . [sending me] *wandering in my sleep With burning temples and a throbbing pulse* and if I have refrained from suicide the merit I fear is scarcely my own." Clearly Mulready's fear concerning her emotional stability was not unfounded. Yet the remainder of her

letter, rambling and at times incomprehensible, gives good cause for her depressed state. Citing her husband's violent behavior (clearly reflected in Redgrave's memoirs), she continues, "I had four infant boys for whose sake I took blows and curses and suffered every indignity that cold-blooded malice could invent—To whose welfare I devoted all the best years of my young life. . ." only to lose the children in the end.[42]

In the midst of this expression of sorrow over her ill-treatment and the loss of her children she alludes to much more substantial and socially inflammatory explanations for their separation, coupling her own infidelity with an accusation of homosexuality on his part. She explains, "I was accountable to you for nothing, you had taken a low boy to your bed, and turned me adrift at midnight, to seek one at the house of an unmarried man. What allegiance could I owe to such a husband?" Her unmarried companion remains a mystery but Mulready's companion, the "low boy" to whom she refers, must surely be the young John Linnell, from a poor family, unschooled by his own account, and six years Mulready's junior.

John Linnell had entered John Varley's school in about 1804/5 at Mulready's suggestion, and at a time when Mulready was assisting Varley with his pupils. Linnell reported in his Autobiographical Notes that his "first desire and earnest wish was to be under Mr. Mulready whose work and personal qualities made a great impression upon me. He was so far above me in everything and at the same time so communicative that I might be said to be under his influence far more than Varley's."[4] Mulready and Linnell became constant companions. Linnell's Autobiographical Notes attest to their very close relationship, describing their meals together and their enthusiastic boxing matches, as well as Mulready's close supervision of Linnell's artistic training. As Linnell explained, "Mul[ready] was really my tutor in Everything; my companion, playmate and guide." In November 1805 Linnell joined Mulready in attendance at the Royal Academy Schools, although by this time Mulready was in the upper division. Alfred Story, Linnell's nineteenth-century biographer, reports that "During these Academy days, Mulready and Linnell became inseparable . . . indeed, so marked was their friendship that they were caricatured together, the elder as looking over the junior's shoulder whilst painting. . ."[44]

In 1808 Mulready and Linnell listed the same address (30 Francis Street, Bedford Square) in the Royal Academy catalogue, and in 1809, when Mulready's wife and children were in Kensington, he himself retained the Francis Street address before moving to Hampstead, the same location that Linnell lists as his address for 1809 in his Autobiographical Notes. Linnell then records his move to Kensington Gravel Pits where he lived with Mulready (and Mulready's parents) between 1809 and 1811. Thus Mulready and Linnell lived together or in

close proximity between 1808 and 1811. This unquestionably close relationship (whether homosexual or not) apparently undermined Mulready's marriage, even if Elizabeth's indiscretion—seeking a bed in the house of an unmarried man—created the immediate and perhaps more serious grounds for their formal separation.

An episode narrated by Linnell in his Autobiographical Notes seems to confirm his identity as the "low boy" of Elizabeth Mulready's accusation:

> Mulready and I went to Gravesend and Chatham for about three days [summer 1808] . . . I think we walked home for I know we arrived at Francis Street after midnight . . . we accomplished our entry to the apartments without disturbing the landlord or anyone, with the delicacy and tact of the most accomplished burglar . . . Mull [Mulready] could reach the staircase window which not being kept fastened he pushed up gently and by a sudden spring got so far hold of the inside as to lift up the sash and get in.[45]

Linnell went on to explain that "Mrs Mull[Mulready] and the children were living at Kensington." But Elizabeth's letter suggests otherwise or at least implies that this incident was indeed the occasion for their separation. "[Y]ou alarmed me by your return at midnight [from 'Rochester', near Chatham] and announced it by the smashing of windows. We agreed to separate and from that hour Mulready I owed you no allegiance, have been accountable to none but heaven for my conduct"; whereupon she proceeds with her "low boy" accusation. An additional reference in her letter appears to establish the likelihood that she was referring to the same event. She recounts a recent meeting with their old servant who told her "mid a thousand impertinances she still kept an eye upon Mrs. Linnell she should not forget the boy being locked in the bedroom with her Master while her Mistress and self were actually [?] sitting up for them . . . I should want her evidence yet."

Mulready and Linnell maintained their close friendship throughout their lives, during which time Linnell went on to marry and outlive his first wife, marry another, and father a number of children without any breath of scandal concerning his personal life. Nor can one find any reference to concealed or open homosexual activities concerning Mulready (or Linnell) in the published sources of their time, though one would scarcely expect to find public disclosure of their private and perhaps transitory sexual inclinations.[46]

Elizabeth's nearly explicit charge of homosexual behavior (with her thinly veiled threat of latter-day exposure) was further complicated by references to other women in Mulready's life: "The wretch who supplanted their [the sons'] mother" (possibly a reference to Mulready's mother, who lived with him soon after his separation, presumably

watching over his children, or perhaps to a Mrs Leckie to be discussed later) and the more suggestive "Harriet . . . [whose] little finger" was preferred by Mulready to his wife and sons, probably to be identified as Mulready's pupil of 1806–7, Harriet Gouldsmith (1787–1863).[47] To complicate matters further, she was evidently the same Harriet Gouldsmith who attracted Linnell's amorous attentions in 1811,[48] thus completing a rather delicate circle of personal entanglements.

While Elizabeth's charges of cruelty and infidelity appear very serious, they should be weighed against the evidence that Mulready remained on excellent terms with her brothers, particularly John and Cornelius, long after the Mulreadys' separation. Indeed, John Varley helped to formulate the letters of separation and later mediated on Mulready's behalf when Elizabeth sought to question the terms of separation. Since John Varley was on intimate terms with the couple, Mulready's behavior must have been viewed by both her family and society at large as less reprehensible than hers.

In any case, their marital breakdown—whatever the reason—appears far from unusual when viewed against the background of the late Georgian period, when libertarian views and practices frequently led to the dissolution of marriages, perhaps most notably in the case of the Prince Regent himself. One of Mulready's own drawing pupils was linked to the most sensational separation of the period. Lady Byron (née Anne Isabella Milbanke) was Mulready's student before her marriage in 1816 to the poet, and she remained friends with the artist for years, following her rumor-ridden estrangement from Byron.[49] Mulready was also acquainted with Mary Godwin (daughter of his employer and biographer, William Godwin, and author of *Frankenstein*), who ran off to Europe in 1814 with the poet Percy Shelley, whose wife was left behind and committed suicide shortly thereafter.[50] The rather Victorian fidelity exemplified by the devoted Brownings had yet to raise its respectable head in the literary world.

Nevertheless, Mulready suffered anguish over rumors which circulated concerning his separation, rumors to which Elizabeth Mulready alluded in the sad conclusion of her epistle: "If all the calumny is true your women have heaped upon me, and half is true the world insinuates of you, We are ended a couple worthy of each other." Mulready feared that his marital problems would tarnish his reputation and damage his chance of succeeding in that bastion of artistic respectability, the Royal Academy. He voiced such fears to the indefatigable diarist Joseph Farington, who recorded Mulready's anxiety over "it being known that He separated from His wife, as it wd. cause suspicion & doubt of Him on every slight occasion such as wd. not be regarded in one not so situated. . ."[51] His fears were not unfounded, since personal matters were given due consideration by the Academy. In

fact, a rumor had evidently circulated at the Academy when he was up for election, although without any serious effect.[52] He was voted an Associate of the Royal Academy in November 1815, and his unusually rapid election to Royal Academician followed in February 1816, just a few weeks before his thirtieth birthday.

Mulready's professional career remained relatively unaffected by these personal problems, with one exception. Prior to his separation Mulready earned a large portion of his annual income through the instruction of aristocratic amateurs; but in 1809 and 1810 his teaching income dropped sharply. In those two years Mulready earned only twenty-five pounds from teaching compared to an average yearly teaching income of seventy to ninety pounds.[53] Since his teaching career resumed its normal pace in 1811, remaining a life-time preoccupation, one must presume—barring any disinclination on his own part, which seems unlikely in view of his love of teaching—that his separation and its attendant scandal temporarily made him a less than suitable companion for the aristocratic young women who constituted the majority of his pupils.

To counter any festering suspicions with regard to his moral character, Mulready attempted to become "the very genius of prudence", as his friend Samuel Palmer later described him,[54] a characterization reiterated by the landscape painter Augustus Callcott, who described Mulready as being "sensible of what constitutes propriety of conduct".[55] Although tales abound concerning his good humor, his love of parties,[56] and his masterful storytelling,[57] contemporary assessments of his character stress that eminently Victorian virtue respectability, an image which he himself fostered. By the late 1820s Mulready was singled out for his "high character . . . beyond suspicion"[58] to mediate in a quarrel between John Constable, William Collins, the genre-landscape painter, and their patron Sir Robert Peel. Later in 1833 Constable remarked upon Mulready's concern for his reputation, noting that he would "never notice anything but an attack on his moral character".[59]

In light of this serious and successful effort to rehabilitate his image, one can imagine how unsettling the respectable Mulready found his wife's accusations and threats of disclosure twenty years after the purported events. Even forty years after his separation, when speculation must surely have abated, Mulready remained extremely sensitive to any references concerning his failed marriage. The young W. Holman Hunt discovered this as a Royal Academy student in the 1840s when he unwittingly offended Mulready by remarking upon Mulready's connections with the Varley family.[60]

Mulready avoided any public liaisons in his later life. His professed religion, Roman Catholicism, and social and legal barriers precluded

divorce and hence remarriage. The only female companion consistently linked to Mulready in private correspondence and in the diaries of his contemporaries is the mysterious Mrs Leckie,[61] who evidently kept a lodging house in the Kensington area,[62] and perhaps acted as Mulready's housekeeper for a time. She first appears in Mulready's work as a rather pretty woman with large somber eyes accompanying Mulready's eldest son, Paul Augustus, in a very pale pen and ink drawing of 1826 (Plate 3), which suggests that she might be identified as "the wretch who supplanted their mother" in Elizabeth Mulready's letter. Mrs Leckie is briefly cited again in a letter from one of Mulready's friends who, when visiting Paris, bemoans his loss of the brandy and water drinks that "Mrs. Leckie used to make for us previous to our returning to our virtuous couches"[63] (implying only friendship). In addition, one finds many specific references to their relationship scattered throughout the diaries of Mulready's close friend Henry Cole in the 1840s. He often "called on Mulready at Mrs. Leckie's",[64] and recorded his favorable impression of the artist's "fine lifelike portrait of Mrs. Leckie" in 1842 (3 July)—perhaps the unidentified portrait of a middle-aged woman in the Victoria and Albert Museum (Plate 192). Yet despite this remarkably long and evidently close association for over twenty years, their relationship never gave rise to allegations of any illicit romance.

However, there remain two suggestive references which might add another dimension to Mulready's private life. In Michael Mulready's Diary Notes following his father's death, he reported that "Ada" had been to the Royal Academy "& said that she had no claim and did not require to make one as she was very well off".[65] Could Ada be Mrs Leckie or some other mistress? Cole reported an even more baffling conversation with Michael with possible reference to an illegitimate child: immediately following the exhibition of Mulready's works at the South Kensington Museum in 1864, Cole reported that Michael "agreed to let his share of copyright go to his father's child".[66] Since Mulready's youngest legitimate son, John, was no less than 54 years of age—hardly a child—to whom does Michael refer?

Mulready's separation did not provide the sole basis for insinuations against his character; his custody of his children provided another. Following his separation Mulready received custody of their four sons, although the oldest was barely six years old and the youngest an infant. Elizabeth's pathetic attempts to regain her children (snatching them away when Mulready was absent) were outlined and callously dismissed by Mulready in his own statement: "not having her children with her, looked suspicious". Lest one presume that Mulready received custody because he was deemed the more fit parent one must remember that in 1810 a father had absolute rights over his children; mothers none.[67] At

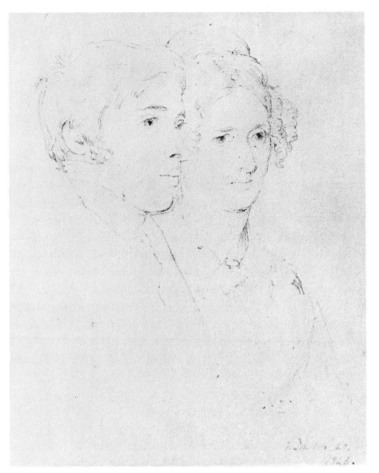

3. *Mrs. Leckie and Paul Augustus Mulready* 1826. Pen and brown ink, $4\frac{3}{4} \times 3\frac{7}{8}$. Collection Mr and Mrs John Harrison

that time a separated wife and mother held a very precarious social and legal position in comparison to her husband. If Elizabeth Mulready wanted her sons in opposition to Mulready's will she had no alternative but to snatch them. In the end her continuous "riots" encouraged Mulready to place their youngest child with her for a number of years.[68]

Their sons did not flourish under Mulready's care. With insufficient supervision they evidently grew up quite wild, their behavior far from exemplary.[69] Professionally, Mulready trained them to follow artistic careers, but none achieved any real fame.[70] Personally, they "never got on well with their father".[71] One son, his namesake, William Jr, brought him profound sorrow, and became the basis for further insinuations against his character. Even today Mulready's descendants dismiss William Jr as the black sheep of the family.[72] In the 1840s, with this estranged son quite destitute and finally imprisoned for debt, it was reputed that Mulready ignored his severe pecuniary problems. The rumors grew so substantial that John Linnell felt impelled publicly to defend Mulready's reputation by disclosing his own position as an

intermediary channelling Mulready's contributions to his son.[73] John
Sheepshanks, Mulready's patron and friend at that time, privately
assured Mulready in an undated letter that he was relieved to learn from
William Jr that he was in debt to his father for a considerable sum, thus
dispelling allegations of his father's supposedly cruel neglect.[74]

Family problems plagued Mulready until his death in 1863. His
eldest son, Paul Augustus, became temporarily insane shortly before
Mulready died, necessitating his commitment to a private clinic.[75]
Thus, his estranged wife (who outlived him by a year),[76] his estranged
son, William, Jr, and his insane son, Paul Augustus, were all absent from
his very quiet, private funeral and burial (so dictated by his son Michael
for family reasons),[77] an unusually low-keyed event for a senior Royal
Academician in an age which prided itself on pompous funeral displays
and extravagant mourning.

Family problems did not overwhelm his private life. His third son,
Michael, lived amicably with him until Mulready's death. They lived in
a large house that Mulready leased and somewhat redesigned for himself
in the late 1820s, in the artistic community of Kensington/Bayswater (1
Linden Grove, Bayswater), now in the heart of London, but then a
suburban residence (Plate 4). It was a home comfortably furnished with
mahogany and rosewood furniture—some of his own design (Plate 5)—
and Brussels carpets, and supplied with Wedgwood ware. Although his
house never became quite what he hoped (extensive floor plans with
exact furniture placement were abandoned when rarely-used rooms
were closed off; and a meticulous garden design never came to fruition,
Plate 6),[78] he nevertheless had frequent visitors.

Sir Henry Cole's Diaries provide a rich source for determining the
nature of Mulready's social life, which seemingly focused on fellow
artists and patrons. While publications after his death suggest that he led
a reclusive life,[79] one must presume that they refer only to the last few
years of his life if any, for in the 1840s and 1850s Cole records his own
weekly visits to Mulready's home as well as the frequent appearances of
Mulready's patron John Sheepshanks and a number of artists including
John Linnell, Daniel Maclise, J. C. Horsley, C. W. Cope, and Thomas
Webster. Cole also casually mentions the many social evenings when he
encountered Mulready—supper with the German museum director and
chronicler of English collections, Dr Gustav Waagen,[80] musical parties

16

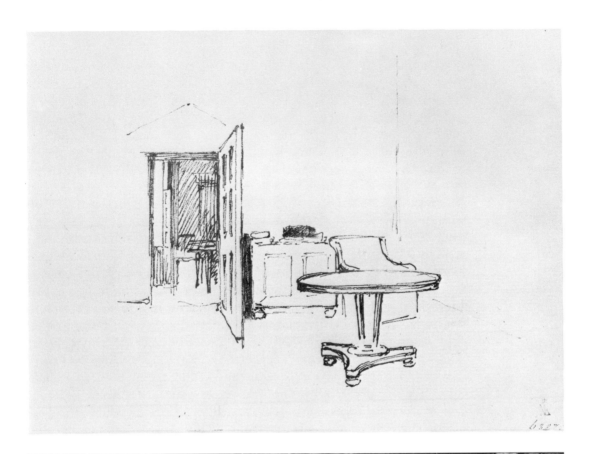

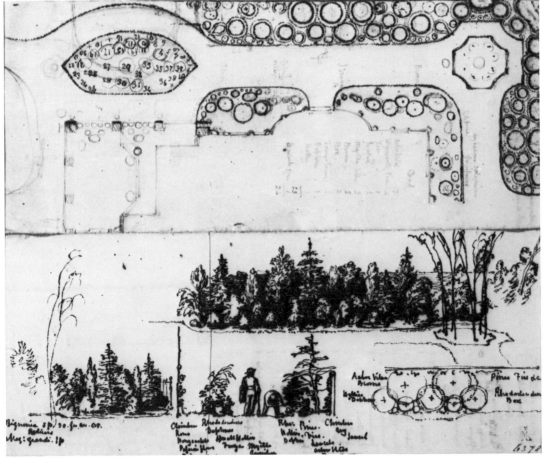

at the home of W. Dilke (the editor of *The Athenaeum*),[81] dinners at the collector Sir Thomas Baring's home,[82] visits to the Marquis of Northampton,[83] not to mention the many evenings that Mulready spent with the Cole family. He even notes Mulready's absences from London, usually explained by his frequent journeys to the homes of his patron Sir John Swinburne in Northumberland and the Isle of Wight.[84]

Correspondence records, other diaries of the period, and published recollections throw additional light on Mulready's private life. In artistic circles, he often visited David Wilkie,[85] participated in the Castle Tavern gatherings in Hampstead with Wilkie, William Collins, and Linnell,[86] and in the same northern suburb had discussions with William Blake and his young friend Samuel Palmer.[87] He shared the simple fare of cheese and port with Turner,[88] attended birthday parties for John Ruskin hosted by the art critic's father,[89] and enjoyed convivial dinners at the homes of Sir Thomas Lawrence,[90] Charles Eastlake,[91] Augustus Egg, and William Powell Frith,[92] where he was likely to meet Frith's great friend Charles Dickens—to cite but a few examples. John Constable wrote Mulready a personal invitation to his landscape lectures and, being aware of Mulready's interest in natural science, bemoaned his absence from the public dissection of a mummy which Constable had witnessed.[93] Such scientific inclinations led Mulready to attend Michael Faraday's lectures at the Royal Institution in 1829 after personal correspondence with the scientist.[94] In fact, Mulready had frequent contact with his most famous contemporaries, from the early years of the nineteenth century when he attended lively evening parties in William Godwin's home where he perhaps encountered Coleridge, Wordsworth, Lamb and Hazlitt,[95] till the later years of his life when he joined the novelist and art critic William Makepeace Thackeray for a quiet fishing weekend.[96] Such luminaries did not, however, keep him from less prestigious engagements. Known for his special rapport with children, Mulready welcomed their visits, and was invited to children's birthday parties long after his own sons were grown.[97]

7. *Figures Boxing* (detail) 1822. Pen and brown ink, sepia wash, $5 \times 10\frac{1}{4}$. Victoria and Albert Museum, London (Crown Copyright)

8. *Figures Boxing* (detail) 1822. Pen and brown ink, sepia wash, $9 \times 7\frac{1}{2}$. Victoria and Albert Museum, London (Crown Copyright)

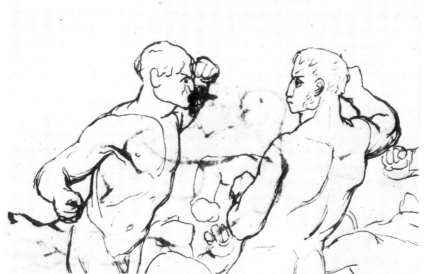

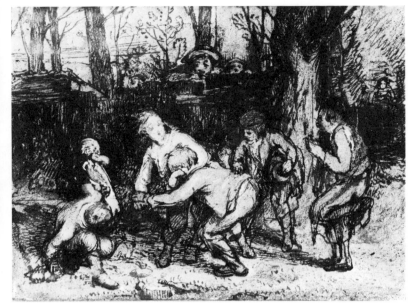

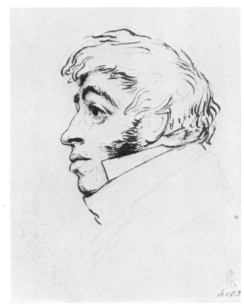

Like so many of his Romantic contemporaries Mulready took great pleasure in two popular pastimes: the theater and boxing. Godwin recorded Mulready's youthful enthusiasm for the theater in *The Looking Glass. . .*, particularly his admiration for the famous actors of the day, an admiration that was reciprocated years later when the illustrious actors Macready and Charles Kemble presented Mulready, then a successful Academician, with guest passes to their theaters.[98] As a struggling young artist with little to spend, he contrived to attend the theater with his young friends and fellow artists, Wilkie and Linnell, both of whom shared his love of the stage.[99] His accounts of a later period, detailing his annual expenditure for the theater, attest to his continued appreciation for the dramatic arts.[100] Mulready even had some loose professional ties with the theater, having undertaken some decorative work for the Sans-Souci Theatre early in his career (1806).[101]

Perhaps boxing was even dearer to his heart (Plates 7, 8). Boxing was a tremendously popular sport in the late eighteenth and early nineteenth centuries, attracting practitioners and patrons from all sections of society from royalty down to the common laborer.[102] Its popularity was such that during the Napoleonic Wars over twenty thousand spectators in London cheered the boxer Tom Cribb when he succeeded in fracturing the jaw of the black fighter Molineux.[103] The Prince Regent and Lord Byron were two of the best-known enthusiasts in Mulready's time. Lord Byron assembled a screen with pasted images of the illustrious boxers of his day, and covered the reverse with theatrical memorabilia, thus echoing Mulready's own special interests.[104]

Mulready himself developed prowess in boxing at an early age. His father frequently brought fighters to his home, and the young Mulready was supposed to have received lessons from the famous pugilist Mendoza.[105] His proficiency in the sport generated a good many

9. *Boys Fighting* Pen and brown ink, sepia wash and watercolor over black chalk, heightened with white, $4\frac{1}{16} \times 5\frac{7}{16}$. Henry E. Huntington Library and Art Gallery, San Marino, California

10. *John Thurtell* 1823–4. Pen and ink, $4 \times 3\frac{1}{8}$. Victoria and Albert Museum, London (Crown Copyright)

stories.[106] In fact, when he was a part of the Varley household, the house was "quite a boxing school for Artists", according to Linnell, whom Mulready schooled not only in the art of painting but in boxing as well.[107] Mulready also instructed his own sons, although withholding some tricks even from them, which remained a source of sore contention years later with his eldest son, Paul Augustus.[108] Mulready's physique—tall, strong, and well built[109]—undoubtedly favored his participation in the sport, until a heart condition contracted as an after-effect of rheumatic fever in 1817 curtailed his boxing activity.[110]

Mulready was also known to enjoy watching rough street fights between boys.[111] Such scenes were often incorporated into his paintings and drawings (Plate 9). In fact the drawing by which Mulready gained admission to the Life School of the Academy featured a wrestling theme—a drawing after the cast of the antique group *The Pancrastinae* or *Boxers* (Plate 2).

Mulready's fighting powers were not restricted solely to sport.[112] On more than one occasion he is reported to have attacked footpads who had the misfortune to approach Mulready or a companion.[113] He is said to have met his patron Sheepshanks by rescuing him from an attempted robbery. His other major patron, Sir John Swinburne, also witnessed his pugilistic skills under similar circumstances.[114]

This energetic contact with criminals had another dimension. Like others of the Romantic period Mulready was fascinated with certain forms of aberrant behavior (one thinks of Géricault's portraits of the insane or Goya's visions of prisons and insane asylums). For Mulready, it centered on criminals, a fascination confirmed by several drawings.[115]

In December 1823 and early January 1824 Mulready attended the trial of John Thurtell, a boxing promoter charged and convicted of murdering William Weare. In a letter to Sir John Swinburne[116] describing the trial, he recounts how he "stood for 15 hours without further rest & without any refreshment except two biscuits", making numerous studies of the various parties. The studies to which he referred are undoubtedly the drawings of Thurtell (Plates 10, 11) in the Victoria and Albert Museum. These sympathetic portraits reflect his compassion for the man not the criminal, further demonstrated by his comments to Sir John that "it was extremely painful to me to see towards the close of the evidence for the Prosecution the agony, & death of his watchfulness & the 'gathering up of himself' to bear the worst".[117]

As an artist, Mulready's empathy and interest may have been stirred initially by having had direct contact with the corpses of criminals following their hangings. Artists were given the bodies for study. For example, Mulready's early tutor Thomas Banks made a cast from the dead body of a newly executed criminal in 1801 to be used for study at the Royal Academy Schools.[118] Mulready was actually invited to view

I. (facing page) *The Rattle* 1808. Oil on canvas laid on panel, 14¾ × 13¼. Tate Gallery, London (cat. 37)

21

11. *John Thurtell* 1823–4. Pen and ink, 5⅞ × 2. Victoria and Albert Museum, London (Crown Copyright)

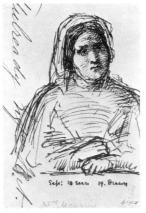

12. *Mrs Manning* 1849. Pen and ink, 3¼ × 2¼. Victoria and Albert Museum, London (Crown Copyright)

"the skeleton of the unfortunate Thurtell . . . as fine a one as ever seen",[119] and the genre painter William P. Frith records that he studied casts from Thurtell's body later at Sass's drawing school.[120] Mulready retained this interest in criminals over the years. As late as 1849 he made drawings after the convicted murderers George and Maria Manning, to be executed for their crime on 13 November 1849 (Plate 12).[121]

Despite Mulready's jocularity in private life—his aggressively physical stance—he was a diffident public speaker and a very cautious man in serious deliberations. Stephens described his poor speaking-manner, and Richard Redgrave mocked his conversational "d'ye sees" and "you knows".[122] Certainly his testimony before two public commissions—one on a proposed site for the National Gallery (1857), and another on the Royal Academy (1863)—reveals a very conscientious, cautious man intent on discussing only those matters which fell within his immediate purview while refusing to express an opinion on any matter that he had not fully considered.[123]

Although cautious by nature, Mulready was not penurious. Having suffered early in his life from poverty,[124] he was anxious to alleviate that condition for others. With the engraver John Pye (Plate 13), he helped revive the Artists' Annuity and Benevolent Fund in 1810 to assist artists and their families who had happened upon bad times. He served frequently as President,[125] working very hard to put the fund on a sound financial basis (although not always with success), and he generously assisted with the collection of funds derived from the Society's distribution of prints after his own painting *The Wolf and the Lamb*, R.A. 1820; an undertaking that brought the Society over one thousand pounds.[126] He also produced a seal for the Society in 1827; the design of which is retained in a preparatory drawing (Plate 14), along with an explanatory note in Mulready's hand describing the nature of the allegory.[127] For his services Mulready received a silver goblet.

Mulready's benevolence also operated on a private level. His Account Book records his loans or gifts to friends or acquaintances, including his notoriously spendthrift brother-in-law John Varley,[128] as well as donations to charities and churches[129] (although he was not a particularly religious man).[130] A wrenchingly sad note from a destitute musician friend, the composer John Liptrot Hatton, who is perhaps portrayed in a very fine pencil drawing of a man examining musical folios (Plate 15), underlines the importance of Mulready's personal loans, when private generosity might be the only alternative to a debtor's prison. Hatton, finding himself imprisoned for debt, appealed to Mulready for "the loan of a few pounds; . . . I feel sure you will pardon me when I tell you that I have only a few shillings left, and that Mrs. Hatton and the Baby . . . are entirely dependent upon me . . . I have avoided troubling my friends until the eleventh hour, but I am now so hard up that I am compelled to borrow."[131] Just three years before, this

same man had written a light-hearted, care-free letter to Mulready when he was visiting Paris, revealing how precarious one's finances could be during this period.[132] Even well-established figures were subject to the whims of the economy; for example, Sir Walter Scott and David Wilkie lost considerable amounts of money in the financial panic of 1825.

The possibility of his own financial failure no doubt encouraged Mulready to assist the indigent and must certainly have contributed to his preoccupation with financial matters. Little scribbled notes abound in his Account Book concerning his conservative and sound investments; but despite these concerns and a successful career he never accumulated the substantial fortune that some of his fellow artists did. His limited production militated against such wealth. Nevertheless he left behind a respectable estate amounting to about fifteen thousand pounds, somewhat below his own expectations.[133]

In the political realm Mulready maintained a low profile although he was a professed democrat. His devotion to everyday scenes can perhaps be linked to his underlying faith in the common man, though only one painting can be construed as a direct political statement: *Returning from the Hustings*, R.A. 1830 (Plate 16), possibly inspired by Hogarth's famous election series. To depict such a scene in 1829 — a drunken voter returning from the notoriously corrupt hustings (electoral proceedings) where votes were openly purchased for the price of a long drinking holiday — to exhibit it at the Royal Academy in 1830 when reform agitation was in full flood leading up to the first major electoral reform

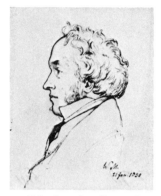

13. *John Pye* 1830. Pen and ink, $3\frac{3}{4} \times 2\frac{7}{8}$. Victoria and Albert Museum, London (Crown Copyright)

14. Sketch for the *Seal of the Artists' Annuity and Benevolent Fund c.* 1834. Pen and ink, $3 \times 2\frac{7}{8}$. Capheaton Collection

15. *A Young Man Examining Musical Folios* 1827. Pencil, $8\frac{5}{8} \times 11$. From the Collection of Mr and Mrs Paul Mellon, Upperville, Virginia

23

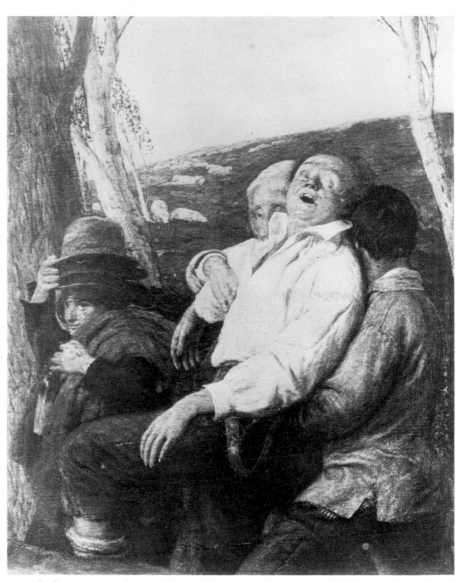

act of 1832 was to throw his weight and influence publicly on the side of democratic reform. An indirect reference to the contemporary class conflict which generated this reform agitation can be seen in Mulready's painting *Dog of Two Minds*, R.A. 1829 (Plate 91), which depicts the suspicion and antagonism between a privileged, disdainful schoolboy and a working lad.

While *Returning from the Hustings* is the only direct reference in his own oeuvre to the reform movement that swept England in the nineteenth century, Mulready was surrounded by close associates who were active reformers. Early in the century he was on intimate terms with the radical libertarian William Godwin.[134] Sir John Edward

24

Swinburne, Mulready's close friend and patron from 1811 until Sir John's death in 1860, was a Whig agitator for electoral reform and religious liberty. In addition Swinburne served as an informal adviser to his northern neighbor and friend Earl Grey, the Prime Minister responsible for guiding the first important electoral reform bill through Parliament in 1832.[135] Grey patronized Mulready, following Swinburne's introduction. The political views of Mulready's close friend and patron John Sheepshanks are not known, although his concern that "the industrial classes"—i.e. the workers—be freely admitted to his collection of paintings on weeknights and Sundays would seem to indicate democratic sympathies.[136] Lastly, Sir Henry Cole, Mulready's devoted friend from 1839 until his death—the man responsible for arranging two major exhibitions of Mulready's works[137]—was an active reformer, although not strictly in the political sense. As a civil servant, he was a major force behind the reorganization of the Public Records, and the introduction of Rowland Hill's Penny Post. Through his interest in better industrial design he gave an important stimulus to the Great Exhibition of 1851. He drew Mulready into the latter two schemes—soliciting his design for the first Penny Post envelope (distributed in 1840), an envelope coveted by collectors today although scorned by the public then (Plate 17)[138] and asking Mulready to contribute to his Art Manufactures, a plan whereby artists designed common everyday objects for public use.[139] Cole was also an acquaintance and a great admirer of Thomas Carlyle and William Makepeace Thackeray and probably introduced Mulready to both.

But Mulready never actively participated in political affairs or movements in social reform. In fact, the only institution which

17. Penny Post Envelope after Mulready's design, 1840 (Crown Copyright)

25

consistently generated his enthusiastic participation was the Royal Academy.

From the time of Mulready's admission to the Schools in 1800 until his death in 1863, the Royal Academy represented much more to him than a mere professional affiliation; it was the focal point of his life. For English artists who had recently emerged from the category of craftsman, membership in the Royal Academy was an intellectual badge and represented a newly established social status.[140] As intellectuals and gentlemen they held respected positions in society. Mulready, an Irish Catholic immigrant and son of a craftsman, was in this way assured of social as well as professional status.

While Mulready's passage from Associate to full Academician was unusually rapid (a matter of a few months) his actual admission to membership in 1816 was far from premature. He turned thirty just a few weeks after the election. While others waited much longer—notably Constable who was only elected an Associate in 1819 at forty-three— some entered at a much earlier age: for example, Sir Thomas Lawrence at twenty-two and Turner at twenty-four. More to the point, his good friend Wilkie had become an Associate in 1809 at twenty-four and a full Academician two years later.

Mulready was first considered for Associate membership in 1811, although he received no votes in the election.[141] A letter from Wilkie in December 1813 suggests that Mulready was in low spirits after another failure to be elected in a recent vote. Wilkie described his own behind-the-scenes effort to support Mulready with the assistance of their mutual friend Augustus Callcott:

At the last election of Associates at the R. Academy you would hear that [William] Hilton and [George Francis] Joseph got in. My hopes of your success was rather diminished, by the names that were talked of, before the election; but when we met, I found a greater disposition to support you than I expected. At the first election there was one scratch for you, which neither Callcott nor myself could find out the author of. & consequently could not secure him for the second. for the second however we thought we had secured two besides ourselves, but unfortunately one of the two failed us, we could not tell how, & your name of course having only three did not come upon the ballot. The utmost we expected to do was to call the attention of the members towards you by having you opposed to the successful candidate but altho we failed even in this, we think there is sufficient encouragement to expect that if you can get something new ready for the spring [R.A. exhibition] you will have a very fair chance at the next years election. I therefore intreat you to take this into your consideration. Think of a subject of interest & with not too many

figures in it. Come to London [Mulready was then in Northumberland with the Swinburnes] and set about it.[142]

Mulready succeeded soon after, in November 1815, following the exhibition of *Idle Boys* (Plates 84, 178) at the Royal Academy that spring, which might quite aptly have been described as a "subject of interest"—a schoolroom scene—"with not too many figures". His election to Academician followed in February 1816.[143]

Once a member Mulready took his responsibilities very seriously. The Royal Academy Ledgers record his participation on the Councils, as the R.A. auditor for a number of years, as inspector of casts, and as a member of the hanging committee for four exhibitions (1817, 1824, 1834 and 1842).[144] He was evidently quite successful in this last position,[145] although when he last served in this capacity his conscientiousness caused a breach with his co-worker David Roberts, who evidently overly favored the works of fellow Scotsmen, much to Mulready's dismay.[146]

Mulready himself could be less than entirely scrupulous with his own friends. For this same exhibition Mulready privately advised Linnell to withdraw two portraits which Mulready was unwilling to hang in a prestigious place. Linnell refused to withdraw them, Mulready gave in, and the portraits were hung favorably;[147] but this capitulation must not be allowed to efface his initial attempt to censure the works of a lifelong friend. Although this scrupulous critical faculty was constantly exercised on his own works as well, often resulting in extensive preparatory studies and inordinate delay in the completion of paintings, his "dread intelligence" as Cole described it was more notoriously brought to bear on the works of fellow artists, both privately and as an active member of the R.A. hanging committees.

The other side of this overt criticism of his own and others' work was pride in his artistic accomplishment and in his own serious judgment. As the younger artist J. C. Horsley recalled, "Mulready entirely shared in [his patrons'] estimate of his own merits, but he was given to making slashing criticisms on his fellow artists. . ."[148] This self-importance or professional pride was remarked upon by his peers and recorded by Farington, firstly when Mulready was a drawing student at the Academy Schools, secondly when Mulready as a young artist charged inflated prices for his earliest works,[149] and lastly when Mulready as a newly elected Academician displayed "sudden self-importance" in the Academy Council.[150] A newspaper critic, while praising John Linnell's fine portrait of Mulready (Frontispiece) complained that Linnell had missed Mulready's "peculiar carriage, which is of the pompous character, in affected imitation of the grace and dignity of Pickersgill".[151] Yet this critical and proud nature was leavened by his generous professional instincts, particularly with regard to less well-established

18. Sketch for a Royal Academy Medal (Turner Prize) 1858. Pen and ink, 3 × 2⅞. Royal Academy of Arts, London

artists. For example, he proposed the motion to abolish Varnishing Days in 1852 (following Turner's death, for whom they had been specially retained). These were the few days before the R.A. annual exhibition when members alone were allowed to retouch their works, often to the disadvantage of non-members whose works hung beside theirs.[152]

But his professional generosity was most openly displayed in his magnanimous instruction at the Royal Academy Schools. Mulready accumulated thirty-four attendances (each a month-long teaching appointment) in the Life Academy and thirty-two attendances in the School of Painting—quite an incredible record. Moreover, this does not include the number of times he substituted for others. For example, in 1853 he not only acted as Visitor on his own behalf in both Schools but also substituted for C. W. Cope in the Painting School (1 August–27 August) and for William Dyce in the Life Academy (over the same period).[153] While Visitors were recompensed for their supervision (one guinea per appearance—averaging twenty-five pounds for Mulready's monthly visiting period) this can hardly account for Mulready's remarkable attendance record,[154] which should rather be explained by his overriding devotion to the students, who welcomed his instruction with unqualified appreciation. Student attendance at the schools (always voluntary) rose perceptibly when Mulready was Visitor. Even at seventy-three, as Redgrave reported with some astonishment, Mulready continued to "work at the 'Life' like any young student", to the extent of declining a dinner invitation, excusing himself "because it was his night at the drawing-class".[155]

This respect for the Academy's important role as a teaching facility was also expressed in his little-known design of 1858 for a Royal Academy medal, the Turner Prize (Plate 18).[156] Rather than reflecting Turner's eminent position as a landscape painter, as did Daniel Maclise in the design which was finally selected by the Academy, Mulready emphasized his own concerns by depicting the Life Academy with students anxiously studying the model.[157]

Mulready's devotion and the skill with which he took up his teaching duties at the Royal Academy were warmly praised by his fellow Academicians during Commission hearings on the Academy in 1863— surely a gratifying experience for the seventy-eight-year-old artist.[158] Though encouraged to criticize the Academy before the Commissioners, Mulready was very reluctant to air any wrongs outside the walls of the institution; if any reforms were in order the Academicians themselves should undertake them, not the public at large. His beloved professional Academy retained his allegiance,[159] support and participation quite literally until his dying day. On the evening preceding his death he acted as Visitor in the Academy Schools followed by a committee meeting which lasted until nearly 11.00 p.m. He died at home in the early hours of the following morning, 7 July 1863.[160]

28

Mulready's subject matter was decidedly diverse, particularly during the first decade of his career. Landscapes (often in conjunction with the by then customary sketching tour), interiors in the Dutch style, literary scenes, history painting, portraits—all fell within his range. He also assisted Robert Ker Porter (1780—1842) with his famous panoramas: the *Battles of Alexandria* (1802), *Lodi* (1802) and *Agincourt* (1804–5) and possibly with the *Battle of Seringapatam* (1800), thus participating in a craze that swept through the artistic world in the late eighteenth and early nineteenth centuries.[161] To provide much needed supplementary income, he illustrated a number of children's books for William Godwin (Plate 19) and John Harris of the Juvenile Library of which perhaps *The Butterfly's Ball and the Grasshopper's Feast* (1807) was the most popular (Plate 20). These wonderfully whimsical designs deservedly earned the praise of one of the most important illustrators of the period, John Flaxman.[162] However, by the time Mulready was elected a Royal Academician in 1816 he had narrowed his scope considerably, concentrating on the field of domestic genre, although he never completely abandoned his other interests.

Following the example of earlier English artists such as Hogarth and Gainsborough, Mulready never travelled abroad to visit the shrines of the old masters, although not for lack of respect and admiration. Whenever possible he studied their works in private collections, exhibitions, and public auctions, or through the more common medium of prints.[163] Seventeenth-century Dutch and Flemish works, and (following the Napoleonic Wars) Italian paintings were heavily collected by the wealthy English and their collections were quite readily accessible to artists, if often for a fee.[164] With the introduction of the old master exhibitions at the British Institution in 1815 such works in private collections were available for public viewing. Even Northern Renaissance painters, though far less popular than Raphael, Guido, Titian and the Teniers, were visible in London with viewing by invitation at the Aders Collection in Euston Square.[165] Mulready took advantage of all such opportunities.

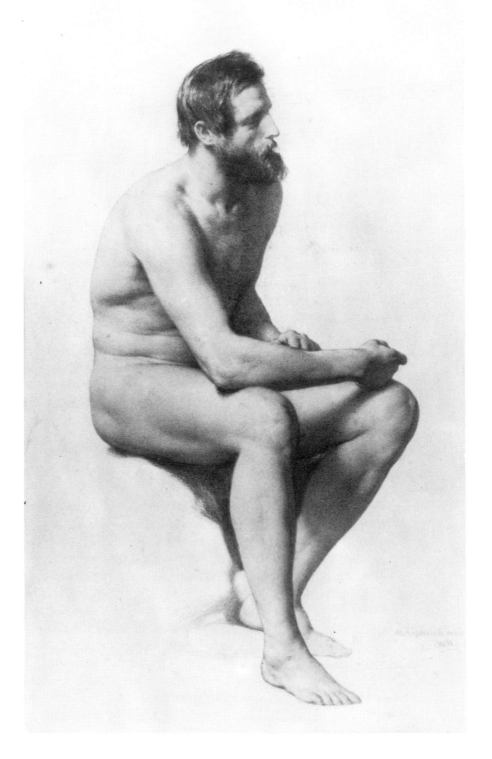

21. *Male Nude* 1860. Black
and red chalk, $20\frac{7}{8} \times 12\frac{5}{8}$.
Courtesy of the National
Gallery of Ireland, Dublin

22. (facing page) *Female Nude*
Black and white chalk on
grey-green paper, $14 \times 11\frac{1}{4}$.
Victoria and Albert Museum,
London (Crown Copyright)

30

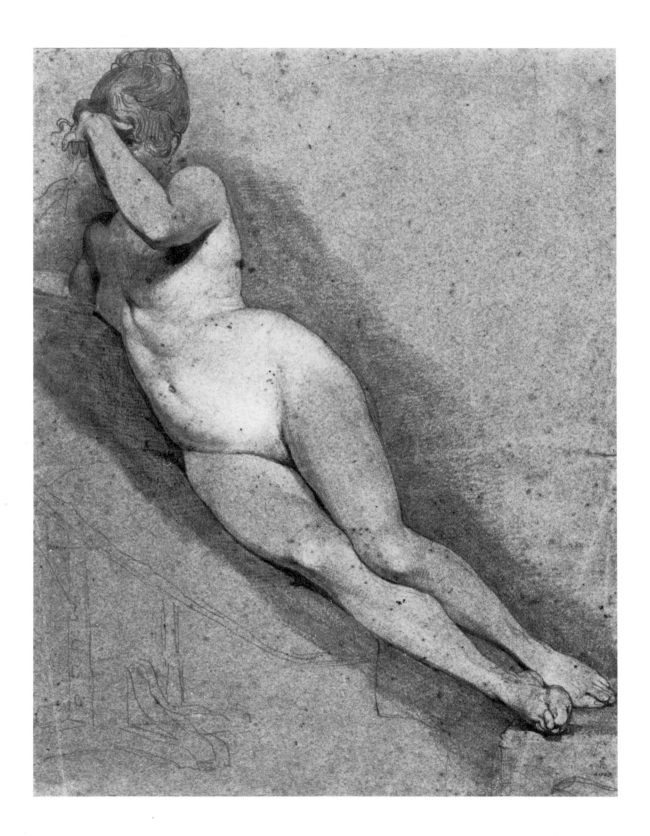

His notebooks reveal his familiarity with art historical writings, including Leonardo de Vinci's *Treatise on Painting* and Vasari's commentary on Michelangelo's Sistine Chapel ceiling. The latter inspired Mulready's precise calculation of the total number of hours required by Michelangelo to complete his masterpiece, an unsurprising if literal-minded preoccupation for an artist who frequently labored for over a year to complete one small oil painting.[166]

Mulready was also acquainted with modern French painting,[167] acknowledging its superiority to the British in drawing and in reverence for the antique. He cited David, Guérin and Girodet for particular praise.[168] While making no reference to his nearer contemporaries Delacroix and Géricault, Mulready's interest in modern French painting was not restricted to the lofty style flourishing at the turn of the century. As late as 1855, when declining an invitation to visit the International Exhibition in Paris (where his own paintings were prominently displayed and well received),[169] Mulready excused his absence from France while disclosing his current interest in things French by explaining that he had already examined "some beautiful things at the French Exhibition in London this year and . . . had a thorough good look at them".[170]

While Mulready was cognizant of past and contemporary accomplishments in the arts, as is often evident in his work, he nevertheless maintained a healthy scepticism in the face of tradition. "The things most praised 'that have stood the test of ages' are overated, and a sound code of laws cannot, in a direct manner be deduced from them." Instead, like a true nineteenth-century empiricist he declared "Never dispute about principles of Art, or the Laws of Nature—*Try them* in your works."[171] In other words, experimental practice not conventional theory should guide the artist. Certainly in his own painting his imagination and the established conventions of the old masters were thoroughly tempered by an overwhelming devotion to nature—to observed reality.

Mulready constantly turned to the real world for inspiration and confirmation, often to the point of dissecting flora and fauna in an attempt to master their mystery. He explained, "You can hardly look too much to nature."[172] And to Mulready nature did not consist of landscape elements alone; the human body was subjected to an equally intensive, almost obsessive study, as evidenced in his innumerable drawings of the human form (Plates 21, 22).

This realism, often quite unfettered by convention in his early landscape studies, later became a mere handmaiden to the humorous incident or tender sentiment contained in his domestic scenes, but it never deserted him. This faith in the actual, if only in the details of his works, relates him to the larger movement of Romantic Realism, as

exemplified by Constable's cloud studies, Philip Otto Runge's flowers or
Ingres' meticulous depiction of material objects. And Mulready's
passion for drawing, a life-long love, was closely associated with his
desire to capture the essence of visible nature. Throughout his career his
surroundings fell under his investigation and the power of his pencil.
Individual leaves, flowers, pebbles, elbows, knees or hands were
subjected to a minute, almost microscopic observation,[173] producing
quite beautiful drawings in the process—drawings seemingly "done
upon oath" as Edwin Landseer aptly described them (Plates 23, 24).[174]

Mulready also held modern, non-academic views with regard to the
recognized importance of formal means and the subsequent demotion of
subject matter, believing that any subject could "be raised into
importance by truth and beauty of light and shade and colour and with
an unostentatious mastery of execution";[175] thus sounding almost like
Courbet or the champion of French Realism Theophile Thoré, who
echoed Mulready's thoughts when he spoke of "an original feeling for
nature and a personal execution. . . When a painter has these two
qualities, even if he applies them to the most inferior objects, he is a
master of his art and in his art."[176]

23. *Sunflowers* (Study for *The
Toyseller*) 1861. Pen and ink,
$11\frac{1}{4} \times 16$. Victoria and Albert
Museum, London (Crown
Copyright)

33

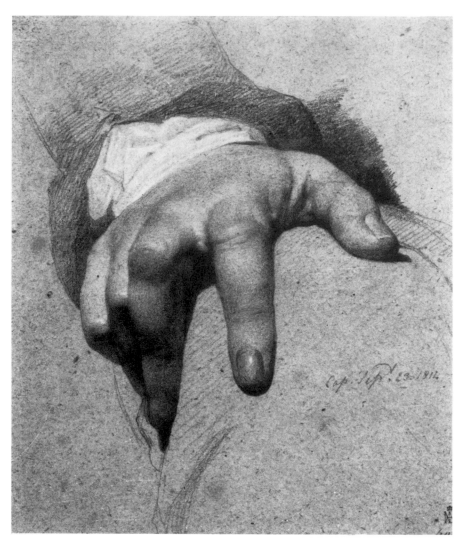

24. *Hand* 1814. Chalk,
$6\frac{9}{16} \times 5\frac{11}{16}$. Victoria and Albert
Museum, London (Crown
Copyright)

But in general Mulready's subjects, though familiar, were not aggressively contemporary, nor, with few exceptions, were they projected to the grandiose scale of history painting as was true of French Realism. His rustic children, his love scenes—relying for the most part on existing formulas—were essentially timeless. He was reluctant to eliminate beauty for the sake of truth[177]—at least in finished oil paintings. This was a sacrifice which both Courbet and the Pre-Raphaelites were willing to make.[178] Expression remained for Mulready a dominant concern, whether humorous, tender or instructive.

During his lifetime Mulready accumulated a number of honors in addition to his Royal Academy membership. He was chosen a charter member of the prestigious Athenaeum Club in 1824. He was nominated an honorary member of such institutions as the Leeds Academy of Art

(1853), the Royal Academy of Amsterdam (1856), the Royal Hibernian Academy (1860), and, along with such famous contemporaries as Carlyle, Tennyson, Browning and Thackeray, was nominated an honorary member of the Pre-Raphaelites' Hogarth Club.[179] Even more importantly for his professional prestige, his paintings were consistently given a prominent place in the recently instituted international exhibitions; he had nine works displayed at the Exposition Universelle in Paris (1855),[180] which earned Mulready the title of Chevalier in the Legion of Honor.[181]

His reputation was sustained for years after his death, declining only with the close of the Victorian period at the turn of the century. In recent years his life work—like that of so many of his contemporaries—has been generating renewed and deserved attention.

II. Landscape

In the early years of his career Mulready's attention was divided between two distinct traditions: history painting, at that time commonly perceived as the prestigious pinnacle of painting; and the picturesque style of landscape painting, then enjoying an unparalleled vogue. Not surprisingly, he opted for the latter; for, while history painting languished with few practitioners, the august walls of the Royal Academy were filled with charming rustic scenes. In focusing his attention on the English countryside—on its decaying monuments and its decrepit cottages—Mulready joined the current and by then conventional craze for the "picturesque" in all its splendid irregularity.[1]

In 1804 Mulready is thought to have submitted a history painting, *The Disobedient Prophet*, to the Royal Academy, but it was rejected for exhibition. According to F. G. Stephens this failure led Mulready to abandon history painting in favor of landscape painting. This is surely an oversimplification. While still a youthful Academy student, Mulready had sought the instruction of the landscape artist John Varley—certainly by 1803, the year of his marriage to Elizabeth Varley, and probably before.[2] This was hardly the action of an artist intent upon channelling his energies solely toward history painting. Moreover in 1804, the year which saw the rejection by the Royal Academy of his historical entry, Mulready successfully submitted three paintings in the picturesque style,[3] which emphasizes his own early preference. Mulready's Account Book, which begins in 1805, underlines this point. Landscape and cottage scenes abound between 1805 and 1815 (approximately twenty-three are listed) whereas historical subjects occur only three times.[4]

Unfortunately, very little evidence remains to demonstrate Mulready's stylistic treatment of historical subjects.[5] The paintings are lost, and are likely to remain so if unsigned, since they are so far removed in their nature from his mature work. The Victoria and Albert Museum retains three undated drawings believed to be preparatory studies for

36

The Disobedient Prophet[6], the historical painting which Stephens "on excellent authority" cites as having been rejected by the Academy in 1804.[7] This grisly Old Testament subject concerns a prophet who was consumed by a lion for disobeying the wishes of God. The drawings (Plate 25) merely show a prostrate male in sharp, raking light, a figure which was clearly based on Mulready's studies in the Academy's life class.

Another historical subject (unidentified) may be retained in a sketch by one of Mulready's pupils. The drawing (Plate 26), thought to be copied from one of Mulready's sketches for a lost painting, shows a similarly prostrate figure, quietly observed by another person, highlighted against a dramatic shipwreck scene, much like the numerous "Deluge" paintings so popular with Romantic artists at the turn of the century.[8] The supine figure itself is reminiscent of several produced by J. H. Fuseli, then Professor of Painting at the Academy.[9] The inherent violence of both subjects suggests that Mulready, like other artists of his generation, was attracted by the contemporary fashion for grand, often apocalyptic historical themes.

But in any case, his few historical pieces should be viewed as experimental aberrations, beyond the usual scope of his youthful oeuvre.[10] By 1808 he was quite well established as a painter of picturesque scenes, having exhibited twelve such paintings at the Royal Academy between 1804 and 1807. Between 1803 and 1814 picturesque scenes or landscape paintings constituted the bulk of his artistic production. They may be divided roughly into three categories: antiquarian studies of architectural monuments, *plein-air* oil sketches and cottage scenes.

The influence of Mulready's tutor John Varley can be seen in the subject matter of Mulready's first exhibited works at the Royal Academy in 1804: two views of Kirkstall Abbey, Yorkshire and a third work, *A Cottage at Knaresborough, Yorkshire*. These paintings were the result of a sketching tour undertaken the previous summer, probably in the

25. Study for *The Disobedient Prophet* Black and white chalk, $14\frac{1}{2} \times 21\frac{1}{8}$. Victoria and Albert Museum, London (Crown Copyright)

26. Frances E. Swinburne (after Mulready?) *Shipwreck Scene* Black and white chalk, $5\frac{3}{4} \times 7\frac{1}{2}$. Capheaton Collection

37

company of Varley.[11] By taking part in such summer sketching excursions Mulready was following not only Varley's example but that of a large corps of landscape artists—primarily watercolorists—who trod the picturesque path before him, including Thomas Girtin, J. M. W. Turner and John Sell Cotman. Mulready continued this practice for several years, visiting North Wales, Eton and Windsor, St. Albans, Rochester and Chatham, as well as Yorkshire;[12] all these are documented by either drawings, paintings or notations in his Account Book.

It is difficult to determine whether Mulready's first exhibited works were oils or watercolors, thus impeding their identification today. He worked in both media, undoubtedly transforming some themes from watercolor sketches to finished oils. But as he worked under Varley, one would expect to discover that some of Mulready's earliest exhibited works were indeed watercolor paintings. This seems to be the case.

Stephens ignored the problem, simply assuming that all his exhibited works were oils, an assumption subsequently followed in the 1964 catalogue of the Mulready exhibition in Bristol. But a manuscript catalogue detailing Mulready's exhibited works, believed to have been compiled by Henry Cole in preparation for the Mulready exhibition at the Society of Arts in 1848 (an exhibition which received Mulready's active cooperation and assistance), describes as watercolors all three works exhibited at the Royal Academy in 1804, as well as two of the three works shown in 1805.[13] Cole was unable to include these works in the 1848 exhibition. However, one of the works, *The Crypt in Kirkstall Abbey* (R.A. 1804, 329), subsequently appeared in the Mulready exhibition at the South Kensington Museum in 1864 where it was clearly described as an oil painting "cracked from the use of asphaltum" (now lost).

This discrepancy need not lead us to dismiss completely the watercolor designation for Mulready's other early paintings, particularly in the light of concrete supporting evidence.[14] For example, the placement of the *West-Front Entrance of Kirkstall Abbey, Yorkshire* in the Royal Academy exhibition of 1804 (411) supports its identification as a watercolor. It was placed alongside John Sell Cotman's *Newburgh Park, Yorkshire* (409), and Paul Sandby Munn's *Richmond, Yorkshire* (410), both certainly watercolors. Moreover, an additional notation in the Cole manuscript catalogue lists the *West-Front Entrance of Kirkstall Abbey, Yorkshire* as being in the possession of "Miss Swinburne", Mulready's pupil and the daughter of his patron Sir John E. Swinburne, Bart. A watercolor drawing in the Victoria and Albert Museum now simply entitled *An Abbey Gateway*, signed and dated 1804 (Plate 27), is in fact the west-front entrance of Kirkstall Abbey and was included in the background of a small self-portrait by Frances Swinburne (Plate 28).

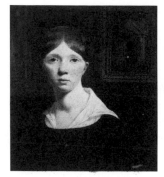

28. Frances E. Swinburne *Self-Portrait* 1813. Oil on panel, $5\frac{1}{8} \times 4\frac{5}{8}$. Capheaton Collection

27. (facing page) *West-Front Entrance of Kirkstall Abbey, Yorkshire* 1804. Watercolor and pencil, $15\frac{3}{4} \times 10\frac{3}{4}$. Victoria and Albert Museum (Crown Copyright) (cat. 4)

39

This drawing was subsequently auctioned in the sale of Miss Julia Swinburne's property at Christie's in 1893 (8 July, no. 47) where it was identified as "A Church Door: An Early Work by W. Mulready, R.A."[15] This watercolor ("Abbey Gateway" or "Church Door"), now identified as portraying the west-front entrance of Kirkstall Abbey, Yorkshire, was probably the painting exhibited at the Royal Academy in 1804. If this is true—and it seems quite likely—then another large watercolor, *The Porch of St. Margaret's, York*, 1803 (Plate 29), now held in the British Museum, should be identified with the work of the same title exhibited at the Royal Academy in 1805.[16]

These two watercolors allow us to assess Mulready's approach to antiquarian monuments, which were then a staple of the picturesque style—though these works hardly conform to the conventional picturesque mold. Rather than situating these architectural relics in craggy, rugged landscapes or in lush, pastoral settings, their fearful contours cast against a stormy sky, their derelict condition symbolizing the transience of human creation subject to the ravages of time—all stock theatrical effects then in fashion[17]—Mulready produced direct, close-up views of sturdy, massive architectural forms naively filling almost every inch of the watercolor's surface. They are faithful, factual representations of Norman doors, with the heavily sculpted decorative elements lovingly, almost tangibly recreated in the strong light.[18]

The Porch of St. Margaret's, York (Plate 29) presents the more unusual view: a scene of solid, massive walls, unrelieved by human habitation,[19] and lightened by a mere sliver of sky. But the Kirkstall Abbey watercolor (Plate 27) is certainly more dramatic, even Romantic, if somewhat less naive in its approach. Here the door assumes even greater proportion within the painting, with a lively contrast established between the brightly illuminated projecting porch and the shadowy interior. The inside of the church is overgrown; lush, natural elements have taken over the ground as the exterior wall is encroached upon by an enormous leafy tree, softening the otherwise strong stone walls of the ruin, and subtly suggesting decay, loss and the passage of time. Most significantly, a child has been introduced (pasted on over the original surface of the drawing), gathering flowers, the short-lived flora surrounding the long-surviving medieval building. Yet even with these Romantic overtones the image is less picturesque, less Romantic than it might have been, since little attention is given to the visibly ruined state of the abbey, a condition that more distant views conveyed so dramatically.[20] Nor is it sublime as were so many views of Gothic ruins. Its earthy, stolid Norman forms scarcely inspire or invoke awe. Rather it is domesticated; the solid Norman relic shelters the child gathering flowers.

The only other artist to approach Mulready's disarmingly direct and

40

domesticated depiction of architectural monuments was John Sell Cotman—and then only rarely. His later *Porch of the Free School, Thetford, Norfolk* (Plate 30), signed and dated 1818, is remarkably similar. Like Mulready's *Porch of St. Margaret's, York*, the building looms in the foreground relieved by a sliver of sky; and, like the Kirkstall Abbey watercolor, the heavy architectural forms are lightened by the presence of children, though here a more indigenous element. This is not the sole example of the closeness of their styles. Mulready and Cotman's cottage paintings can be confused, and on at least one occasion both artists treated the same subject, with Cotman clearly following Mulready's composition. (This will be discussed later.)

Mulready's rather pedestrian approach to architectural monuments can also be discerned on occasion in the topographical work of his tutor Varley, although Varley never confronted the viewer with quite the persistently naive vision displayed in Mulready's two antiquarian views. A print after Varley's drawing *Interior of a Vaulted Chamber, Kirkstall Abbey* (Plate 31) demonstrates his ability to transform a potentially poetic ruin into a mere stable, of no exaggerated proportions, for a shepherd boy and his domesticated animals. But Varley reveals his more characteristic concerns in another close-up view of Kirkstall Abbey (Plate 32), a watercolor painting which draws attention to the decidedly ruinous condition of the abbey.[21] Here Varley exploits the capacity of watercolor to capture the evanescent effects of light and dark playing on the crumbling surface of the ruin, creating nearly abstract patterns.

In contrast, Mulready's architectural drawings seem somehow at odds with the delicate watercolor medium, a means so well suited to

30. John Sell Cotman *Porch of the Free School, Thetford, Norfolk* 1818. Pencil and sepia wash, 10 × 7½. The Toledo Museum of Art, Toledo, Ohio

31. Engraving after John Varley, *Interior of a Vaulted Chamber, Kirkstall Abbey* 1808

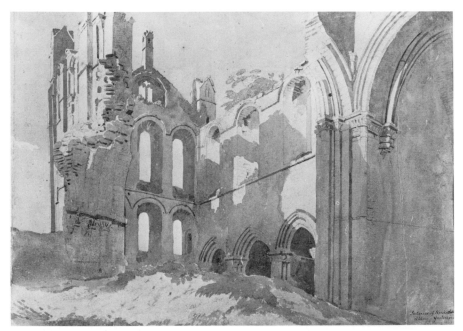

32. John Varley *Interior of Kirkstall Abbey, Yorkshire* 1803. Watercolor and pencil, $10\frac{1}{8} \times 14\frac{1}{8}$. City Museum and Art Gallery, Stoke-on-Trent

rendering transient effects and atmospheric variation, but sadly ill-equipped to create the weighty, geometric mass which we sense to be Mulready's objective. Not that he completely avoids the transparent quality of watercolor; for in both drawings watercolor washes dapple the brown-gray neutral surfaces with light while at the same time creating an almost dazzlingly bright effect on the projecting architectural elements.[22] But his obvious relish in depicting solid material forms would seem to preclude the use of the watercolor medium. His later almost exclusive use of oil for finished paintings seems appropriate in the light of his demonstrated desire to capture the illusion of solid full-bodied matter.

In some respects, Mulready's most important landscape paintings are his bold, painterly *plein-air* oil sketches of 1806 (Plates 33–35, 170).[23] Painted in the open air not as studies for specific paintings but as independent works of art, they are among the earliest examples of this form of landscape painting.[24] Although John Varley worked almost exclusively in watercolor, he was evidently responsible for encouraging Mulready to sketch in oil directly from nature.

Varley instructed his pupils to "Go to nature" for their inspiration[25] and he, along with other touring artists, including his younger brother and pupil, Cornelius Varley, sketched directly from nature using watercolor or black-lead. An 1805 watercolor by Cornelius Varley inscribed "Evening at Llanberris C. Varley 1805" (Plate 36) comes quite close to the direct, informal approach that appears in Mulready's oils of the succeeding year. But by far the closest parallels can be found

43

33. *Hampstead Heath* 1806.
Oil on millboard, $5\frac{1}{2} \times 10$.
Victoria and Albert Museum,
London (Crown Copyright)
(cat. 16)

34. *Hampstead Heath* 1806.
Oil on millboard, $6\frac{1}{2} \times 10\frac{1}{4}$.
Victoria and Albert Museum,
London (Crown Copyright)
(cat. 17)

35. *Hampstead Heath* 1806
Oil on millboard, $6 \times 10\frac{1}{4}$.
Victoria and Albert Museum,
London (Crown Copyright)
(cat. 18)

in the paintings of John Varley's other pupils, John Linnell and William Henry Hunt, who likewise produced broad open-air oil sketches in 1806 (Plate 37).[26] Mulready, the eldest and the artist to whom both Linnell and Hunt looked for guidance, was the leader of this trio. Years later, Linnell testified to this guidance in his Autobiographical Notes: "I always received more instruction from Mulready than from anyone. Indeed, I feel bound to say that I owe more to him than to anyone I ever knew. . ."

The Victoria and Albert Museum has several open-air oil sketches by Mulready: three views of Hampstead Heath and probably another, *Cottages on the Coast*, signed and dated 1806. In the briefest, boldest painting (Plate 33) Mulready sketched out broad areas of light and dark—sky and ground—with patchy notations of somber color, roughly applied to the millboard. In the other three more detailed paintings (Plates 34, 35, 170) he economically indicated foliage, cows, birds, cottages and people with just a few well-placed strokes. Of the Hampstead Heath oils, the more highly finished painting (Plate 35) is signed with his full name, the other two only with initials, perhaps providing an index of his own assessment of the sketches as complete artistic statements.

The most remarkable aspect of the Heath scenes—beyond their immediacy and the bravura of their brushstrokes—is the correlation between skies and foreground, the play of light and shadow over the ground. In the landscape with caravan (Plate 34), the dark shadow hovering over the right half of the canvas, deepening the sandy foreground area as well as the grassy area above, echoes the cumulus cloud formations over the strolling figures: a naturalistic effect reinforced by the exceptionally high horizon which, though artistically unconventional, captures the essence of the looming, swelling hills of Hampstead Heath. The generally overcast slate-gray sky in the landscape with cows (Plate 35) casts a gloomy gray tone over the entire foreground slope, particularly the steely pond in the immediate foreground.

Mulready's brother-in-law Cornelius Varley had made extensive notes on the changing appearance of skies on a Welsh tour the previous

36. Cornelius Varley *Evening at Llanberris* 1805. Watercolor, $7\frac{7}{8} \times 9\frac{3}{8}$, Tate Gallery, London

37. John Linnell *At Twickenham* 1806. Oil on millboard, $6\frac{1}{2} \times 10$. Tate Gallery, London

year (1805).[27] Mulready's studies of Hampstead Heath under various skies provide a parallel. Such concerns seem less evident in the work of his sketching companions Linnell and Hunt, although their works feature similarly bold and brief transcriptions of nature.

Mulready and his younger followers were painting these *plein-air* oil sketches at approximately the same time that their more famous contemporaries Turner and Constable produced their earliest outdoor oil sketches; and perhaps before. Turner's scenes along the Thames are believed to have been done about 1806–7,[28] and like Mulready's they dwell on the briefest indications of the landscape. Yet Turner's viewpoint, encompassing broad views of the Thames, seems somehow more composed, more carefully chosen to realise aesthetic possibilities. And in fact exhibited oils were later based on these bold sketches. Mulready's sketches, painted for their own sake, spawned no finished landscape paintings.

Constable's open-air oil sketches were primarily undertaken after 1808 although he probably painted partly out of doors as early as 1802 when he made his famous remark to John Dunthorne: "I shall make some laborious studies from nature . . . there is room enough for a natural painture."[29] Like Turner and Mulready, he sought to render the essence of the scene before him with the barest indications of form. But true to his later development, Constable favored cool green foliage and high-keyed blue skies, vibrating with a fresh, dewy clear light. Mulready's little oils (and Turner's too) look muddy by comparison.

Unlike Constable, Mulready abandoned open-air oil painting, perhaps as a result of its great inconvenience, a practical problem recognized decades later by the Pre-Raphaelite circle.[30] But he never abandoned sketching outdoors. He created exceedingly beautiful drawings from nature long after he abandoned the practice of *plein-air* oil sketching—in fact, up until his death. Only a few of these drawings are directly related to specific oil paintings. This persistent, life-long devotion to sketching from nature was undertaken (in his own words) to "strengthen our knowledge of the structure [of the natural world] . . . to enable us to paint better views with increased truth and feeling".[31] These beautifully conceived drawings range from highly finished studies of landscape scenes (Plates 38, 39), to delicately brief sketches of foliated branches, almost Oriental in flavor (Plate 40), to acutely perceived and minutely drawn botanical diagrams (Plate 41),[32] attracting contemporary comparisons with Dürer's work.[33] Mulready's landscape studies could even take on a rather modern, expressionistic aura, as seen for example in a pen and ink drawing (Plate 42) where the human figure is dwarfed by massive, gnarled treetrunks, foreshadowing in its Romantic Realist way the expressive quality found in later Symbolist works.[34]

38. (facing page above) *Mounces Know, Capheaton* 1814. Pencil, heightened with white on grey-green paper, $10\frac{5}{8} \times 14\frac{1}{4}$. The Marc Fitch Fund

39. (facing page below) *Capheaton, Moonlight c.* 1845. Pastel, $3\frac{9}{16} \times 5\frac{15}{16}$. Courtesy of the National Gallery of Ireland, Dublin

40. *A Branch* 1850. Pencil, $4\frac{7}{8} \times 5\frac{1}{4}$. Whitworth Art Gallery, University of Manchester

41. *Sycamore Pods* 1860. Pen and brown ink, watercolor, 7×5. Whitworth Art Gallery, University of Manchester

Mulready's intensive, almost scientific analysis of nature extended to the study of clouds as well. Clouds *per se* had attracted the attention of English artists since the latter part of the eighteenth century, some as mere formalized schema—for example, Alexander Cozens' sky types— or as natural phenomena, or more often as a combination of both. John Malchair (Sir George Beaumont's painting tutor) made meteorological notes in the late eighteenth century; Cornelius Varley (as stated earlier) observed the sky at specific times of day;[35] Mulready's open-air oils evidenced a certain interest in the sky as actually seen; and of course Constable painted remarkable cloud studies in oil about 1820–2. Constable's devotion to scientific enquiry and his belief that landscape painting should in some measure parallel natural philosophy supported his meteorological interests. It is well known that one of Constable's cloud studies of 1822 appears to have the notation "cirrus" on the back, indicating his familiarity with the meteorologist Luke Howard's classification of clouds in *The Climate of London* published in 1820.[36]

Just two years later in 1824 Mulready made much more extensive notes and drawings on the nature of clouds, using Howard's full nomenclature; in fact one of his drawings is devoted entirely to the illustration of this classification system with brief descriptive drawings beside each cloud category (Plate 43) i.e. Cirrus, Cirrostratus, Cirrocumuli, Cumuli, etc. While this sheet itself is not dated, another sketching sheet with several landscape studies devoting particular attention to skies is dated "Sept 24 & Oct 18th 1824". Like Constable,

48

Mulready recorded changing weather conditions on his drawings: "N.E. 11.A.M. Oct 18 1824 The Day brightened in half an hour ... bright points of cloud appeared above: thin Cirrus & Cirrostratus & higher floating bright warm cumuli."[37] Constable may have popularized Howard's work among artists or Mulready may have encountered it on his own. In any case, he surely cited Howard's classification system more specifically and wholeheartedly than Constable did with his nearly illegible scribble.

Strangely, Mulready's innumerable nature drawings, both meteorological and botanical, followed his most active period as a fresh, naturalistic landscape painter during the first decade of his career. The landscape backgrounds of his later genre paintings only rarely suggest the visual perspicacity of his contemporary sharp-focused botanical sketches. But this later development is far removed from his early cottage scenes and studio landscapes painted prior to 1814, which are characterized by their precise delineation of the natural world.

Cottage scenes, like antiquarian monuments, played a large role in the picturesque style. Mulready's tutor Varley encapsulated his view on the subject in *A Treatise on the Principles of Landscape Design*, published in 1816–18, where he explained that

> the great interest which is excited by cottage scenes, originates in the facility of finding so many of those subjects in nature subdued in all their primitive and formal eccentricities and offensive angles; where age and neglect have both united to obliterate the predominance of art, and to blend them with nature by irregularity of lines, and neutrality of colour; with growth of weeds, varieties of plaster, mortar, bricks, tiles, old greenish glass windows, ... ancient and greyish beams of timber, gently contrasting with the sober and subdued warmth of tiles and brick.

42. *Woman in a Forest* 1845. Pen and brown ink, sepia wash, $4\frac{1}{4} \times 5\frac{1}{2}$. Trustees of the British Museum

43. Study of *Clouds c.* 1824. Pen and brown ink, $5\frac{7}{8} \times 4\frac{1}{4}$. Whitworth Art Gallery, University of Manchester

In its meandering fashion this list of picturesque ingredients provides a catalogue of the elements in Mulready's cottage scenes. If coupled with the elements cited earlier by those two important formulators of picturesque theory William Gilpin and Uvedale Price (i.e. winding roads, wheel tracks, old carts, old oak trees and gypsies), Mulready's rustic scenes appear mere illustrations of the style.

By the beginning of the nineteenth century the aesthetic appreciation of rustic cottages was ubiquitous; they were sanctified and popularized by the paintings of Thomas Gainsborough and George Morland, fabricated by the architect John Nash in Blaize Hamlet, and the taste itself was lampooned by Jane Austen in *Sense and Sensibility* (1811).[38] Mulready's cottage paintings form part of this tradition. But in their clear, sharp-focused depiction of the rural scene, they embody a distinctively fresh and individual quality of their own.

George Morland's works featuring cottages, inns, stables, peasants, and gypsies provide the most immediate and pervasive example of the portrayal of the picturesque rustic scene around 1800. And Mulready surely encountered these paintings[39] even without the probable intervention of his close friends John Linnell and George Dawe, who were on especially intimate terms with Morland's works. Linnell's first artistic efforts were Morland copies sold through his father's framing shop.[40] George Dawe, another member of the Varley circle, wrote the first critical biography of Morland in 1807,[41] and his criticism of Morland illuminates some crucial differences between Morland's and Mulready's painting styles.

Dawe severely criticized Morland's sloppy execution and the vulgar character of his peasantry, linking their vulgarity with Morland's dissipated lifestyle. Mulready's paintings—crisply delineated, frequently inhabited by children—might almost be seen as a "corrected Morland" following Dawe's prescription. Whereas Morland's landscapes are highly stylized and his architectural features are barely plausible as three-dimensional forms, Mulready's landscapes, particularly his foreground flora, are highly naturalistic, and his buildings, despite their visible decrepitude, are sound structural entities. Dawe complained that Morland "never made a complete sketch for the plan of his pictures (which resulted in) . . . numerous faults in composition, perspective, and effect",[42] whereas Mulready prepared several sketches, sometimes highly finished, elaborate drawings, before committing his compositions to oil. As a result, Mulready produced keenly observed, solidly painted, fresh naturalistic landscapes, quite removed from Morland's formulas. Both were based on Dutch and Flemish precedents.

Dutch and Flemish seventeenth-century paintings were influential in the development of Mulready's early style—in his rustic scenes and his early genre—and as such their representation in English collections

deserves some attention. As is well known, the Dutch/Flemish School was avidly acquired by the English. By the late eighteenth century English collections (frequently open to professional artists)[43] were well stocked with such paintings, so much so that William Blake could complain to a friend in 1806 that "The taste of English amateurs has been too much formed upon pictures imported from Flanders and Holland."[44] This taste was shared by George IV, who amassed a distinguished collection of such works, and by his aristocratic compatriots, who generously lent their paintings to the first in a series of Old Master Exhibitions organized by the British Institution in 1815, an exhibition expressly devoted to the Dutch and Flemish masters so well represented in English collections.[45]

While Mulready's paintings provide the best proof of his familiarity with the Dutch and Flemish masters, the diary of his friend David Wilkie (who was likewise influenced by the Dutch tradition) testifies to the broad availability of these models for the professional artist in the first decade of the nineteenth century. Dealers and patrons freely lent their seventeenth-century paintings to Wilkie for study.[46] He also recorded his visits to many collections, including the substantial Dutch/Flemish collection of Sir Francis Bourgeois,[47] which was later destined to form the nucleus of the works exhibited at the Dulwich Picture Gallery, and which could have supplied numerous dilapidated cottage models for the young Mulready.[48] The Hope collection,[49] perhaps the most important private accumulation of such paintings, may have been accessible to Mulready also, for he was patronized in 1807 by Thomas Hope, the well-known classical connoisseur, who was a member of the wealthy Hope family which had recently returned from long residence abroad in Holland.[50]

The nature of this collection—that of a family holding Dutch/Flemish works also collecting contemporary English artists working in the same style—was far from unique. For example, Ridley Colborne, who lent an Ostade and a Teniers to Wilkie, also patronized Wilkie, Linnell and Mulready. The Baring and Peel families had substantial holdings of Dutch and Flemish paintings, while collecting the work of similarly inclined English artists. Mulready's later patron John Sheepshanks first concentrated his collecting activities on Dutch and Flemish prints and drawings before turning his attention to contemporary English genre and landscape art.[51] And of course George IV combined a taste for the seventeenth century with a taste for contemporary British genre painters, including such artists as Wilkie, Mulready and William Collins.[52] Even the Royal Academy— particularly through the writings of its first President, Sir Joshua Reynolds—half-heartedly supported the popularity of the Dutch/ Flemish School, for while Reynolds disparaged their low-life themes

he praised the remarkable technical skill displayed in their works,[53] an assessment frequently cited by later admirers of the School.[54]

But beyond the presence of Dutch and Flemish works in private collections, artists could always rely on prints for additional exposure to the style. At the time of their deaths, both Mulready and Wilkie held extensive print collections favoring Netherlands masters. However, Mulready's rustic scenes, if ultimately based on the earlier seventeenth-century tradition, nevertheless display their own vision, a vision primarily based on aspects of the rapidly disappearing rural world and the newly emerging suburban surroundings of London, tempered by his own formula, and executed with pristine clarity.[55]

One can perceive a certain rather loose development in Mulready's cottage scenes. Initially, he depicted close-up, frontal or gable-end views of simple, dilapidated cottages (Plates 44, 47). Soon after, he painted more substantial houses viewed from a greater distance, with a hint of a village setting (Plate 45). He then progressed to more extensive street scenes featuring a full panoply of individual houses, sheds, gates

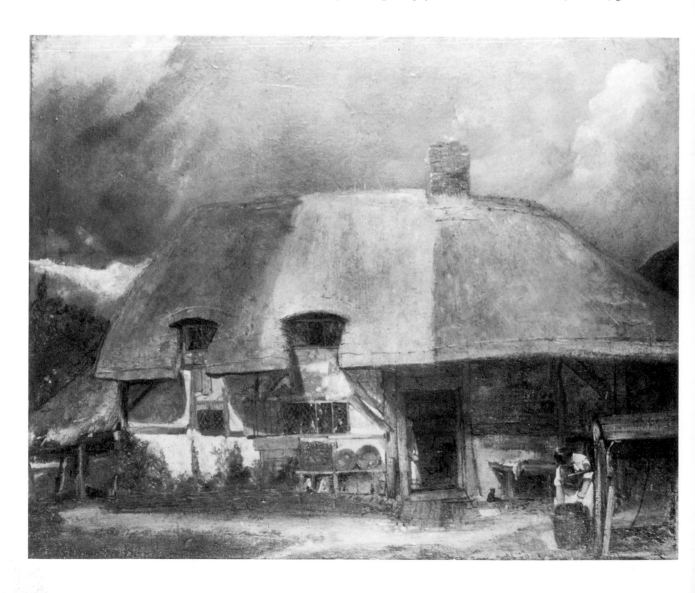

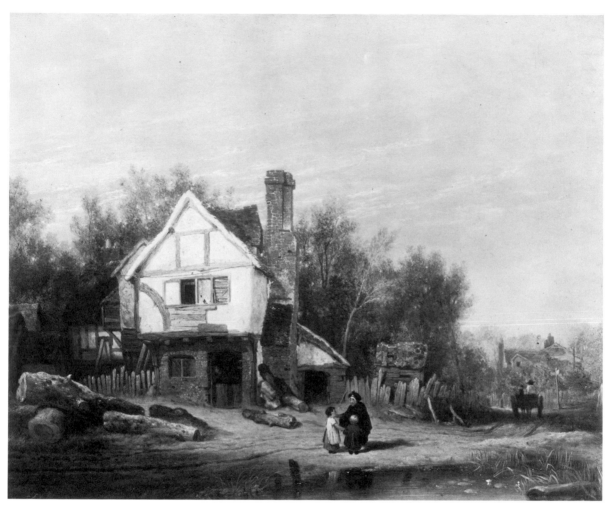

45. *Landscape with Cottages*
c. 1810–12. Oil on panel,
14 × 17½. Victoria and Albert
Museum, London (Crown
Copyright) (cat. 68)

46. Study for *Eton c*. 1805.
Pencil, 3¼ × 5½. Victoria and
Albert Museum, London
(Crown Copyright)

54

and genre figures (Plates 62, 63). They were frequently based on specific buildings or sites: *The Cottage at Knaresborough, Yorkshire* (R.A. 1804), *The Cottage at St. Albans* (R.A. 1806), *Old Houses at Westminster* (Account Book, 1805), *Eton* (Account Book, 1807, Plate 46); or on townscapes: *View of St. Albans* (R.A. 1807), *The Mall, Kensington Gravel Pits* (1811). Even when paintings were designated simply "Cottage and Figures" they were probably based, at least in part, on actual buildings or sites. For example, the cottage scene now held in the Tate Gallery (Plate 47) includes the tower of St Albans in the far distance. Moreover, the meticulous, almost photographic depiction of wattle, plaster, and brick on the gable end has the distinct ring of vivid actuality, of a specific model. Another oil exhibited under the title *Boys Playing Cricket* in 1813 (R.A. 1813) was recorded in Mulready's Account Book under the location of the game, "Heston"—now

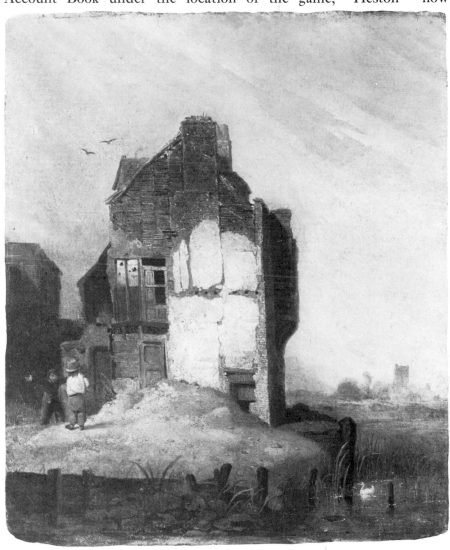

47. *Cottage and Figures* *c.* 1806–7. Oil on paper mounted on board, $15\frac{5}{8} \times 13\frac{1}{8}$. Tate Gallery, London (cat. 24)

55

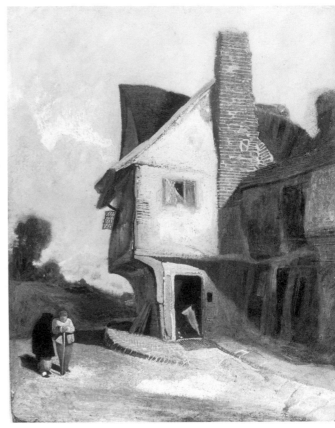

48. *Chimney-Pots* Pencil, 9½ × 6⅝. Victoria and Albert Museum, London (Crown Copyright)

49. John Sell Cotman *An Old Cottage at St. Albans* Millboard laid on panel, 16½ × 12⅞. P & D. Colnaghi & Co. Ltd, London

50. (facing page) *An Old Cottage, St. Albans c.* 1805–6. Oil on canvas, 14 × 10. Victoria and Albert Museum, London (Crown Copyright) (cat. 13)

Hounslow, a south-western suburb of London, the setting for several of Mulready's early but now lost oil paintings, and the site of the playing fields of St Paul's School.

These early landscapes, disparagingly dismissed as "privys" by Constable,[56] were based on numerous first-hand studies. As J. L. Roget reported (citing an earlier source) Mulready, Linnell and Hunt would sit "down before any common object, the paling of a cottage garden, a mossy wall, or an old post, [and] try to imitate it minutely".[59] From these exercises Mulready produced a large number of drawings detailing parts of cottages, chimneys (Plate 48), run-down sheds, posts, and fences to serve as guides for his finished oils. One of his first extant cottage scenes, *An Old Cottage, St. Albans* (Plate 50), benefited from such preparation.

The painting appears in his Account Book in 1806 and was at the Royal Academy the same year (101). It established a compositional format used in several subsequent works with little variation: the gable-end of a cottage, slightly off-center, is placed in the immediate foreground, frequently complemented by a smooth glassy pond and several rustic figures. Here a black-hooded woman, dark air-borne birds, and a somber, threatening sky cast a morbidly Romantic mood over the scene.

56

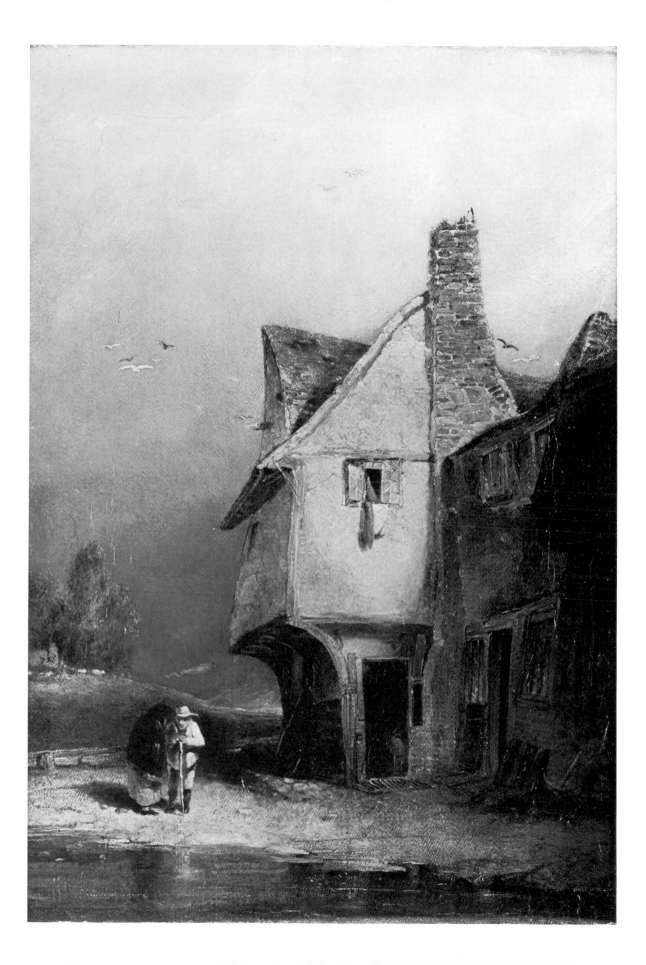

Two pencil studies exist for this painting, which suggests the extensive preparation undertaken for these rather simple compositions: one a very brief notation delineating the mere outlines of the cottage with some crude shading (Plate 51), the second a highly finished pencil study nearly identical to the completed oil (Plate 52). The latter is an amazing demonstration of Mulready's drawing skills. Signed but not dated, it apparently came from a sketchbook containing a similar drawing of the same size and nature, *Archway in St. Albans*, signed and dated 1805 (Plate 53). Both drawings were finished with elaborate care, delicately disclosing the various building materials, the play of light and dark across the surfaces—in fact, embodying tour de force exercises in the pencil medium. Mulready depended heavily on the pencil composition for his painting *An Old Cottage, St. Albans*.

Such meticulous preparation for a relatively simple composition is astounding. The Victoria and Albert Museum has several undated chalk drawings of cottages by Mulready; one in particular approaches the precision and finish shown in the above pencil studies. Featuring a gable-end with a child below, it could easily be a preparatory study for one of his lost "Cottage and Figure" oils (Plate 54). Certainly the detail and the overall clarity that characterize his finished oils would not be inconsistent with such minutely executed preparatory studies, nor would they be inconsistent with the working habits demonstrated in his genre works, where pen and ink drawings, finished chalk studies, watercolor compositions, or small oil sketches preceded the finished painting. But generally speaking, preparatory studies for the early landscape works were not finished to such a high degree, being instead quick jottings, carefully blocked out compositions, or sketches confined to one particular aspect of the proposed painting. This is illustrated by the pencil drawing of a gable-end (Plate 55) which served as the model with some simplification for the cottage in *An Old Gable* of 1809 (Plate 56). The two exceptionally refined pencil drawings discussed above were probably undertaken not as mere preparations for a finished oil but as independent, saleable works of art. Mulready's Account Book for 1805 confirms this suggestion. The engraver Wilson Lowry[58] purchased six of these pencil cottages in 1805[59] and "Munn", probably the watercolorist Paul Sandby Munn, several more the same year.[60]

Despite Mulready's dependence on specific models, his paintings betray a number of recurrent stock ingredients: stagnant pools (providing an excellent opportunity to depict water lilies, thistles and ducks spotted with brilliant white), gnarled old oak or elm trunks in subtle tones of gray and brown, preferably scattered in the foreground and creamy road-beds marked by the tracks of passing carts: motifs frequently encountered in Dutch seventeenth-century models[61] and cited as picturesque elements in contemporary literature.

51. (above left) *An Old Cottage, St. Albans c.* 1805. Pencil, 5 × 3. Victoria and Albert Museum, London (Crown Copyright)

52. (above right) *An Old Cottage, St. Albans c.* 1805. Pencil, 8 × 6⅜. Collection David and Kathryn Heleniak

53. (left) *Archway in St. Albans* 1805. Pencil, 6¼ × 8. Collection Professor and Mrs I. R. C. Batchelor

This could apply even to a specific site. *The Mall, Kensington Gravel Pits* of 1811–12 (Plate 62, Color Plate II) was reportedly taken partly "from the Mall as it stood in 1811, and partly composed".[62] This inclination toward composing is illustrated by examining two variations (one horizontal and one vertical) of *Horses Baiting*. Both versions were painted *circa* 1809–10, the horizontal composition (Plate 57) probably being the earliest. The upright version is signed and dated 1810 (Plate 59). A preliminary pen and ink sketch for the figure and tree at the left (Plate 58) contains seeds of both compositions. The tree slants to the left as in the horizontal panel, while the stance of the figure and horses is closer to the vertical version. Although both compositions are essentially planar, featuring a frieze of figures and animals before a cottage backdrop (with the forelegs of the white horse marking the central axis), the placement of the tree is crucial within each painting. Like Constable in his versions of *The Leaping Horse*,[63] Mulready manipulated the tree for compositional emphasis. Slanting to the right in the upright panel, paralleling the gable roof, the tree creates a loose, triangular configuration in conjunction with the background mass of soft, mossy trees. Slanting to the left in the horizontal composition, paralleling the forward outline of the white horse, it creates a parallelogram with the low, long cottage behind. Both are subtle adjustments to their respective formats although the upright panel, by reducing the scale of the disproportionately large white horse in the horizontal composition (a strikingly imposing animal beside the diminutive boy), and by creating a strong, stable and compact composition, is by far the more successful painting.

Mulready continued to experiment with this theme and painted yet another variation, turning the composition on its side (Plate 60). Here

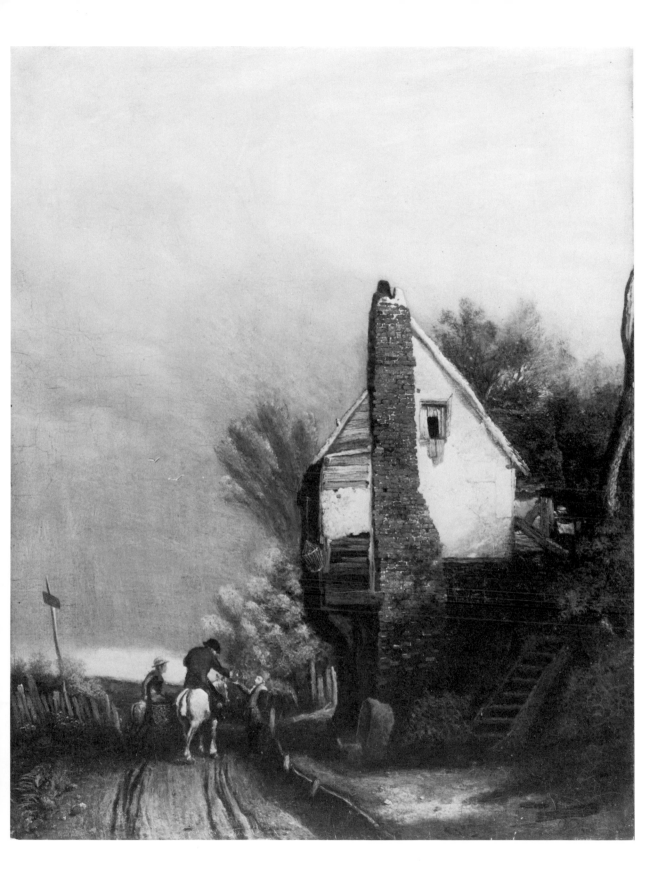

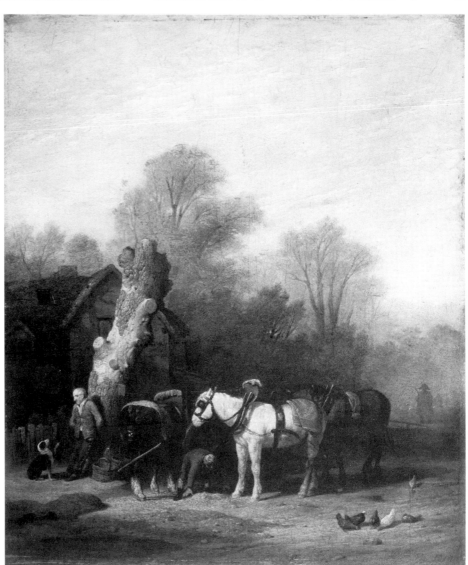

57. (above left) *Horses Baiting*
1809–10. Oil on panel, $13 \times 16\frac{1}{8}$.
Location unknown (cat. 60)

58. (above right) Study for
Horses Baiting c. 1809. Pen
and ink, pencil, $2\frac{7}{8} \times 4\frac{1}{8}$.
Victoria and Albert Museum,
London (Crown Copyright)

59. (right) *Horses Baiting*
1810. Oil on panel, $15\frac{3}{4} \times 13$.
Whitworth Art Gallery,
University of Manchester
(cat. 61)

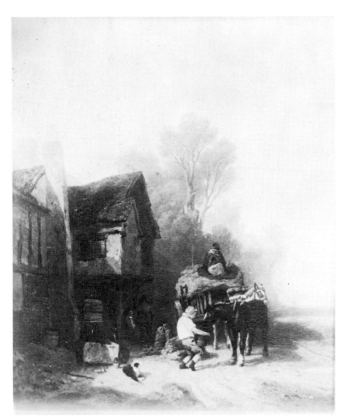

the artist observed the baiting scene before a similar building (all three cottages or inns are slightly different, though all share protruding gabled elements at the far right end) but from an oblique rather than frontal position. The gnarled tree disappears (it would otherwise block our view) along with its attendant rustic figure. The haycart is now filled, and the blond youth who worked in the upright oil continues with his chores, now accompanied by a seated figure astride the hay. Again a brilliant white area, this time the boy's white shirt, anchors the center of the panel. These three works, all painted within a very limited time (*c.* 1809/10) with a limited number of elements, may be seen as a puzzle where the artist juggled the pieces until he achieved three satisfactory resolutions. Generally such re-arranging, or composing, was confined to preparatory drawings with a measure of economy introduced. If a portion of a composition proved unsatisfactory Mulready simply pasted a new drawing over the less successful area of the design.[64]

These compositional experiments of 1809/10 prepared the way for his more complicated Kensington Mall paintings of 1811 and 1812 (Plates 62, 63, Color Plate II). Mulready had moved from central London to the Kensington Gravel Pits area in 1809, and these paintings can be viewed as his ordered response to his new suburban surroundings. Kensington Gravel Pits was a small village located in what is now the Notting Hill area of London, receiving its name from the

60. *Horses Baiting* 1810. Oil on panel, 16 × 12¾. Location unknown (cat. 62)

61. Leaf in Mulready's Sketchbook. Pen and ink, 4¼ × 3½. Victoria and Albert Museum Library

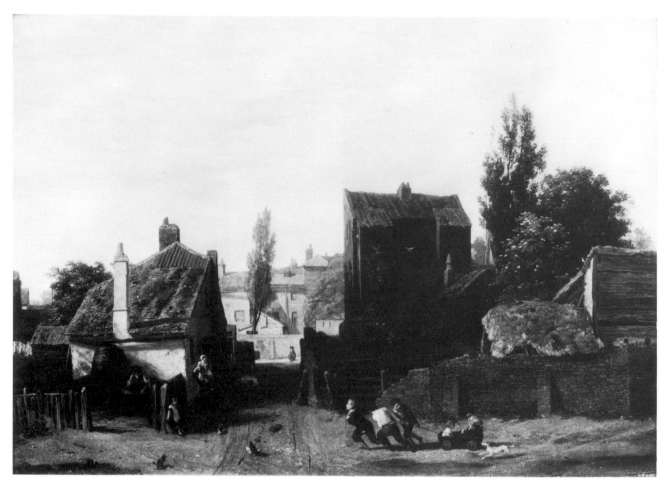

62. *The Mall, Kensington Gravel Pits* 1811–12. Oil on canvas, 14 × 19¼. Victoria and Albert Museum, London (Crown Copyright) (cat. 78)

gravel pits located just south of the village. Whereas Mulready's friend Linnell chose to depict the working gravel pits in his painting of the same title, a rare unsentimental view of working men engaged in their everyday labor,[65] Mulready more conventionally concentrated on the peaceful village itself, focusing his attention on the activity of the ever-popular itincrant pedlar (a recurrent theme in his own work) and children at play. Mulready's paintings feature the precise delineation of deep red bricks, soft creamy stucco, salmon-colored tile roofs, and gray wooden fences, with De Hooch-like clarity.[66] Even the leaves on the nearby trees are depicted with varied yet individual dollops of green pigment, occasionally highlighted with white. The overall effect is one of fresh yet harmonious natural color, a palette of soft browns, grays, greens and salmon pink overhung by white scudding clouds streaked with clear blue. Rich intense primary colors are generally confined to the staffage figures punctuating the compositions. (See, for example, the bright red vest on the pedlar and his blue and white pottery ware in *Near the Mall* or the small baby in the cart sporting the only touch of true red in her cap in *The Mall*. . . (Color Plate II).

64

In compositional terms both works display an orderly, nearly classical arrangement of forms, perhaps most evident in the earlier work, *The Mall* . . . (Plate 62, Color Plate II) where the strong vertical elements — solid geometric buildings with straight, elongated chimneys — are carefully balanced by horizontal planes: the foreground frieze of children, the series of succeeding brick walls culminating in the row of houses, brilliantly illuminated and thereby harmonizing with the light horizontal foreground area. Moreover, the secondary genre figures — the children at the left, the man with the wheelbarrow, the figure against the far wall — are placed to form a loose diagonal, marking off the precisely measured receding space. This same sense of measured space is equally evident in *Near the Mall* (Plate 63) where the center core of the painting forms a deep triangular well in space with the lines of intercession (here indicated by the receding trees on the right and the building faces on the left) meeting somewhere above the head of the dark-haired boy.[67] As in the earlier painting, areas of bright light and shadow help to produce this spatial effect, often creating delicate decorative patterns on the surfaces. Thumb-nail drawings (Plate 61) in Mulready's Sketchbook underline

63. *Near the Mall.* 1812–13. Oil on canvas, $13\frac{1}{2} \times 18\frac{3}{4}$. Victoria and Albert Museum, London (Crown Copyright) (cat. 79)

65

his fascination with deep, recessional space. In fact, Mulready's taste for well-ordered, rather deep suburban vistas survived this early landscape phase. His exterior genre scenes through the 1820s continue to display these enclosed womb-like Kensington settings.[68]

This fastidious ordering recalls Mulready's own manuscript notes on this subject: "A Well Ordered Multitude, one, divided, subdivided and further devisible upon further research".[69] By combining this classicizing order with a rustic village scene Mulready produced what could be termed a "Poussinesque" picturesque style.[70] And in many respects the contemporary landscape artists who came closest to Mulready's style, in both composition and execution (without suggesting any mutual influence), were the French landscape artists Jean-Victor Bertin and his pupil Louis-Auguste Gérard, who inherited Poussin's sense of order while applying it to less dignified subject matter.[71]

Parallels for Mulready's oil paintings of rustic cottages[72] can also be found closer to home in the work of the landscape artists of the Norwich School: John Crome and John Sell Cotman. Cotman apparently produced two nearly identical paintings (Plate 49) based on Mulready's *An Old Cottage, St. Albans*.[73] Of course, St Albans was a popular sketching site, frequented by Cotman, Thomas Girtin, the Varleys, Mulready, and a host of other artists.[74] Cotman produced drawings based on other picturesque cottages in the vicinity.[75] However, the depiction of precisely the same cottage in this instance cannot be considered coincidental. The viewpoint is exactly the same. But more importantly the staffage figures are the same, although they are somewhat less significant in Cotman's paintings. Since two preparatory drawings exist for Mulready's paintings (Plates 51, 52), the second showing slightly different staffage figures than those included in his finished oil, and since Cotman first took up oil painting several months after Mulready's work was exhibited at the Royal Academy in 1806,[76] one must assume that Cotman used Mulready's composition as the basis for his own paintings.

Cotman had painted picturesque cottage scenes in watercolor as early as 1800,[77] long before Mulready is known to have embarked upon the theme. Perhaps Cotman's own established interest in such scenes attracted him to Mulready's oil examples in the same vein. Certainly Cotman and Mulready were acquainted,[78] and, if Cotman's friend Paul Sandby Munn is indeed the "Munn" who purchased several of Mulready's pencil cottage scenes, Cotman (through Munn)[79] may have been familiar with Mulready's composition in 1805 when it was in preparation for the Royal Academy exhibition the following year. In any event he surely would have seen the work in the exhibition. Its purchase by an important Norfolk family, the Proctor-Beauchamps, may have

given it additional importance in his eyes. It is even possible that he had access to it after it reached the private Norfolk collection.

While depicting the same subject, Cotman's oils differ markedly from Mulready's in execution. Painting in a much broader fashion, Cotman eliminated the details so lovingly depicted by Mulready; shadows transparent in Mulready's work became opaque abstract patterns in Cotman's paintings, echoing the patterned surfaces so admired in his watercolors.

The broader, freer execution found in Cotman's oils is also prominent in the cottage scenes of his fellow Norwich artist John Crome. It distinguishes the work of both artists from that of Mulready. Crome's cottage scenes in oil are thought to have inspired Cotman's. But perhaps both were inspired by Mulready's scenes.[80] For if Crome's abiding devotion to Dutch seventeenth-century artists undoubtedly sparked his interest in such scenes, Mulready's contemporary example may have provided another impetus for his own exploration of the theme. Crome exhibited two works at the Royal Academy for the first time in 1806, the year in which one of Mulready's cottage scenes was praised by a London critic as "a brilliant little picture which kills every subject in its vicinity".[81] Perhaps he too got wind of the Proctor-Beauchamp purchase of a Mulready cottage painting in 1806. However, if Crome hoped for similar success with his cottage scenes he was surely

65. John Crome *Old Houses at Shop Near Hingham, Norfolk* R.A. 1808. Oil on canvas, 60½ × 48. Philadelphia Museum of Art, John H. McFadden Collection

65. John Crome *Old Houses at Norwich*. Oil on canvas, 21½ × 16½. Yale Center for British Art, Paul Mellon Collection

disappointed. For this one Proctor-Beauchamp sale, Mulready obtained twice the price Crome averaged for his comparable oils. By 1807, Mulready's prices—though far from spectacular—were up to ten times the price that Crome's patron Dawson Turner paid for Crome's similar scenes.[82]

Despite their similarlity, Crome's cottage scenes can generally be distinguished from Mulready's on several counts. As stated earlier, they are more painterly and less detailed, reflecting Crome's reputed saying that "Trifles in nature must be overlooked."[83] A darker, more artificial tonality pervades his canvases; he employed tobacco shades quite unlike the fresher, naturalistic appearance of Mulready's palette. His cottages are generally askew, their outlines more rounded and crooked (Plate 64), exhibiting less angularity, less geometric solidity in comparison with the architectural elements in Mulready's paintings.[84] And when Crome painted several cottages, or townscapes (Plate 65), he created a more complicated, congested view.[85] Lastly, Mulready's rustic scenes place greater emphasis on the genre figures—a pedlar, people stopping at an inn, children gesticulating, playing games or musical instruments. Nevertheless, Mulready and Crome shared a profound attachment to observed reality, although Crome adhered more closely to the academic theory of generalized rather than particularized nature.[86]

Crome's paintings also provide an instructive contrast to Mulready's work in a slightly different vein. Mulready painted a number of extant

66. (facing page) *A Gravel Pit* *c*. 1807–8. Oil on canvas, 15 × 12½. Private Collection (cat. 34)

67. John Crome *Slate Quarries c*. 1804. Oil on canvas, 48¾ × 62½. Tate Gallery, London

69

landscapes without architectural interest, the earliest of which is *A Gravel Pit*, of about 1807–8 (Plate 66).[87] With its dramatic chiaroscuro this painting represents Mulready's nearest approach to the sublime.[88] With two small children perched on the edge of a shaded cavernous pit, man's insignificance in the face of nature is at least hinted at.[89] But how far removed it is from Crome's more forceful expression of the same conception in his *Slate Quarries*, of about 1804 (Plate 67).

Children appear prominently in Mulready's other pure landscapes as well. *A Sea Shore* of 1809 (Plate 174) is quite a remarkable painting. In a Claudian sunset (perhaps inspired by Turner's *Sun Rising through Vapour*, R.A. 1807) children play on the shore, while others frolic in the water. This painting is perhaps the earliest extant nineteenth-century example of the presentation of the seashore as a site of pleasure and leisure,[90] a theme which later engaged William Dyce, W. P. Frith[91] and on the Continent Eugéne Boudin and the French Impressionists. Of course, Mulready's light-hearted scene does not feature fashionable "daytrippers" or urban dwellers as was true of the later works. But it does foreshadow those later paintings by emphasizing the pleasurable, non-workaday aspects of the seaside.

The theme of his painting *A Gypsey Encampment* dated 1810 (Plate 68) is typically picturesque[92] (made even more so by the inclusion of a blasted tree and the glow of the setting sun). A child also appears, but its role is less important than that of the children in his last landscape of this early period, *Boys Fishing* of 1812–13 (Plate 69). Here, before the lush growth of greenery (accurately described by a nineteenth-century critic as "fresh, green and spring-like"),[93] a man and two boys in a boat prepare angling lines. At this point Mulready was considerably removed from his earlier tutelage under Varley, yet this painting seems closest to Varley's developed schema. In his publication *A Treatise on the Principles of Landscape Design* (London 1816–18), Varley carefully analyzed river scene compositions, detailing how the placement of each element—a bridge, a boat, the distant trees—formed an irresistible and necessary link in the design. Following his precepts, Mulready established a diagonal from left foreground to deep background with strategically placed objects marking the steps into space and across the canvas: the boys' boat, a fork of land, another boat, the mound of land, the bridge.

This rather ambitious landscape, a large work (30 by 40 inches) by Mulready's standards, represented a desperate attempt on his part to attract the attention of the Academy. As explained in the previous chapter, Mulready was despondent in 1813 over his failure to be elected an Associate in the Royal Academy. Wilkie had counselled him to "Think of a subject of interest & with not too many figures in it . . ." for the 1814 exhibition. *Boys Fishing* was Mulready's only exhibited work in

68. (facing page above) *A Gypsey Encampment* 1810. Oil on canvas, 12½ × 15½. Courtesy of the National Gallery of Ireland, Dublin (cat. 67)

69. (facing page below) *Boys Fishing* 1812–13. Oil on canvas, 30 × 40. Spink & Son, Ltd, London (cat. 81)

that exhibition. Mulready (who valued Wilkie's opinion) must have believed that this painting, begun before his advice, accorded with it. The subject was certainly popular with landscape artists; Constable, Crome, and Linnell all employed it, to name but a few.[94] But for Mulready (as for the others) it failed to rouse the Academic body, whereas his interior scene of mischievous schoolboys succeeded the following year.

Mulready abandoned landscape painting after 1813 in favor of the type of genre scene which brought him success at the Royal Academy, although he continued to value his early rustic scenes. In fact, Richard Redgrave reported with some astonishment how Mulready carefully restored one of these early paintings in the 1850s, removing the pigment piece by piece to a new support in order to save it.[95] More importantly, Mulready exhibited three of these early rustic scenes at the Academy in the 1840s, rather more than thirty years after their execution: the two Kensington Mall paintings (R.A. 1844, 330 & 334) and *A Gravel Pit* (R.A. 1848, 125). His exhibition of the Kensington scenes was especially significant, since both paintings had been rejected for exhibition soon after their completion[96] as well as having been rejected by his friend the artist Augustus Callcott, who had arranged for their commission.[97] At the time they were criticized for being too detailed. But by the 1940s taste had clearly changed. All three paintings were well received by artists and critics alike.[98]

The display of these minutely-rendered scenes preceded and nearly coincided with the inception of the Pre-Raphaelite Movement,[99] a movement that called for an intensive fidelity to nature. Mulready's simple rustic scenes scarcely harbored the moral allegories which later accompanied the Pre-Raphaelites' depiction of nature, (nor their brilliant color) yet they presented a fresh, highly detailed vision of the rural world which would have endeared them to the young Pre-Raphaelites, who raged against "sloshy", indistinct painting.[100] Indeed, one of the members, Thomas Woolner, sought out Mulready's early landscapes for his own private collection in later years.

The warm reception given to these early works may explain Mulready's resumption of landscape painting in the early 1850s, so long after he had abandoned the theme. In 1851 he began his painting *Blackheath Park*, which was completed in 1852 and exhibited at the Royal Academy the same year (Plate 70). It depicts a view from the house of his patron John Sheepshanks. Unlike other "window-compositions" famous for their spontaneous, unstudied appearance, Mulready's painting is broader in scope, depicting an eminently conventional landscape terrain with reflecting pool, rolling land and picturesque genre figures. The composition itself, while far removed from the compact structural clarity of his earlier landscapes,

nevertheless reveals a strong underlying structure. Massed trees close off the composition on both sides; a line of foliage and shacks moves along the lower third of the canvas; a horizontal strip of land connects the light foreground area on the right with the bright landscape areas at the left and back, and a small genre figure divides the composition in equal halves. All such devices create a decidedly studied effect.

But the most remarkable aspect of this painting is its execution, an elaborate effort at verisimilitude, quite unlike the summary treatment of the background scenery in his early landscapes or in his contemporaneous genre paintings. When exhibited in Paris at the Exposition Universelle of 1855, critics compared it to a "daguerréotype transporté dans la peinture".[101] Daguerreotypes or photography may have influenced Mulready, for photography was receiving considerable attention at the time. The Society of Arts, which had given Mulready a one-man exhibition in 1848, mounted a photography show in 1852. An exhibition of "sun-pictures" at the Photogenic Society in 1853 was also mentioned in a letter from Mulready's brother-in-law Cornelius Varley to his friend John Linnell where Varley remarked how "works in the Royal Academy show that photography is doing much good to the arts".[102] Mulready himself collected landscape photographs; twenty appeared in the Artist's Sale following his death.[103] However, while the camera's ability to record minutiae may have influenced Mulready in his painting style (creating a sense of all-over density), it seems unlikely that he actually used photographic aids. The Victoria and Albert Museum

73

has a pen and sepia wash preparatory drawing for the central area of the composition; an oil painting, more painterly though still displaying some precise leaf work, may be a study for the pool from a different angle (cat. 205).

The other factor most frequently cited to account for the appearance of this new painting method was the work of the Pre-Raphaelites. The *Art Journal*, generally an admirer of Mulready's paintings, criticized *Blackheath Park* for its "Pre-Raffaellesque eccentricity".[104] Like the rest of the art world, Mulready was of course aware of the Pre-Raphaelite revolution. In fact, in contrast to fellow Academicians, Mulready was favorably disposed toward their paintings. Ford Madox Brown, praising the works of J. E. Millais and William Holman Hunt in a letter of 1851, wrote that Mulready thought "most highly of them" too.[105] Whether their meticulous depiction of natural detail affected Mulready's execution here is uncertain. Their first exhibited works were not pure landscapes,[106] although the landscape backgrounds of their exhibited oils displayed the same detail that characterized their figure painting.[107] But more likely, as suggested earlier, Mulready was simply competing with his own precisely rendered, early works, recently exhibited and highly praised. At any rate, he must have been quite happy with the result, for *Blackheath Park* was among the paintings sent to the international exhibition in Paris in 1855 (a selection which was carefully supervised by Mulready). Yet it remained an isolated example, the only pure landscape to be painted and exhibited by Mulready in his later years.

From approximately 1813 until his death Mulready devoted himself to genre painting, frequently depicting children in and out of their domestic settings. The children who inhabited his early rustic scenes became the focus for much of his later painting.

III. Scenes of Childhood

Children play an extremely important role in Mulready's oeuvre: they appear in his earliest landscape scenes and in his last canvas, *The Toyseller*, left unfinished upon his death in 1863. Far from being simply static signs or symbols conveying a single attitude or viewpoint, they were instead vehicles for expressing a variety of attitudes or reflections upon society: for revealing underlying and at times perhaps unconscious meaning. And although such childhood imagery was often couched in humor or sweet sentiment, its significance should not be lightly dismissed or diminished.

The child became an important focus for both painting and literature in the late eighteenth century, following the influential writings of Jean-Jacques Rousseau, who glorified the innocence, the purity, the unfettered imagination of childhood. No longer viewed as the embodiment of Original Sin, children supplied a near-at-hand substitute for Rousseau's noble savage, untainted by corrupt civilization and in close harmony with the deep well-spring of Romantic inspiration, Nature. In England, Joshua Reynolds and Thomas Gainsborough provided the most notable eighteenth-century paintings in this vein, as exemplified in their portraits of children and in their "fancy pictures".[1] Others soon followed suit. By the 1790s W. R. Bigg, Francis Wheatley, and George Morland shifted some attention from such idyllic pastoral imagery, which favored children coyly surrounded by pets or domesticated sheep, to more lively children engaged in truly child-like, often naughty activities, thus foreshadowing Mulready's later penchant.[2] Idealization was giving way to some measure of reality; although even here the children were generally charming, elegant creatures, quite unlike the heartier characters developed in Mulready's paintings.

However, in the early years of the nineteenth century when Mulready took up his children's scenes, the most prevalent treatment remained the idyllic pastoral, which often associated children with animals in arcadian fantasies. Mulready did not completely avoid this sentimental pattern.

His early cottage scene with a child blowing a horn (Plate 171) is infused with this bucolic spirit, as were two other paintings, now lost but known by description: *A Shepherd Boy and Dog* 1809–10; and *A Girl and Kitten*, 1811, "a child, half undressed, seated on a low stool, . . . giving some milk to a kitten on the top of a barrel",[3] a description which recalls Gainsborough's *Girl with Pigs* 1782, or the work of the French eighteenth-century artist J. B. Greuze, who specialized in half-undressed girls engaged in innocent activities.[4]

But with these few exceptions Mulready ignored such sentiment, creating instead vital, robust children swimming, fishing, fighting or playing. Eschewing the delicacy of the eighteenth century, Mulready turned to Dutch and Flemish seventeenth-century painting for a heartier children's model. This was certainly true of his first interior genre painting of children, *The Rattle*, 1808 (Color Plate I).[5]

Mulready was not the first British artist to translate the Dutch/Flemish seventeenth-century model into the needs of nineteenth-century domestic genre. David Wilkie successfully popularized the style when he exhibited *Village Politicians* at the Royal Academy in 1806, and *The Blind Fiddler* the succeeding year, earning the sobriquet "the English Teniers". Mulready's *Rattle* followed Wilkie's popular works. Begun in December 1807, it was exhibited at the British Institution in 1808. Mulready must have known Wilkie's work. He was acquainted with Wilkie as early as August 1806 when they dined together in William Godwin's home; moreover Mulready's own

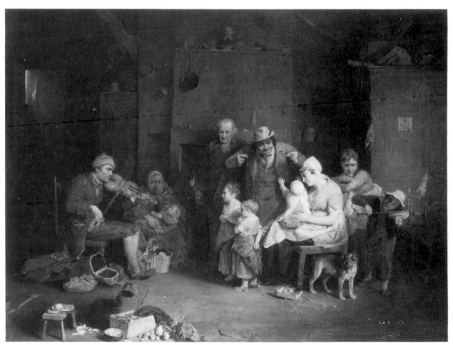

71. David Wilkie *Blind Fiddler* R.A. 1807. Oil on panel, 23 × 31. Tate Gallery, London

72. (facing page) *A Carpenter's Shop and Kitchen* 1808. Oil on canvas, 38½ × 29½. Location unknown (cat. 42)

73. *A Lady Sewing*
Watercolor and chalk,
$6\frac{1}{4} \times 4\frac{3}{4}$. Eton College,
Windsor

74. W. R. Bigg *A Cottage
Interior* 1793. Oil on canvas,
24×29. Victoria and Albert
Museum, London (Crown
Copyright)

painting *Cottage and Figures* hung beside Wilkie's *Blind Fiddler* at the Royal Academy in 1807. The crowds attracted to Wilkie's work undoubtedly drew Mulready's attention to this popular painting. They became friends, and Mulready is recorded in Wilkie's Journal on 11 May 1808.[6] Once acquainted, they remained good friends until Wilkie's death in 1841.[7]

Many writers have noted that Mulready was influenced by Wilkie's example when he turned to genre painting in 1807/8.[8] Mulready himself acknowledged his dependence on Wilkie for professional advice and guidance in the early years of his career.[9] And certainly Wilkie's formative role in the field of Dutch-style genre scenes was recognized very early on by their contemporaries. Their mutual friend Benjamin R. Haydon commented upon Wilkie's position in 1831, while generously assessing his own place in history: "It is curious what a set came in together under Fuseli—Wilkie, Mulready, Collins, Pickersgill, Jackson, Etty, Hilton and myself. I have produced Landseer, Eastlake, Lance, Harvey & Wilkie the whole domestic school."[10] In another instance he made an elaborate chart of his own supposed followers and Wilkie's, placing Mulready in the latter's camp.[11] Collectors appreciated the similarity of their work as well, causing Mulready at one point to proclaim his unwillingness "to enter into competition with Wilkie".[12]

But while Wilkie's successful example undoubtedly encouraged Mulready to turn his attention to simple scenes from daily life, inspired by Dutch seventeenth-century models,[13] his first paintings in this vein are markedly different from Wilkie's. In *Village Politicians* and *Blind Fiddler* (Plate 71) Wilkie produced lively compositions with amusing casts of characters. The strong humorous element was central to their

78

success and immediately attracted the attention of critics and collectors who drew comparisons with Hogarth's earlier example.[14] Sir George Beaumont went so far as to present Wilkie with Hogarth's own mahl stick, then a cherished item in Beaumont's collection, in recognition of Wilkie's link to the earlier English master.[15]

In contrast, Mulready's first genre scenes project a different spirit, that of subdued, quiet, peaceful serenity. They are scenes of gentle domesticity without humorous or vulgar overtones. In fact, his second genre scene, *A Carpenter's Shop and Kitchen* 1808 (Plate 72), is imbued with a reverential, almost religious aura; its theme and treatment recall Holy Family imagery.[16] Only the introduction of an additional child removes it from traditional Christian iconography.

This same peaceful mood undoubtedly characterized Mulready's *Girl at Work* (or The Young Seamstress), 1808, now lost, but whose nature can perhaps be suggested by an early drawing (Plate 73) of a woman sewing by her window. The painting was probably based on Dutch seventeenth-century scenes of single figures occupied with simple daily tasks. W. R. Bigg, not Wilkie, had previously resorted to this model (Plate 74), isolating individual women in their cottages, surrounded by appropriate domestic objects.[17]

Mulready differed from Wilkie not only in mood but in his painting method as well. Wilkie's oil-rich brushstroke is in marked contrast to the dry, meticulous drawing employed by Mulready in his early genre scenes. Moreover, Mulready delighted in intricate spatial illusions, perhaps inspired by the example of Peter de Hooch.[18] In *The Rattle* (Color Plate I), the setting—one simple room—is complicated by the inclusion of a window view overlooking three additional interiors: the room immediately beyond the playroom, perhaps a workshop, with its hanging saw and satchel; the loft above; and the living room or parlor, glimpsed through the open door and identifiable by the decorative pictures hanging on the wall. Each room is illuminated by a different light source.

Despite the spatial play, the effect is ordered. The strong organization observed in Mulready's cottage scenes is equally evident here. The triangular arrangement of the two children balances the rectangular window view; the rent in the child's pinafore forms an invisible line with the inner frame of the window dividing the composition in two. Clearly, Mulready was attempting a tour-de-force statement with his first exhibited genre painting—one that was decidedly distinguishable in manner from Wilkie's work, if nevertheless emulating his style. In fact, Mulready's artistic means came closer to Wilkie's in his pen and ink drawings than in his finished oils, as can be seen by comparing Wilkie's pen and ink drawing for *Blind Man's Buff* (Plate 75) with Mulready's sketch of an interior (Plate 76).

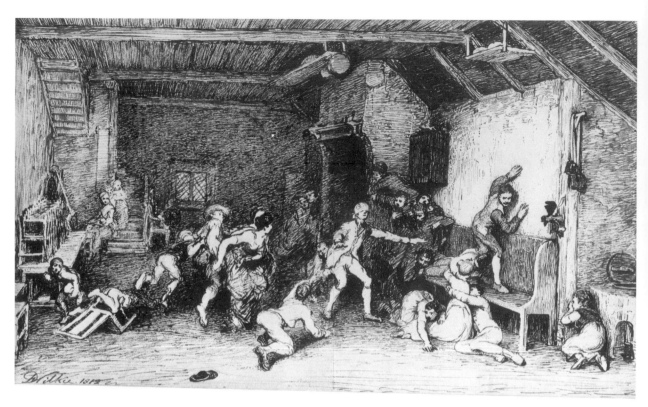

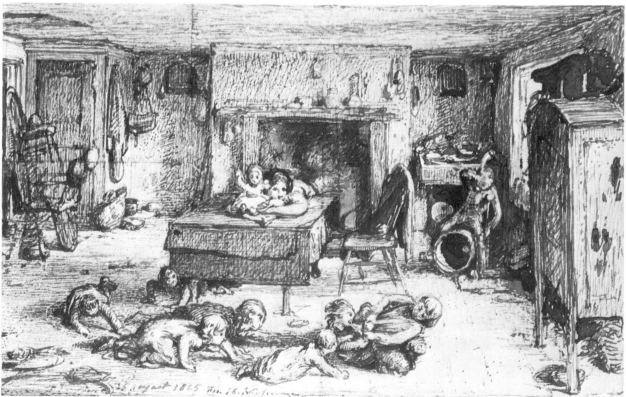

Wilkie himself may have been affected by Mulready's work, at least temporarily. His *Jew's Harp* (Plate 77), begun in May 1808[19] following the exhibition of Mulready's *Rattle* at the British Institution, is remarkably quiet in comparison to his earlier, energy-filled compositions. It contains three figures: a picturesque peasant playing a musical instrument, and two children. The poses of the children are much like those in Mulready's painting: a baby seen from behind with an older child seated in profile. It embodies a sweet domesticity quite unlike Wilkie's earlier works, but resembling Mulready's gentler genre mood.

But the humor displayed in Wilkie's first paintings, so well received by both critics and patrons, did not elude Mulready for long. *Returning from the Ale House*, first exhibited in 1809 (Plate 78), touches upon an amusing incident: children gather coins from drunken revelers while two shrivelled schoolmasters disapprovingly frown on the proceedings. Unfortunately, Mulready misread public taste with this painting. As a result it remained on his hands for years. While scenes of drunken debauchery were permissible for Dutch artists though far from laudable, such vulgar subjects were generally considered unsuitable for the nineteenth-century British artist. This may have been partly due to the work of the burgeoning Temperance Movement, which was just raising its head in reaction to the proliferation of drinking establishments throughout the country.[20] One contemporary critic exclaimed

77. David Wilkie *The Jew's Harp* 1808. Oil on panel, $10\frac{1}{16} \times 7\frac{7}{8}$. Walker Art Gallery, Liverpool

78. *Returning from the Ale House* or *Fair Time c.* 1808–9 and *c.* 1840. Oil on canvas, $31\frac{7}{8} \times 27\frac{1}{8}$. Tate Gallery, London (cat. 46)

75. (facing page above) David Wilkie Study for *Blind Man's Buff* 1812. Pen and brown ink, $5\frac{1}{2} \times 9$. Nottingham Castle Museum

76. (facing page below) *Cottage Interior* 1825. Pen and brown ink, $3\frac{3}{4} \times 6$. Ashmolean Museum, Oxford

79. Study for *The Barber's Shop c.* 1811. Pen and sepia wash, $5\frac{7}{8} \times 4\frac{5}{8}$. Victoria and Albert Museum, London (Crown Copyright)

80. Study for *Punch c.* 1812. Chalk, pen and ink, wash, $15\frac{1}{4} \times 21\frac{3}{4}$. Victoria and Albert Museum, London (Crown Copyright)

after viewing Mulready's painting: "Are all violations of decency and propriety to be tolerated, because the Dutch painters practised them? To our feelings, human nature does not present any more obscene or disgusting spectacle than a drunken father surrounded by his children; and yet, this is what Mr. Mulready has chosen to make the subject of a picture. Here it is that Wilkie towers above all his competitors—here his fine taste is eminently conspicuous. He is content to raise our passions without 'touching the brink of all we hate.' "[21] The introduction of children to the scene, here gleefully revealing their greed, could scarcely mitigate the general thrust of the subject; in fact, they made the scene more odious for the above reviewer.

After attempting an experiment with elegant genre in the style of Terborch and Metsu in *The Music Lesson*, 1809 (Plate 173), Mulready developed a more popular approach to comic subject matter. In *The Barber's Shop* 1811, now lost, (Plate 79), an entertaining incident of a boy having his long locks shorn, and *Punch*, now lost, (Plate 80), begun the succeeding year, Mulready seized upon humorous material which was apparently deemed by the public to be more suitable.[22] In fact, *Punch*, a long horizontal composition filled with comical characters, primarily children, watching an outdoor theatrical entertainment, shows Mulready at his most Wilkiesque.[23]

While Mulready retained this humorous note in many of his paintings through the 1830s, the style of his paintings slowly shifted away from Wilkie's early manner. *Punch* itself was never finished, perhaps indicating Mulready's uneasy attachment to Wilkie's compositional format. But more significantly both artists slowly moved away from Dutch models in their later careers, creating independent styles far removed from their early oils. Wilkie looked to the Spanish seventeenth-century masters for his new painting technique of the 1820s and 1830s;

Mulready experimented with a darker, richer tonality in the 1820s only to emerge in the 1830s with a brilliant, almost shrill palette quite his own.

Mulready achieved professional recognition, election into the Royal Academy as an Associate, in 1815, following the exhibition of *Idle Boys* (Plates 84, 178), a painting which displays a juvenile escapade: here their misbehavior in school. Although his youthful friend and mentor Wilkie had not specialized in childhood scenes, he had turned to the theme in a few of his early paintings, including his diploma picture for the Royal Academy in 1811, *Boys Digging for a Rat*, thereby conferring legitimacy upon such lowly scenes. Mulready's growing reputation, unlike Wilkie's, would be based on just such children's scenes.

In the first decade of his career, Mulready conveyed a conventional Romantic attitude toward the children inhabiting his earliest landscapes. As mentioned earlier, on a few occasions his children, wrapped in Greuzian sentiment, were posed in idyllic pastoral scenes. In others, more robust children romped in their natural settings, swimming, fishing, pulling carts, thereby suggesting the joys and freedom of childhood. In both approaches, the child is in intimate harmony with his surroundings. But in later works, another aspect of childhood is stressed: the overwhelming vulnerability of the child, his fears and anxieties. The child who controlled nature in Mulready's early Kirkstall Abbey watercolor (Plate 27), happily picking greens before the Abbey door, becomes the shuddering child in his last work, *The Toyseller* (Color Plate VIII), who, wide-eyed and fearful, shrinks back in horror before both man and nature—before the unknown pedlar and the looming, nearly overpowering sunflowers, which were normally traditional symbols of burgeoning life, growth and development, like children, but are here transformed into a life-threatening force.[24]

This concept of vulnerable childhood, subject to fears and pitfalls, is expressed most pointedly in *The First Voyage*, 1833 (Plate 81). Apparently a comic scene of a child boating in a washtub, it is one of many "first" events in children's lives chronicled by the artists of the late eighteenth and the nineteenth centuries.[25] Generally, such scenes expressed an optimistic, comforting image of children embarking on life under the benevolent and assured care of a smiling mother or nurse—seen for example in a French eighteenth-century work, *The First Step* c. 1785–95, by Marguerite Gérard, or in a slightly later English painting, Henry Thomson's *Crossing the Brook*, R.A. 1803. In both works, young mothers encourage their offspring without disturbing their rococo charm and delicacy. But in Mulready's painting the normally playful experience of a child's first adventure in a floating tub, a common Victorian theme,[26] is undertaken with the seriousness associated with affairs of state. Rococo delicacy gives way to solemnity.

81. *The First Voyage* 1833.
Oil on panel, 20½ × 25. Bury
Art Gallery (cat. 138)

The child is supported by mother and father, both equally cheerless, while an older brother (assuming a classical Poseidon-like pose) guides the tub along its watery path. Needless to say, with such care neither the child nor the child grown man should run astray. Yet the child remains fearful. What should be a light-hearted voyage assumes instead the Romantic symbolism of the storm-tossed boat; the precarious position of the child, like the well-worn image of the boat, suggests the perilous course of human life.[27]

This sense of man's uncertain fate as reflected in the life of children is implied again, although less forcefully, in Mulready's later work, *Now Jump*, 1840, now lost (Plate 82). Here a child balances precariously on the top of a wall, encouraged by his mother to leap from certain insecurity to the possible safety of her arms. Surely with her guidance he cannot fail. Yet again one senses the fearful caution; the child crouches back with his muscles tense, fearful of his future action. The mother, unsmiling, contributes to the pervasive sense of insecurity. The child's dilemma, his balancing act, is again suggestive of man's future life,

84

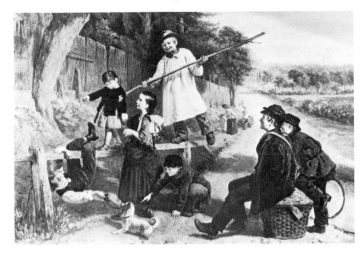

fraught with uncertainties and false steps. How unlike the more commonplace, cheerful spirit of a similar children's scene by W. H. Knight, *Rivals to Blondin*, 1862 (Plate 83), a painting which shows several children playfully balancing on a fence in imitation of the amazing feats of the French tightrope walker and acrobat Blondin.

In both of Mulready's paintings, authoritarian figures exercise control over the child. The puritanical implication, as in a number of other paintings by Mulready, is that man, even in his most natural state, childhood, is in need of guidance and direction. Goodness and wisdom are not innate. The solemn assistance offered to the children in *The First Voyage* and *Now Jump* becomes overt chastisement in other paintings.

Authoritarian figures in the form of schoolmasters, parents, nurses, or older siblings repress the natural ebullience of children and stifle their playfulness (or naughtiness) in a number of Mulready's works. In his *Idle Boys*, 1815, now lost (Plates 84, 85, 178)—no doubt inspired by Jan Steen's more raucous scenes of a similar nature (Plate 86)[28]—the children receive the grim, even painful, admonition of the schoolmaster following their clandestine game of tic-tac-toe. Mulready reiterated this disciplinarian theme when he returned to the schoolroom some twenty years later with *The Last In*, 1835 (Plate 87), which is here couched in

82. (above left) *Now Jump* 1840. Oil on panel, $6\frac{3}{4} \times 8\frac{1}{2}$. Location unknown (cat. 152)

83. (above right) W. H. Knight *Rivals to Blondin* 1862. Spenser S. A., London

84. (below left) Study for *Idle Boys*, c. 1815. Pencil, $13\frac{1}{2} \times 11\frac{3}{4}$. Formerly Count Matsukata Collection, Japan

85. (below center) Study for *Idle Boys* c. 1815 Pencil and white chalk, $9\frac{1}{2} \times 5\frac{1}{4}$. Whitworth Art Gallery, University of Manchester

86. (below right) Jan Steen *A Village School* Oil on canvas, 43×23. Courtesy of the National Gallery of Ireland, Dublin

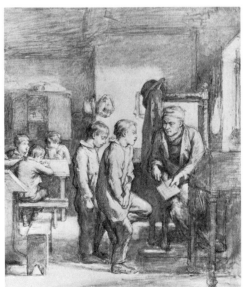

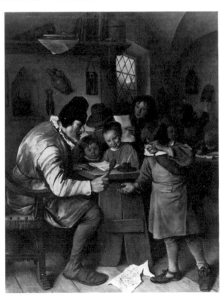

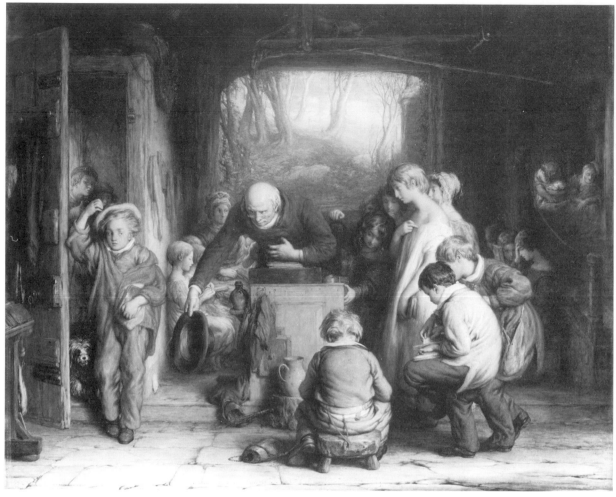

87. *The Last In* 1835. Oil on panel, 24¾ × 30. Tate Gallery, London (cat. 144)

III. (facing page) *The Wolf and the Lamb* 1820. Oil on panel, 23⅝ × 20⅛. By gracious permission of Her Majesty Queen Elizabeth II (cat. 99)

more humorous terms. A tardy, frightened youth enters the schoolroom to the deep ironic bow of the master. The pupil is scarcely deceived by the master's action; the shackled boy and the birch before the teacher's desk testify to his imminent fate. The fear on his countenance is fully warranted.

Outside of the schoolroom mothers or sisters could issue strict censure or gentle reproofs. In *The Careless Messenger Detected*, 1821 (Plate 180), a child cowers before the severe reprimand of his mother for neglecting the baby left in his care. In a gentler, less fearful vein, in *The Barber's Shop*, now lost (Plate 79), a grandmother forces the indignity of a haircut on a reluctant long-haired lad, much to his disgust. In *A Sailing Match*, 1833 (Plate 88), an attractive young woman pushes a boy to school, gently urging him to ignore the conduct of nearby children who freely and energetically play with their toy boats, thus discouraging his natural inclination to join in the harmless fun.

86

 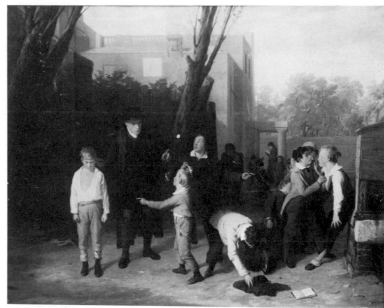

In all these scenes the plight of the children evokes sympathy, bringing to mind William Blake's pity for the schoolboy in his *Songs of Innocence* (1789) or Wordsworth's lament over the increasingly imprisoned state of children who unwillingly succumb to the binding constraints of society in his *Ode on Intimations of Immortality from recollections of Early Childhood* (1806). But although for Mulready children deserve sympathy and understanding, it is not for the loss of their natural state of innocence, slowly crumbling under the weight of society's inhibiting constraints. On the contrary, children, like humanity in general, are intrinsically weak, indolent, irresponsible, tardy, even cruel; their very nature demands constant vigilance and care.[29] Their vulnerability is their inheritance. For this, they deserve sympathy.

This pessimistic, pre-Enlightenment view of human nature as embodied in childhood is perhaps most evident in his scenes of children fighting, where the conflict between child and child replaces that between child and adult, thus underlining the inherent imperfection of human nature. In *The Fight Interrupted*, R.A. 1816 (Plates 89, 90), an elderly schoolmaster has just broken up a fight between two belligerent boys; one nurses his injured lip while the other glumly clenches his fists. Despite the efforts of the gentle old man one senses only a temporary cessation of hostilities. With his absence the conflict will resume. Their companions, anxious to assign blame, point accusingly at both combatants. But there is no consensus. The fault lies in both, in their very nature.

In *The Wolf and the Lamb*, 1820 (Color Plate III), Mulready borrows an old French fable to express his rather caustic view of human nature as

89. Study for *The Fight Interrupted c.* 1815. Pen and brown ink, wash, 5 × 4⅛. Yale Center for British Art, Paul Mellon Collection

90. *The Fight Interrupted* 1815–16. Oil on panel, 28½ × 37. Victoria and Albert Museum, London (Crown Copyright) (cat. 93)

88. (facing page) *A Sailing Match* 1833. Oil on panel, 14 × 12¾. Victoria and Albert Museum, London (Crown Copyright) (cat. 137)

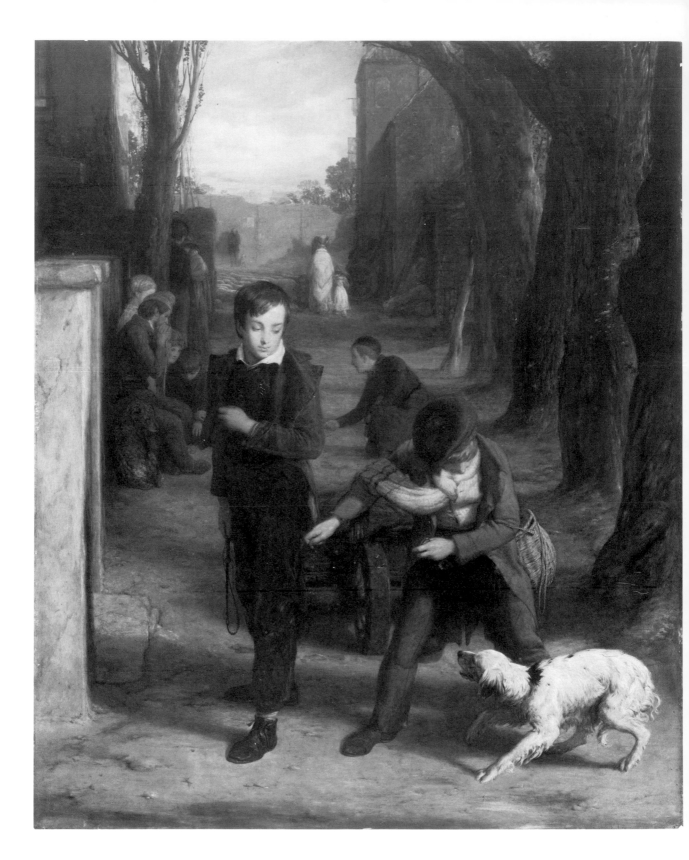

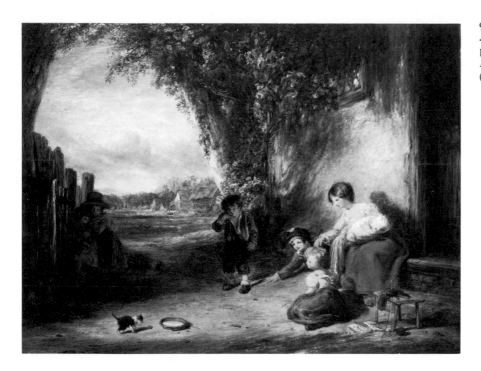

92. William Collins *The Stray Kitten* 1835. Oil on panel, 18 × 24. Victoria and Albert Museum, London (Crown Copyright)

revealed most instinctively in childhood. Without enlightened guidance (or strict censure) the strong boy, the wolf, bullies the lamb, a small boy who defensively recoils from the aggressive advance of his antagonist. This explicit animal metaphor suggests man's affinity with lower animal nature, the implied content of a number of Mulready's other paintings.

Mulready often introduced animals into his paintings. They engage in activities not unlike those of their human companions, at times reinforcing the narrative of the picture. But they do not necessarily embody the conventional Victorian expression of the pathetic fallacy: pets assuming admirable human characteristics while mimicking man. Instead, one senses a pre-Darwinian recognition that human behavior merely echoes the natural and less than virtuous instinctual behavior of the animal world.

In *The Dog of Two Minds*, 1829 (Plate 91), a painting perhaps inspired by Gainsborough's *Two Boys and Fighting Dogs*, R.A. 1783,[30] the conflict between two children centers upon the dog. The boy on the right urges his dog to do his fighting for him; the other boy defends himself with a cold disdainful stare and a whip held ready in his hand. Naturally, the dog quails before both boys. Although willing to bite the haughty boy, the dog nevertheless fears the painful retaliation of the whip. Of course, the viewer sympathizes with the dog's quandary. But neither the dog nor the children come off well in this match. Expressions of aggression, cruelty and disdain are thinly clad in this purportedly amusing children's scene.

The same might be said for *Giving a Bite*, 1834 (Plates 93, 94), a

91. (facing page) *A Dog of Two Minds* 1829–30. Oil on panel, 24⅜ × 20⅜. Walker Art Gallery, Liverpool (cat. 122)

93. Study for *Giving a Bite*
Pencil heightened with white,
11¾ × 4¾. Victoria and Albert
Museum, London (Crown
Copyright)

94. (facing page) *Giving a
Bite* 1834. Oil on panel,
20 × 15½. Victoria and Albert
Museum, London (Crown
Copyright) (cat. 139)

reworking of *Lending a Bite* of 1819 (Plate 179). Here a youth grudgingly allows a loutish lad a bite of his apple. Generosity is not the subject of the painting, but rather covetousness on the part of one boy and a grasping selfishness on the part of the other. Two animals below present the conflict in starker terms: the monkey's own life seems at stake in the face of the menacing dog—not merely its possessions.

Of course, focusing attention on the expression of animals was a typically Romantic concern. Animals became the exclusive conveyors of vivid emotion in the works of a number of artists; in England most notably in the sublime paintings of George Stubbs and James Ward, and later in the sometimes beautiful, yet often trivial works of Sir Edwin Landseer. For Mulready, animal activity underscored or paralleled the central human narrative, an effective device which was neither his own invention nor his sole preserve. Hogarth had introduced two chained dogs into the foreground of the first painting in his series *Marriage à la Mode*, 1745, to mirror the ill-fated union of the man and woman above;[31] later Mulready's friend David Wilkie included a dog in *The First Earring*, 1835, comically rubbing its ear as its young mistress has her ear pierced.

The dogs which accompany Mulready's children are marvelously natural, suggesting the genuine spirit of domestic animals—sometimes guarded, sometimes quizzical, sometimes dull, sometimes playful. They are rarely if ever idealized. Even in Mulready's few courtship paintings, where sweeter sentiment reigns, the dogs are no less natural. Their actions are simply those commonly observed, plucked from nature and employed by Mulready to emphasize a tender human scene: the dogs touching noses with their tails madly wagging in *First Love*, 1838–9 (Plate 125), characterizing quite openly the urgent vitality of adolescent love (which the human scenario could only imply); the dogs playfully chasing each other in *Haymaking*, R.A. 1847 (Plate 137), echoing the more placid scene of Burchell wooing Sophia from *The Vicar of Wakefield*; the curled, sleeping spaniel in *Choosing the Wedding Gown*, 1845 (Color Plate VII) symbolizing in the fashion of Northern medieval painting the marital fidelity of the betrothed couple.

Mulready accomplished this life-like rendering of animals by careful observation, doing innumerable, almost Düreresque drawings,[32] and by dissecting animals for more careful, nearly scientific study (Plates 95, 96). This fresh and direct observation of the animal world is present even in his earliest paintings, his landscapes which frequently incorporate lively dogs, stodgy cart horses, or peaceful ducks. But it is perceived perhaps most directly in his straightforward portrait of Sir John E. Swinburne's family pet, *The Ass*, 1814 (Plate 97).[33] Avoiding the more common pattern that surrounds a well-loved pet with small, clinging, affectionate children, Mulready instead isolates the simple

92

95. *Dead Dog* 1814. Pencil,
$6 \times 7\frac{5}{8}$. Whitworth Art
Gallery, University of
Manchester

96. *Dead Mouse* 1849. Pen
and brown ink, $4\frac{1}{8} \times 6$.
Whitworth Art Gallery,
University of Manchester

97. (facing page) *The Ass*
1814 Oil on panel, $15 \times 11\frac{3}{4}$.
Capheaton Collection
(cat. 91)

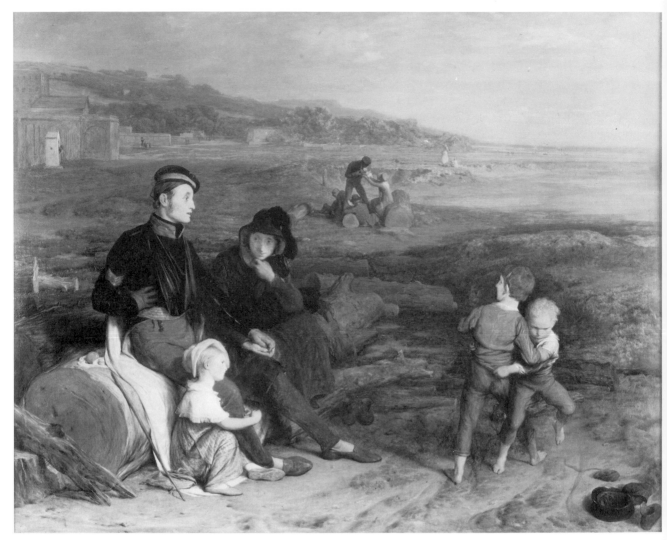

98. *The Convalescent from Waterloo* 1822. Oil on panel, 24 × 30½. Victoria and Albert Museum, London (Crown Copyright) (cat. 105)

beast, the object of their devotion, thereby giving greater dignity to the animal.

In fact, with the exception of his *Girl and Kitten*, 1811, now lost, Mulready generally refrained from employing the more common sentimental associations of children and animals, where children fondle or feed rabbits, birds, cats, dogs or of course, lambs;[34] or, more poignantly, mourn dying or dead animals: for example, in Joseph Wright of Derby's *Experiment on a Bird in an Air Pump*, exhibited at the Society of Artists in 1768; or in William Collins' *Disposal of a Favorite Lamb*, R.A. 1813.[35] In fact, the sentimental nature of Collins' paintings of children with animals provides an instructive comparison with Mulready's work.

Animal response is the subject of Mulready's *Dog of Two Minds*, 1829 (Plate 91) and Collins' *Stray Kitten*, 1835 (Plate 92). In both, the animals are somewhat hesitant. But in Collins' work the children are a

96

life-giving force, providing sustenance for the apprehensive, defenseless kitten;[36] in Mulready's painting a child encourages his dog to commit a destructive, aggressive act. The dog's hesitancy is the result of the violent threat of his master and the equally threatening stance of his opponent. The hesitation of both animals is expressed in the face of markedly different human motives. Collins' children are depicted in a warm, benevolent light whereas Mulready's children embody his more pessimistic view of human nature.

Children also betray their imperfect, animalistic nature in *The Convalescent from Waterloo*, 1822 (Plate 98), Mulready's belated response to the Napoleonic Wars. In this sorrowful scene, an anonymous wounded sergeant is solemnly nursed by his wife, who wears mourning, a mute reminder of a family member less fortunate than her husband. Her soldier husband looks with sadness upon their wrestling sons, recognizing man's inherent warlike instincts in their behavior. In contrast to David Wilkie's *Chelsea Pensioners ... R.A.* 1822, which expresses a joyful scene of war veterans reacting to the news of victory, Mulready's painting brings the tragic effects of war home. Forsaking heroic death scenes and glorious battles, Mulready creates a drama of quiet domestic suffering, underlined by the prophetic image of small fighting brothers.[37]

But the fractious behavior of the brothers harbors another contradictory interpretation as well. Mulready's feisty, pugnacious children embody the resilient spirit of the burgeoning empire and a competitive capitalist society. The public did in fact read such meaning into these paintings. When David Wilkie sold his painting *The Cut Finger*, 1809, a simple narrative of a child hurting his finger while placing a mast in a toy boat, its purchaser retitled it "The Young Navigator", seeing in it "the maritime glory of England in the dawn. . ."[38] The pugnacious pupils in Mulready's *Fight Interrupted* (Plate 90) actually reminded the critic for the *New Monthly Magazine* of the "gallant general, who had fought and bled for his country, [who had] declared that he owed all his success and reputation to the first black eye he received at Westminster [school]".[39] Later Thomas Webster's painting of children playing a rough game of football was described by the *Art Union* in similar terms: "eager urchins rush forward in the very spirit of rivalry; each ardently struggl[ing] to get 'the ball at his foot,' as he will do for more important purposes in after life".[40] The playing fields of England became the pictorial arena for displaying the nation's future strength. In this light, the fighting and conflict incorporated in Mulready's paintings can also be seen as the depiction of children proving their mettle, testing their strength for life's future struggles, both personal and national. They constitute a pictorial preview of Thomas Arnold's muscular Christianity.[41] Thus, the fighting brothers

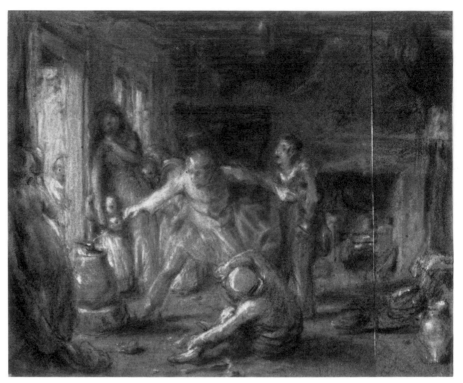

in *The Convalescent from Waterloo*—"Displaying ... true British pluck", a description Mulready used (according to W. P. Frith) when observing two street boys "pummelling one another"[42]—become the seed of Britain's future fighting men; the boy firing a cannon in his painting of the same title (now lost, Plates 99 and 100) becomes the enthusiastic marksman of a future war; the boys with their toy boats in *A Sailing Match* (Plate 88) become the future sailors, perhaps admirals of Britain's superior naval fleet.[43]

Such nationalistic considerations undoubtedly colored Mulready's depiction of Indians and blacks, human symbols of Britain's growing empire, in *Train Up a Child ...* (Plate 101) and *The Toyseller* (2 versions, (Plate 103, Color Plate VIII). Again fear—Mulready's fear and in a more general sense, British xenophobia in the face of these exotic races—comes to the surface. Both the Indian and the black appear in the role of the mendicant, although the black as a pedlar of toys offers a trinket in return for the requested alms. In both, the subject is charity, a traditional theme. But the fear of the shuddering children in both paintings, as if they were in imminent danger when faced with poverty, recalls E. Bulwer Lytton's famous line: "In other countries poverty is a misfortune—with us it is a crime"[44]—and hence the poor are seen as criminals.

In fact, extreme poverty represented a problem of enormous

98

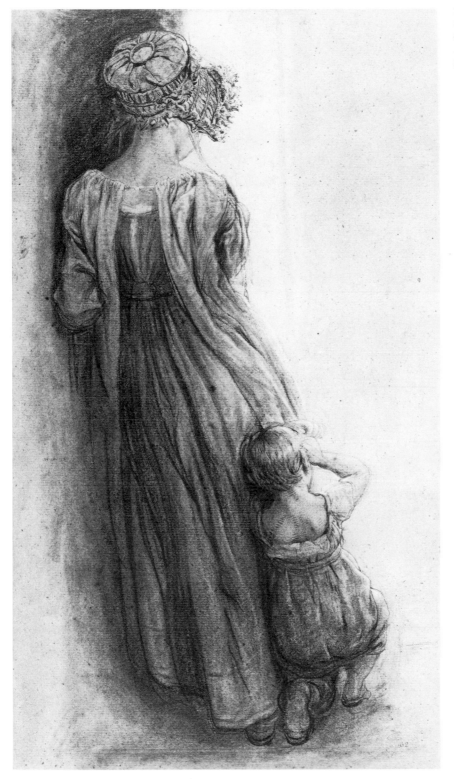

100. Study for *A Boy Firing a Cannon c.* 1827. Black and white chalk, $16\frac{1}{4} \times 9$. Victoria and Albert Museum, London (Crown Copyright)

99

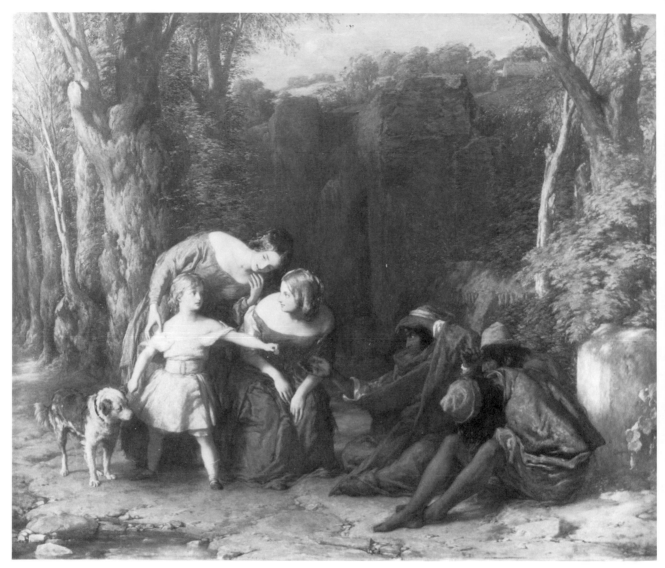

101. *Train Up a
Child* . . . 1841. Oil on panel,
25½ × 31. Collection John A.
Avery (cat. 154)

magnitude for the emerging English industrial society. Outside of the
dreaded workhouses, private charity constituted the major bulwark
against indigence, although it was woefully insufficient. Philanthropy
served the social order, mollifying the poor. As such, it was encouraged
not only as a Christian virtue but as a socially prudent virtue.[45] Beggary
remained a very visible, often frightening public phenomenon.[46]

In *Train Up a Child in the Way He Should Go; and When He Is Old
He Will Not Depart from It* (to cite the complete title), 1841 (Plate 101)
Mulready illustrated a moral lesson: the importance of training children
for their future responsibility, alleviating poverty.[47] But the object of the
child's charity is not the common London street beggar nor the decrepit
rural peasant but a trio of fearsome foreign Lascars,[48] Indian sailors
whom the child approaches with considerable trepidation. In effect,
Mulready re-enacts the myth of British imperial beneficence, but on
English rural soil.

100

The painting fits uneasily into the well-established category of Rustic Charity developed in the late eighteenth century in both France and England. Thomas Gainsborough, Francis Wheatley, W. R. Bigg, W. Owen, Sir Augustus Callcott, William Collins all dealt with the theme of benevolent charity.[49] In such paintings, women and children—the supposedly innocent, good but also weak and protected members of English society—graciously give alms to the even weaker, pathetic poor, presenting quite a charmingly virtuous scene. In contrast, Mulready's exotic beggars, dark and mysterious, troubled the public.

The image of the noble savage—of strange foreign races in general—had tarnished somewhat by mid-century.[50] England was acquiring an empire in far-flung places and their inhabitants were becoming subject to unsympathetic scrutiny. Indians, particularly Hindus, both fascinated and repelled the English, as a later excerpt from the *Spectator* indicates, describing the "Hindoo mind" as that "strange pit full of jewels, rags, and filth, of gleaming thoughts, and morbid fears, and horrid instincts".[51] Their reported habits of widow-burning, in-fanticide, self-mutilation and human sacrifice added a dreadful luster to their reputation.[52] And the supposed salaciousness of Hindu holy men and beggars so vividly described and condemned in the *Oriental Annual* (to which Mulready subscribed) was especially disturbing (and alluring) to the English public.[53] No wonder Mulready's child with his attractive

female companions looks unduly timid (a timidity exaggerated in a preparatory sketch [Plate 102]). As Théophile Gautier explained, "il n'a pas fallu plus de bravoure à Macbeth pour s'approcher des sorcières qui faisaient une si infernale cuisine sur la bruyère de Dunsinane, et n'étaient, à coup sur, pas plus horribles."[54] Mulready had turned to members of the expanding British empire for his horrific imagery.

The subject was unusual. Certainly East Indians were visible in London. They were brought over in East India Company ships as sailors, discharged upon arrival, and then left for several months without employment before embarking on a return voyage. Early in the century, they were prominent among the low-grade pedlars and professional beggars in the poorest sections of the city. They even became the subject of some missionary activity. A religious tract addressed to "Lascars and Chinese", dated 1814, details their pitiable condition: "They are practically and abominably wicked. They are a prey to each other and to the rapacious poor, as well as the most abandoned of our fellow countrywomen. They have none or scarcely any who will associate with them but prostitutes and no house that will receive them except the public house and the apartments of the abandoned. They are strangers in a strange land and demand our hospitality."[55] Their condition warranted a report by a Parliamentary Committee in 1814–15. The London Society for the Suppression of Mendicity and the Homeless Poor Society gave them some relief.[56] But while Indians were the object of some charity in England, they were not a common sight. Richard and Samuel Redgrave pronounced the subject of Mulready's painting obscure,[57] as did the critic for the *Art Union*, who found the subject "not agreeable, and certainly not easily intelligible" and "marvelled . . . that the fair young maidens did not 'make off' as rapidly as their delicate limbs could bear them—following the examples of the little boy in their company, who, though he seems a stout lad, shrinks back with instinctive dread from contact with the rascal-looking fellows who are asking charity".[58] By depicting these Indians as beggars in a traditional charity picture, Mulready avoided dealing with the plight of the everyday English poor—in a sense, distancing the genuine misery surrounding the more affluent classes in England by concentrating on these exotic subjects, while at the same time undeniably embodying English fear of the dark races.

Of course, Indians had appeared in English painting before, but they were generally confined to portraiture and to staffage figures in scenic views of India.[59] In both they signified a noble exotic race.[60] Even when Indians appeared in other categories of painting they retained their exotic flavor, as for example in George Stubbs' animal painting *Cheetah and Stag with Two Indians*, *c.* 1765 where the Indians are accompanied by rare foreign animals, or in William Etty's mythological scene *Pluto*

Carrying Off Proserpine, R.A. 1839, where a recognizably Indian model is cast in the form of the rapacious antique god Pluto.

However, the immediate precedent for a consciously Indian theme was provided by his friend David Wilkie, who exhibited *Sir David Baird Discovering the Body of Tippoo Sahib* at the Royal Academy in 1839, a scene which, like Mulready's, ignores the nobler side while emphasizing the fearful aspect of Indians.[61] Tippoo Sahib (1753–1799), Sultan of Mysore, had led Indian troops against the British in the 1780s and 1790s, subjecting British prisoners (including Sir David Baird) to cruel and inhuman punishment. Baird eventually defeated this notorious Indian in 1799 at the Battle of Seringapatam. But here the fearful element is somewhat diminished by the historical nature of the subject, and by showing the rebellious Indian leader in defeat and death, vanquished by Baird and his victorious British troops. And Wilkie, like other artists of the Romantic generation, depicted the Indians, the exotic race, *in situ*—in India. Mulready brought the Indians home to England where they intrude on the peaceful English rural world, which to city dwellers was the one symbol of stability (however false) in an ever-changing, increasingly urban society.[62]

The elemental fear which is so central to the impact of *Train Up a Child . . .* is also present in Mulready's two versions of *The Toyseller*, a scene which focuses attention on a black man, another important symbol of England's empire, in this instance Africa and the West Indies.

Blacks had been subject to two divergent characterizations in late eighteenth-century England: the noble savage brutalized by slavery but ripe for perfectibility once released from his abject state (the position of the philanthropists and the abolitionists) and the subhuman savage, closer to the animal world (rumored to copulate with wild beasts), shiftless, untrustworthy and sexually promiscuous (the racist caricature propagated by slave interests).[63] The sympathetic view of the black predominated in England, eventually leading to the abolition of the slave trade in Britain in 1807. Complete emancipation of slaves followed in 1834 without, however, obliterating the black caricature so well established by the slave lobby. This emancipation of Britain's blacks may have inspired Mulready to undertake the first version of *The Toyseller* in 1835 (Plate 103), a work which he entitled quite simply "The Black" in his Account Book.

In both versions, separated by over twenty years, the blond child draws back in terror before the black pedlar, an emotion seeming perceptibly stronger in the later painting (Color Plate VIII), a nearly life-size version of the theme. In this, the earlier black of ambiguous sex, a broadly treated, nebulous character, gives way to a strongly individualized man, an expressive face depicted with photographic realism and recorded with even greater immediacy in the preparatory

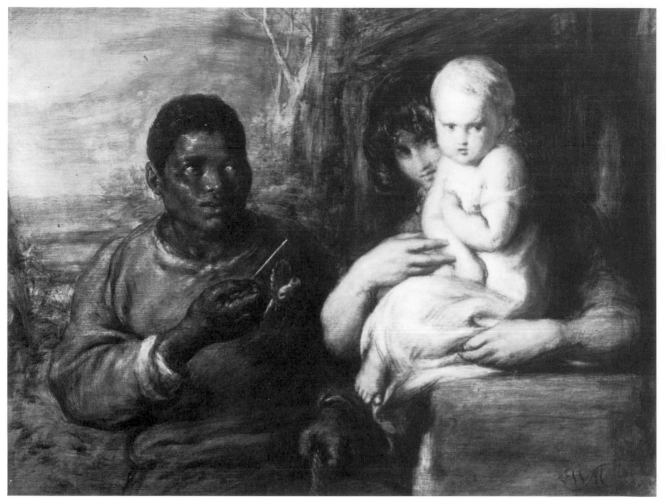

103. *The Toyseller* 1835. Oil
on panel, $7\frac{1}{2} \times 9\frac{3}{4}$. Victoria
and Albert Museum, London
(Crown Copyright) (cat. 141)

drawing (Plate 104). The noble savage of an earlier generation
metamorphoses into a menacing black pedlar, like the Indian Lascars a
fearful intrusion on the English rural scene. While blacks had appeared
in Western painting in various guises (but primarily as servants) for
centuries, Mulready's treatment of the black says something more
specific about growing prejudice and reviving racist fears in nineteenth-
century England, fears which accompanied society's nobler humani-
tarian sentiments.

Cruel caricatures circulated by the slave interests of the late
eighteenth century were far from dormant in nineteenth-century
England, and the emancipation of the slaves in the West Indies
precipitated an enormous economic decline in the islands, bringing
some harsh judgments upon the recently emancipated slaves. One of the
most notable was Thomas Carlyle's vituperative attack "Discourse on
the Nigger Question", in 1849, a damaging and prejudicial assessment
of blacks reiterated a decade later by the prolific and popular novelist
Anthony Trollope in his article "The West Indies and the Spanish

104. (facing page) Study for
The Toyseller 1858. Chalk,
$9 \times 6\frac{1}{4}$. Collection Mr and
Mrs Vincent E. Butler

104

Main" (1859).[64] Even Thackeray, Mulready's friend and champion, turned from his early, rather benevolent treatment of fictional blacks to a more critical spirit in his later writing, underlining the continuous erosion of humanitarian views after emancipation; for, as Dickens so wisely observed, "when it was firmly established, not so very long since, that the negro was 'a man and a brother' [the abolitionists' battlecry] he forthwith ceased to be a friend".[65]

In addition to these views, pseudo-scientific racism under the guise of ethnology and anthropology rose in the 1830s and 1840s with the decline of English abolitionism, further diminishing the status of the black.[66] Strong racist sentiments even penetrated well-meaning expressions of England's governing responsibilities such as that which appeared in the *Daily Telegraph* describing the government's "hopelessly difficult [task] ... of governing wisely, humanely, and justly a community in which unequal and antagonistic races are largely intermingled".[67] Such views crystallized in the 1850s, a decade which saw a particularly sharp rise in unfortunate English governing experiences in New Zealand, the Cape Colony and of course, India, with the violent mutiny of 1857.[68] The above, in conjunction with the unsettling agitation for the emancipation of slaves in America (Harriet Beecher Stowe's *Uncle Tom's Cabin* achieved great popularity in England in the 1850s, precipitating the arrival of a spate of destitute blacks from the American slave states who expected a sympathetic reception)[69] may have encouraged Mulready to return with a vengeance to the racial theme of *The Toyseller* in 1858, now reinterpreted on an enormously enlarged scale and imbued with a much higher level of anxiety and urgency.

The disturbing nature of Mulready's depiction of the black was by no means common, although blacks appeared quite frequently in the works of other artists. For example, *Othello* provided an occasion for the depiction of dashing black men in romantic costume. Mulready contributed an example in his own youthful illustration to Charles and Mary Lamb's *Tales of Shakespeare*, 1807. But it was only in the setting of an historical stage production that a black man could be viewed as a suitable lover and husband for a white woman without outraging the British public. A writer in *Blackwood's Magazine* (1850) explained that the subject would be "loathful if real".[70] Earlier Hogarth had brought blacks and whites together in sensual union on several occasions. But taboos against miscegenation had grown considerably stronger in the nineteenth century, so that the mere encounter of Mulready's black pedlar with the fair mother and child surely created feelings of agitation, uneasiness and dread in the contemporary English viewer.[71] And the near "Venus Pudica" pose of the tremulous child undoubtedly served to reinforce the viewers' dread.

Blacks also continued to appear in the traditional role of servant, as

seen for example in William Etty's paintings, where blacks often provided a colorful and exotic counterfoil to his voluptuous women.[72] But other Romantic artists employed the black in new categories. J. S. Copley and Theodore Géricault incorporated blacks prominently in their modern history paintings (for example, Copley's *Watson and the Shark*, 1778 and *The Death of Major Pierson*, 1781–7, or Géricault's *Raft of the Medusa*, Salon, 1819, exhibited in England in 1820).

The condition of slaves elicited great sympathy from the Romantic generation, presenting a rich theme for their collective imagination. Géricault was working on the subject of the "Negro Slave Trade" when he died in 1824. But such themes were even more prevalent in England where William Blake and George Morland made sympathetic reference to the enslaved blacks in their work[73] as did Turner in his painting *Slavers Throwing Overboard the Dead and Dying*, R.A. 1840, although the latter scarcely focused on the black man as such, but rather on Turner's beloved exploration of water and light, his perennial subjects. Lesser artists dealt with the theme more directly. For example, L. Beard exhibited a painting entitled *The Slave Trade* in the same year, depicting a slave being examined for sale. This led the *Art Union* to place the artist "in the ranks with Clarkson, Wilberforce and Brougham", prominent abolitionists, for stirring "within the breasts of the spectators a virtuous indignation against the cruelties inflicted upon our fellow-men".[74] On a gentler note, Charles Lamb provided the title and poetic verse to accompany Henry Meyer's painting *The Young Catechist*, exhibited at the Society of British Artists in 1827, in which a fair young girl, looking "not to the skin but heart", instructs a black man in Christian prayer. After the publication of *Uncle Tom's Cabin* in 1852 there was an upswing in such themes including a painting by Sir Edwin Landseer directly inspired by Stowe's work.[75] Other artists turned to slightly earlier American literature; for example, Richard Ansdell used H. W. Longfellow's poem *The Slave in the Dismal Swamp* (1842) for his pathetic scene *Hunted Slaves*, R.A. 1861.[76] But in all such scenes, blacks were the object of sympathy, of humanitarian concern, not the source of fear as in Mulready's late *Toyseller*.[77]

Lastly, of course, there were scenes of blacks as "noble savages" with exotic animals—much like Stubbs' *Cheetah and Stag with Two Indians*. Mulready's friend George Dawe won a prize from the British Institution in 1811 for his painting *A Negro Overpowering a Buffalo*; William Carpenter, Junior continued such scenes on a more prosaic, genre level with paintings entitled *Nuts to Crack*, R.A. 1843, showing a black boy feeding nuts to a macaw, or *Moved by a Feather—Tickled by a Straw*, R.A. 1844, showing a small black boy playing with a monkey.

Interestingly, Wilkie again provided the most relevant precedents for Mulready's blacks, having integrated them into the contemporary

105. *Chimney Sweep* Pen and brown ink, $2\frac{7}{8} \times 2\frac{5}{8}$. Whitworth Art Gallery, University of Manchester

English scene. For example, Wilkie depicted a black as a casual observer in one of his oil sketches for *Card Players*, 1808, as a tavern drinker in *Village Festival*, 1811,[78] and as a prominent figure in *Chelsea Pensioners . . . R.A.* 1822. But integration is the key word, differentiating his blacks from Mulready's later examples. Wilkie's are neither mysterious nor frightening but seemingly natural inhabitants of the local English scene.[79]

Mulready's fear seems sadly misplaced in such scenes. While producing unlikely images of colonial people, Indians or blacks, he ignored the truly frightful role of contemporary children as expendable industrial fodder—a tale so matter-of-factly related in the reports of the Royal Commissions on child labor[80]—or as abandoned "Oliver Twists" of the British urban world, so graphically portrayed by Charles Dickens. Evidently such concerns rarely penetrated Mulready's fabricated rustic microcosm. In a pen and ink drawing of a soot-blackened chimney sweep (Plate 105), he dealt with the sad plight of children whose lives were threatened and thwarted by their hazardous occupation.[81] Unlike the sympathetic treatment given to their condition in the writings of William Blake, Charles Lamb, and Charles Dickens,[82] Mulready betrayed no compassion for their abominable state. As with the Indians and blacks, the children who surround the young chimney sweep draw back in horror before the outstretched hand of the social outcast who begs for assistance. Their youthful kinship is denied in this disheartening confrontation.[83] Mulready never translated this disturbing scene into an oil painting.

Not that Mulready completely avoided the theme of working children; he simply turned to more picturesque "types"[84] for inclusion in his paintings. See, for example, the boy feeding his horses in *Horses Baiting* (Plate 60)—a more colorful yet perhaps a less common sight than youthful workers in an agricultural gang; the delivery boy skillfully balancing his many pottery jugs in *Giving a Bite* (Plate 94); the cherry seller, the laundry boy, the butcher boy of *The Butt—Shooting a Cherry*, 1847 (Plate 106), who all enjoy the relative freedom of their rural work which allows them an idle moment of play—unlike their counterparts in the factories and mines. In effect, the social ills which truly threatened British children did not surface in Mulready's paintings. Instead, the universal underlying psychological anxieties of childhood found symbolic expression in the terrifying "otherness" of colonial Indians and blacks.

Surprisingly, despite this preoccupation with fear-ridden vulnerability, Mulready never explored the subject of childhood's ultimate vulnerability: death, a very popular theme with his contemporaries in both painting and literature.[85] In fact, when painting the subject of the sick child in *The Travelling Druggist* of 1825 (Plate 107), a scene which

108

could so easily lend itself to morbid interpretation, he chose to minimize the child's physical fragility, to dispel thoughts of hovering death. Instead, the old pedlar in oriental dress attracts our interest and sympathy as well as the awe, fear, and wonder of the sick child and his healthy sister. This Rembrandt-like figure[86] foreshadows (in a more commonplace fashion) the intrusion of the Indians and blacks in Mulready's later paintings.

Mulready also portrayed the more popular and placid image of children protectively ensconced in Ruskin's "vestal temple"[87]—the nineteenth-century English home with all its idealized, sanctified trappings. *The Rattle* (Color Plate I) and *A Carpenter's Shop and Kitchen* (Plate 72) of 1808 (discussed earlier), *Interior of an English Cottage* (The Gamekeeper's Wife), 1828 (Color Plate V) and *The Artist's Study*, 1840, now lost, but retained in a magnificent and characteristic chalk cartoon (Color Plate VI), all place children in enclosed, peaceful domestic interiors, bathed in warm, almost hallowed

106. *The Butt—Shooting a Cherry* R.A. 1848. Oil on canvas, $15\frac{1}{4} \times 18$. Victoria and Albert Museum, London (Crown Copyright) (cat. 166)

107. (facing page) *The Travelling Druggist* 1825. Oil on canvas laid on panel, $31\frac{1}{8} \times 26\frac{3}{8}$. Harwood Gallery, Leeds (cat. 109)

108. *A Girl Dozing Over her Lessons* 1826. Pen and ink, sepia wash, $6\frac{1}{8} \times 4\frac{3}{8}$. Ashmolean Museum, Oxford

109. *A Sleeping Girl* 1826. Pen and brown ink, $3\frac{1}{4} \times 6\frac{1}{2}$ (sight). Whitworth Art Gallery, University of Manchester

light—not, by the way, in urban ghettos or middle-class homes, but in idealized rural settings, taking up and perpetuating the social myth of the poor but happy home of the worker: the carpenter, the gamekeeper, the young struggling artist.[88] And the stunning window views in the latter two paintings (one of Mulready's favorite compositional devices) serve as a special reminder of the idyllic countryside surrounding these rustic people.

This idealized rural home and family provide the natural setting for children's vital learning experiences, both intellectual and moral, in Mulready's paintings. Whereas the school, the institutional setting for learning, has a prison-like atmosphere,[89] and is a source of strict censure and nasty fighting as seen in *Idle Boys* (Plate 84), *The Fight Interrupted* (Plate 90), and *The Last In* (Plate 87), the home is a haven of gentle instruction where even a refreshing nap is tolerated in the interest of accommodating a pupil (Plates 108, 109). This view was scarcely new. Its roots lay deep in the Enlightenment. And Mulready inherited this favorable, sentimental view of the home and family as the ultimate fount of valuable childhood learning, while eschewing the cherished Enlightenment belief in perfectibility.

In the *Origin of a Painter*, 1826, now lost (Plate 110) Mulready envisioned the origin of his noble profession in the bosom of a rural family. Ignoring Pliny the Elder's ancient tale of the Corinthian maid outlining the shadow of her lover's profile on the wall, a hypothesis much favored by neo-classical painters,[90] Mulready placed the "origin" in a simple moonlit cottage where a young boy outlines the shadowed profile of his sleeping father while his mother and brother look on[91] (a motif which should also be associated with the Romantics' fascination for the imagined formative years of famous artists).[92] On a more prosaic level in *The Forgotten Word* of 1832 now lost, but known by an engraving (Plate 111) a cottage garden nurtures the learning efforts of a small child resting on the knee of an attractive, barely adolescent sister who sits on the stump of a tree, leaning back against the cottage wall, daydreaming.[93] How unlike the chaotic schoolroom is this tranquil seat of learning, this sanctuary buttressed by home and family.

Mulready's preference for the school-at-home is demonstrated most explicitly in his contribution to Henry Cole's series of illustrated children's books, published in the 1840s.[94] Cole originally suggested that Mulready illustrate "Jack the Giant Killer".[95] But Mulready declined, considering the subject unsuitable for his imaginative powers. Instead he provided the frontispiece for *The Mother's Primer*, 1844 (Plate 112), charming scenes of a mother and father supervising the lessons and play of their well-behaved children at home.[96] Of course, the governess who normally supervised such activities is nowhere in evidence. Painful ruminations on her unfortunate social position would have soured Mulready's delightful vision of home instruction.[97]

112

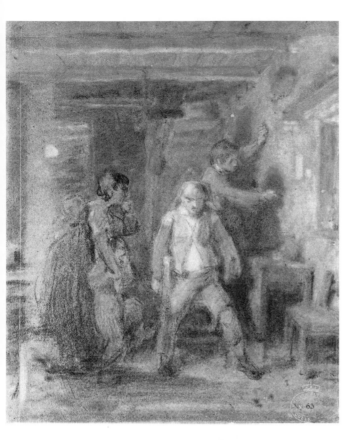

110. (above left) Study for *Origin of a Painter c.* 1826. Black and white chalk on brown paper, $7\frac{1}{2} \times 6$. Victoria and Albert Museum, London (Crown Copyright)

111. (above right) Engraving by C. Rolls after Mulready's *The Forgotten Word* R.A. 1832

112. (left) Frontispiece, *The Mother's Primer* (detail) 1844. Drawn on zinc, $3\frac{3}{8} \times 3\frac{3}{8}$

113. *Father and Child*
1828–30. Oil on panel,
$8\frac{1}{2} \times 7\frac{1}{8}$. Collection Mrs
Brigid Hardwick (cat. 117)

114. (facing page) *The Lesson*
1859. Oil on panel, $17\frac{1}{2} \times 13\frac{1}{2}$
(within oval frame). Victoria
and Albert Museum, London
(Crown Copyright) (cat. 171)

Quite naturally, Mulready extended familial responsibility to the moral education of children. In *Father and Child*, 1828–30 (Plate 113) a father reads the Bible to a small child who happily follows the scriptural illustrations. In *The Lesson*, 1859 (Plate 114) a Madonna-like mother teaches her son to pray while behind them a family of doves symbolically reiterates the sanctity of their occupation. The latter, exhibited under the appropriately edifying Biblical verse "Just as the twig is bent the tree's inclined", was a grave reminder of parental responsibility, not unlike the sentiment expressed in *Train Up a Child. . .*[98] In all three paintings, religious instruction was assigned to the family, not to the clergy.

114

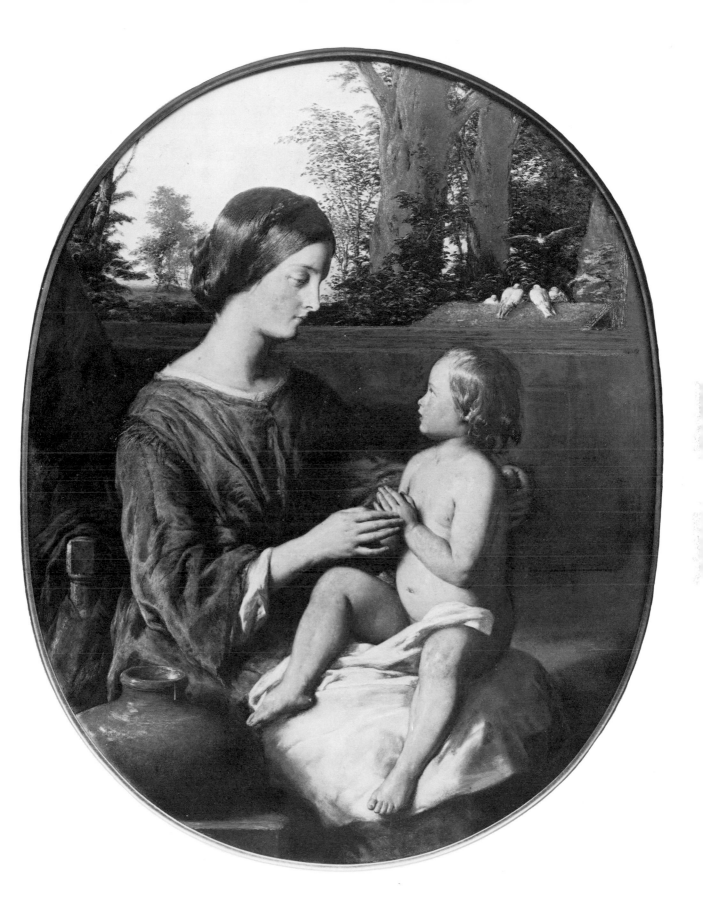

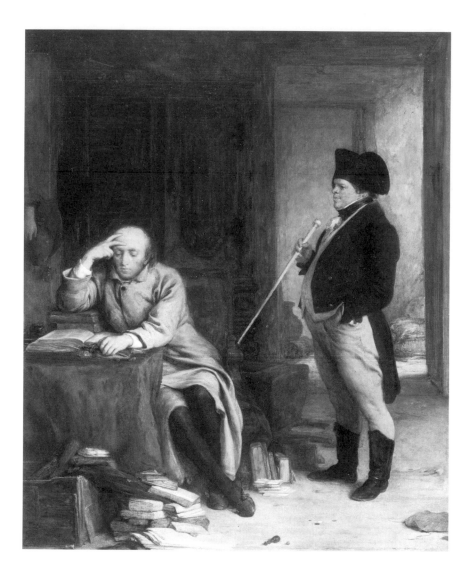

115. *Cargill and Touchwood*
1831. Oil on panel, 20¼ × 16½.
Yale Center for British Art,
Paul Mellon Collection
(cat. 128)

116 *The Street Preacher* 1809
or 1822. Pen and sepia wash,
4⅜ × 5⅛. Victoria and Albert
Museum. London (Crown
Copyright)

In fact, the church, or rather its disputatious clergy, met with Mulready's disdain or derision. As Holman Hunt's *Hireling Shepherd*, 1851–61, contained his symbolic condemnation of bickering clergymen who neglected their flock in favor of their much-loved doctrinal controversies,[99] so too did two literary paintings by Mulready reflect his displeasure with such concerns—albeit more directly. In *Cargill and Touchwood*, 1831 (Plate 115) from Sir Walter Scott's *St. Ronan's Well* (1824), the Revd Cargill, pale, unkempt, wallowing in philosophical tracts, buried in his dusty study, absent-mindedly ignores the spiritual needs of his parishoners as well as the more immediate physical presence of Mr Touchwood, who seeks his attention. In *The Whistonian Controversy*, 1843 (Plate 135) from Oliver Goldsmith's *Vicar of Wakefield* (1766), familial peace is nearly destroyed by the doctrinal argument between Dr Primrose, the Vicar, and his old friend and a neighboring minister, the Revd Mr Wilmot, the future father-in-law of the Vicar's eldest son. Their dispute concerns the contention of the Revd William Whiston (1667–1752) that ministers of the Church of England should not remarry upon the death of a first wife. The Vicar righteously agreed with Whiston (and wrote obscure articles on the subject); Mr Wilmot, then courting his fourth wife, vehemently disagreed. And thus did the Anglican ministry dissipate its energies.

Mulready also proposed a painting entitled "Church and Dissent", presumably a more naked expression of his critical opinion of such practices. Its would-be owner remarked with satisfaction upon the unsettling nature of the theme for clergymen.[100] Unfortunately, it was never completed, perhaps because the subject, once removed from popular literary inspiration, was too raw for Mulready's respectable public position. But in Mulready's view, even if a religious man ignored such wasteful preoccupations and concentrated instead on reaching the population with his moral message, as for example in Mulready's sketches and notes for "The Street Preacher" (Plate 116), a painting never undertaken by the artist,[101] his sermon was likely to be irrelevant. While Mulready's preacher harangues his audience with his tidings that "all is vanity", he is casually surrounded by the infirm (a blind man begging), the poor, the weak, the helpless (a sleeping chimney sweep, charity boys) and the vice-ridden (a drunken mechanic, a prostitute who turns out his pockets). The preacher emerges as an impotent, derisory figure. In Mulready's eyes, only the home and the family are capable of instilling sound moral and religious training. Avoiding doctrinal disputes and useless sermonizing while emphasizing good example and religious ritual (bible reading and prayer), the ideal family could protect and promote the child's spiritual and material welfare and hence the spiritual and material welfare of the state.

But Mulready's interest in children, in hallowed homes or in

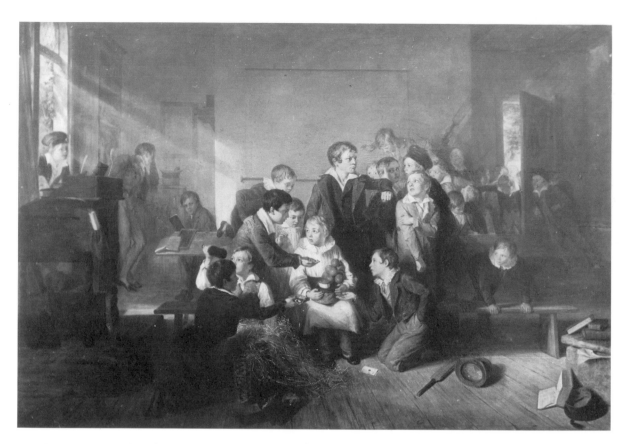

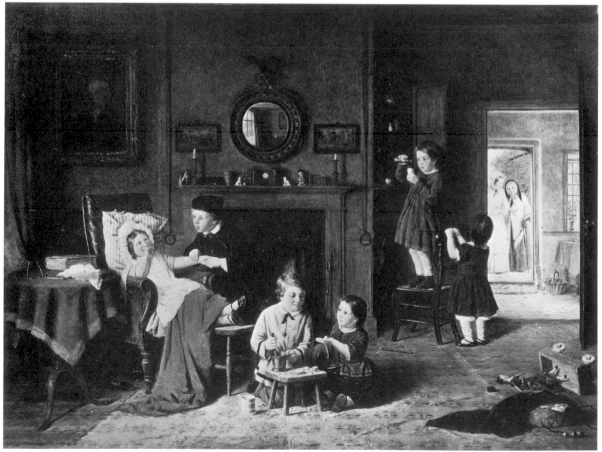

pugnacious play, lessened in the last two decades of his career—possibly as a result of the charges of triviality frequently levelled against such themes[102] (although his own works generally escaped those barbs). Instead, his attention gravitated to new and perhaps for Mulready more challenging areas of expression: to courtship, to literary themes, to the painting of nudes.

The prevalence of paintings depicting childhood life in nineteenth-century England makes Mulready's influence difficult to assess. The exhibition halls of both London and the provinces were filled with such scenes. And today these paintings are often lost, hidden in private collections, or buried in the storerooms of provincial museums throughout Great Britain. More importantly, few have received the attention of modern art historians. In view of this unwarranted neglect of an important aspect of English painting, only a limited evaluation of Mulready's influence can be offered.

Certainly the substantial success and fame accorded to Mulready's particular brand of feisty children, seen for example in *Idle Boys*, 1815 (Plate 84), *The Fight Interrupted*, R.A. 1816 (Plate 90), or *The Wolf and the Lamb*, 1820 (Color Plate III)—the latter made especially popular by King George IV's supposed fondness for the scene[103]—encouraged others to follow his example. While painters had produced images of mischievous children before, their fame did not rest on this accomplishment as did Mulready's. His name and fame were inextricably and understandably linked with scenes of naturalistic, often naughty children. And artists who took up this theme after Mulready's success were clearly painting in his shadow.

A number of artists occasionally produced paintings in this vein, for example Sir Edwin Landseer in his painting, *Naughty Child*, B.I. 1834 (Plate 119), a study of a petulant pupil throwing down and breaking his writing board in a tantrum; or William Henry Hunt, Mulready's old

117. (facing page above) Thomas Webster *The Boy with Many Friends* 1841. Oil on panel, $24\frac{1}{2} \times 35\frac{1}{2}$. Bury Art Gallery

118. (facing page below) F. D. Hardy *Children Playing at Doctors* 1863. Oil on canvas, $17\frac{5}{8} \times 24$. Victoria and Albert Museum, London (Crown Copyright)

119. Edwin Landseer *The Naughty Child* exhibited British Institution 1834. Oil on millboard, 15×11. Victoria and Albert Museum, London (Crown Copyright)

120. G. B. O'Neill *Nestlings* 1870. Oil on canvas, 24×30. Central Art Gallery, Wolverhampton

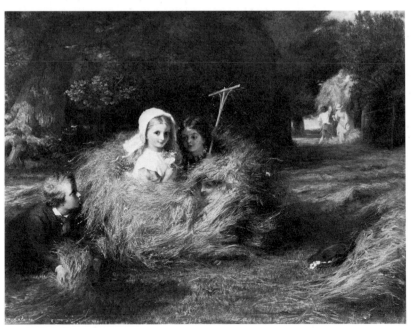

friend from Varley's studio, who painted the motif of humorous rustic youths in numerous watercolors after the late 1820s.[104] But the artist most closely associated by far with images of robust, naughty, sometimes pugnacious children in Mulready's pattern was Thomas Webster (1800–86), who eventually earned the nick-name "Do-the-Boys" Webster.[105] He built his reputation on amusing scenes of children's foibles and fun. He began painting such works in the 1820s, soon receiving some measure of acclaim. Thereafter his rowdy scenes of play and school alternated with quiet, domestic scenes of children at home under the watchful eye of their elders.

At times, Webster's paintings can be confused with Mulready's. The confrontations of his youthful protagonists recall Mulready's earlier oils. For example, the aggressive and defensive poses of the central figures in Webster's *The Boy with Many Friends*, 1841 (Plate 117) brings to mind the drama depicted in Mulready's *The Wolf and the Lamb* (Color Plate III). Moreover, the rather wry assessment of human nature suggested by the subject links Webster to Mulready's own rather caustic point of view as seen, for example, in *Giving a Bite* (Plate 94). But in stylistic terms Webster, unlike Mulready, was not an adventurous colorist. While Mulready, after the 1820s, prided himself on his unusual color schemes, often employing offbeat combinations of brilliant color shimmering on a light or white ground, Webster retained a palette of muted colors, in no way remarkable or unusual. More importantly, the strange anxiety, the shuddering vulnerability hovering above and below the surface in a number of Mulready's paintings is rarely if ever exhibited in Webster's work; and this distinction applies even more to the work of a group of younger artists who assembled around Webster at Cranbrook, Kent in the 1850s and 1860s, emulating his style and, at a greater remove, Mulready's own earlier example.

The so-called "Cranbrook Colony", which included F. D. Hardy (1827–1911), J. C. Horsley (1817–1903), and G. B. O'Neill (1828–1917) (a faithful mourner at Mulready's funeral), specialized in light hearted genre scenes often depicting children (Plate 120).[106] Even when a more serious note was introduced, as for example in F. D. Hardy's *Children Playing at Doctors*, 1863 (Plate 118), where the children's playacting alludes to their grandmother's ill health (she can be spied through the open door), the overall tone of the painting is merry.[107] With emphasis on the playful activity of the cherry-cheeked, buttoned-eyed, middle-class children, the ironic nature of their playful imitation is diminished. The peculiarly expressive undertone associated with Mulready's works is absent.

In fact, such anxieties, fears and vulnerabilities are noticeably absent from most Victorian children's scenes, thus indicating the escapist nature of many of these works.[108] Often amusing, quite lively, but more

120

often cloyingly sweet, they comforted and entertained the British population, then experiencing convulsive social changes, diverting their attention to warm, idealized memories of childhood with the edges of youthful fear and uncertainty blunted. While Mulready also avoided depicting the convulsive changes which characterized his own urban English society—indeed, removing his urchins to rural or suburban settings—one nevertheless senses the uncontrollable nature of these changes in the anxious expressions of many of his children, and in their continual conflicts. The universal vulnerability of childhood provided a metaphor for contemporary social instability. Such images were less than comforting and often, perhaps unconsciously, threatening, seeming to reveal the cracks in the surface of an otherwise placid rural world. And although some of Mulready's visions of childhood conformed to conventional artistic norms—for example, showing children in close harmony with nature (in his early works), or in their protected homes, or in lively schoolrooms—his revelatory views of children's inner ambivalence, their vulnerability and fear were unusual and constitute a valuable, although jarring, contribution to nineteenth-century paintings of childhood life.

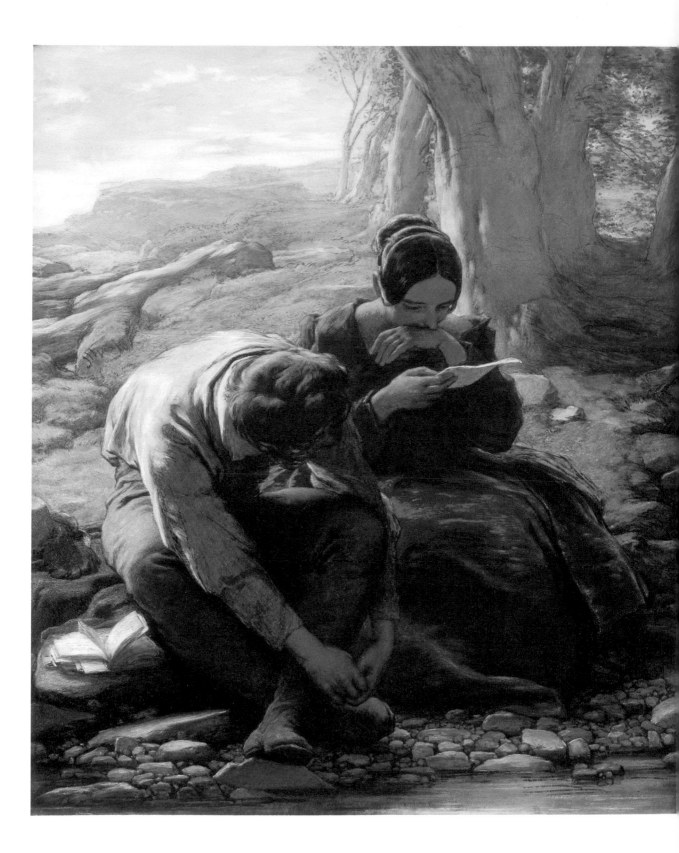

IV. Courtship and Literary Themes

While Mulready's children's scenes established his reputation, some of his most popular and certainly most beautiful paintings have courtship themes, often inspired by literature.

His earliest love scenes exude the same comical spirit that infuses a number of his successful paintings of children. In *The Village Buffoon* of 1815–16 (Plate 121), his diploma piece for the Royal Academy, Mulready depicted the traditional theme of the old fool courting a young maid, a scene invested with recognizable country humor. Before a meticulously rendered cottage backdrop, an elderly suitor assumes a pathetic pose with fluttering, flattering fingers, as he solicits the attention of the young woman, who retreats to the security of her own cottage door, shunning the advances of this unwelcome, balding Romeo. While her mother registers shocked disbelief at the suitor's proposal, a young child candidly explores the appearance of the odd visitor, trying to fathom the meaning of his fawning manner. The response of each character is carefully distinguished by the position of their arms: the old man's hope reflected in his tentative gesture (the focus of the painting); the mother's shock shown by her bolt-straight arms; the small child's open wonder suggested by her arms brought back; and, of course, the young woman's heart-felt rejection expressed by the way her arms protectively cover her torso, physically shielding her body from the old man's advances. The viewer smiles, acknowledging the old man's folly and presumption.

An amusing view of courtship also appears in *The Wedding Morning* (Plates 122, 123), an oil sketch, undated but probably painted in the early years of Mulready's career. Rather than emphasizing the sweet sentiment of young love which Mulready explored so successfully in his later paintings, he instead depicts an entertaining incident, the last inspection of the groom before his departure for the wedding, a composition perhaps inspired by a similar scene in Hogarth's series, *A Rake's Progress* (I). The young, self-conscious bachelor submits to the

IV. (facing page)
The Sonnet 1839. Oil on panel, 14 × 12. Victoria and Albert Museum, London (Crown Copyright) (cat. 151)

123

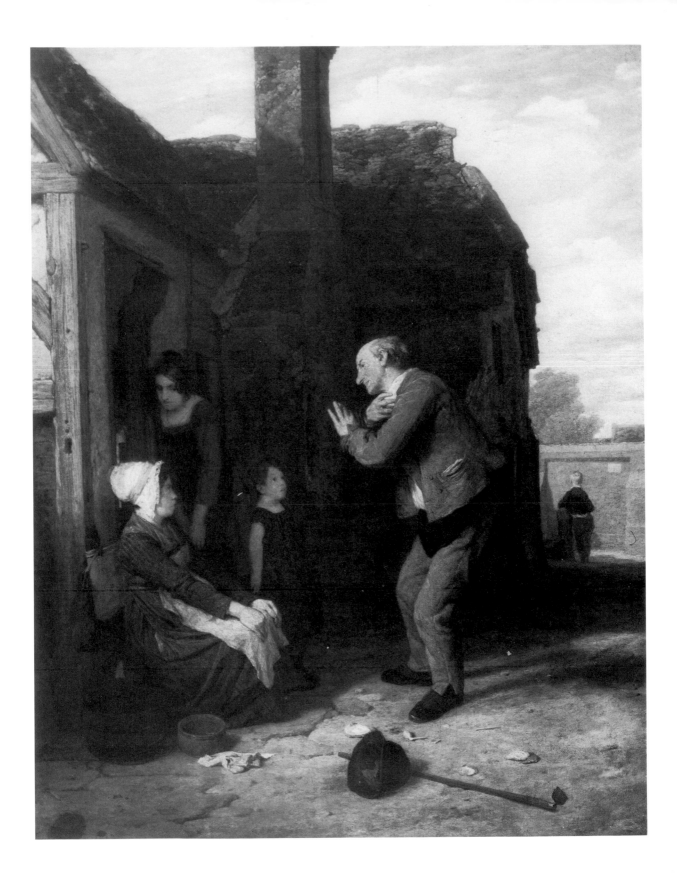

poking and fussing of his family. The elderly gentleman at the right (perhaps the groom's father) is resigned to waiting with good-humored patience until the ritual is over. He smirks, like the viewer, at the last-minute preparations.

In *The Widow* of 1823 (Plate 124) Mulready moves from the peasant-like characters of *The Village Buffoon* and *The Wedding Morning* to the merchant class and to a more sophisticated and caustic commentary on love, marriage, and its materialistic concerns. The widow and her orphaned children, who were commonly objects of overblown sentiment, bringing tears to the eyes of the most hardened mercantile viewers, are here rendered humorous. The wholesome and hearty widow is placed in a prosperous home with servants and silver. A well-placed window allows her to survey her thriving business, presumably the inheritance from her late, departed, but no longer mourned husband. Surrounded by luxuries, she is courted by a jolly, robust man—who is not unaware of her good fortune.[1] The children, far from being wan and weary orphans suffering from the recent loss of their father, welcome the new father-figure with a heartless joy. Only the pouting older child reminds one of the recently deceased family member. In this way Mulready dispenses with the maudlin and much-loved theme of the pre-Victorian and Victorian audience, the death of a loved one, emphasizing instead with a cynical eye the comical courtship of the rich widow.[2]

The comical tone of these early paintings is very different from the

122. Study for *The Wedding Morning* Pen and sepia wash, $6\frac{3}{4} \times 3\frac{5}{8}$. Victoria and Albert Museum, London (Crown Copyright)

123. *The Wedding Morning* c. 1808 (?). Oil on panel, $6\frac{5}{8} \times 7\frac{5}{8}$. Lady Lever Art Gallery, Port Sunlight (cat. 43)

121. (facing page) *The Village Buffoon* 1815–16. Oil on canvas, $29\frac{1}{2} \times 24\frac{5}{8}$. Royal Academy of Arts, London (cat. 94)

125

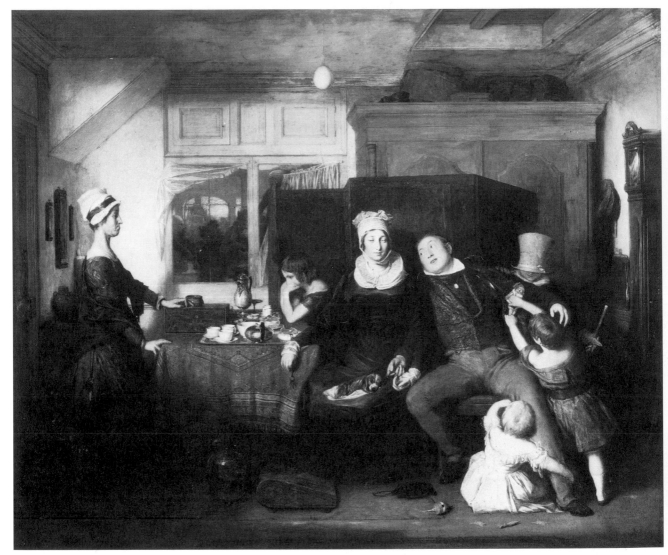

124. *The Widow* 1823. Oil on canvas laid on panel, 27 × 31½. Private Collection (cat. 107)

125. (facing page) *First Love* 1838–9. Oil on canvas, 30½ × 24½. Victoria and Albert Museum, London (Crown Copyright) (cat. 150)

sweet sentiment contained in his full-blown love scenes of 1839, *First Love* (Plate 125) and *The Sonnet* (Color Plate IV), both quiet, touching scenes of young romantic love.

In *First Love*, a painting reminiscent of Gainsborough, the adolescent couple seems a natural extension of Mulready's interest in children. Adolescence, like childhood, was a newly appreciated stage of human life. Its unsteady course, its uncertain footing were subtly suggested by Mulready in a slightly later painting, *Crossing the Ford* of 1842 (Plate 126). Here the common theme of people or animals crossing a stream[3] is translated into a metaphor for insecure adolescence: two boys carefully carry an adolescent girl across the rock-strewn water; their sober expressions convey a sense of the perilous path from childhood to adulthood.[4]

126

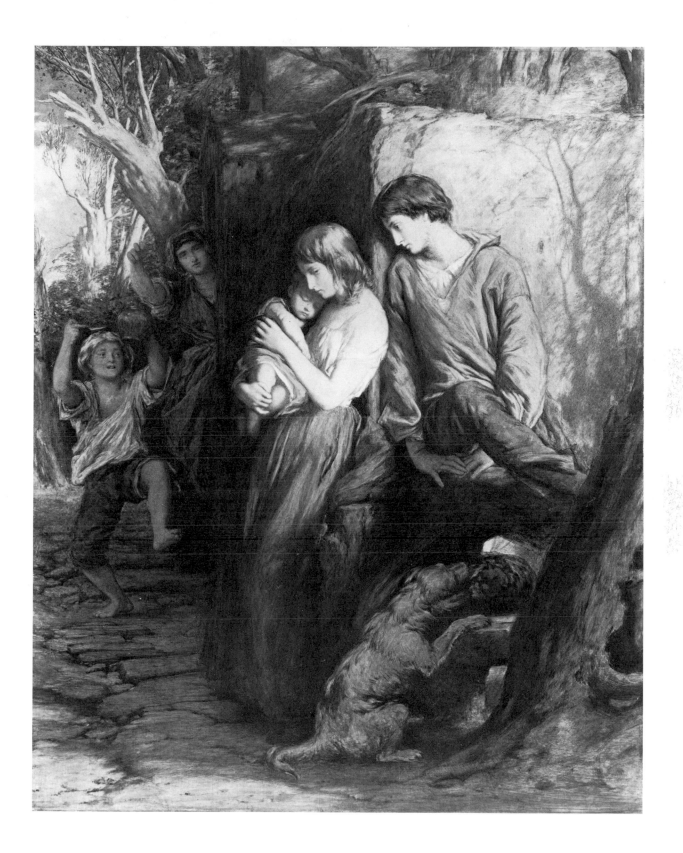

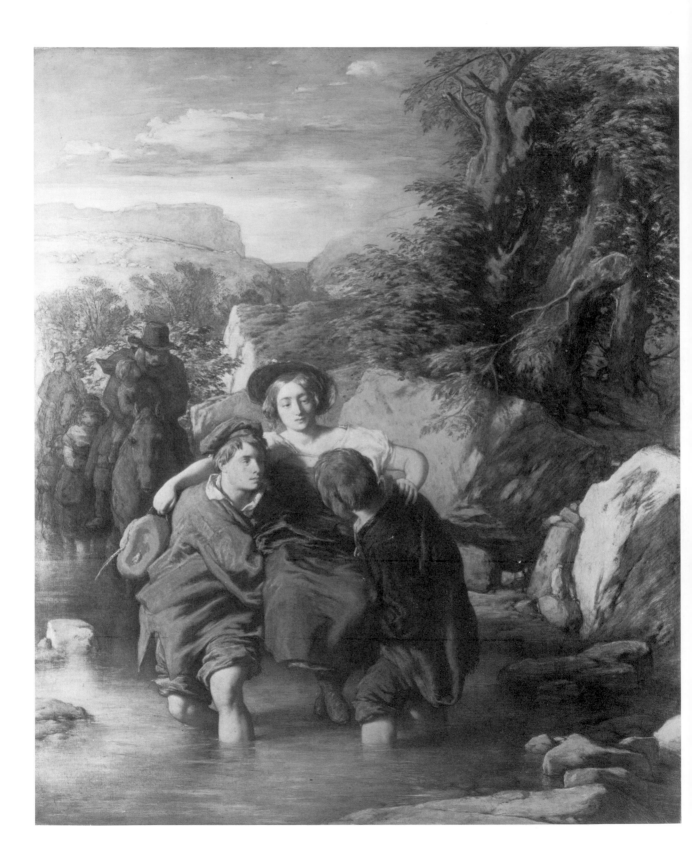

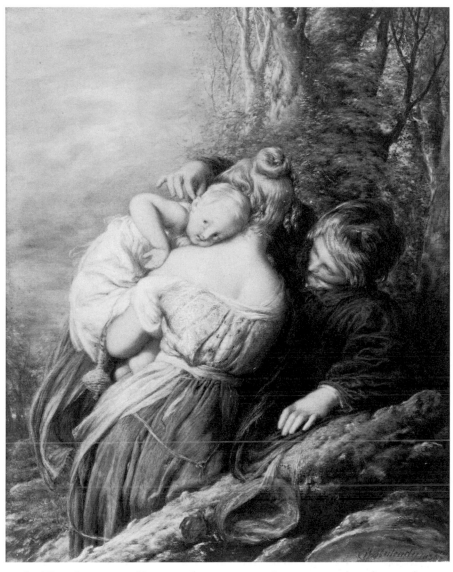

127. *Brother and Sister* 1835–6
Oil on panel, 12 × 9¾.
Victoria and Albert Museum,
London (Crown Copyright)
(cat. 147)

In *First Love* one glimpses the new tumultuous emotional experiences of adolescence; the energetic dogs below suggest the vital, repressed sexuality, the "puppy love", of the blushing girl and yearning boy above. The small baby cuddled in the arms of its older sister becomes an undeniable if unconscious sign or symbol of the longed-for sexual union between the two youthful lovers; for children presented a constant and ever present reminder of sexual activity then unacknowledged in polite English society.

Mulready's depiction of tender romantic courtship in *First Love* was preceded by two earlier works of the 1830s, *Brother and Sister* (or *Pinch of the Ear*, Plate 127) and *Open Your Mouth and Shut Your Eyes* (Plate 130) which, while not ostensibly courtship scenes, nevertheless

126. (facing page) *Crossing the Ford* 1842. Oil on panel, 23⅞ × 19¾. Tate Gallery, London (cat. 157)

129

128. Study for *First Love*
dated 17 July 1835. Pen and
ink, $4\frac{7}{8} \times 3\frac{3}{8}$. Victoria and
Albert Museum, London
(Crown Copyright)

129. Study for *Brother and
Sister*, dated 17 July 1835.
Pen and ink, $4\frac{7}{16} \times 3\frac{5}{8}$.
Collection Leslie Parris

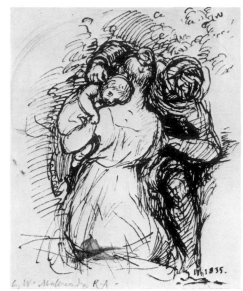

contain the seeds of the barely disguised sexuality which pervades *First Love*. Like the later painting, both depict a male/female couple accompanied by a small baby (again suggesting a family group or, on another level, potential sexual union).

In *Brother and Sister*, a work repeated by Mulready two decades later on an enlarged scale (Plate 153), a youthful lad in close proximity to a young blond woman puts his arm around her to twitch the ear of a small baby. The young woman, with small waist and seductively bare shoulders, nestles between the baby and the adolescent boy. While she could conceivably be the boy's older sister (as the title implies and as contemporary reviewers read the painting), their close proximity and her attractive shoulders suggest, perhaps inadvertently, another interpretation—one that apparently occurred to the artist as well, for Mulready's earliest sketches for *Brother and Sister* and *First Love* were drawn on the same day (Plates 128, 129).

Undertones of sexuality are even more prominent and provocative in *Open Your Mouth and Shut Your Eyes* (Plate 130). The trio now consists of a pre-adolescent girl at the left being fed cherries by a robust, muscular young man sporting whiskers; a small baby accompanies the couple, partially obscured by the man. As with *Brother and Sister*, the figures are situated in a pale, unreal landscape confection: a backdrop which tends to heighten the physicality of the human figures. Despite the seemingly innocent theme of rustic family life, this "delicious subject", as the *Art Union* described it,[5] demands an alternative reading in view of its inherent sensuality, which was unconsciously acknowledged in the *Art Union's* commentary. The young girl at the left, with partially closed eyes, open mouth and rounded, bare shoulders

130. *Open your Mouth and Shut your Eyes* 1835–8. Oil on panel, $12\frac{1}{2} \times 12$. Victoria and Albert Museum, London (Crown Copyright) (cat. 145)

is a powerful image of innocent purity and sexuality, a titillating and potent combination. The presence of the cherries and green apples suggests her own unripe state as "green fruit", to borrow the nineteenth-century phrase for girlish virgins.

While love scenes between children were not uncommon in nineteenth-century painting (or literature)—one thinks of Millais' *The Woodman's Daughter* of 1851[6] inspired by Coventry Patmore's *The Tale of Poor Maud*, or James Hayllar's *The First Flirtation* of 1867,[7] both showing the amorous encounters of very young children—this scene by Mulready harbors the visualization of a nineteenth-century English sexual fetish: the predilection of mature men for young girls. One can easily call to mind the more notorious examples: John Ruskin's love for the young Rose La Touche, or Lewis Carroll's admiration for pre-adolescent girls (and his nude photographs of them). Among lesser known figures, E. W. Benson, later to be Archbishop of Canterbury, courted a girl who was only eleven years old, when he was twenty-three, with a view to marriage. As he explained in his Diary (1852), "Whatever

131

she grows up to be, she is a fine and beautiful bud now."[8] This passion for the bud, the unripe fruit, engendered a flourishing market in very young girl prostitutes or older women coyly dressed to look like children.[9] *Open Your Mouth and Shut Your Eyes* can be viewed in this context; its expressive power derives in part from the suggestion of seduction, of innocence violated.

Mulready brought the underlying sexual vibrations of these earlier paintings to a conscious level in his more acceptable, conventional presentations of the theme in *First Love* and *The Sonnet*, both 1839. *The Sonnet* (Color Plate IV) is perhaps Mulready's most successful painting. Though it is only a small cabinet painting, its two lovers nevertheless seem heroic, a quality achieved through Mulready's dependence upon Michelangelesque forms. Following Reynolds' advice in his *Discourses* to use great compositions from the past when suitable for the subject, Mulready based both the young man and the woman on the Prophet Jeremiah from the Sistine Chapel.[10] This transformation of the Renaissance pre-Christian prophet into two romantic lovers was a typical nineteenth-century transposition of earlier source material. Rather than the horrific imagery of Michelangelo's *Last Judgment*, which inspired Fuseli, James Barry and William Blake in the late eighteenth century, here a more tranquil Michelangelesque spirit infuses a certain nobility into the fresh young love scene.[11]

The theme itself, a young woman reading the sonnet of her hopeful yet bashful lover,[12] may have been influenced by a painting exhibited by Mulready's son, William, Jr, at the Royal Academy in 1838 (Plate 131), which depicted an interior scene with a young woman reading a note, while a shy suitor, eyes cast down, sits beside the doorway waiting for her response.[13] But in more general terms, Mulready's scene of courtship belongs to the French and English tradition of timeless, arcadian love scenes of the late eighteenth century. An untilled, non-agricultural country setting of hills, rocks, trees and streams serves as the idyllic trysting place for this contemplative couple.

In clinging to this eighteenth-century pastoral mode Mulready avoided a contemporary spirit and setting. The hothouse atmosphere of an urban middle-class interior does not hamper this innocent meeting as it did in W. P. Frith's *The Proposal* of 1853.[14] No harsh stone wall or hardy old tree serves to symbolize the strict separation of the sexes—the stalwart social forces which worked against the consummation of courtship, as seen, for example, in Arthur Hughes' paintings, *April Love* and *The Long Engagement*.[15] It differs, too, from an apparently similar rustic scene by W. Holman Hunt, *The Hireling Shepherd* of 1851,[16] a work perhaps inspired by Mulready's painting *The Sonnet*. Its heavy moral symbolism, the knowing, rather vulgar expression of the country lass are in marked contrast to the utter innocence and simplicity of

Mulready's idyllic scene. What Mulready's painting does, however, have in common with these later works is its high-keyed color. For although the spirit of Mulready's painting looked back to the past, its execution, particularly its vibrant color, looked to the future. His brilliant and novel palette inspired a host of younger artists, most significantly the Pre-Raphaelites. And like the Pre-Raphaelites, Mulready received some criticism for employing "colouring so unnatural that we can only account for . . . it by supposing him not to be wholly exempt from that species of unwise admiration for the ancient painters".[17]

The Sonnet (Color Plate IV) is painted in brilliant shades of red, fawn, sharp acid green, and violet, shot through with luminous white. Painted on a white ground which gleams through the glazed, broken colors, the small painting shimmers like a jewel, suggesting the glaring effects of bright sunlight. This was not the first instance of Mulready's brilliant color. His palette had gradually grown lighter and brighter in the 1830s, culminating in 1839 with *The Sonnet*. It became the distinguishing feature of his painting style.

Mulready's experimentation with color probably developed from his own insecurity with color composition. As early as 1816, Farington reported how Mulready "spoke of the great difficulty He found in colouring, being always uncertain in forming his combinations".[18] This uncertainty led Mulready to experiment with various colors before

131. William Mulready, Jr *Interior* R.A. 1838. Oil on panel, $16 \times 20\frac{1}{2}$. Victoria and Albert Museum, London (Crown Copyright)

133

undertaking a final painting. These color studies or sketches were sometimes in oil, as with *The Rattle* of 1808, or in watercolor, as for example with *Giving a Bite* of 1834.[19] To increase his understanding of the physical properties of color he became acquainted with George Field, an important contemporary color maker, who speculated on the nature of color in his publications, most notably in *Chromatics, An Essay on the Analogy and Harmony of Colour* (1817).[20]

Mulready's careful scrutiny of old master paintings also contributed to the development of his color. In manuscript notes he commented upon Titian's use of pigment and on the color of Van Dyck, Rubens and Murillo.[21] He particularly admired Venetian painting, hoping to graft its color onto Dutch-like subjects. But Mulready's palette, almost electrifying in its intensity, was even more vivid than the Venetians'. It was as if he was attempting to recapture the imagined brilliance of Venetian painting in its original state, unsullied by varnish and time.[22] "The old painters used the brightest colours they could get" (as he explained to Samuel Palmer) and he would do the same.[23]

Mulready began moving away from his early style in the 1820s when experimentation with color and painting technique was much in vogue. His contemporaries David Wilkie and William Etty returned from European visits in the 1820s heavily influenced by the rich, glazed surfaces of earlier Venetian and Spanish painting, and introduced such qualities (then rather unusual) into their own works. Not only did Turner's painting become exceptionally bright and light-filled in this period, but his correspondence with one of Mulready's old friends, George Jones, contained many comments on color and chemistry.[24] In general, exhibitors at the annual R.A. exhibitions were forced to lighten their palettes or enrich the surfaces of their canvases to attract the attention of viewers surfeited with undistinguished paintings strung up and down the Academy's walls.[25]

Mulready began glazing his color on a brown ground in the mid-1820s with three transitional paintings: *The Travelling Druggist, Origin of a Painter*, and *A Boy Firing a Cannon*. According to Richard and Samuel Redgrave's first-hand account of Mulready's color experimentation in *A Century of Painters of the English School* (1866), this method was far from successful; the color pitted or cracked on the surface, and the dark ground produced a muddy effect. Although this may be a faithful description of *Origin of a Painter* and *A Boy Firing a Cannon*, both now lost, it does not accurately reflect the rich, golden tonality of *The Travelling Druggist* (Plate 107), which was clearly inspired by Rembrant's example.[26] To improve this manner Mulready introduced the use of a white ground for *Interior of a Cottage* of 1828 (Color Plate V). The warm toned pigments were now applied to a luminous white surface to create an especially effective impression of a lowly

interior illuminated by the setting sun and a glowing hearth fire. The curiously mottled application of paint which is evident here became characteristic of Mulready's style in the late 1820s and early 1830s.[27] But it was not until the mid-1830s that Mulready employed a white ground, glazes, and high-keyed color to produce the brilliant, eye-searing effects of his later works, a development which is reflected in his expressed desire to combine "The greatest quantity of light consistent with the greatest quantity of colour".[28]

Several of his paintings immediately preceding *The Sonnet* display the new manner, including *Open Your Mouth and Shut Your Eyes*; but perhaps *The Seven Ages of Man* (Plate 132) is the most revealing. Begun in 1836 and based on Mulready's frontispiece design for John Van Voorst's *The Seven Ages of Shakespeare*,[29] it was exhibited at the Royal Academy in 1838. Though highly praised when it appeared, it attempts to do the impossible: to illustrate Jacques' musings on the Seven Ages of

132. *Seven Ages of Man* 1836–8. Oil on canvas, $35\frac{1}{2} \times 45$. Victoria and Albert Museum, London (Crown Copyright) (cat. 149)

135

Man from Shakespeare's *As You Like It*.[30] Its value today lies in its unfinished state, a condition which allows one to examine Mulready's new painting method. The unfinished portions of the painting display thin, transparent glazes delicately applied directly to the white ground over semi-solid pure pigments (seen as well in his last, unfinished painting *The Toyseller*, Color Plate VIII). The underdrawing is often visible, which cannot be attributed solely to its unfinished state. As the Redgraves wisely observed, Mulready "seemed to have a great dislike to losing his *ground*". Even in paintings brought to completion, as for example with *The Sonnet*, the underdrawing often remains visible.

The brilliance of Mulready's paintings derives not only from his white ground and vivid palette but from his shadows, which are often transparent, reflecting local color. In this important perception he preceded the Pre-Raphaelites and the Impressionists. Seeking to simulate the effects of natural light Mulready observed: "*The blue that prevails in a local colour should also prevail in its shade*, unless satisfactorily accounted for by reflected light."[31] But at this stage in his career Mulready did not combine this study of light and color with outdoor painting as did the later artists. He was satisfied merely to sketch out of doors, often making color and light notes. He composed his paintings in the studio in the tradition of the old masters or, rather, following Sir Joshua Reynolds' description of their manner. That is: making "a variety of sketches; then a finished drawing of the whole; after that a more correct drawing of every separate part—heads, hands, feet and pieces of drapery" before painting the final composition.[32]

In addition to this elaborate and painstaking approach, Mulready often stippled his color onto the surface. Since he generally camouflaged his stippling, although not always, one can presume that he was not seeking the optical mix of colors that later inspired the Impressionists and the Pointillists. Nor, judging from Mulready's paintings, was he seeking the lively, patterned surfaces created by his friend the watercolorist William Henry Hunt, who began stippling and hatching his paintings in the late 1820s. The technique was probably generated by another need. At the time stippling was generally employed by miniaturists working on ivory. It afforded them the necessary precision for their small-scale work. Mulready's good friend John Linnell used this method for his miniature portraits of the 1820s and 1830s. Perhaps Mulready, using a white ground with the luminescent effect of ivory, employed stippling for the same reason: greater precision. He is known to have placed just one or two colors on his small palette, laying them in "mosaically"[33] (his own word) before moving to another color. The stippling technique offered a meticulous, cautious method for painting these individual colors.

While Mulready reached the apogee of brilliant color in *The Sonnet*,

136

the precise drawing and the high finish (seen only in the foreground rocks, and in the woman's head and hands in this painting) became more prominent in his later work, thus foreshadowing the Pre-Raphaelites not only in high-keyed color but in a meticulous rendering of the material world. As Mulready explained: "*In the greatest breadth preserve a traceable individuality.* vapour and distance, dazzling light, and intense shade account for the exceptions."[34] This meticulous detail emerges in his *Vicar of Wakefield* paintings of the 1840s, his literary paintings which focus on courtship themes.

One of Mulready's earliest paintings, *Old Kaspar* 1805, now lost, was based on Robert Southey's poem *The Battle of Blenheim*. But it was not until the early 1830s that Mulready returned to literary themes in his oil paintings, producing three oil studies and one exhibited work based on his engraved designs for Sir Walter Scott's writings.[35] The most important was *Cargill and Touchwood* (Plate 115) from Scott's *St. Ronan's Well*, exhibited at the Royal Academy in 1832 and discussed in the previous chapter. Two other oils (now lost, Plates 187, 188) fall into the category of "Keepsake Beauties", bust-length studies of female characters from two of Scott's novels. The last, *Margaret of Anjou Throwing Away the Red Rose of Lancaster*, 1832 (now lost, Plate 133), from Scott's *Anne of Geierstein*, presents a fascinating contribution to Romantic cliffhanger imagery. It bears comparison with the treatment by William Etty or Turner of the parting of Hero and Leander.[36] Unfortunately, it was never translated into a full scale painting.

This rash of literary or literary–historical scenes was undoubtedly

133. Engraving by R. Graves after Mulready's *Margaret of Anjou Throwing Away the Red Rose of Lancaster*

134. G. S. Newton *Yorick and the Grisette* R.A. 1830. Oil on canvas, $29\frac{7}{8} \times 22\frac{1}{2}$. Tate Gallery, London

inspired by the popular paintings in this vein by C. R. Leslie and G. S. Newton. Mulready looked to Newton's example when undertaking his most successful literary painting, *Choosing the Wedding Gown*, R. A. 1846 (Color Plate VII), from Oliver Goldsmith's *Vicar of Wakefield*. The graceful young woman carefully examining some material is clearly based on the grisette in Newton's painting *Yorick and the Grisette*, R. A. 1830 (Plate 134), from Sterne's *Sentimental Journey*.[37] This painting was then in the private collection of Robert Vernon, who was also Mulready's patron. Newton's fashionable shop provided an obvious source for Mulready's similar scene. But the slightly wicked air of Newton's scene is absent from Mulready's later painting. The tone of Mulready's work is sweet simplicity, in accordance with the contemporary perception of Goldsmith's tale.[38]

The Vicar of Wakefield, first published in 1766, was extremely popular with the English reading public. Sir Walter Scott's appreciation of the book was shared by many: "We read [it] in youth and in age, we return to it again and again, and bless the memory of an author who contrives so well to reconcile us to human nature . . . the wreath of Goldsmith is unsullied; he wrote to exalt virtue and expose vice."[39] The Victorian reader agreed with this pious assessment and the novel was reissued repeatedly throughout the nineteenth century. In 1840 Mulready was commissioned by John Van Voorst to illustrate a new edition. It was published in 1843 and contained thirty-two wood engravings by John Thompson based on Mulready's designs (one for each chapter head). This was the most extensively illustrated version to date, following earlier editions illustrated by Daniel Dodd (1780), Thomas Stothard (1792), Thomas Uwins (1812), Thomas Rowlandson (1817) and George Cruikshank (1830, 1832). Only the volume illustrated by Rowlandson with twenty-four aquatints approached Mulready's in sheer quantity of illustration. Mulready's version was warmly received by the public and press[40]—indeed, it maintained its popularity into the twentieth century. It was reissued twice by Van Voorst (1848, 1855) and several more times by other publishers in London, Boston, and New York.

Following its publication in 1843, Mulready was encouraged to translate some of his designs into paintings. He was not, however, the first painter to be inspired by *The Vicar*. G. S. Newton exhibited a painting at the Royal Academy in 1828, entitled *The Vicar of Wakefield reconciling his wife to Olivia*.[41] George Cruikshank followed with another example in 1830.[42] By the late 1830s and early 1840s several artists had exhibited paintings based on *The Vicar*, including Daniel Maclise, Richard Redgrave, W. P. Frith, and C. R. Leslie.[43] By the time Mulready appeared at the Royal Academy in 1844 with his first *Vicar of Wakefield* subject, *The Whistonian Controversy*, the novel was being

V. (facing page) *Interior of an English Cottage* 1828. Oil on panel, $24\frac{1}{2} \times 19\frac{7}{8}$. By gracious permission of Her Majesty Queen Elizabeth II (cat. 116)

138

criticized as a "hackneyed source" for pictorial treatment.[44] Critics moaned, "When shall we see the last of the Vicar?"[45] And W. M. Thackeray, novelist and art critic, emphasized the point by referring to the popular novel only as the V———r of W————d.[46] Despite the prevalence of such paintings, Mulready's were singled out for high praise, and patrons continued to clamor for paintings based on this much loved Goldsmith novel. In 1846 Prince Albert asked Mulready to paint a copy of one of his Vicar subjects, *Choosing the Wedding Gown*, which Mulready declined to do. As late as 1853, when such subjects appeared less frequently on the Academy's walls, a potential patron requested a scene from the novel for his private collection.[47] In fact, Mulready once remarked to a friend that "he had commissions offered to him for pictures from these designs sufficient to keep him at work for the remainder of his life".[48]

Mulready translated only three of his illustrations into oils for exhibition; two additional designs reached the stage of oil sketches. All, at least in a loose sense, have courtship themes.

The Whistonian Controversy, R.A. 1844 (Plate 135), relates to Mulready's earlier, more caustic treatment of courtship. Here the coming marriage of Mr Wilmot, the much-married minister friend of the Vicar, generates a heated discussion on the propriety of second marriages for clergymen, thus highlighting the kind of religious wrangling still much in evidence in Mulready's day. The cabinet painting combines a rich, brilliant palette, which even the critical B. R. Haydon greatly admired,[49] with a meticulous delineation of the palpable, material objects filling the comfortable middle-class interior. The Holbein-like table cover, the untidy pile of scholarly leather-bound books, the shiny glass globe on the warm wooden wardrobe are all lovingly depicted and vie with the central figures for the viewer's attention. And as is so often the case in Mulready's paintings, lively hands are the expressive focus of the composition.[50]

This is certainly true of *Choosing the Wedding Gown* (Color Plate VII), his next *Vicar of Wakefield* painting, exhibited at the Royal Academy in 1846. Here the future Mrs Primrose carefully examines silken material for her wedding gown, while the anxious merchant enumerates its fine points with his open right hand. The Vicar, with quiet, clasped hands, observantly admires the beauty and taste of his fiancée.

The composition was inspired by a single sentence in the first paragraph of *The Vicar*: "I had scarce taken orders a year before I began to think seriously of matrimony, and chose my wife as she did her wedding gown, not for a fine glossy surface, but such qualities as would wear well."[57] With such unpromising material, Mulready produced one of his most beautiful paintings, somewhat embellishing Goldsmith's rather bare text. The original illustration depicted only the three central

135. (facing page) *The Whistonian Controversy* 1843. Oil on panel, 24 × 19½. Private Collection (cat. 158)

140

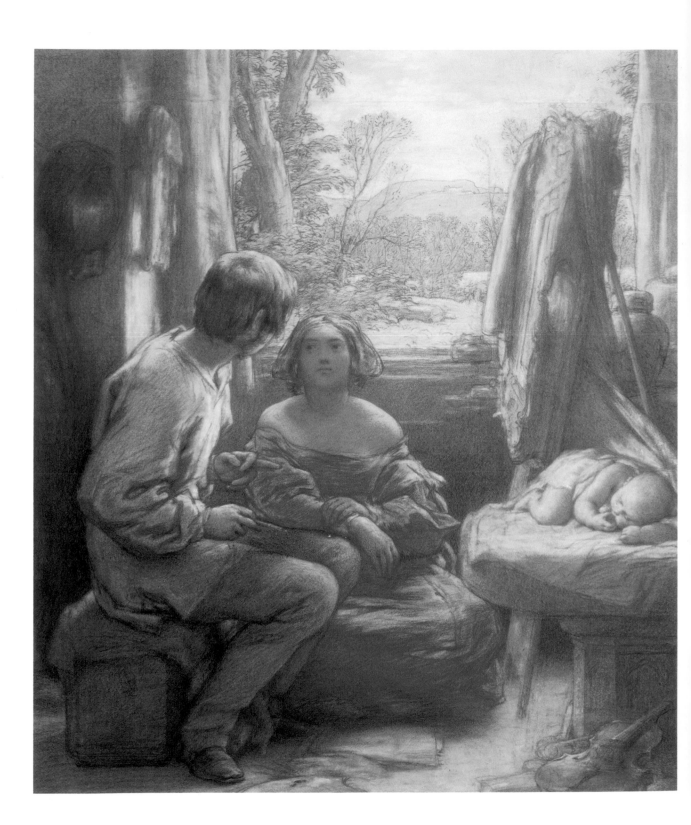

figures: the Vicar, his future wife and the mercer, giving little indication of their setting. Mulready expanded this composition to include the mercer's wife, a small delivery boy, and a recognizable draper's shop as background for all the figures in a very fine, highly finished chalk cartoon, R.A. 1844 (Plate 136).[52] A small oil sketch followed (now lost). The final painting, completed in 1845, and exhibited at the Royal Academy in 1846, differs only in small details from the cartoon.

The final painting was far from spontaneous; the composition was conceived and sketched in smaller scale several times before Mulready began to paint the exhibited panel. This approach was necessitated by his method of applying pigment, for he brought one small area of the painting to completion before proceeding to the next portion of the composition.[53] In his own mind, Mulready may have compared this method to that of the early fresco painters where the medium itself demanded this technique.[54] F. G. Stephens noted parallels with "the early Germans and Flemings, Holbein and the much abused Pre-Raphaelites".[55] Ruskin similarly linked Mulready's style to the early Germans—Dürer, to be precise.[56] All these associations most certainly are suggested by the brilliant, rich color and the meticulous finish of Mulready's paintings. Perhaps Mulready had Jan Van Eyck's *Arnolfini Wedding Portrait* in mind when he painted this panel.[57] Its acquisition by the National Gallery in 1842 must surely have attracted his attention and Mulready's inclusion of the sleeping spaniel and the bouquet of orange blossoms, signifying the forthcoming marriage, looks back to the symbolism of the early Northern masters.

On the other hand, Mulready's preoccupation with the depiction of various patterns and textures recalls the technical feats of the seventeenth-century artists Gabriel Metsu and Gerard Terborch, who skillfully recreated silks, satins, and velvets with lifelike verisimilitude. Naturally, the draper's shop provided an excellent opportunity to display Mulready's own skills in this line. Works by another seventeenth-century artist, Frans Van Mieris, who painted a number of shop interiors, may have suggested the specific artistic possibilities of this scene to Mulready.[58]

Mulready rendered all of the objects with great care, from the florid, decorative cloth which the practical young woman rejects, to the crisply delineated, transparent glass globe behind the mercer's wife. The light entering from the left plays across the various textures, defining the nature of each material: the separate strands of the young woman's hair; the delicate puff of white feathers on the deep crimson hat; the hard, shiny surface of the burled counter; the dull, soft velvet bolt with its rich ornate arabesques on the foreground stool.

This incredible display of detail, emphasized by the stippling technique which remains visible in this painting,[59] was something the

VI. (facing page) Cartoon for *The Artist's Study c.* 1840. Red chalk and pencil, $15\frac{1}{2} \times 13\frac{3}{4}$ (sight). City of Manchester Art Galleries

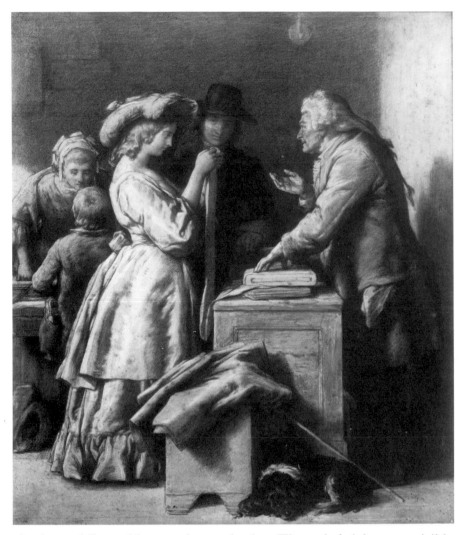

viewing public could appreciate and value. The artist's labor was visible for all to see and praise. In fact, such visible labor carried moral weight for an audience who worshipped hard work, as demonstrated by the following description printed in the *Illustrated London News*: "There is no loose or dishonest painting, as it is called in any part of the Picture."[60]

Mulready next brought his "honest painting" to bear on another subject from *The Vicar of Wakefield*: *Haymaking, Burchell and Sophia*, (Plate 137), exhibited at the Royal Academy in 1847. In this scene, the Vicar, long since married, watches his daughter Sophia in the hay field, "observing the assiduity of Mr. Burchell in assisting . . . [her] in her part of the task".[61] Quite appropriately, this subject reminds one of the ideal rustic haymaking scenes of the late eighteenth century: the pastoral scenes of Boucher, Wheatley, and Gainsborough. But the lighthearted, carefree nature of earlier pastorals is absent here. The man and woman

144

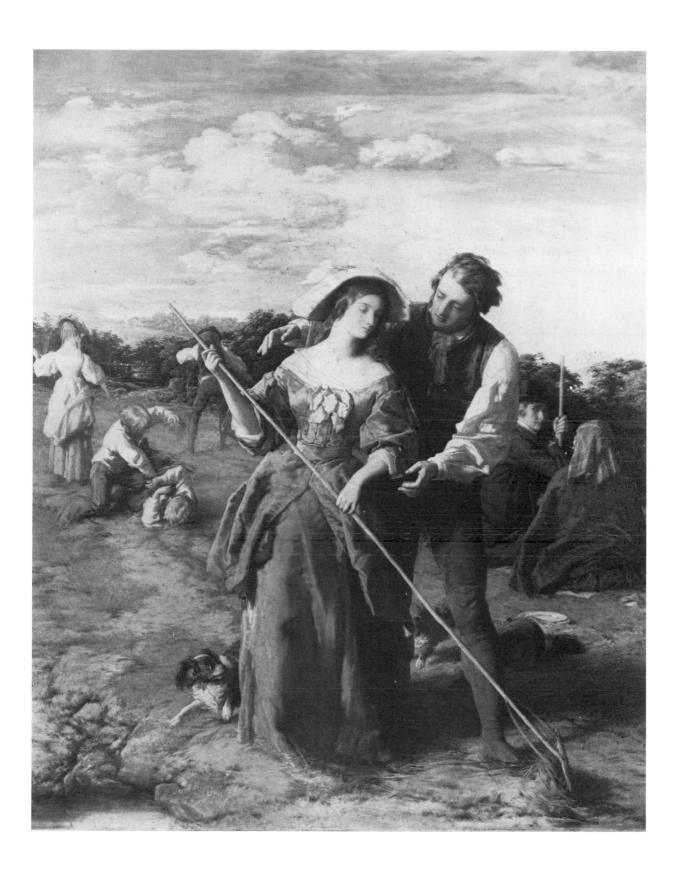

138. Study for *Haymaking*
c. 1846. Pen and brown ink,
$4\frac{7}{8} \times 4$. Trustees of the British
Museum

139. *Elopement c*. 1843. Pen
and sepia wash, $4\frac{5}{8} \times 3\frac{3}{4}$.
Victoria and Albert Museum,
London (Crown Copyright)

are constrained. Sophia, expressionless, continues with her labor,
seemingly oblivious to the amatory advances of her assistant Mr
Burchell. There is no physical contact between them; Burchell's arms
are gingerly suspended around Sophia. In fact, the frolicsome, free-for-
all hayfight of the children behind (Plate 138) serves to highlight the
cautious, reticent meeting of the two foreground adults. And, as with
First Love, the frisky action of the dogs seems an open acknowledgment
of the human emotions forced below the surface in this young couple.

Like *The Sonnet*, the scene is set in dazzling sunlight. The harsh light
bleaches out Sophia's rounded forms, flattening her face, neck and
shoulders while at the same time highlighting the sharp luminous color
of her vivid dress and Burchell's plum-colored vest. Unlike *The Sonnet*,
we do see the couple engaged in agricultural labor; although it is scarcely
the back-breaking work favoured by the French Realists. Neither is the
scene set in the placid, lush working fields featured in the harvest
paintings of Mulready's friend Linnell. The beautiful Sophia with her
curving hat and her floppy bows, her delicate, pale hands gracefully
holding the rake, is playacting. The agrarian activity simply provides an
attractive backdrop; the field work affords Burchell an opportunity
to assist her, to approach her in an unassuming yet intimate way.

Mulready contemplated painting two additional scenes based on his
Vicar of Wakefield illustrations: *Measuring for Heights*, where Mrs
Primrose, the Vicar's wife, measures her daughter's height against the

146

young Squire Thornhill (Plate 193), a transparent effort to encourage their courtship, and *The Elopement*. Neither developed beyond oil sketches painted in 1844. While the first merely echoed W. P. Frith's treatment of the subject (exhibited at the Royal Academy in 1842),[62] the latter, *The Elopement*, promised to be an exceptionally fine painting. Although the oil sketch is now lost, the illustration and an exquisite pen and sepia preparatory drawing for the subject (Plate 139) suggest the power of the original design.

Unlike the other courtship scenes the couple here is united; but the union represents the seduction of the Vicar's daughter, not a conventional courtship. It was inspired by the following lines of the novel: "Yes, she is gone off with two gentlemen in a post-chaise, and one of them kissed her, and said he would die for her; and she cried very much, and was for coming back, but he persuaded her again, and she went into the chaise, and said, 'O What will my poor pappa do when he knows I am undone!' "[63] The woman's windswept gown, her distraught pose, and the younger brother's persistent pleas admirably suggest the moral agitation of the moment. Had Mulready translated the scene into a full-scale painting it would have been a moving and expressive contribution to the Victorian preoccupation with fallen women—with male perfidy and lost, unrecoverable female innocence.

Although *The Elopement* never materialized, Mulready did treat the fallen-woman theme obliquely in an historical costume piece, *The Intercepted Billet* (Plate 140), exhibited at the Royal Academy in 1844. Here the emphasis is not upon the quandary of the seduced woman, her guilt, shame or fear, as seen in *The Elopement*; but rather on the husband's discovery of his wife's infidelity. An embittered, sinister man somberly clutches the bouquet and love note which reveal his cuckolded position.[64] But the impact of this painting is weakened by its vague historical setting, by its avoidance of modern life. It lacks the expressive anguish detailed in Augustus Egg's modern dress series, *Past and Present* of 1858, the tale of a wife's infidelity and her resultant fall from grace; or the redemptive moral force implied by the awakening of the modern young mistress to her sinful state in W. Holman Hunt's famous painting *The Awakening Conscience* of 1853. In general, neither contemporary scenes nor modern moral dilemmas engaged Mulready's artistic imagination. His popular characters—children, lovers, literary figures—dwell in a timeless rustic world, or in romanticized historical or literary settings. Mulready moved away from this formula only in two paintings, *The Convalescent from Waterloo* and *The Widow* of the 1820s, both markedly unsuccessful with patrons (see Ch. VI) and in occasional drawings.

The betrayed modern woman replaces the wronged Italian nobleman of *The Intercepted Billet* in an undated drawing (Plate 141), perhaps a

147

140. *The Intercepted Billet*
1844. Oil on panel, 10 × 8¼.
Victoria and Albert Museum,
London (Crown Copyright)
(cat. 159)

preliminary study for a painting never undertaken by the artist. A young, distressed woman grasping a note in one hand and her stomach with the other waits for a potion in the chemist's shop.[65] Her faithful dog unsuccessfully attempts to soothe her. Through the window a couple can be seen embracing. If painted, the spirit of the work would have been remarkably close to the view of the difficult relationship between the sexes held by the Pre-Raphaelites,[66] or to that held by artists following in their wake.[67] But Mulready refrained from introducing such themes into the public forum in exhibited oils.

His private drawings also contain his more explicit, even erotic explorations of lovemaking; shown sometimes in modern dress, sometimes in undress, and sometimes in the classical guise of satyrs and nymphs. Often undated, these drawings move from rather tender scenes of ordinary young couples embracing[68] (Plates 142, 143), to the animal vitality of nude intertwined bodies (Plates 144, 145). The restrictions

148

which governed his exhibited courtship scenes contrast with the sensual abandonment expressed in the poses of his private lovers—not, by the way, an unusual dichotomy in the work of artists.

The prudery of the viewing public ensured that such candid scenes remained in an artist's sketchbook or if exhibited received condemnation (the reception, for example, accorded Mulready's slightly risqué painting *The Widow*). This would be true not only for explicit love scenes but often for the depiction of female nudes as well:

Female beauty and innocence will be much talked about, and sell well. Let it be *covertly* exciting. [Let it be] material flesh & blood approaching a sensual existence, and it will be talked more about and sell much better. Well in the first state, doubly well in the second. But let excitement appear to be the object, and the hypocrites will shout and scream and scare away the sensualists.[69]

142. (right) *Lovers* 1824. Pen
and ink, sepia wash, $8\frac{1}{2} \times 10\frac{7}{8}$.
Victoria and Albert Museum,
London (Crown Copyright)

143. (below) *Lovers* Pen and
ink, sepia wash, $8 \times 12\frac{1}{4}$.
Victoria and Albert Museum,
London (Crown Copyright)

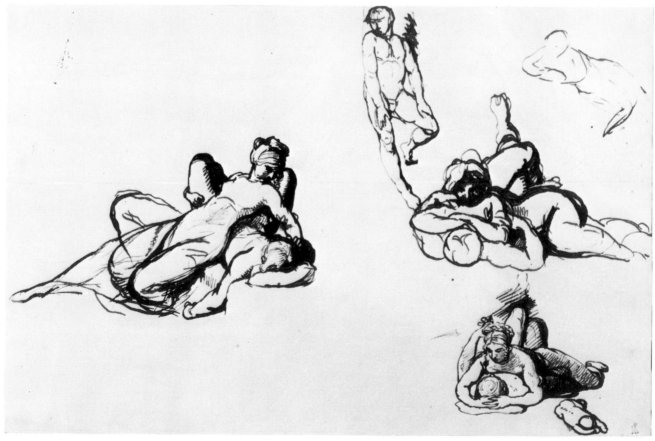

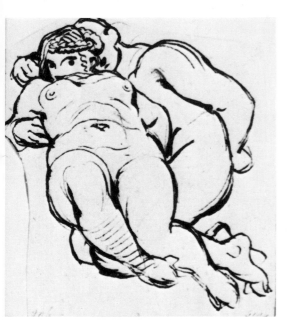

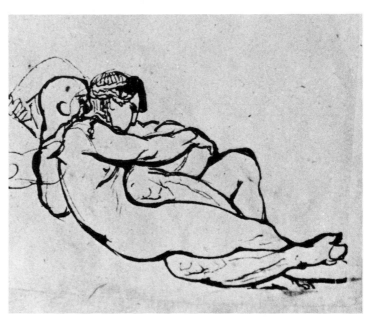

Mulready's concern with this questionable public response derived from his own pre-occupation with the nude—a pre-occupation which blossomed late in his career. In his mid-sixties Mulready, then famed for his genre works and his *Vicar of Wakefield* scenes, turned to an entirely new and, in the light of his previous production, surprising theme: women bathing.

144. *Lovers (Satyr and Nymph?)* c. 1823–4. Pen and ink, $4\frac{1}{2} \times 4$. Victoria and Albert Museum, London (Crown Copyright)

145. *Lovers (Satyr and Nymph)* c. 1823–4. Pen and ink, $5 \times 10\frac{1}{4}$. Victoria and Albert Museum, London (Crown Copyright)

151

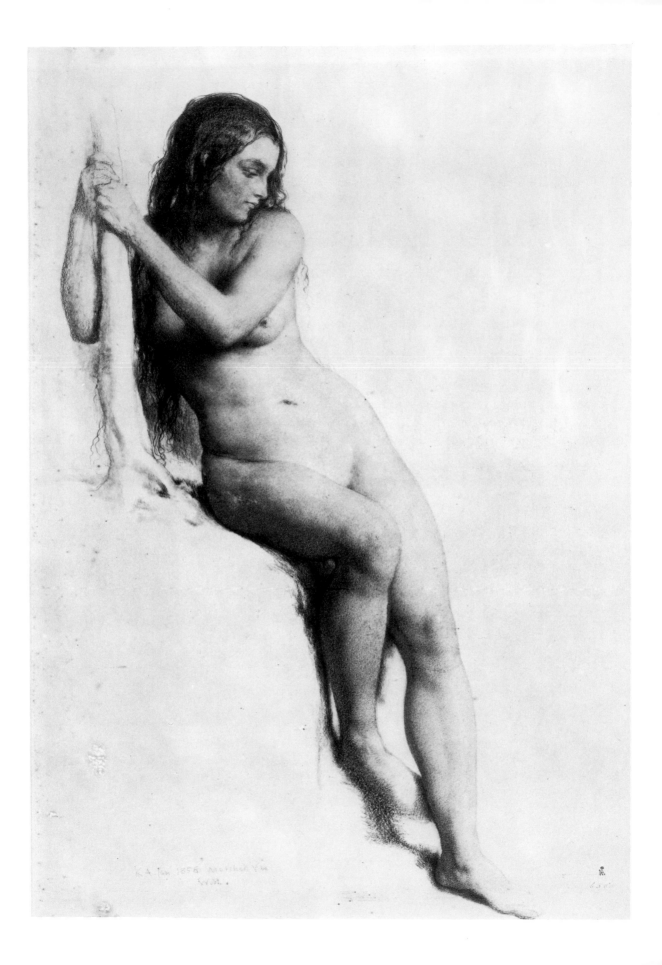

V. The Nudes

Mulready painted two scenes of women bathing, one in 1848 (Plate 148) and the other in the early 1850s (Plate 149). While these paintings seem entirely out of character in the light of his earlier work, they are directly related to his life-long drawing pursuits.

Mulready had drawn nudes, both male and female, from his earliest student days. And, as a member of the Royal Academy, he took his role as a Visitor at the Life School very seriously,[1] placing the nude model for the students and then drawing the model himself. As he explained: "My own practice as a visitor in the Academy is, after setting the model in a position for the student, to see that they are all placed, and I then sit down amongst them and draw, as they do, from the model, taking a position in which I can see what is going on. . . . I think that I do good by drawing myself, though I am not bound to draw. I think it is beneficial to the students for the visitor not only to say, 'Go in such a direction,' but to go in that direction himself."[2] In this way, he not only supervised student work but provided an excellent example for them to follow.[3] His diligent attitude toward the study of the nude was rare and was summed up quite simply in his own testimony before the Commission examining Academy methods in 1863: "I have from the first moment I became a visitor in the life school drawn there as if I were drawing for a prize."[4]

In the 1840s these life studies were undertaken with increased zeal and often with a new technique.[5] Avoiding the spontaneous effects normally associated with drawing, Mulready created highly refined, detailed yet delicate drawings of the human figure in black and red chalk (or in pencil and red chalk). Using subtle shifts of light and shadow over rounded, rippling anatomy, he produced a marvelous simulation of flesh tones with very limited means.[6] These human images (Plates 21, 146, 148), often slightly idealized, were drawn over and over again, in different poses, in different lights, not only at the Academy's Life School but also, during the 1850s and 1860s, at the Kensington Life Academy,

146. (facing page) *Female Nude* 1858. Pencil, black and red chalk, $19\frac{1}{2} \times 11\frac{1}{8}$. Victoria and Albert Museum, London (Crown Copyright)

153

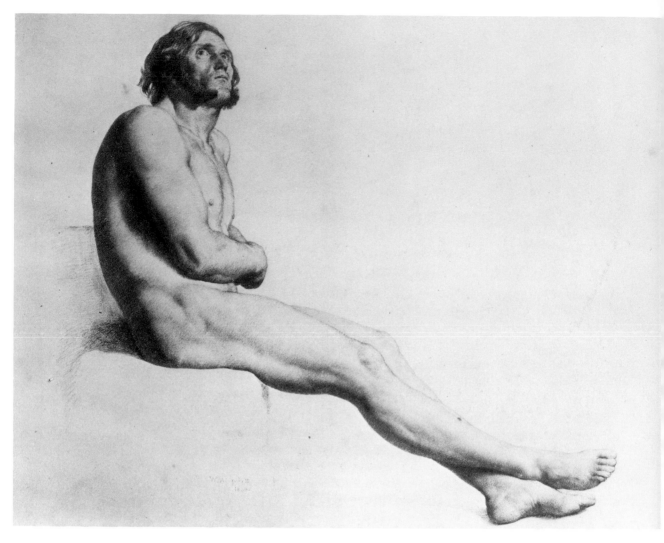

147. *Male Nude* 1848. Black
and red chalk, $14\frac{3}{8} \times 17\frac{1}{2}$.
Royal Library, Windsor
Castle

148. (facing page) *Women
Bathing* 1848–9. Oil on
millboard, 18 × 14. Courtesy
The Hugh Lane Municipal
Gallery of Modern Art,
Dublin (cat. 167)

an informal academy which met three evenings a week in Kensington,
probably in Richard Ansdell's residence.[7] These drawings must have
been an especially satisfying and liberating vehicle for the aging genre
painter for they provided an arena for posing challenging formal
problems without the necessity of burdensome narrative. And of course,
such studies had a prestigious history. Mulready's depiction of the nude
linked him to the great traditions of Western European art: to the
Antique and to the Venetian School, both of which held his profound
respect and admiration.

Mulready's two bather paintings were a natural development out of
his own interests as a draughtsman. And as with such modern masters as
Renoir, Cézanne, Picasso, and Matisse, Mulready's painting of the nude
represented his own ambitious desire to measure himself against the
grand heritage of Western European art.[8]

Nudes in both painting and sculpture were not as rare as one might

154

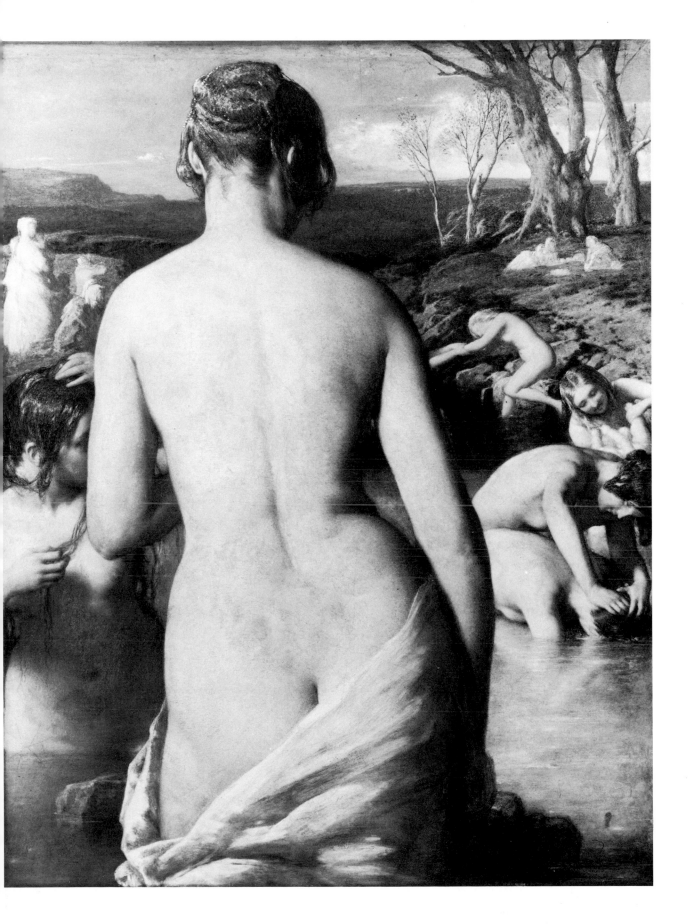

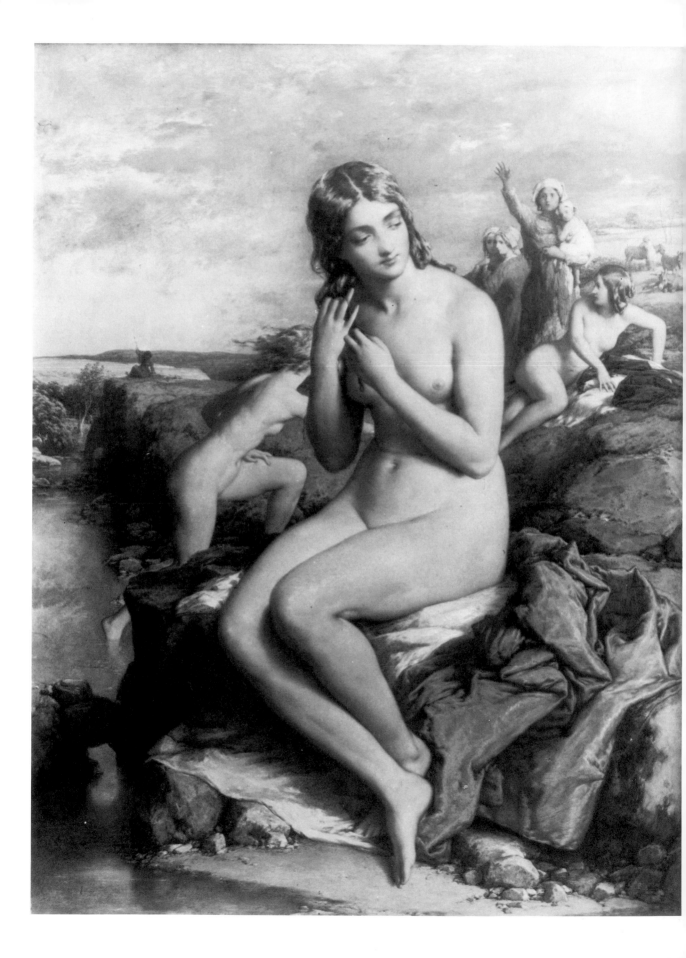

expect during this prudish period. The prestige accorded the nude by its association with classical art and by its place in the Academy's curriculum of study encouraged its survival. In fact, several themes occurred with considerable regularity in the Academy's exhibitions, especially the voyeuristic subjects of "Diana and Actaeon",[9] and "Musidora"[10] from James Thomson's *Seasons* (scenes of chaste nudity and self-conscious female modesty), as well as simple Nymphs or Bathers. Mulready's friend William Etty was the most prominent and prolific painter of female nudes and his success in the 1840s including an entire exhibition devoted to his works at the Society of Arts in 1849 may have encouraged Mulready to venture into this realm himself.[11]

Public criticism of such images was based upon two factors: the offense that such naked forms gave, particularly to young and/or female viewers; and the feared corruption of the female models who posed for such works. A critic in the *Literary Gazette* complained: "Why are the modest and lovely young females who daily grace the rooms of Somerset House with their presence, to have their feelings outraged, and blushes called into their cheeks, by a work like this [James Ward's *Venus rising from her Couch*, R.A. 1830]—placed too in a situation in which it cannot possibly escape near notice?"[12] Even some artists objected vigorously to the study of nudes as can be seen from J. R. Herbert's testimony to the Royal Academy Commission in 1863: "I would exclude altogether the nude female model from the Academy, because I conceive that art, the true aim of which is to elevate and to divinize, does not require the use of anything which might corrupt him who studies or the person who sits as

149 (facing page) *Bathers Surprised c.* 1852–3. Oil on panel, 23¼ × 17½. Courtesy of the National Gallery of Ireland, Dublin (cat. 169)

150. Titian *Venus Anadyomene* Oil on canvas, 29 × 23½. Ellesmere Collection

151. *The Young Brother* R.A. 1857. Oil on canvas, 30½ × 24¾. Tate Gallery, London (cat. 170)

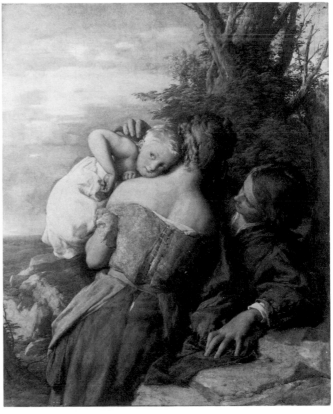

the model . . ." To protect female models, the Royal Academy stipulated that among students under twenty years of age only those who were married could study the female nude in the Life School. This in itself did not safeguard the women. That "moral corruption" of female models continued to be a problem is confirmed by Mulready's manuscript notes on the subject. Recording his own advice to models, he cautions them against conversing or becoming familiar with the male artists, married or not. With care, they need have no problem. As he explained: "An intelligent woman who at the commencement of this dangerous profession, is well prepared for . . . danger, will have much fewer cases of trouble, than poor innocent creatures who with distracted minds are flung unprepared amongst its smiling faces, flattering manner, its painting and gilding."[13]

Such well-known critics as Thackeray and Ruskin objected to nudity on general moral principles. Thackeray suggested that "A great, large curtain of fig-leaves . . . be hung over every one of . . . [Etty's] pictures".[14] Ruskin judged Mulready's "drawings from the nude . . . more degraded and bestial than the worst grotesques of the Byzantine or even Indian image makers";[15] and on another occasion, as "most vulgar, and in the solemn sense of the word, most abominable".[16] But such revulsion from the human form was by no means universal. Queen Victoria admired Mulready's nude drawings; she even requested one from the artist as a gift for Prince Albert (Plate 147).[17] And the exhibition of Mulready's *Women Bathing* at the Royal Academy in 1849 raised no moralistic outcries from the *Art Journal*'s critic, only mild regret that Mulready had turned away from his earlier subject matter.[18]

Both of Mulready's oils concentrate on one central nude bather placed in the foreground. In the first, *Women Bathing* (Plate 148), the

152. *Diana and Actaeon* c. 1853. Pen and brown ink, $6\frac{1}{2} \times 10\frac{7}{8}$. The Cecil Higgins Art Gallery, Bedford

figure is seen from behind. It appears to be a simple life study in oil,
given an extensive backdrop only as an afterthought. The lowly
millboard ground and the extension of that ground at the top support
this conclusion.[19] Behind the weighty nude a number of women frolic in
the stream; while others, clothed, rest on the banks.

In *Bathers Surprised* (Plate 149) the graceful nude, seen from the front
and modelled upon a *Venus Anadyomene* by Titian in the Ellesmere
Collection (Plate 150)[20], sits quietly on the foreground rocks with
vividly colored robes gathered beneath her. She remains tranquil while
the nude figures behind her scramble for their clothing, alarmed by the
approach of a distant male figure in the woods below.[21] Although lacking
any precise Biblical or mythological underpinning, this scene of women
disturbed while bathing recalls the traditional subject of Diana and
Actaeon, a theme treated by Mulready in a contemporary drawing
(Plate 152) which may lie behind this composition.[22]

Both scenes take place in brilliant sunlight which washes the figures in
pearly gray light, producing stippled violet/blue shadows on the central
figures.[23] The incredible clarity—the absence of aerial perspective—

153. *Bathers c.* 1859. Black
and red chalk, 43 × 55.
National Gallery of Scotland,
Edinburgh

159

creates a strange hallucinatory effect, bringing the background figures up to the surface in both paintings, but striking a particularly harsh note in *Bathers Surprised* between the tranquil bather in the foreground and the athletic figure striding up the banks of the stream behind her. Moreover, the dry, chalky surfaces of both works, and the rather miserly application of paint, seem disturbingly at odds with the potentially sensuous nature of the subject. For despite the abundance of tumbling nude bodies, Mulready's two bathing scenes seem remarkably sterile and cold beside the voluptuous, lustrous nudes of his friend William Etty, or beside contemporary French examples: the sensuous exoticism of Ingres' late nudes or the earthy realism of Courbet's.[24] In fact, Mulready wanted his nudes to be seen against the much trumpeted French tradition, choosing to send his *Bathers Surprised* to the International Exhibition in Paris in 1855, where it received both praise and criticism.[25]

Bathers Surprised was one of Mulready's last important paintings. While he contemplated painting another more extensive composition of bathing women in the late 1850s, retained in a large and very beautiful chalk drawing (Plate 153), where the confluence of nude and clothed female figures in the foreground produces a more sensuous effect than in his two completed paintings, it did not come to fruition.[26] Mulready's production, never very prolific, slowed down considerably during the last decade of his life. He painted just three oils after this work and of those, two were variations on earlier works: *The Young Brother*, R.A. 1857 (Plate 151) which features the same model who posed for the principal figure in *Women Bathing*, and his last, unfinished canvas, *The Toyseller* (Color Plate VIII). When *Bathers Surprised* was exhibited in Paris Mulready was nearly seventy years old. Thus these barely mature, nude women with their plump bodies and their Victorian coiffures represent his swansong, his effort to liberate himself from genre painting; just as his last unfinished painting, *The Toyseller*, a nearly life-size image, was, by its sheer size, another bid for a grand or eloquent statement, something beyond the scope of his earlier work. While *The Toyseller* succeeds—its very scale heightens the mystery of the group and the impact of the painting—his Bathers fail to rise above their origins as academic life studies. They remain testimony to an aging artist's respect for traditional standards; for a purposeful step away from popular taste toward something he perceived as timeless. In this, as in most other developments in his career, Mulready was supported by faithful patrons.

VI. Patrons, Pupils and Portraits

Mulready's career was supported by a few loyal and generous patrons, principally Sir John Edward Swinburne, Bart. (grandfather of the poet Algernon Swinburne), John Sheepshanks, Robert Vernon, and Thomas Baring. But Mulready only encountered the first of his important patrons, Swinburne, in 1811. Before that time, he suffered the rigors of the open market.

Mulready began his career during the period of the Napoleonic Wars when patronage of English art was at a low ebb. The wars had brought an influx of old master paintings to English shores and earnest collectors invested their money in illustrious "name" artists with well-established reputations.[1] The native living artist had difficulty competing with long-dead painters and the prestige attached to the possession of their works; a predicament described and bemoaned by Mulready's contemporary Martin Archer Shee in his book *Rhymes on Art* (1805).[2] Mulready later complained of his own dismal poverty during these early years: "I remember the time when I had a wife, four children, nothing to do, and was six hundred pounds in debt!"[3]

Despite the inadequacy of Mulready's early patronage, his paintings or drawings were purchased by a wide variety of collectors. Some of his early rustic scenes went to Thomas Hope, famed for his collection of antiquities;[4] some to a local dentist;[5] others to a music master;[6] one to a newly rich tradesman;[7] still others to titled gentry.[8] Surprisingly, none was purchased by Sir George Beaumont, John J. Angerstein, or Sir John Leicester,[9] the three most prominent and enthusiastic collectors of English painting during the early years of the century.[10]

While less well known than the collecting activities of Beaumont, Angerstein, or Leicester, the patronage of Sir John Edward Swinburne (1762–1860, Plate 154) was courageous and liberal. He generously supported contemporary British painting when few others ventured into the field.[11] His collection contained paintings by Turner, John Flaxman, Thomas Stothard, William Hilton, David Wilkie, Mulready

154. *Sir John Edward Swinburne c.* 1830. Pen and ink, 3¾ × 2⅞. Victoria and Albert Museum, London (Crown Copyright)

and a host of lesser known artists—thus revealing his wide-ranging taste.[12]

Sir John's private correspondence frequently attests to his concern for budding British artists: the progress of their paintings,[13] their financial security,[14] their personal health.[15] One letter also contains his rather wry commentary on the shortcomings of the British Institution formed by fellow aristocrats to encourage British art. Having vainly recommended a painting by John Thompson for purchase, he sadly declared,

> Nothing can shew the perfect inutility of the Institution more strongly than that when an avowed occasion presents itself, of patronizing British Art, their funds are inadequate, from having been applied, to the silly purpose of adorning the gallery, to gratify the Vanity of a few private collectors, & to make it a pretty shew Box, lighted up, for the Amusement of fine Ladies & Gentlemen.[16]

Although Swinburne generously supported numerous living artists by his patronage, Mulready was a favorite, as both artist and friend. Swinburne purchased Mulready's *Boys Fishing* (Plate 69) in 1812; by 1833 the Swinburne family possessed six major paintings by Mulready, several lesser studies, a number of family portraits and two paintings of their pets (a few received as gifts from the artist).[17] Farington reported the family's attachment to Mulready as early as 1815: "Callcott called. He had been at Sir J. Swinburne's in Northumberland 8 or 10 weeks, and during 6 weeks of the time William Mulready was there and was a great favourite in the family."[18] Over the years, Mulready corresponded with Sir John, keeping him advised on Academy affairs;[19] he visited his homes in Northumberland, London and the Isle of Wight;[20] and even invested money with him.[21] They remained friends until Sir John's death at the age of ninety-nine in 1860,[22] long after his patronage ceased in the early 1830s.

Mulready was introduced to the Swinburne family in 1811 as an art instructor for Sir John's daughters.[23] Private instruction was especially gratifying to Mulready. He once observed that he was really a "drawing master all his life long with intervals for painting pictures".[24] As a result, the proceeds from his teaching frequently exceeded the income from his paintings in any given year.[25] The few pictures that he did paint were often purchased by his faithful pupils. For Mulready frequently attracted buyers through his instruction. The Countess of Gosford, Lady Russell, Miss Shutz, Lord Grey, the Countess of Dartmouth, the Earl of Durham, Misses Pitt and Hook all appeared in Mulready's Account Book for the payment of teaching fees (for themselves or their families) and as patrons.[26]

One suspects that Mulready attained his affectionate place in the

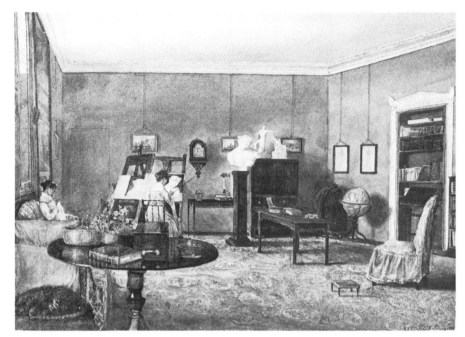

155. Frances E. Swinburne
Interior, Capheaton 1813.
Watercolor, 10 × 14.
Capheaton Collection

Swinburne family circle by his treatment of Sir John's daughters, his pupils. By far the majority of Mulready's private pupils were women, often daughters or wives of the landed gentry, or aristocrats like the Swinburne women. Drawing, painting, sewing and light reading were the principal activities allowed these ladies. A watercolor by Frances Elizabeth Swinburne, dated 1813 (Plate 155), captures the nature of this pleasant if limited life; showing one sister sewing while another copies an antique cast.[27] One can almost hear the clock ticking on the back wall, slowly measuring out the minutes of their quiet existence. Mulready did not however view his pupils' artistic pursuits as mere pastimes. He treated their work with respect. While we have no correspondence between Mulready and the Swinburne daughters, his warm relationship with other female pupils is documented in letters[28] which often underline his support for their artistic ambitions.

Mulready gave these pupils most precise and detailed advice on paintings which they had submitted for his criticism:

The picture is very much better than it was. The changes made about the chair are very great improvements. The heads might be still improved by some little reduction of the red tints—the tint between the boy's right eye and eyebrow, the tint on the mother's nose, the tint on the little girl's right cheek bone, which makes an outline of red on that cheek, while the other cheek bone is fair . . . The stool below is too like the colour of her dress—Try a greenish figure or pattern worked on it.

163

Mulready's response was not patronizing but professional, revealing his own painting methods while correcting his students' errors. In a discussion recorded by his pupil Hilary Bonham Carter, in a letter to her soon-to-be-famous cousin, Florence Nightingale, Mulready expressed his views most succinctly. When Hilary

> said that women never drew well, he had stopped her at once and said that in that case it was no use his teaching her. Afterwards they agreed that the fact that women could not be such good artists as men depended on certain conditions which might be changed centuries hence, but hardly before. At present, if there were one hundred men and one hundred women who began the study of Art with the same advantages, they could not go on in the same way. [As Mulready explained] 'There will perhaps be three hundred living beings crying after the ladies—ten may remain quite free, but then how much more likely that the excellent should come out of the one hundred (uninterrupted) men than the ten women. Where a man is, his business is the law; and a woman must adapt herself, and hers to circumstances.'[30]

That women were not intrinsically poor artists Mulready believed; rather, social circumstance and custom thwarted their artistic ambitions. Had Miss Nightingale's own ambitions run toward art rather than nursing, one might have seen these social customs turned around in her own lifetime. Either Florence or more likely her sister, Frances Parthenope, studied under Mulready in 1844.[31]

Another student, Anne Isabella (or Annabella) Milbanke, later Lady Byron, testified to Mulready's influence not only on her art but on her character as well: "As I know you have pleasure in being useful, I ought to tell you how beneficial your acquaintance has been to me in many respects . . . you have given me an additional confidence in my powers and capacity which will probably throughout my life increase the happiness of those with whom I may be concerned, and consequently, my own."[32]

Mulready's support and encouragement of women students resulted perhaps from his own early marriage to an artist, Elizabeth Varley, and from his youthful friendship with his pupil, Harriet Gouldsmith, both of whom exhibited works publicly.[33] Mulready, who occasionally advised Sir John E. Swinburne on his acquisitions,[34] undoubtedly directed his attention to Miss Gouldsmith's merits, leading Swinburne to purchase one of her oils for his collection.[35]

Sir John Swinburne, a Whig, may have been responsible for introducing Mulready to a broad circle of Whig politicians and patrons—certainly to Lord Grey (1764–1845), his Northumberland neighbor; perhaps to Lord Whitworth (1752–1825); Lord Durham

164

(1792–1840) who married Lord Grey's eldest daughter; Lord Ducie (1775–1840); even perhaps to the Prince Regent, who was associated with the Whigs—all of whom purchased paintings by Mulready. Sir John was on particularly close terms with Lord Grey, who as Prime Minister guided the first electoral reform act through Parliament.[36] This patronage extended into the 1820s when Whig aristocrats continued to buy scenes of chastised children—not generally on commission but following their exhibition.

That such taste for Dutch-style scenes was not strictly a Whig phenomenon can be seen by examining the collection of Sir Robert Peel (1788–1850), a Tory Home Secretary and Prime Minister.[37] He principally collected Dutch and Flemish seventeenth-century paintings; but he also dallied in contemporary English portraiture and Dutch-style genre scenes, including Mulready's painting *A Boy Firing a Cannon* of 1827 (Plate 183).[38] His wealth derived from commerce, and in a sense his patronage heralds the arrival of a new breed of collectors: the merchants, the industrialists, the bankers, whose wealth supported Victorian artists.

Although there is no dramatic division between the old and new patronage, one can discern a gradual shift in Mulready's patronage from the aristocratic patrons of the 1810s and 1820s to the newly rich commercial classes thereafter. This general shift in English patronage (frequently remarked upon by historians of the period) accompanied a change in Mulready's own painting style.

In the 1830s the Dutch-like coloring of his early style gave way to the high-keyed palette of his later works. At this time, he was attempting to graft Venetian color onto Dutch subject matter: an impossible task, as he later described it.[39] As a result he slowly moved away from his established subject matter to love scenes, literary scenes and nudes: to subjects in his mind more in keeping with his new style. Strictly speaking, the only children's scene painted in the last twenty years of his career, *The Butt—Shooting a Cherry*, was finally completed in 1848 upon a friend's urging, after having been set aside for many years.[40]

The aging Whig patrons neglected Mulready's new painting style, but the change cannot be attributed to their neglect, nor for that matter to the influence of the new collectors—for the two most important, John Sheepshanks and Thomas Baring, obtained works from Mulready's early period as well as from his current production. And one important industrialist, John Gibbons (d. 1851), concentrated his collecting activities on Mulready's early scenes after the artist had long since turned to his new manner.[41]

Mulready was aware of the potential power of patrons and evidently attempted to shield himself from their influence. He once explained to a friend in 1845 that "at one time he wd not take commissions in order that

he might not be fettered—Now he did because he cd do as he liked."[42] His Account Book seems to confirm this assertion. Generous patrons like Swinburne, and later John Sheepshanks and Thomas Baring, allowed him this privilege.

Thomas Baring (1799–1873), a Tory M.P. and like Peel a descendant of a prominent commercial family, became one of Mulready's most important patrons. His collecting activities embraced a broad spectrum: old master paintings with an emphasis upon Dutch and Flemish works, and contemporary paintings by both European and British artists.[43] His purchases from Mulready reflect his independent and spirited taste. He bought an early landscape long after Mulready painted it (Plate 66); a children's genre piece, *Train Up a Child* . . . (Plate 101), certainly one of Mulready's most interesting and provocative works; two literary scenes from the *Vicar of Wakefield* (Plates 135, 137); and Mulready's two paintings of women bathers (Plates 148, 149).[44] Moreoever, he showed considerable generosity by freely lending his paintings to the newly burgeoning public exhibitions of his day. Thus his Mulready paintings travelled to Paris, Manchester, and Edinburgh.

In the 1830s both John Sheepshanks (1787–1863) and Robert Vernon (1774–1849) became important patrons of Mulready's paintings; particularly Sheepshanks, who accumulated the astounding number of thirty paintings, eleven purchased directly from the artist; the others obtained either as gifts from Mulready,[45] or from dealers, auctions or previous owners. Vernon obtained only five; one of which he pruned from his own collection.[46]

Both Sheepshanks and Vernon have come to represent the new patronage of art during the nineteenth century. Sheepshanks (Plate 156) was the son of a cloth-manufacturer in Leeds; Vernon made his fortune supplying horses to the Army during the Napoleonic Wars. They distinguish themselves from numbers of lesser-known collectors of their class by their genuine love of painting, untainted by its investment value. In fact, they began to patronize contemporary artists before their works constituted an investment. Their support contributed to the tremendous rise in the value of contemporary paintings, and to the speculation that soon developed around contemporary art, enabling living artists to command much higher prices.[47]

Both Vernon and Sheepshanks shared the dream of founding a national gallery of British art, with their own collections as the nucleus of such an institution. With this hope in mind, they both gave their works to the state: Vernon in 1847, Sheepshanks a decade later.[48] Their motives were not entirely pure. They relished the prestige attached to patronage and Vernon in particular was anxious to have his name permanently associated with his gift to the state.[49] While their combined collections would have presented an impressive and instructive array of

early nineteenth-century British art, Vernon insisted that his collection be held apart. As a result, the Sheepshanks collection (233 oils, 289 drawings and sketches) is now housed in the Victoria and Albert Museum; while the Vernon collection (157 oils) is held in the Tate Gallery, an unfortunate dispersal of nineteenth-century English painting.[50] Their taste was similar and somewhat tame, taking in a wide range of British painting, while avoiding anything extreme.[51] Both men were eccentric bachelors and given to odd habits.

167

Perhaps Sheepshanks' greatest eccentricity was his enthusiastic patronage of Mulready. Mulready was by far the best represented painter in Sheepshanks' collection. He obtained Mulready's children's scenes, love scenes, and literary scenes, as well as his early landscapes; although one of the latter, decorating his breakfast room, may have had less merit in his eyes.[52] On occasion, he even purchased paintings rejected by others.[53] In fact, for many years Sheepshanks was Mulready's sole patron, and his purchases (along with Mulready's teaching fees) completely supported the artist.[54] In time, he and Mulready became extremely close friends, and Mulready is said to have been at his wittiest and warmest in Sheepshanks' presence.

The generous patronage of Swinburne, Sheepshanks, Vernon and Baring saved Mulready from financial insecurity and from the niggling requests of small-minded art collectors; those who would "like something humerous an out Door scene . . . [up] to 100 gs but not more";[55] or another wishing to "know the price of the smallest picture you paint" and hoping to exchange that for the Duke of Wellington's autograph signature.[56] Another collector, Thomas E. Plint, a stock-broker and non-conformist leader of Leeds and a noted patron of the Pre-Raphaelites, requested "a small painting . . . on terms which could come within my reach", preferably a theme from the *Vicar of Wakefield* or from Sir Walter Scott's writings; this, without ever having seen a painting by Mulready but simply on the strength of Mulready's illustrations, and more importantly, on the basis of John Ruskin's praise—mixed praise at that—which reflects the rising influence of the art critic.[57] There is no evidence to suggest that Mulready obliged any of these would-be collectors. Mulready even rejected Prince Albert's specific request to copy a painting,[58] something Mulready did on occasion but evidently not for such an illustrious patron.

The beneficent patronage of a few liberal patrons did not protect Mulready from some unhappy experiences. His early years were difficult and, as noted in earlier chapters, Mulready's paintings were sometimes refused by collectors. The Hoare family rejected two history paintings in 1808; two small landscapes were refused by a patron in about 1812 because of their excessive detail; *First Love* was purchased by Sheepshanks only after its rejection by the Duke of Bedford in 1839 (the Duke evidently objected to the subject).

Four other notable paintings went unsold in exhibitions; the first because of its high price. Mulready hoped to receive three hundred guineas for *A Carpenter's Shop and Kitchen* (Plate 72) at the British Institution in 1809. Although buyers were interested,[59] it went unsold. His asking price was considered too high, and rightly so. Turner, already a Royal Academician, at that time asked the same price for an eight-foot canvas; Wilkie, with an established reputation, was still struggling to

raise his picture price above fifty guineas in 1808.[60] Mulready's painting eventually went to Lady Swinburne in 1812. No fee is recorded in Mulready's Account Book.

The other three paintings failed to find buyers because of their unpopular or unsuitable themes. *Returning from the Ale House* (Plate 78) R.A. 1809, with its drunken revelers, offended public taste, as discussed earlier in Chapter III. Partially repainted, and retitled *Returning from the Fair* (or *Fair Time*), it was purchased over thirty years later by Robert Vernon. The sale of two additional oils was also delayed by seemingly unsuitable subject matter. *The Convalescent from Waterloo* (Plate 98) was exhibited by Mulready in 1822. By then, Mulready was a sought-after artist, having recently sold *The Wolf and the Lamb* to the Prince Regent for a good price. Yet this painting did not sell; the contemporary subject was too controversial. The injured sergeant succored by his family reminded the public of the poor treatment afforded the veterans of the Napoleonic Wars. Their condition was an embarrassment to the government. The painting was presumably too painful for most potential buyers. It was eventually purchased by Lord Northwick four years later when the subject was no longer a live issue. It was displayed uneasily among his extensive collection of old master and modern paintings in his Cheltenham gallery.[61] Northwick must have found it somewhat unsettling for he attempted to sell it during his lifetime. The painting was eventually sold along with the rest of his collection following his death in 1859.[62]

The Widow, (Plate 124) painted in 1823, and given prominent and prestigious place at the Royal Academy exhibition in 1824, waited much longer for an owner. Its critical reception may provide an explanation. The theme of the callous young widow pursued by a jovial suitor in an unrestrained, almost licentious pose received the disapproval of the *New Monthly Magazine* reviewer who found it an

> instance of much talent, both in conception and execution, in a great measure thrown away on a very uninviting subject. That 'such things be' as we meet with here, is true enough, but it is not so true that either the morals or the manners of the age are likely to be bettered by thus depicting them. In fact, we cannot admire that the extreme cleverness displayed in this picture throughout atones for the scarcely covert grossness of it. Mr. Mulready should not have painted a picture of which he would be sorry to be called upon to explain the purport to any inquirer.[63]

The "considerable coarseness in the conception" was also commented upon in *Blackwood's Magazine*.[64] It was finally purchased in 1841 by a London grocer, George Knott,[65] who may have found the shop scene in the background especially appealing. When the painting was sold a few

years later along with the rest of Knott's collection, it brought a lower price than Mr Knott paid for it.[66] The commercial failure of these two modern-dress scenes with their sharp social criticism undoubtedly discouraged Mulready from pursuing such subjects.

Although Mulready suffered some setbacks, the generous patronage of Sheepshanks, Vernon and Baring saved him from another peril: the dealers, whose activities increased rapidly in the 1840s.[67]

Mulready's friends William Etty and John Linnell both benefited financially from their association with dealers, although their art suffered as a consequence. Dealers encouraged the production of potboilers, works quickly conceived and executed for the growing market. The dealer Ernest Gambart openly admitted to this state of affairs in a letter to Linnell: "I have often taken away Pictures on which you spent but little time you and I thinking they might go off in their imperfect state and as we where both anxious to make money as fast as possible we have thus plotted many an unfinished picture."[68]

Such incentives would have appalled Mulready, who felt a moral responsibility to the owners of his paintings[69] and valued his own meticulous painting method, which precluded high productivity. Of course, on occasion his works did pass through dealers' hands: rarely by direct sale from the artist,[70] more often after leaving the collection of an original owner. When such paintings did come from dealers rather than from the artist, prospective buyers were understandably wary.[71] Skeptical collectors wrote directly to Mulready requesting verification of the authenticity of works.[72] A gentleman from Leominster asked: "Would you kindly inform me by what mark I may distinguish your painting? . . . I am offered one (for sale) label to be by you—It is a beautiful painting & were I sure it were a genuine one I would purchase it—but would not give the price, unless I am certain of it."[73] A collector from Sheffield, having recently purchased Mulready's *Idle Boys*, wrote: "If you thought there was any possibility of its not being the original (I scarcely think there can be any doubt) I would take the picture up with me to London & show it to you."[74]

Had Mulready cooperated fully with the dealers he could have made a fortune as others did. Although far from cavalier concerning his earnings,[75] he was content to depend upon the certain sale of a few paintings to his steady patrons.

Portraiture could have provided another avenue for increasing Mulready's income if this had been his sole concern. Certainly he painted portraits. In fact, they constituted almost his entire production in 1811, when they were probably undertaken somewhat reluctantly to make up for his low earnings of 1809 and 1810—the years accompanying the dissolution of his marriage with the concomitant loss of student fees.[76] But more often his portraits were gifts to friends, pupils or patrons, who were often the same people.[77]

Some of his portraits border on genre scenes. His delicate watercolor of the young Elizabeth Swinburne (1805–1896) of 1811 (Plate 157) falls into this category. She is observed while reading, fully absorbed in her book. The portrait presents a lovely image of serene childhood complemented by the formal play of lively patterns: her pinafore and dress, the border of the slip-covered chair, the multi-colored floral carpet.

This approach proved equally successful with Mulready's more mature and sophisticated subjects: Frances Talbot, Countess of Dartmouth, 1827–8 (Plate 158) and John Sheepshanks of 1832–4 (Plate 159). Fanny Talbot was Mulready's pupil for a number of years, as was her mother-in-law, the Dowager Countess of Dartmouth. Fanny died in 1823 shortly after her marriage to the Earl of Dartmouth who commissioned this portrait from Mulready after her death. In many respects it looks forward not only to Mulready's portrait of Sheepshanks, but also to his more celebrated painting *Choosing the Wedding Gown* from the *Vicar of Wakefield*, R.A. 1845 (Color Plate VII), especially in the very skillful depiction of material objects: the glittering silver pot and porcelain vase on the mantel, the glistening mirror above the fireplace, the intricate floral covering on the wall, and the beautiful reverentially recreated Claude landscape above Fanny. The sleeping black and white dog (as in *Choosing the Wedding Gown*) provides a sharp

157. *Elizabeth Swinburne* 1811. Watercolor, 12 × 8⅛ (sight). Capheaton Collection

158. *Frances Charlotte Talbot, Countess of Dartmouth* 1827–8. Oil on panel, 24¼ × 19⅞. Lord Dartmouth (cat. 114)

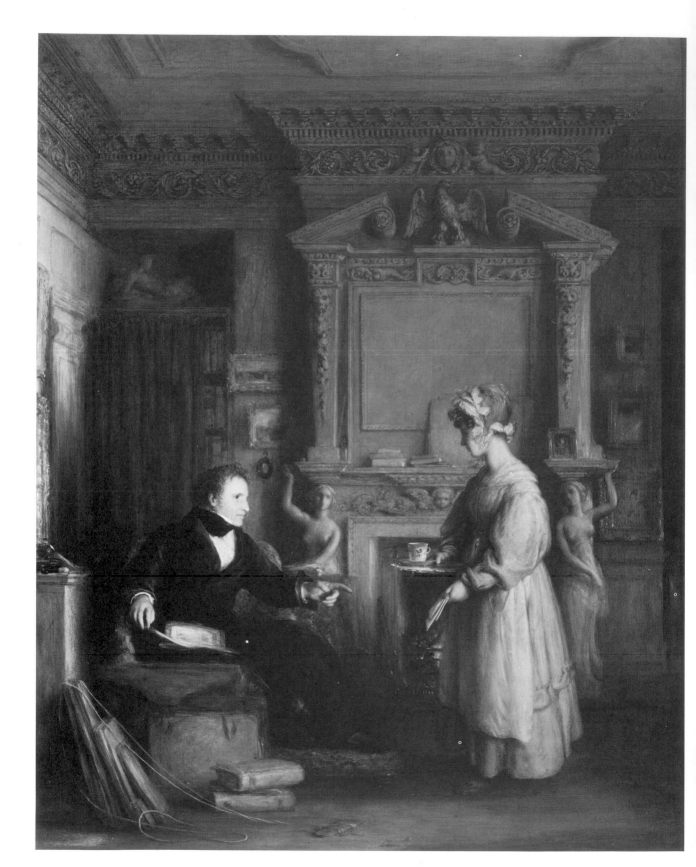

visual counterpoint to the rich, colorful interior and is a gentle reminder
of the peaceful domesticity which surrounded this fragile woman in her
brief life. Fanny's graceful pose and her placid, patrician profile cast a
calming spirit over her decorative and luxurious surroundings.

A few years later, Mulready produced a more elaborate version of this
genre-like profile portrait for his patron John Sheepshanks (Plate 159).
Listed in Mulready's Account Book as an "Interior", the painting was
worked on from 1832 through 1834. Sheepshanks is shown seated in his
drawing room examining his portfolios; his housekeeper (Plate 160)
approaches with the mail and his morning tea. Their encounter is set
against an elaborate interior, his residence at 172 New Bond Street,
where small oil paintings in shimmering gold frames surround an ornate

159. (facing page) *Interior,
Portrait of John Sheepshanks*
1832–4. Oil on panel, 20 × 15¾.
Victoria and Albert Museum,
London (cat. 133)

160. Study for *Interior,
Portrait of John Sheepshanks*
1832. Pen and brown ink,
sepia, 9 × 7¼. Victoria and
Albert Museum, London
(Crown Copyright)

173

mantelpiece supported by two prominent caryatids, which are almost additional characters in the scene. The architectural elements, particularly the heavily sculpted cornice, are drawn with great precision and probably with great accuracy. In effect, the collector is nearly dwarfed by his prestigious possessions: his residence, his paintings, his portfolios, his books—even his comely maidservant. Yet, despite this bewildering profusion of material and human distractions, Sheep-shanks, by his alert expression, his forceful gesture, his somber clothing commands attention. In this sense, it is a successful portrait, embodying both the interests and the energy of the man himself.

Mulready's other portraits are much simpler but nevertheless interesting. Whether busts, half-length or full-length portraits, they are direct, uninflated records of the sitters without poetic allusions or dazzling effects. Their value resides in their simplicity.

Three small portraits of Sir John Swinburne's daughters, which were painted as gifts for Mulready's patron, confirm this judgment. By far the most attractive panel (Plate 161) portrays Emily [Emelia-Elizabeth] Swinburne (1798–1882), later Lady Ward. Her colorful costume gave Mulready an opportunity to display his skillful simulation of material. A gauzy white collar emerges from a pale blue gown sashed with gold; a red shawl with a delicate floral design graces her shoulders. Gay little flowers replace the jewelry one might expect to see at her throat. But the decorative effect of her clothing and the sprightly inclusion of flowers fail to relieve the sadness created by the pensive expression of her downcast eyes.

This direct, unsmiling approach is repeated—even enhanced in his portraits of Elizabeth, now quite mature (Plate 162), and Julia Swinburne (1795–1893, Plate 163). Eschewing flattery, the expected ingredient of female portraiture, Mulready records their plain features with deadpan honesty. The somber air of Emily's portrait gives way here to cool, detached observation: emotionless faces in rigid frontal and profile poses, portraits which look back to the example of early Northern Renaissance artists[78] and forward to the harsh focus of modern-day photo-realists, a manner which by the way, appears in his portrait drawings as well (Plate 164). Another Swinburne daughter, Frances Elizabeth (Fanny, 1799–1821), adopted this austere style for her own self-portrait (Plate 28), proving herself a more than able pupil of her tutor Mulready.[79]

Mulready also employed this matter-of-fact vision in a small 1814 portrait of his friend and brother-in-law, John Varley (1778–1842) (Plate 177); and in a full-length portrait of a small child, Mary Wright (Plate 165), daughter of a carpenter. The latter was painted in 1828, soon after Mulready moved to a new residence. It may have been a gift to the carpenter employed by Mulready, or perhaps painted in exchange for services rendered. In any case, it is a charming portrait: straightforward,

VII. (facing page) *Choosing the Wedding Gown* 1845. Oil on panel, 21 × 17¾. Victoria and Albert Museum, London (Crown Copyright) (cat. 163)

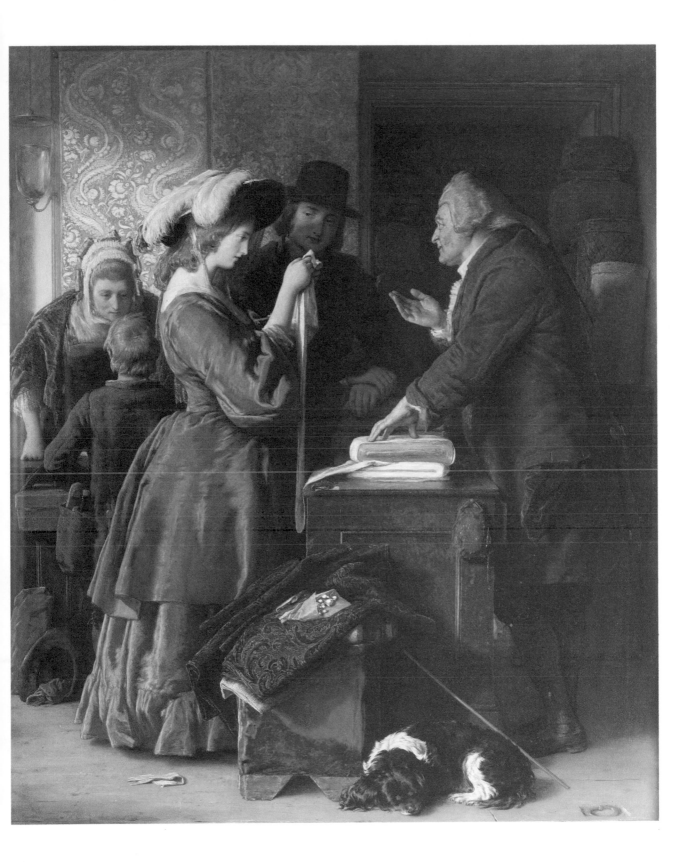

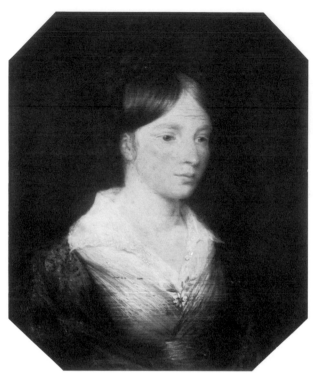
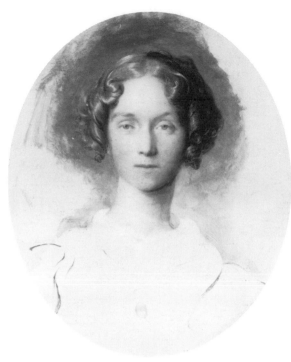
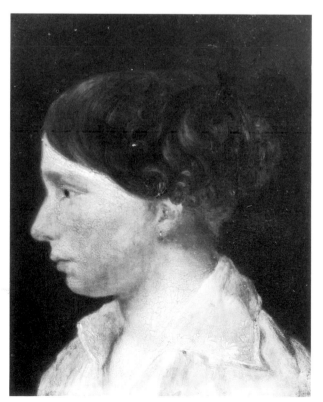

unsentimental, and free of the coyness that often accompanies portraits of children.[80]

The quality of these private portraits vanishes in Mulready's official portrait of Mr Joseph Pitt (1759–1842) probably the father or grandfather of one of Mulready's long-term pupils (Plate 181). Striking a conventional pose with flowing drapery behind him, this solid citizen peers out steadily from the canvas. Presumably an accurate record of the man—warts and all—it remains a lifeless, leaden, and dull portrait without the pleasing austerity of Mulready's private portraits nor the revealing profusion of his formal depictions of Fanny Talbot and Sheepshanks.

Mulready left no major self-portraits; just a few drawings,[81] (Plate 166) and one unfinished oil painting, of about 1835–40 (Plate 167).[82] The latter is a serious and somber record of the artist's

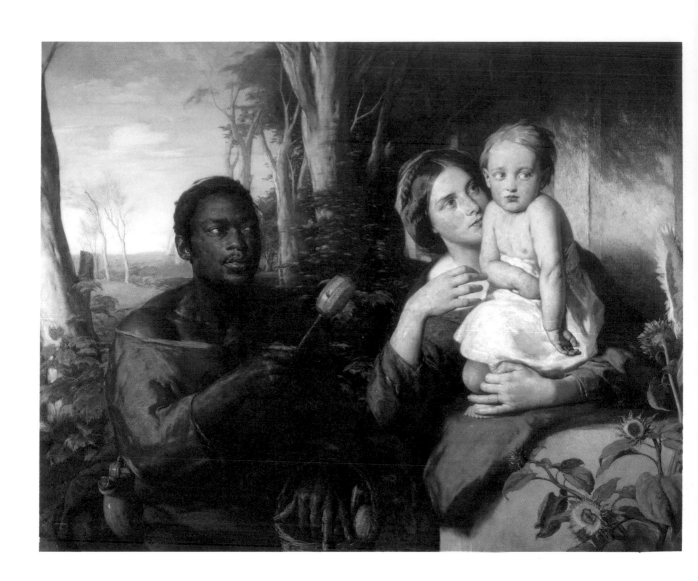

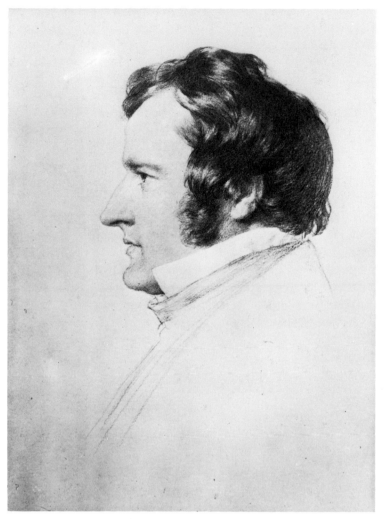

166. *Self-Portrait c.* 1840.
Black and red chalk, 9 × 7.
Royal Academy of Arts,
London

features; it is certainly no tortured self-image in the Romantic tradition.
This should surprise no-one. Mulready established his respectable
public pose at some cost. He would scarcely wish to uncover his
innermost feelings or probe his own psyche for the public's pleasure.
One must seek the undercurrents of his personality in his everyday
painting, perhaps most notably in his fear-ridden scenes of childhood,
paintings at the core of his oeuvre.

Mulready's working methods also prove self-revelatory, disclosing
more about the man than a mere self-portrait could reveal. His
experimentation with subject matter and painting technique, coupled
with his very low productivity, suggest not an adventurous risk-taker
but rather an insecure character, who forever tampered with his style,
tinkering with compositions and color before committing himself to a
final painting, and then often showing reluctance to complete his works
for fear of failure.

VIII. (facing page) *The
Toyseller c.* 1857–63. Oil on
canvas, 44 × 56. Courtesy of
the National Gallery of
Ireland, Dublin (cat. 172)

179

A conversation recorded by his friend Samuel Palmer sheds some light on this behavior: "I remember [William] Collins saying 'Why don't we begin again?' Mulready replied, 'I do begin again.' Mulready was one of the few who realized Lavater's advice to devote ourselves to each new undertaking as if it were our test—our first work and our last."[83] This attitude naturally led to hesitancy, to diffidence.

But despite this timidity, or perhaps because of his caution, Mulready produced some memorable, often beautiful, sometimes haunting paintings; works which one would scarcely believe were by the same hand—his early watercolors and rustic scenes, his children's genre, his courtship paintings, his Bathers. And this very variety in his long, multi-faceted career makes Mulready's life work an excellent lens for viewing the development of nineteenth-century British art and patronage. His own importance derives from his personal, often innovative approach to established themes, whether landscape or genre, and from the originality of his late, brilliant palette, the high-keyed color which inspired a generation of younger artists, most notably the Pre-Raphaelites.

167. *Self-Portrait c.* 1835–40.
Oil on canvas, $8\frac{1}{2} \times 6\frac{5}{8}$.
National Portrait Gallery,
London (cat. 146)

Introduction to the Catalogue

This catalogue lists Mulready's paintings, many of which are now lost but known through extensive documentary evidence consisting primarily of Mulready's annual Account Book (1805–*c*. 1861) which generally cites the title, buyer, payment and sometimes the progress of paintings; catalogues for the comprehensive Mulready exhibitions held at the Society of Arts in 1848 which was supervised by the artist, and at the South Kensington Museum shortly after his death in 1864 which was supervised by Mulready's friends Henry Cole and Richard Redgrave, supported by his Executors, and which claimed to be as "complete as possible"; and the Artist's Sale at Christie's, April 1864. A manuscript catalogue of Mulready's paintings by Henry Cole (?) *c*. 1848, probably assembled in preparation for the Society of Arts exhibition, is also extremely informative. This material is supplemented by F. G. Stephens' monograph published in 1867 (revised 1890) which includes a list of Mulready's important paintings. These records allow for a reliable compilation of Mulready's small oeuvre, although some works, especially early paintings and oil sketches have surely slipped through this fine net of documentation.

A very few watercolors have been catalogued here separately because they were exhibited as independent works of art early in Mulready's career and have since been mistaken for oil paintings. Life studies in oil, often combined with chalk and pencil, have not been included. For the most part, undocumented works which could not be convincingly assigned to Mulready have been excluded; only a very few entries at the end of the catalogue treat problematic paintings.

Exhibitions, detailed provenances and selected references, both published and unpublished, are provided. Contemporary reviews or opinions are appended to the entries to suggest the critical reception given the paintings; descriptions of lost works are quoted when possible. Sketches, studies, versions and engravings for paintings are recorded, although this is by no means an exhaustive list; preparatory drawings in the Artist's Sale are cited only if they did not appear previously in

exhibitions. The exhibition record printed in Stephens' monograph is not cited under references but instead appears under exhibitions for the appropriate entries. Measurements are in inches, height before width, unless otherwise indicated. Dimensions for lost paintings (taken from old catalogues) can only be approximate. With the exception of a few paintings of questionable provenance, the discussion of the works takes place in the text and notes, not in the catalogue.

It is important to state here that paintings resembling Mulready's may very well be the work of his sons. Moreover, signed paintings may be the work of William Mulready, Jr. Mulready's four sons were trained as artists and studied directly under their father. In Mulready's designs for his new home (occupied in 1828), he placed the "boys" painting room right beside his own. Two of his sons, Michael (1807–89) and John (c. 1809–92), were principally portrait painters. His eldest son, Paul Augustus (1804–64) also did portraits but painted genre scenes too. William Mulready, Jr (1805–78) specialized in genre and animal painting (Plate 131). They all exhibited sporadically at the Royal Academy.

While the one signed painting by William Mulready, Jr in the Victoria and Albert Museum carries a signature including the "Jr", there is little reason to suppose that all of his paintings were so signed. In commercial postal directories he is listed simply as Wm. Mulready, Esq., Artist. His letters from the 1840s to John Linnell, Sr (The Linnell Trust) display a signature very much like his father's. And as these very letters disclose, this son may have been overly tempted by circumstances to drop the "Jr" from his signature to attract a higher price for his paintings. He was quite destitute in the 1840s, receiving a stipend from his father through John Linnell, although he remained penniless, and was eventually imprisoned for debt in the mid-1840s. As late as 1860, his difficult home situation, especially the insecure, impecunious position of his children, was reported to Mulready in a letter from Elizabeth Robinson Mulready (Victoria and Albert Museum Library). This notorious black sheep of the family may even have been so unscrupulous as to sell his paintings as the work of his famous father (or others may have done so without his approval).

William Mulready, R.A. was renowned for being an exceptionally slow and unproductive painter. One should not expect to encounter numerous undocumented paintings by his hand. And yet previously unknown, inferior works, well below the quality of his documented paintings have surfaced in recent years in sale rooms or galleries signed W. Mulready (many dated in the 1840s and 1850s). They are clearly not the work of the aging Royal Academician. They need not be forgeries (although some certainly are). They are more likely the work of this errant son, William Mulready, Jr.

182

Abbreviations used in the Catalogue

Account Book Mulready's Account Book, 1805–*c.* 1861, Victoria and Albert Museum Library

Artist's Sale Executors' sale of Mulready's property, Christie's, 28–30 April 1864

B.I. British Institution

Bodkin, *Dublin Magazine* Thomas Bodkin, "William Mulready, R.A.", *Dublin Magazine*, I, 1923, 420–9

Cole Diaries The manuscript diaries of Sir Henry Cole, Victoria and Albert Museum Library

Cole MS. A manuscript catalogue listing Mulready's paintings along with notes on their location, their condition, their appearance in exhibitions; thought to be in Sir Henry Cole's hand, probably assembled in preparation for the Mulready exhibition at the Society of Arts, 1848. Later notes added in another hand, initialled R.R. (Richard Redgrave?). Victoria and Albert Museum Library

Cork 1971 Cork, Crawford Municipal School of Art, *Irish Art in the 19th Century*, 1971

Cunningham, *British Painters* Allan Cunningham, *The Lives of the most Eminent British Painters*, rev. ed. Mrs Charles Heaton, 3 vols., London, 1879–80

Cunningham, *Wilkie* Allan Cunningham, *The Life of Sir David Wilkie* . . . 3 vols., London, 1843

Dafforne James Dafforne, *Pictures by William Mulready, R.A.*, London [1872]

Farington Joseph Farington, *The Farington Diary*, ed. James Greig, 8 vols., London, 1922–8

Frith, *Autobiography* W. P. Frith, *My Autobiography and Reminiscences*, 3 vols., London, 1887–8

Gautier T. Gautier, *Les beaux-arts en Europe*, Paris, 1855

Grant M. H. Grant, *A Chronological History of the Old English Landscape Painters* . . . , 2 vols., London, 1926

Grosvenor Gallery 1888 London, Grosvenor Gallery, *A Century of British Art from 1737 to 1837*, 1888

Guildhall 1904 London, Guildhall, *Works by Irish Painters*, 1904

Horsley J. C. Horsley, *Recollections of a Royal Academician*, ed. Mrs Edmund Phelps, London, 1903

Linnell's Autobiographical Notes John Linnell's MS. Autobiographical Notes, written in 1863, The Linnell Trust.

Louvre 1938 Paris, Louvre, *British Art*, 1938

Millar Oliver Millar, *The Later Georgian Pictures in the Collection of Her Majesty the Queen*, 2 vols., London, 1969

Palgrave Francis T. Palgrave, *Gems of English Art*, London, 1869

Palmer, *Life* A. H. Palmer, *The Life and Letters of Samuel Palmer*, London, 1892

Philadelphia Museum of Art 1968 Philadelphia Museum of Art, Detroit Institute of Arts, *Romantic Art in Britain, Paintings and Drawings 1760–1860*, 1968, prepared by Frederick Cummings and Allen Staley, with an essay by Robert Rosenblum

Prov. Provenance

R.A. London, Royal Academy of Arts

R.A. 1934 London, Royal Academy of Arts, *British Art*, 1934

R.A. 1951–52 London, Royal Academy of Arts, *The First Hundred Years of the Royal Academy*, 1951–2

R.A. 1968 London, Royal Academy of Arts, *Bicentenary Exhibition 1768–1968*, 1968

Redgrave, II Richard and Samuel Redgrave, *A Century of Painters of the English School*, 2 vols., London, 1866

Redgrave, *Memoir* Richard Redgrave, *Richard Redgrave: A Memoir compiled from his Diary by F. M. Redgrave*, London, 1891

Rorimer London, Victoria and Albert Museum, *Drawings by William Mulready*, 1972, prepared by Anne Rorimer

Ruskin, *Works* John Ruskin, *The Works of John Ruskin*, eds. E. T. Cook and Alexander Wedderburn, 39 vols., London, 1903–12

Stephens F. G. Stephens, *Memorials of William Mulready R.A.*, London, 1890

Stephens, List or Addit. List F. G. Stephens compiled a "List" of Mulready's important paintings for his monograph in 1890 citing present or recent ownership. Paintings recorded here are securely assigned to Mulready. Stephens appended this list with some additional entries in a footnote—paintings which had appeared in sales which he may or may not have seen, some in private collections without previous documentation, or a very few which were simply omitted from the original list. This reference appears as Stephens, Addit. List; it does not alone supply secure documentation for a Mulready painting.

Waagen, *Galleries* Gustav F. Waagen, *Galleries and Cabinets of art in Great Britain ...*, London, 1857

Waagen, *Treasures* Gustav F. Waagen, *Treasures of art in Great Britain ...* 3 vols., London 1854

Whitley William T. Whitley, *Art in England, 1800–1820*, Cambridge, 1928

Winchester College and Southampton Art Gallery, 1955 Winchester College and Southampton Art Gallery, *Pictures from Hampshire Houses*, 1955

1848 London, Society of Arts, *A Catalogue of the Pictures, Drawings, sketches, etc. of William Mulready, R.A.*, 1848

1855 Paris, *Exposition Universelle*, 1855

1857 Manchester, *Art Treasures of the United Kingdom*, 1857

1862 London, *International Exhibition*, 1862

1864 London, Science and Art Department, South Kensington Museum, *A Catalogue of the Pictures, Drawings, sketches, etc. of the late William Mulready, Esq., R.A.*, 1864

1964 Bristol, City Art Gallery, *William Mulready*, 1964, prepared by Arnold Wilson

Catalogue

1 The Porch of St. Margaret's, York 1803 (Plate 29)
Watercolor and ink on paper, $12\frac{3}{8} \times 6\frac{1}{2}$
Signed and dated W. Mulready 1803, lower left
British Museum (1864-5-14-271)
Exh. R.A. 1805 (556); 1964 (27)
Prov. Artist's Sale, see Ch. II, note 16
Related works Pencil drawing, signed, inscribed and dated
 27 July 1803, with Sotheby's, 22 Dec. 1977 (98/ii)
Ref. Cole MS. described this as a watercolor; Stephens, List

2 Crypt in Kirkstall Abbey *c.* 1803–4
Canvas, $15\frac{1}{2} \times 11\frac{1}{4}$
Location unknown
Exh. R.A. 1804 (392); 1864 (1)
Prov.; by 1864, Charles West Cope (it did not appear in
 the Artist's Sale following Cope's death, Christie's, 22
 June 1894)
Related works Pencil drawing, "Crypt, Kirkstall 1803",
 appeared 1864 (117); see also cat. 4
Ref. Cole MS., where it is described as a watercolor;
 Stephens, List and pp. 46, 49, 89
The Cole MS. identifies the painting exhibited at the Royal
Academy in 1804 as a watercolor; it may have been. This oil
painting, exhibited in 1864 (1) after Mulready's death where
it was described as the work exhibited in 1804, may be
another painting altogether.

3 Cottage at Knaresborough, Yorkshire *c.* 1803–4
Watercolor
Location unknown
Exh. R.A. 1804 (507)
Related works Drawing, *Knaresborough Castle*, signed and
 dated 1804 appeared 1864 (119)
Ref. Cole MS. identifies it as a watercolor; Stephens, List
 and pp. 46, 49

**4 West-Front Entrance of Kirkstall Abbey, York-
shire** 1804 (Plate 27)
Watercolor and pencil on paper, $15\frac{3}{4} \times 10\frac{3}{4}$
Signed and dated Wm. Mulready. 1804, lower left
Victoria and Albert Museum (P. 49–1936)

Exh. R.A. 1804 (411)
Prov. Sir John E. Swinburne's family, Miss Julia Swin-
 burne, her sale, Christie's, 8 July 1893 (47); Dr Herbert
 A. Powell, given by him to the museum through the
 National Art Collections Fund
Related works Pencil drawing, *Principal Entrance to
 Kirkstall Abbey*, signed and dated 21 July 1803, appeared
 1864 (116); several sketches in Artist's Sale (181)
Ref. Cole MS. identifies this painting as a watercolor, then
 in the possession of Miss Swinburne; Rorimer, pp. 7,
 84–5; Stephens, List and pp. 46, 49

5 Portrait of Elizabeth Mulready, née Varley
 (1784–1864) *c.* 1804
Oil miniature
Location unknown
Prov. Albert Varley, her nephew
Ref. Stephens, List and below
Stephens, p. 42: "it represents a young girl of about
nineteen, must have been produced near the time of their
marriage . . . there is something charming in the piquancy of
this portrait, with its bright and white skin, and decidedly
retroussé nose. The little head, with tawny-brown hair
drawn high up and off the ears, is, with all the freshness of
just perfected youth, balanced, so to say, on the longest
tendril of a neck with a dainty *insouciant* demeanor that
might have piqued the coldest man to love and a more
daring imprudence than Mulready committed in marrying
the fair damsel. . . We do not know from any other source
that the lady was so attractive."

6 A Woman Weeping Sketch *c.* 1804–10 (Plate 168)
Canvas, $7\frac{3}{8} \times 7\frac{1}{8}$
Collection Mr and Mrs John Harrison
Prov. By descent. John Harrison is Mulready's great-great-
 great-grandson.
Could this be Elizabeth Mulready, née Varley? She was said
to have reddish-brown hair much like that displayed in this
painting. Perhaps this work is related to Mulready's
miniature portrait of his wife described by Stephens (cat. 5).

186

168. *A Woman Weeping c.* 1804–10. Oil on canvas, $7\frac{3}{8} \times 7\frac{1}{8}$. Collection Mr and Mrs John Harrison (cat. 6)

7 Still-life: Jug and Pitcher *c.* 1805
Location unknown
Ref. Account Book 1805 "Jug & Pitcher Hobson 1.1"

8 Two Portraits of Indian Women *c.* 1805
Oil (?)
Location unknown
Ref. Account Book 1805 "2 Portraits of Indian Women Ly Russell 3.3"
If the portraits were separate works of art, the low price (£1.10.0 each) would indicate pencil or watercolor drawings rather than oil paintings. As it is, the price of £3.3.0 is rather low for an oil painting of two women.

9 A Cottage Sketch *c.* 1805
Watercolor
Location unknown
Exh. R.A. 1805 (548)
Ref. The Cole MS. identifies this painting as a watercolor, confirmed by its location in the R.A. exhibition; Stephens, p. 46

10 Landscape *c.* 1805
Location unknown
Exh. R.A. 1805 (106)
Ref. Cole MS. describes this as "destroyed".

II A Cottage, Woman Hanging Clothes Out 1805
Millboard, $12\frac{1}{4} \times 14\frac{7}{8}$
Location unknown
Exh. R.A. 1806 (88); 1848 (11); 1864 (3, "View of an Old House, Westminster")

Prov. Wilson Lowry, the engraver; by 1848, William Russell
Ref. Account Book 1805 "Old Houses at Westminster, Lowry 5.5"; Cole MS. "A Cottage, in Westminster near Downing St., woman hanging clothes out."; for contemporary review, see p. 67

169. *St. Peter's Well, in the Vestry of York Minster* 1803. Pencil, $12\frac{1}{2} \times 8\frac{1}{2}$. With Sotheby's, 1977

12 St. Peter's Well, in the Vestry of York Minster 1805
Canvas, $28\frac{1}{2} \times 19\frac{1}{4}$
Location unknown
Exh. R.A. 1806 (503); 1848 (XII, "Painted in 1805"); 1864 (2)
Prov. Ogilvie, his sale, Christie's, 14 July 1830 (75), bt Bone; by 1848, Joseph Neeld; by 1864, Sir John Neeld, Bart.; by descent to L. W. Neeld, his sale, Christie's, 8 Feb. 1946 (25, "Interior of a Chamber in York Minster"), bt Bernard
Related works Pencil drawing, signed and dated 8 Aug. 1803 with Sotheby's, 22 Dec. 1977 (98/i), Plate 169
Ref. Account Book 1809 & 10 "St Peters Well Yorkminster D°[Ogilvie] 15"; Linnell's Autobiographical Notes "when I first saw Mul[ready] at Varley's in Broad St. His wife and first child were in the room, he very kindly asked me to give my opinion of his picture of St. Peter's Well then on the easel"; Stephens, List and below

Stephens, p. 89: "[It] testifies to the seductive powers of asphaltum. . . *St. Peter's Well* is an experiment in *chiaroscuro*. The subject is a woman washing linen, on which a boy pours water from a tall old pump placed in a crypt; standing beside them is a vesture chest gray with age; the whole is lighted by a Gothic window."

13 An Old Cottage, St. Albans *c.* 1805–6 (Plate 50)
Canvas, 14 × 10
Victoria and Albert Museum, Sheepshanks Collection (F.A. 151)
Exh. R.A. 1806 (101); 1864 (9); 1964 (2)
Prov. Lady Beauchamp-Proctor; John Sheepshanks
Related works Pencil drawing, Victoria and Albert Museum (back of 6236), Plate 51; and pencil drawing, collection David and Kathryn Heleniak, Plate 52; for J. S. Cotman's interpretation see Plate 49.
Ref. Account Book 1806 "Cottage St Albans Ly B. Proctor 6.6"; Cole MS. "[Collection] Lady Beauchamp Proctor"; Stephens, List and p. 89

14 Old Kaspar *c.* 1805–6
Textual source: Robert Southey's *Battle of Blenheim*
Panel, 10¾ × 10½
Location unknown
Exh. R.A. 1807 (215); 1864 (4)
Prov. Miss Sparrow, later Lady Acheson; by descent to the Earl of Gosford in 1864
Ref. Account Book 1805 "Old Gaspar Miss Sparrow 6.6"; and 1806 "Old Gaspar Ly Acheson 12.12" and see below; Stephens, List and pp. 46, 48

Redgrave, II, pp. 299–300: "It is solidly and crisply painted, with the evident want of knowledge of a beginner, but showing that the painter had looked to his Dutch predecessors . . . there is a great want of truth and knowledge of the constructive details in the parts of the cottage shown in the background. . . There is a foreshadowing of his future finish in the hair and beard of the old man."
The Account Book seems to suggest two paintings of the same title; however, a barely legible list of Mulready's illustrations for children's books in his Account Book (1806) includes "1 Old Gaspar 6" followed by "1 Dᵒ[Ditto] Oil 12g" which suggests that the first was a drawing. If so, it was an unusually expensive drawing, for his finished oils were then generally selling for 6–8 guineas. The "Miss Sparrow" and "Lady Acheson" who appear as buyers of both compositions in Mulready's Account Book are the same person. Upon marriage in 1805 Miss Sparrow became Lady Acheson; she took the title of Countess of Gosford in 1807.

15 Still-life: Pitcher and Bottle Sketch *c.* 1806
3½ × 3
Location unknown
Exh. 1864 (11)
Prov. Wilson Lowry, the engraver; by 1864, Joseph Wilson Lowry
Ref. Account Book 1806 "Study Pitcher & Bottle Lowry 1.1"

16 Hampstead Heath Sketch 1806 (Plate 33)
Millboard, 5½ × 10
Signed and dated W M 1806, lower right
Victoria and Albert Museum, Sheepshanks Collection (F.A. 155)
Exh. 1864 (5)
Prov. John Sheepshanks
Ref. Stephens (List) mentions only two Hampstead Heath paintings in the Sheepshanks Collection; in fact there are three.

17 Hampstead Heath Sketch 1806 (Plate 34)
Millboard, 6½ × 10¼
Signed and dated W M 1806, lower right
Victoria and Albert Museum, Sheepshanks Collection (F.A. 153)
Exh. 1864 (8); Arts Council, *English Romantic Art*, 1947 (54); 1964 (1); 1971 (81)
Ref. Stephens, List

18 Hampstead Heath Sketch 1806 (Plate 35)
Millboard, 6 × 10¼
Signed and dated W. Mulready 1806, lower left
Victoria and Albert Museum, Sheepshanks Collection (F.A. 161)
Exh. 1864 (6)
Prov. John Sheepshanks

19 Hampstead Heath Sketch *c.* 1806
Location unknown
Prov. Possibly John Jeffries Stone, his sale, Christie's, 7 June 1880 (37), bt. Polak; . . . Mr. Thomas Woolner in 1890
Ref. Stephens, Addit. List

170. *Cottages on the Coast* 1806. Oil on millboard, 6½ × 8½. Victoria and Albert Museum, London (Crown Copyright) (cat. 20)

20 Cottages on the Coast Sketch 1806 (Plate 170)
Millboard, 6½ × 8½
Signed and dated W M 1806, lower right

Victoria and Albert Museum, Sheepshanks Collection (F.A.
 162)
Exh. 1864 (7)
Prov. John Sheepshanks
Ref. Stephens, List

21 Old Houses *c.* 1806
Location unknown
Ref: Account Book 1806 "Old Houses WhiteChapple 6.6"
Perhaps "WhiteChapple" is not the buyer but is instead the
East London area of Whitechapel.

22 Cottage Carnarvon (Carnaervon?) *c.* 1806
Location unknown
Exh. R.A. 1807 (probably 146)
Prov. John Henderson, his sale, Sotheby's, 18 Feb. 1830
 (608, "A small landscape with cottage"), bt Quelch (?)
Ref. Account Book, 1806 D⁰[Cottage] Carnarvon Hender-
 son 8.8"; Cole MS. identifies this painting with the
 Cottage and Figures, R.A. 1807 (146) which had been in
 the possession of a Mr Henderson, Dentist of Charlotte
 St., Fitzroy Square (Mulready lived on Fitzroy Square in
 1806–7).
This may be cat. 25.

23 A View in St. Albans 1806
Millboard, or panel?, 16¼ × 12¼
Location unknown
Exh. R.A. 1807 (136); B.I. 1808 (474); 1848 (XI, "Painted in
 1806"); 1864 (10)
Prov. Thomas Hope; by descent to Lord Francis Pelham
 Clinton Hope, his sale, Christie's, 20 July 1917 (15,
 "Views at St. Albans, A Street Scene"), bt Peacock
Related works Pencil and wash drawing of St. Albans,
 Victoria and Albert Museum (6053), illus. Rorimer 50;
 and a pencil drawing, signed and dated 1805, Collection
 Professor and Mrs I. R. C. Batchelor (Plate 53)
Ref. Account Book 1807 "St Albans T. Hope 21"; and 1813
 "Thos Hope Retˢ [retouches] 2 Pictures 10"; *Annals of
 the Fine Arts*, IV, 1819 (Catalogue of the Works of
 English Artists, in the Collection of Thomas Hope, Esq.),
 p. 96; Rorimer, p. 42; Stephens, List, p. 46 and below
Stephens, p. 89: "Above the houses rises the square tower
of the church that was built of Roman bricks removed from
the neighboring Verulamium; the whole, despite a fitful
gleam of moonlight, is gray with clouds."
According to his Account Book Mulready retouched this
painting in 1813.

24 Cottage and Figures *c.* 1806–7 (Plate 47)
Paper mounted on board, 15⅝ × 13⅛
Tate Gallery (T. 1746)
Exh. R.A. 1807 (probably 149)
Prov.; Charles Meigh, his sale, Christie's, 21 June 1850
 (83, "A Picturesque cottage on the bank of a river with a
 group of children"), bt James Lenox of New York; New
 York Public Library (Lenox Collection), 1895, probably
 sold to Coleman Galleries in 1943; . . .; Sotheby's, 4

April 1973 (169), bt Colnaghi; from whom purchased by
the museum
*Ref. James Lenox Library; A Guide to the Paintings and
 Sculptures exhibited to the public*, N.Y., 1897 as "A
 Picturesque Cottage on the bank of a river, bought
 Christie's, 21 June 1850 from Charles Meigh"; *Tate
 Gallery Biennial Report*, 1972–4, p. 63
The tower of St Albans Abbey appears in the distance. This
painting is probably one of the *Cottage and Figures* oils
bought by Ogilvie (cat. nos. 29, 30).

25 Cottage and Figures *c.* 1806–7 (Plate 44)
Paper mounted on board, 16 × 19¾
Collection David and Kathryn Heleniak
Prov.; Thomas Woolner, R.A., his sale, Christie's, 12
 June 1875 (56, "A Cottage and figures: girl at well"), bt
 in; and Christie's, 18 May 1895 (108, "Landscape with
 cottage and girl at well"), bt Debb; . . .; A. Malim, his
 sale, Sotheby's 26 March 1975 (42), Martyn Gregory,
 thence to present owners
Ref. Stephens, Addit. List
This painting shows evidence of very early, tiny retouch-
ings. Mulready frequently retouched his early oils; see for
example, the Ogilvie and Hope cottage scenes (cat. nos. 23,
29, 30, 32). This may be one of the Ogilvie *Cottage and
Figures* paintings (cat. nos. 29, 30) or the Henderson work
(cat. 22).

26 Landscape *c.* 1806–10
Location unknown
Ref. Stephens, Addit. List "a small early landscape, in oil, is
 in the possession of Mr. Linnell".
This work was not included in the sale of John Linnell's
property by his descendants (Christie's, 15 March 1918).
Perhaps it has since been mistakenly identified as an early
work by Linnell.

27 Still-life: Bottle and Earthenware Bowl 1807
Panel, 4¼ × 3⅛
Signed and dated 1807
Location unknown
Exh. 1864 (12, property of Richard Ansdell, A.R.A.)
Related works Probably an oil study for *The Rattle* (cat. 37)
Ref. Stephens, p. 90 "[This still-life] comprised [of] two
 glass bottles and a red earthenware bowl, is a gem of the
 most exquisite quality, equal in all respects to the finest
 Teniers."

28 Still-Life Earthenware jug, potatoes, etc. 1807
Panel, 4⅞ × 4¼
Signed and dated 1807
Location unknown
Exh. 1864 (13)
Prov. By 1864, Henry McConnel, his sale Christie's, 27
 March 1886 (38), bt Agnew, thence to T. Woolner
Related works Probably an oil study for *The Rattle* (cat. 37)
Ref. Stephens, Addit. List

29 Cottage and Figures *c.* 1807
Location unknown
Exh. R.A. 1807 (149)?
Ref. Account Book 1807 "June 13 Cottage & Figures Ogilvie
 12.12"
A note in the Account Book 1809 & 10 probably refers to this
painting: "Retouch^d two Pictures D^o[Ogilvie] 5". This
painting may be cat. 24 or cat. 25.

30 Cottage and Figures *c.* 1807
Location unknown
Exh. R.A. 1807 (149)?
Ref. Account Book 1807 "D^o[Cottage & Figures]
 D^o[Ogilvie] D^o[12.12]"
A note in the Account Book 1809 & 10 probably refers to this
painting: "Retouch^d two Pictures D^o[Ogilvie] 5". This
painting may be cat. 24 or cat. 25.

31 Eton *c.* 1807
Canvas, 14¼ × 19½
Location unknown
Exh. R.A. 1872 (39)
Prov. John Henderson; probably S. Mendel; Christie's, 22
 Sept. 1873, bt Agnew, thence to Charles Skipper, his sale,
 Christie's 24 May 1884 (84), bt Agnew, thence to John
 Fowler; Agnew to F. Fish 1885, his sale, Christie's, 24
 March 1888 (278), bt Agnew, thence to F.A. Beer, Mrs
 Rachel Beer, her sale, Christie's, 22 July 1927, bt
 Permain; Christie's, 14 March 1930, bt Wyatt
Related works Several pencil drawings and one black and
 white chalk drawing of Eton and Windsor, some dated
 1805, Victoria and Albert Museum, Rorimer 124–33, 137
 (some illus.) are probably related to this painting; several
 drawings appeared 1864 (121, 122). See Plate 46.
Ref. Account Book 1807 "May 1 Eton Henderson 9"; Al-
 pheus, Addit. List mentions several river scenes without
 titles or dimensions.
The Christie's sale, 1884, describes this painting as "An
English Landscape, with cottages near a pond and three
children with a boat".

32 Old Houses in Lambeth *c.* 1807
Panel, 16⅛ × 13
Location unknown
Exh. B.I. 1808 (472, "Old Houses"); 1848 (XIII, in-
 correctly dated 1808); 1864 (16)
Prov. Thomas Hope, by descent to Lord Francis Pelham
 Clinton Hope, his sale, Christie's, 20 July 1917 (15,
 "Views at St. Albans, A Courtyard of an inn, with
 figures"), bt Peacock
Ref. Account Book 1807 "Westminster D^o[T. Hope] 31",
 and 1813 "Tho^s Hope Ret^s [Retouches] 2 Pictures 10";
 Annals of the Fine Arts, IV, 1819 (Catalogue of the Works
 of English Artists, in the Collection of Thomas Hope,
 Esq.), p. 96; Stephens, p. 75; see Ch. VI, n. 4 for
 Westmacott description
Mulready retouched this painting in 1813 (Account Book).

33 Sketch of a Gravel Pit *c.* 1807–8
Panel, 8½ × 7
Location unknown
Exh. 1864 (18, property of John Jeffries Stone, Esq.)
This could be "Hampstead Heath", sold property of J. J.
Stone, Christie's, 7 June 1880 (37), but see cat. 19. No
"Gravel Pit" was sold in Stone's sale.

34 A Gravel Pit *c.* 1807–8 (Plate 66)
Canvas, 15 × 12½
Private Collection
Exh. R.A. 1848 (125, "Painted from nature in 1807 or 1808");
 1864 (17); 1964 (3)
Prov. Thomas Baring, by descent to current owner
Ref. Account Book 1809 & 1810 "Gravel Pit given to
 Gouldsmith"; and in Mulready's Abstract of Expendi-
 ture, Account Book 1827 "Picture of Gravel Pit 21" (Did
 he buy it back?); Account Book 1848 "Sep 15 Baring
 Gravel Pit 135"; MS. Catalogue of the Baring Collection
 "Sand-pit 1848 £135"; Cole MS. places the gravel pit "in
 Russell Square"; S. C. Hall (*Retrospect of a Long Life. . .*,
 N.Y., 1883, p. 430) claims that not this painting but yet
 another "gravel pit" picture depicts Russell Square;
 Stephens, List; for discussion and the *Art Union's*
 comments, see Ch. II, n. 87; for Ruskin's, Ch. II, n. 88.
Mulready may have done three "gravel pit" paintings. His

171. *Landscape, A Cottage with Trees and Two Children*
c. 1807–10. Oil on millboard, 13 × 10½. Victoria and Albert
Museum, London (Crown Copyright) (cat. 35)

Account Book notes that he gave one to Gouldsmith, probably his friend and student Harriet Gouldsmith, in 1809–10. In 1827 Mulready expended 21 pounds to buy back a "gravel pit". Was this the Gouldsmith painting or perhaps another oil? Was this the same painting that later entered the Baring Collection in 1848? One cannot be sure.

35 Landscape, A Cottage with Trees and Two Children *c.* 1807–10 (Plate 171)
Millboard, 13 × 10½
Victoria and Albert Museum, Sheepshanks Collection (F.A. 160)
Exh. 1864 (26)
Prov. John Sheepshanks

172. Sketch for *The Rattle* 1807. Oil on panel, 4⅛ × 3⅞. Victoria and Albert Museum, London (Crown Copyright) (cat. 36)

36 The Rattle Sketch 1807 (Plate 172)
Panel, 4⅛ × 3⅞
Victoria and Albert Museum, Sheepshanks Collection (F.A. 156)
Exh. 1848 (LXIII, "Painted in 1807"); 1864 (14)
Prov. John Sheepshanks
Related works Cat. 37
Ref. Cole MS. "Sketches in oil—Rattle"; Rorimer, p. 42; Stephens, Addit. List—"sold at Christie's", he must be mistaken (or perhaps he was referring to cat. nos. 27 and 28).

37 The Rattle 1808 (Color Plate I)
Canvas laid on panel, 14¾ × 13¼
Signed and dated W. MULREADY 1808, lower right
Tate Gallery (T. 1899)
Exh. B.I. 1808 (93); 1848 (LVI); 1864 (15)
Prov. Capt. Felix Agar; Joseph Gillot, his sale, Christie's, 27 April 1872 (265), bt Agnew, thence to H. W. F. Bolckow, his sale, Christie's, 2 May 1891 (88), bt Agnew; . . . ; Spink & Son, Ltd, London, 1974, bt Tate Gallery
Related works Oil sketch (cat. 36), pencil study, Victoria and Albert Museum (6022). Cat. nos. 27, 28 (both now lost) were probably oil studies for this painting.
Ref. Account Book 1808 "Sunday 27 Dec. 1807. began Rattle. Fin Jan 8. 1808 Capt Agar 31.10"; Cole MS. "bought by Sir Felix Agar, Bart."; Redgrave, II, p. 300; Rorimer, pp. 8, 42; Stephens, List and pp. 46, 48, 81, 90

38 A Girl at Work *c.* 1808
Panel, 12 × 8½
Location unknown
Exh. R.A. 1808 (25)
Prov. Mr M. Hoare (?) for loan; Cole MS. placed it in the collection of Sir H. Bunbury, 1848, his sale, Christie's, 15 June 1901 (13, "The Young Seamstress"), bt in
Related works The watercolor and chalk drawing of "A Lady Sewing", Eton College (Plate 73) may very well be a study for this lost painting.
Ref. Account Book 1808 "A Girl at Work Dº[refused by M. M. Hoare] given for the Loan of 25 for a month."

39 The Dead Hare *c.* 1808
Location unknown (probably destroyed)
Exh. R.A. 1808 (23)
Ref. Cole MS. list this work as "destroyed"; the 1864 catalogue states that "This picture is believed not now to be in existence"; Stephens, List

40 Endymion *c.* 1808
Location unknown
Related works Cat. 41
Ref. Account Book 1808 "Endymion refused by Mr. M. Hoare"

41 Endymion *c.* 1808
Location unknown
Related works Cat. 40
Ref. Account Book 1808 Dº[Endymion] small Dº[refused by Mr. M. Hoare]

42 A Carpenter's Shop and Kitchen 1808 (Plate 72)
Canvas, 38½ × 29½
Location unknown
Exh. B.I. 1809 (91); 1848 (XXIX); 1862 (304); 1864 (19)
Prov. Lady Swinburne, Miss Julia Swinburne, her sale, Christie's, 8 July 1893 (52), bt O'Brien; Christie's, 20 June 1896 (91), bt Gooden; Christie's, 26 May 1900 (108), bt Sampson; C. F. Southgate, his sale, Christie's,

24 Jan. 1913 (139), bt Vicars; Christie's, 5 Nov. 1954 (30), bt Greene

Related works Pencil sketch, Victoria and Albert Museum (6020), illus. Rorimer 52

Ref. Account Book 1808 "Carpenter Shop. Ly Swinburne in 1812."; Cunningham, *Wilkie*, I, p. 222; Farington (see Ch.I, n. 149); Redgrave, II, pp. 301–304; Rorimer, p. 43; Stephens, List and pp. 49, 57–60, 75, 90

The Examiner, 1809, p. 46; "Mr. Mulready has surpassed all his former productions in his picture of the Carpenter's Shop. It has all the finish and identity of object so requisite in this class of painting and perfect perspective, with brilliancy of effect; but though his 'Carpenter' is well enough, yet there is a clumsiness of form, and deficiency of character in the female, the reverse of which is looked for from her being the principal object."

Art Journal, 1864, p. 131: "With some alterations which he might deem necessary, the head of the carpenter seems to be a study from himself, and the carpenter's wife appears to have been painted from his own wife. . ."

43 The Wedding Morning Sketch *c.* 1808, or possibly the mid-1820s (Plate 123)

Panel, $6\frac{5}{8} \times 7\frac{5}{8}$

Port Sunlight, Lady Lever Art Gallery

Prov. . . . ; Thomas Woolner, his sale, Christie's, 12 June 1875 (68), bt Goupil (?); James Orrock; bt from Orrock by Goodin & Fox 1907 for Lord Leverhulme, thence to gallery

Related works Two pen and sepia wash drawings, Victoria and Albert Museum (6051, 6052), illus. Rorimer 333–4 (see Pl. 122) but not associated by Rorimer with this oil

Ref. Illus. in color, "The Royal Academy from Reynolds to Millais", *The Studio*, Summer 1904

This small panel appears to be an oil sketch for a painting never undertaken by Mulready.

44 Chatham Sketch 1808

Location unknown

Prov. David Wilkie

Related works Chalk sketches of Chatham, dated 1808 appeared 1848 (CXXXVI, CLXIV) and 1864 (128); also a drawing, *Cottage at Chatham*, signed and dated 1808, in 1864 (130)

Ref. Account Book 1808 "July with Linnell to Chatham. 3 or 4 carefull sketches one in oil D. Wilkie."; it did not appear in the Wilkie sale, Christie's, 3 May 1842

Perhaps this is *A Coast Scene* (cat. 45), or *A Sea Shore* (Cat. 52). Chatham is on the sea.

45 A Coast Scene *c.* 1808 (?)

Location unknown

Exh. (?) R.A. 1872 (250, "Scene on the Thames, 14 × 12, property of Thos. Woolner, A.R.A.")

Prov. . . . ; Thomas Woolner, his sale, Sotheby's, 12 March 1913 (102)

Ref. Stephens, Addit. List

This may be *Chatham* (cat. 44).

46 Returning from the Ale House or **Fair Time** *c.* 1808–9 and *c.* 1840 (Plate 78)

Canvas, $31\frac{7}{8} \times 27\frac{1}{8}$

Tate Gallery, Vernon Collection (394)

Exh. R.A. 1809 (148, "Returning from the Ale House"); R.A. 1840 (116, with a new background as "Fair Time"); 1864 (82); 1964 (5)

Prov. Robert Vernon

Related works Engraving by H. Bourne; an enamelled miniature after the painting by G. Gray, R.A. 1857 (662)

Ref. Account Book 1840 "Jan 6 Vernon 100 Feb 7 100 May 16 100 Oct 5 120 Returning from the Fair 420"; Cole MS. "background painted in 1817"; for *Ackermann's Repository of Arts. . .* (p. 82); *Art Union*, 1840, p. 74; Stephens, List and pp. 62, 64

W. M. Thackeray as M. A. Titmarsh in *Fraser's Magazine*, June 1840, p. 726: "[comments on the] gaudy, prismatic colours. . . But, for consistency's sake, a protest must be put in against the colour; it is pleasant, but wrong; we never saw it in nature."

The background of this painting was repainted and the figures were touched up before it was exhibited again in 1840 with a new title. The Cole MS. suggests that the repainting took place in 1817. In the light of the brilliant color employed on the figures, and the treatment of the sky and trees, this early date seems unlikely. It was probably repainted shortly before its second exhibition in 1840, and was purchased by Robert Vernon that same year.

47 Supper at Emmaus *c.* 1808

Location unknown

Related works Cat. 48

Ref. Account Book 1808 "Supper a Emmaus Shutz 20"

48 Supper at Emmaus 1809

Millboard, $17\frac{3}{4} \times 23\frac{3}{4}$

Location unknown

Exh. 1864 (112*, "Painted in 1809")

Prov. Artist's Sale (505), bt Cox

Related works Cat. 47

Ref. Redgrave, II, pp. 229–30

Stephens, p. 48: "it was a very dingy and unsatisfactory instance".

49 Still-life: Utensils and Vegetables 1809

Millboard, $5\frac{1}{8} \times 5\frac{1}{2}$

Signed and dated W M 1809

Location unknown, formerly Victoria and Albert Museum

Exh. 1848 (IX); 1864 (20)

Prov. John Sheepshanks, Victoria and Albert Museum (F.A. 154), stolen from the museum in the 1950s, never recovered

Ref. Stephens, List

It was described in 1864 (20) as: "A small highly finished study of a stone bottle, a glass bottle, earthen pan, etc."

50 Harry Sumpter Sketch 1809

Panel, $6\frac{3}{4} \times 5\frac{3}{8}$

Location unknown
Exh. 1848 (LXV, "Painted in 1809"); 1864 (23)
Prov. Mulready's executors
Ref. Cole MS. "Sketches in oil—Portraits H. Sumpter.";
 Stephens (Addit. List) identifies Sumpter as a painter of
 still-life exhibiting 1816–47.

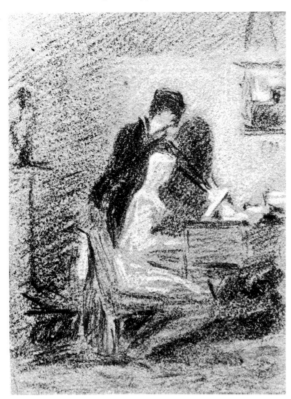

173. Frances E. Swinburne after Mulready's study for *The
Music Lesson* Black and white chalk, $4\frac{7}{8} \times 3\frac{1}{2}$. Capheaton
Collection

51 A Music Lesson 1809
Canvas on panel, $15\frac{1}{4} \times 12$
Private Collection
Exh. R.A. 1851 (168, "Painted in 1809"); 1864 (24)
Prov. John Jeffries Stone, his sale, Christie's, 7 June 1880
 (36), bt M.S.
Related works Black and white chalk drawing by Mulready's
pupil Frances E. Swinburne, after Mulready's sketch for
The Music Lesson (Plate 173) in the Capheaton Collection;
two drawings appeared 1864 (131, 132)
Ref. Cole MS. "Music Master 1810 Stone," and again
 "Music Master Stone 1809"; W. E. Fredeman, *The
 P.R.B. Journal*, Oxford, 1975, p. 91; Ruskin, *Works*,
 XII, p. 322; Stephens, List and p. 62.
In 1864 (24) it was described: "A gentleman (portrait of the
artist himself) stands beside the chair of a young and
beautiful lady who is seated at an open piano." Marcia

Pointon will be publishing an article on this painting, which
she located recently in a private collection.

174. *A Sea Shore* 1809. Oil on canvas, $14\frac{3}{4} \times 19\frac{3}{4}$. Tate
Gallery. London (cat. 52)

52 A Sea Shore 1809 (Plate 174)
Canvas, $14\frac{3}{4} \times 19\frac{3}{4}$
Signed and dated 1809 on the sail of the boat (no longer
 visible)
Tate Gallery (1181)
Exh. 1864 (102)
Prov. ...; by 1864, George Vaughan, presumably by
 descent to Mrs E. Vaughan, by whom bequeathed to the
 museum in 1885
Ref. (?) Possibly Account Book 1808 "July with Linnell to
 Chatham. 3 or 4 carefull sketches one in oil D. Wilkie."
 (Chatham is on the sea.)
This may be *Chatham* (cat. 44).

53 An Old Gable 1809 (Plate 56)
Panel, $16\frac{3}{4} \times 13\frac{1}{8}$
Signed and dated W M 1809, lower right
Yale Center for British Art, Paul Mellon Collection (2518)
Exh. R.A. 1811 (131 or 248, "Cottage and Figures"); 1848
 (XXXV, "Exhibited in the Royal Academy in 1811");
 1864 (21); R.A. 1890 (33); Burlington Fine Arts Club
 1933 (38); R.A. 1951–2 (229); Arts Council, *Early English
 Landscapes from Col. Grant's Collection*, 1952–3 (37)
Prov. Thomas Welsh; by 1848, John Gibbons; Mrs
 Gibbons; Revd B. Gibbons; sale of John Gibbons'
 property, Christie's, 26 May 1894 (41), bt Colnaghi; Mrs
 Burns; Christie's, 19 Dec. 1919 (140), bt Col. M. H.
 Grant; by 1966, Oscar and Peter Johnson, thence to Mr
 and Mrs Paul Mellon, who presented it to the museum
Related works Pencil drawing (Plate 55), Victoria and Albert
 Museum; engraving by Freebairn in the *Book of Gems*,
 1853
Ref. Account Book 1809 & 10 "Cottage & Figures T. Welsh
 17"; Grant, II, p. 286; Stephens, p. 62

54 Heston 1809
Panel, 13 × 16¾
Signed and dated 1809
Location unknown
Exh. 1848 (LVIII, property of Newman Smith, Esq.); 1864 (22, property of Mrs Newman Smith)
Related works Chalk drawing, dated 1808, appeared 1848 (CLXIII), 1864 (129); see cat. nos. 55–7, 63
Ref. Account Book 1809 & 10 (There are four works entitled "Heston"; one sold to Horsley [cat. 63, *Boys Playing Cricket*]; one sold to Ogilvie; two sold to A. Davison); Stephens, List
Heston was described in 1864 (2) as: "A cottage, with boys playing outside. A horse is looking over the gate."
This painting is probably one of the "Heston" works originally sold to Ogilvie or Davison (cat. nos. 55–7). A painting entitled *Cottage at Hendon*, 17 × 13, was exhibited at the Royal Academy 1877 (3), property of Mrs Newman Smith and may be this work; perhaps the same painting which was later exhibited R.A. 1888 (5, "Cottage near Hendon"), then the property of Mrs Ross.

55 Heston *c.* 1809–10
Location unknown
Related works Cat. nos. 54, 56–7, 63
Ref. Account Book 1809 & 1810 "Heston Ogilvie 25"

56–7 (2) Heston *c.* 1809–10
Location unknown
Related works Cat. nos. 54–55, 63
Ref. Account Book 1809 & 1810 "2 Dᵒ[Heston] A Davison 60"

58 Conversation *c.* 1809–10
Location unknown
Ref. Account Book 1809 & 1810 "Conversation C. F. Williams 20"; Redgrave, II, p. 247 mentions a painting entitled "Village Gossips" which may refer to this work.
Perhaps this is *A Snow Scene* (cat. 197), a village scene with a group of figures talking in the foreground.

59 A Shepherd Boy and Dog *c.* 1809–10
Millboard, 8¼ × 6⅜
Location unknown
Exh. R.A. 1848 (130); 1864 (25)
Prov. C. F. Williams; by 1864, John Jeffries Stone, his sale, Christie's, 7 June 1880 (33), bt Joy (?)
Related works Watercolor entitled *Sleeping Lad with Hound*, formerly Haldimand Collection, in the collection of Sir Ralph and Lady Clarke, 1965 (ref. Sydney H. Paviere, *Dictionary of British Sporting Painters*, Leigh-on-Sea, 1965) may be related to this oil painting; a drawing appeared 1864 (132)
Ref. Account Book 1809 & 1810 "Boy & Dog Dᵒ[C. F. Williams] 10"; Cole MS. "Shepherd—Stone"
It was described in 1864 (25): "The shepherd boy is leaning forward seemingly asleep, at his feet lies his dog"; and by the *Art Union*, 1848, p. 168: "The effect is evening, and the sweetness of this diminutive picture consists in its subdued manner of treatment."
Mulready seems to have bought back this painting. (sold to C. F. Williams in 1809/10) sometime before it was exhibited at the R.A. in 1848, it was then probably given to his friend John Jeffries Stone, the recipient of several of his paintings.

60 Horses Baiting 1809–10 (Plate 57)
Panel, 13 × 16⅛
Location unknown
Exh. R.A. 1811 (? 246, "Horses Baiting"); 1848 (I, "Roadside Inn with Haycart and Horses Baiting, Painted in 1810 . . . Exhibited in the Royal Academy in 1811"); 1864 (30, "Roadside Inn, with Hay Cart and Horses Baiting"); R.A. 1890 (34)
Prov. Thomas Welsh; by 1848, John Gibbons, Mrs Gibbons, Revd B. Gibbons, sale of John Gibbons' property, Christie's, 26 May 1894 (43), bt Agnew, thence to Boussod Valadon & Cie, Paris; Buchanan Collection, Parke-Bernet, 28 Feb/1 March 1945 (187, "Loading the Cart"), bt Henry Jordan
Related works Cat. 61; pen, ink and pencil drawing, Victoria and Albert Museum (6034), Plate 58
Ref. Account Book 1809 & 1810 "Cottages & Figures T. Welsh 17"; Stephens, List and p. 62 as "Roadside Inn"
The exhibition record for this painting may be confused with cat. 62.

61 Horses Baiting 1810 (Plate 59)
Panel, 15¾ × 13
Signed and dated W M 1810, lower right
Whitworth Art Gallery, University of Manchester
Exh. 1848 (X); 1864 (28)
Prov. Thomas Lister Parker; Mr Acraman Bristol; Mr R. Colls; by 1848, Joseph Gillot, his sale, Christie's, 27 April 1872 (266), bt Agnew, thence to J. C. Harter, his sale, Christie's, 26 April 1890 (49), bt Agnew, thence to George Holt; by 1891, Agnew, thence to Miss Woodcock, bequeathed to the museum in 1910 with the Kay-Cox Collection (formed by Alice Woodcock, her first husband Frederick Kay, and her second husband George Ferdinand Cox)
Related works Cat. 60; pen, ink and pencil drawing, Victoria and Albert Museum (6034), Plate 58
Ref. Account Book 1809 & 1810 "Horses Baiting T. L. Parker 31.10"; Cole MS. "A repetition of this picture or similar subject [Horses Baiting R.A. 1811] Figures only was purchased by Mr. Colls, at the sale of Acraman Bristol. painted for Thomas Lister Parker—Gillot"; Rorimer, p. 43; Stephens, Addit. List

62 Horses Baiting 1810 (Plate 60)
Panel, 16 × 12¾
Signed and dated 1810
Location unknown
Exh. 1848 (LVII, "Cottage and Figures loading the Cart. . . . Never exhibited", incorrectly dated 1809 (?)); 1864 (29); R.A. 1890 (28)

Prov. Leader; by 1848, John Gibbons, Mrs Gibbons, Revd
B. Gibbons, sale of John Gibbons' property, Christie's,
26 May 1894 (42), bt Agnew, thence to Wallis & Co.;
C. A. Barton, his sale, Christie's, 3 May 1902 (38, as "The
Roadside Inn, with a waggon and figures"), bt Gooden;
J. D. Charrington, his sale, Christie's, 9 June 1911 (49, as
"The Roadside Inn, with a haycart and figures"), bt Ellis
Ref. Account Book, 1809 & 1810 "Horses Baiting Leader
60"; Stephens, List as "Cottage, with Figures loading a
Cart"
The price probably indicates two paintings of the same
subject for Leader; perhaps the second painting was
exhibited as a *Cottage with Figures*, R.A. 1811, cat. 66. The
exhibition record for this painting may be confused with
cat. 60.

63 Boys Playing Cricket 1810
Panel, $13\frac{1}{2} \times 18\frac{3}{8}$
Location unknown
Exh. R.A. 1813 (73); 1848 (XXXIV, "Painted in 1810");
1864 (31)
Prov. William Horsley; by 1864, Mrs Gibbons
Related works Cat. nos. 54–7
Ref. Account Book 1809 & 1810 "Heston Horsley 31.10";
Cole MS. "painted in 1810"; Stephens, List
Athenaeum, 10 June 1848, p. 584: "the old and picturesque
grey trunk of the tree which traverses the foreground [is]
marvelously wrought."
Perhaps cat. 183 is an oil sketch for this painting.

64 Copy from J. Varley *c.* 1809–10
Location unknown
Ref. Account Book, 1809 & 1810 "Copy from J. Varley
D°[T. Welsh] 20"
This may be *A Gypsey Encampment* (cat. 67).

65 Landscape with Cottage *c.* 1810 (Plate 175)
Coach panel, $8\frac{3}{4} \times 7\frac{1}{2}$
Victoria and Albert Museum, Sheepshanks Collection (F.A.
157)
Exh. 1864 (37)
Prov. John Sheepshanks
This work is seriously cracked.

66 Cottage with Figures *c.* 1809–10
Location unknown
Exh. R.A. 1811 (131 or 248)
Ref. The Account Book 1809 & 1810 cites a "Horses Baiting
Leader 60", a price which suggests two paintings; cat. 62
represents one painting, perhaps the other was exhibited
under the title "Cottage with Figures" at the Royal
Academy in 1811.

67 A Gypsey Encampment 1810 (Plate 68)
Canvas, $12\frac{1}{2} \times 15\frac{1}{2}$
National Gallery of Ireland (963)
Exh. 1848 (XLII, "Gipsies. Painted in 1810 for Thomas
Welsh"); 1864 (27)

175. *Landscape with Cottage c.* 1810. Oil on coach panel,
$8\frac{3}{4} \times 7\frac{1}{2}$. Victoria and Albert Museum, London (Crown
Copyright) (cat. 65)

Prov. Thomas Welsh; by 1848, John Gibbons, Mrs
Gibbons, Revd B. Gibbons, sale of John Gibbons'
property, Christie's, 26 May 1894 (44), bt Agnew, thence
to Boussod Valadon & Cie; Agnew in 1895; Lord Ronald
Sutherland Gower, his sale, Christie's, 28 Jan. 1911 (54,
"landscapes, with gipsies on panel 2 [?]"), bt Sergeant &
Fisher; Christie's, 21 July 1913 (131), bt Evans; B.
Capper, his sale, Christie's, 17 Nov. 1933 (25), bt Thomas
Bodkin, who presented it to the museum
Ref. (?) Account Book 1809 & 1810 "Copy from J. Varley
D°[T. Welsh] 20"; Cole MS. "1810 Gipsies Gibbons";
Stephens, p. 62
In Mulready's Account Book T. Welsh is listed as having
purchased three paintings: two "Cottage & Figures", both
of which also entered the John Gibbons Collection (cat. nos.
53, 60) and a "Copy from J. Varley" (cat. 64). This may
possibly be the latter, although I have seen no Varley work
that corresponds with this painting.

68 Landscape with Cottages *c.* 1810–12 (Plate 45)
Panel, $14 \times 17\frac{1}{2}$
Victoria and Albert Museum, Sheepshanks Collection (F.A.
158)
Exh. 1864 (38)
Prov. John Sheepshanks

69 A Cottage Sketch Before 1811
Millboard, $10\frac{3}{8} \times 8\frac{3}{8}$
Location unknown
Exh. 1864 (103)
Prov. Artist's Sale (484), bt Crofts

70 Lady Gosford's Children 1810–11
Location unknown
Ref. Account Book 1809 & 1810 "Ly Gosfords Portraits nearly finished"; and 1811 "Jan 23 Lady Gosford 3 Portraits 31.10"; Cole MS. under "Portraits—Ly Gosfords children"
There may be three separate portraits rather than this one painting. There are no paintings attributed to Mulready in Lord Gosford's collection today. Several members of the Gosford family were Mulready's pupils.

71 Portrait of Sir F. Ford's Mother *c.* 1810–11
Location unknown
Ref. Account Book 1811 "Feb. 19 Sir F. Ford Portrait of his Mother 8.8"; Cole MS. under "Portraits—Lady Ford"

72 Portrait of Three Love Sisters *c.* 1811
Location unknown
Ref. Account Book 1811 "March 16 Love Portraits of 3 Daughters 21"; Cole MS. under "Portraits—Children of Love"
There may be three separate portraits.

73–4 (2) Portraits of Lady O. B. Sparrow (?) *c.* 1811
Location unknown
Ref. Account Book 1811 "Lady O. B. Sparrow 2 Portraits 31.10"
These portraits may be for Lady Sparrow rather than portraits of her. Members of the Sparrow family studied with Mulready.

75 The Barber's Shop 1811
Canvas laid on panel (?), 40 × 30
Location unknown
Exh. R.A. 1811 (229); 1848 (XXIII); 1857 (347); 1864 (35)
Prov. Lord Ducie; by 1857, Richard Hemming, his sale, Christie's, 28 April 1894 (78), bt Polak
Related works Pen and ink drawing, dated 4 March 1811, Whitworth Art Gallery, University of Manchester (D.95.1895); six drawings (two dated 13 March 1811), Victoria and Albert Museum, illus. Rorimer 54–7 (Plate 80); several sketches appeared 1848 (CXLIII), 1864 (136–9). Mulready did a great number of sketches for this painting; 32 drawings were sold under just one lot number in the Artist's Sale (290), bt. Agnew.
Ref. Account Book 1811 "July 13 Lord Ducie. Barber Shop 84"; Redgrave, II, pp. 304–6; Rorimer, pp. 44–5 quoting *Art Union*, 1848; Stephens, List and pp. 49, 59, 64

76 A Kitchen Fire 1811
Panel, $8 \times 6\frac{1}{4}$
Signed and dated 1811
Private Collection
Exh. 1848 (LIII); 1864 (32)
Prov. J. Smith; Ridley Colborne (later Lord Colborne); by 1864, his daughter the Hon. Mrs Gurdon, by descent to current owner
Ref. Account Book 1811 "Feb 11 Smith Kitchen Fire 7.7"; Cole MS. has jottings which may refer to this painting or to *A Girl and Kitten* (cat. 77): "painted in 1811 sold for 6£. J. Varley sold to J. Smith—R. Colborne 12 gns. shewn at Sir J. Swinburne—sent to Br. Inst. but rejected. Ld Stafford wanted to buy—refused. It is possessed Ld Colborne"; Stephens, List
It was described in 1864 (32) as: "A dog asleep before a kitchen fire. A kettle and pan are on the fire, and on the shelf above a bowl, bottles, candlestick, etc." The painting is now very dark.

77 A Girl and Kitten 1811
Panel, $8 \times 6\frac{1}{2}$
Location unknown
Exh. 1848 (LIV, "Painted in 1811"); 1864 (33)
Prov. Ridley Colborne (later Lord Colborne); by 1864, his daughter the Hon. Mrs Gurdon
Ref. Account Book 1812 "Mr R Colborne Girl & Kitten 12.12"; Cole MS., see cat. 76; Stephens, List
It was described in 1864 (33) as: "A child, half undressed, seated on a low stool, . . . giving some milk to a kitten on the top of a barrel".

78 The Mall, Kensington Gravel Pits 1811–12 (Color Plate II and Plate 62)
Canvas, $14 \times 19\frac{1}{4}$
Victoria and Albert Museum, Sheepshanks Collection (F.A. 136)
Exh. R.A. 1844 (330, "Painted in 1811"); 1848 (XXV, "Painted in 1812"); 1864 (34); R.A. 1951–2 (228); 1964 (6); Philadelphia Museum of Art 1968 (147); Colnaghi's, *John Linnell and his Circle*, 1973 (122); Tate Gallery, *Landscape in Britain*, 1973 (240)
Prov. Mr J. (?) Welbank; by 1843, John Sheepshanks
Related works Pen and ink drawing, Victoria and Albert Museum (6032), illus. Rorimer 60
Ref. Account Book 1812 "Mall given to Welbank"; and 1814 "Mall Rep[aired?] given Welbank"; Cole MS. "given by the Artist, in return for some professional service to Mr. J. [?] Welbank in 1818 or 19 and purchased [by Sheepshanks] in 1843 for £120"; for Cole Diary, see Ch. II, n. 96 & n. 97; for *Art Union*, see Ch. II, n. 98; Grant II, pp. 285–6; Rorimer, pp. 46–7 with contemporary reviews; Stephens, List and pp. 61, 64, 100, 107
Examiner, 1844, p. 309: "Mulready has two small landscape subjects painted many years back, for which we would gladly give the two finest Ostades we ever saw (if they happened to be ours to give). . . ."
This painting was described in 1864 (34) as being "repaired under Mr. Mulready's sanction, but again cracking." It was

originally commissioned by A. W. Callcott on behalf of Mr
W. Horsley; it was rejected because of its excessive detail.
Stephens claims that this work went to Mr Thomas Welsh
before entering the Sheepshanks Collection, but Mulready's
Account Book and the Cole MS. indicate that it went to Mr
Welbank.

79 Near the Mall 1812–13 (Plate 63)
Canvas, $13\frac{1}{2} \times 18\frac{3}{4}$
Victoria and Albert Museum, Sheepshanks Collection
(F.A. 135)
Exh. R.A. 1844 (334, "Painted in 1812"); 1848 (XXVII,
"Painted in 1813"); 1864 (36)
Prov. Mr J. (?) Welbank; by 1843, John Sheepshanks
Related works Pencil drawing, Victoria and Albert Museum
(6308), illus. Rorimer 61
Ref. Account Book 1813 "Hoggs Square [Near the Mall]
given to Welbank 1814"; for Cole MS. and Diaries, *Art
Union, Examiner,* Rorimer, and Stephens, see cat. 78;
Stephens, List
This work was commissioned by A. W. Callcott on behalf of
Mr W. Horsley; it was rejected because of its excessive
detail.

80 Portrait of Egan *c.* 1812
Location unknown
Ref. Account Book 1812 "Portrait of Egan"; Cole MS.
under "Portraits—Dr. Egan"
This was probably a portrait of Pierce Egan (1772–1849),
author of *Boxiana. . .*, London, 1812, for which Mulready is
thought to have supplied several illustrations. Egan is most
famous for his publication *Life in London*, London, 1821.

81 Boys Fishing 1812–13 (Plate 69)
Canvas, 30 × 40
Signed on the boat W. M.
London, Spink & Sons, Ltd
Exh. R.A. 1814 (75); 1848 (XIV); 1864 (42); R.A. 1882 (10)
Prov. Sir J. E. Swinburne, Miss Julia Swinburne,
Christie's, 20 June 1896 (93), bt Gooden, thence to
Agnew, to Sir Charles Tennant in 1900; Mrs Lubbock;
by 1918, Agnew, their property, Christie's, 11 Feb. 1921
(151), bt Sampson; . . .; Sotheby's Belgravia, 29 June
1976 (62, illus. in color), bt Spink
Related works Two pen and ink drawings, Victoria and
Albert Museum (E. 1801, 1802–1910), illus. Rorimer
64–5, 1864 (143); one pen and ink drawing containing two
sketches of the painting inscribed 14th and 15th, Art
Gallery of Hamilton, Canada (68–483)
Ref. Account Book 1812 "May 14 Sir J E Swinburne 1/2
Boys Fish$^{\text{g}}$. 63"; and 1813 "Sir J E Swinburne 1/2 Boys
Fish$^{\text{g}}$. 50"; and 1814 "Boys Fishing Rep$^{\text{d}}$ [repaired]";
Rorimer, p. 50; Stephens, List and pp. 60, 64, 91
Athenaeum, 10 June 1848, p. 584: "the figures are sub-
ordinate in interest to a fresh, green and spring-like
landscape. Increased freedom of execution is here visible".
Mulready repaired this painting in 1814.

82 Self-Portrait 1813
Location unknown
Ref. Account Book, 1813 "I of self nearly done"; Cole MS.
under "Portraits—2 of Self"

83 Portrait of Julia Swinburne (1795–1893) 1813
(Plate 163)
Panel, $4\frac{1}{8} \times 3\frac{1}{2}$
Capheaton Collection
Exh. 1848 (LXVII, "Painted in 1813"); 1864 (41)
Prov. Sir J. E. Swinburne, Miss Julia Swinburne, by
descent to present owner
Related works Cat. 84
Ref. Account Book 1813 "1 D$^{\text{o}}$ [Portrait] Julia to Sir John
[Swinburne]"; Cole MS. under "Sketches in oil—
Portraits Miss Swinburne"; Stephens, List and p. 64
Julia Swinburne was the eldest daughter of Sir John E.
Swinburne, one of Mulready's most important patrons. She
was Mulready's pupil for a number of years.

84 Portrait of Julia Swinburne (1795–1893) *c.* 1813
Location unknown
Related works Cat. 83
Ref. Account Book 1813 "1 Large Sk$^{\text{h}}$ D$^{\text{o}}$[Portrait of Julia]
to L$^{\text{y}}$ Swinburne"

176. Sketch for *Punch c.* 1811–12. Oil on canvas laid on
panel, $8 \times 12\frac{1}{2}$. Victoria and Albert Museum, London
(Crown Copyright) (cat. 85)

85 Punch Sketch *c.* 1811–12 (Plate 176)
Canvas laid on panel, $8 \times 12\frac{1}{2}$
Victoria and Albert Museum, Sheepshanks Collection (F.A.
159)
Exh. 1864 (39)
Prov. John Sheepshanks
Related works Cat. 86

86 Punch unfinished 1812–14
Canvas, 38 × 52
Location unknown
Exh. R.A. 1813 (327); 1848 (XVI); 1864 (40)

Prov. Sir J. E. Swinburne, Bart., his sale, Christie's, 15 June 1861 (126), bt Pennell; Sir A. Ashton, by 1864, Mr Thomas Ashton; Mrs Gibbons (according to Stephens)

Related works Oil sketch (cat. 85); pencil and chalk drawing, Victoria and Albert Museum (6565), illus. Rorimer 62; chalk, pen and ink and wash drawing, Victoria and Albert Museum (E. 1859–1910), illus. Rorimer 63; and pencil drawing, Victoria and Albert Museum (6066); several drawing sketches appeared 1864 (140–2, 150, 161)

Ref. Account Book 1812 "Punch 1/3 done"; and 1813 "Punch 1/3 done"; and 1814 "March 4 Sir J E Swinburne Punch 100 g[ns] April 29 100 g[ns] May 20 100 g[ns] 324 [Total payment: 324 gns.] Punch 1/3 done"; and 1816 "worked on Punch" (The painting was described as "unfinished" in 1848); Dafforne, pp. 11–12; Rorimer, pp. 48–9 quoting contemp. reviews; Stephens, List and pp. 62, 64

Art Union, 1839, p. 59 in "The Gallery of Sir John Swinburne Bart.": "This picture is full of admirable character. A group of old men, and women, and young boys and girls, are at the very summit of enjoyment, from the freaks of the mimic despot, who, having slain his wife, is arguing with the devil. An old sober Darby and Joan are as thoroughly pleased as the young urchins, one of whom is peeping under the drapery to discover the source of the fun; others are pointing with excessive glee to the object of attraction. One diminutive brat is holding up a brat still more diminutive to catch a glimpse of the scene; and a homely market woman, standing by her donkey, is pausing, and placing her hand to her mouth to suppress her loud laughter. The work is full of matter; it abounds in strong and pointed humour, and yet is in no degree exaggerated."

Art Union, 1848, p. 208: "it is clear he has had much embarrassment in drawing, character, and composition".

87 Portrait of Emily Swinburne (1798–1882) *c.* 1813–18 (Plate 161)

Panel, $5\frac{3}{4} \times 5\frac{1}{4}$

Capheaton Collection

Exh. 1964 (7)

Prov. Sir J. E. Swinburne's family, by descent to present owner

Related works Pencil sketch, Capheaton Collection. This drawing may be by one of the daughters of Sir J. E. Swinburne rather than by Mulready.

Ref. Account Book 1813 "2 Portraits given to ES" (A reference to this painting and the pencil sketch?)

Emily (or Emelia-Elizabeth) Swinburne, later wife of Sir Henry George Ward, Governor of Madras, was the daughter of Sir John E. Swinburne, one of Mulready's most important patrons. She was probably one of Mulready's pupils.

88 Portrait of J. Swinburne (Julia Swinburne?) *c.* 1814

Location unknown

Ref. Account Book 1814 "Portrait of J. Swinburne D°[given] Sir J. [Sir J. E. Swinburne]"

89 Portrait of H.G. 1814

Location unknown

Ref. Account Book 1814 "Portrait of H.G. not find^d"

H.G. probably refers to his pupil and friend Harriet Gouldsmith (1787–1863), discussed in Ch. I.

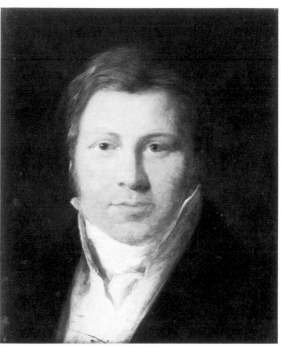

177. *John Varley* 1814. Oil on panel, $3\frac{1}{2} \times 2\frac{1}{2}$. National Portrait Gallery, London (cat. 90)

90 Portrait of John Varley (1778–1842) 1814 (Plate 177)

Panel, $3\frac{1}{2} \times 2\frac{1}{2}$

London, National Portrait Gallery (1529)

Exh. 1864 (44, "Painted in 1814"); Colnaghi's, *John Linnell and his Circle*, 1973 (125)

Prov. John Varley, by 1864, Charles S. Varley, purchased by the museum in 1909 from Mrs Fanny Varley, widow of Edgar Varley

Related works Mulready used John Varley, his friend and brother-in-law, as the model for the suitor in *The Widow* (cat. 107); there is a profile portrait drawing of Varley by Mulready in the British Museum (1878-7-13-1271).

Ref. Account Book 1814 "Portrait of Varley given"; Cole MS. under "Sketches in oil—Portraits J. Varley"; Stephens, p. 78 n.

John Varley, the watercolor painter, was Mulready's early teacher and friend, and became his brother-in-law.

91 The Ass 1814 (Plate 97)

Panel, $15 \times 11\frac{3}{4}$

Capheaton Collection

198

Exh. 1848 (LII); 1864 (43); 1964 (8)
Prov. Sir J. E. Swinburne, Miss Julia Swinburne, by
descent to present owner
Ref. Account Book 1814 "Portrait of Ass Do[given] X[Sir
J. E. Swinburne]"; Cole MS. "1814 Maltese Ass Miss
Swinburne"; Stephens, List
The Swinburne records report that this ass, aged 14, was the
one on which the Swinburne children first learned to ride.

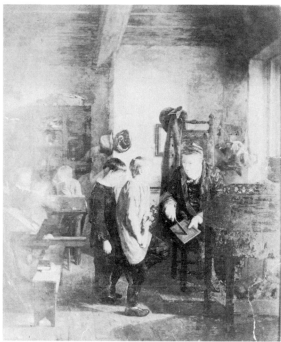

178. *Idle Boys* 1815. Oil on panel, $30\frac{1}{2} \times 25\frac{1}{2}$. Location
unknown (cat. 92)

92 Idle Boys 1815 (Plate 178)

Panel, $30\frac{1}{2} \times 25\frac{1}{2}$
Signed and dated 1815
Location unknown
Exh. R.A. 1815 (286); 1848 (XV); 1864 (45); Grosvenor
Gallery 1888 (62); Glasgow 1901 (195); Guildhall 1904
(127)
Prov. Earl Grey; Joseph Gillot; by 1860, Henry McConnel,
his sale, Christie's, 27 March 1886 (41), bt Agnew, thence
to Thomas Woolner, his sale, Christie's, 18 May 1895
(103), bt Agnew, thence to Sir Charles Tennant
Related works Pencil sketch on panel (Plate 84), formerly
Count Matsukata, Japan, now lost, 1864 (159); two pencil
and chalk drawings, Whitworth Art Gallery, University
of Manchester (D. 47. 1895, D. 48. 1895) (Plate 85); a
pen and ink wash drawing, Henry E. Huntington Art
Gallery (72.11) contains a figure quite similar to the
central figure standing on one foot (although reversed)

Plate 9; several drawings appeared 1864 (see above and
160–1)
Ref. Account Book 1815 "July 4 Earl Grey Idle Boys R.A.
105"; H. McConnel letter, see p. 170; Redgrave, II,
p. 309 (long description); Stephens, List and pp. 19, 64,
92
Examiner, 1815, pp. 365–6: "*Idle Boys* is honourable to Mr.
Mulready's exact observance and portraiture of incidental
character. The stern resentment of a Schoolmaster, and the
Schoolboy's pangs and diffused terror, are seen in every
form and thrill in every nerve of the boys who are looking
on, and the boy to whom the instructor is pointing out his
cyphering blunder, after having inflicted the twinging
strappado for which he is writhing. This writhing is
poignantly marked in his twisted features and limbs. The
down-dropping head and arm of his companion, who is
about to shew his sum also, and the awful glances of the
other boys, are the pictorial looking-glasses to juvenile
emotions. A delicate touchiness and squareness of pencil,
and a beautiful sunny effect, shine in this masterly work."
New Monthly Magazine, July 1815, p. 551: "This fine
picture, if we mistake not, will place Mulready nearly upon a
level with Wilkie and Bird. The attitude and expression of
the boy who has just felt the ferule, are excellent; as is also
that of the urchin who, as you perceive, deserves and expects
punishment. The figures in the background are not at all
inferior."
An old photograph of the painting (Tate Gallery, photo-
graphic archives), Plate 178, reveals a seriously damaged
painting with considerable peeling. Mulready used asphal-
tum occasionally during this period which resulted in
damaged paintings. For example *The Fight Interrupted*
(Cat. 93) and *The Wolf and the Lamb* (cat. 99) also suffered
from this although they were repaired in the 19th century.

93 The Fight Interrupted 1815–16 (Plate 90)

Panel, $28\frac{1}{2} \times 37$
Signed W. Mulready; dated 1816 on the pump according to
the 1864 catalogue (no longer visible)
Victoria and Albert Museum, Sheepshanks Collection (F.A.
139)
Exh. R.A. 1816 (65); Royal Hibernian Academy 1817 (?,
according to Walter G. Strickland, *Dictionary of Irish
Artists*, 1913); 1848 (XXXII, "Painted in 1815"); 1864
(46); Guildhall 1904 (115); R.A. 1951–2 (324); Arts
Council, Coronation Exhibition, *British Life...*, 1953
(103); 1964 (9); R.A. 1968 (193)
Prov. Lord Viscount Whitworth, Viceroy of Ireland, by
descent to Earl of Delawarr; John Sheepshanks
Related works Pen and ink drawing (Plate 89), and one chalk
drawing, Yale Center for British Art, Paul Mellon
Collection; chalk sketch, A. Kirkup, appeared 1848
(CXXII), 1864 (154); and several other sketches
appeared 1864 (150, 156–7, 158, 214); engravings by
Charles Fox for the Dublin Art Union, and by Lumb
Stocks in *Art Journal*, 1875
Ref. Account Book 1815 "Fight Interrupted Comp L & D

[Composition light and dark] 1/2 done"; and 1816 "July 22 Lord Viscount Whitworth Fight Interrupted 157.10"; and 1860 "Ap 2 Restoration of Fight Interrupted J. S. Col[John Sheepshanks Collection] 58.16"; Cole Diaries, 17 Feb. 1860 "[The Queen] was tickled at the notion that Mulready was mending the trousers of the boy in *The Fight Interrupted*"; Farington, VIII, p. 44; Redgrave, II, pp. 310–11; Stephens, List and pp. 91–2, 100; Whitley, p. 258

Ackermann's Repository of the Arts, June 1816, p. 355: "[In comparison to Wilkie's *The Rabbit on the Wall*] This picture is, in every respect, superior to the last: it has far more expression, better drawing, and chaste colouring. It is, in fact, the point of attraction in the great room."

New Monthly Magazine, July 1816, p. 542: "The interest which this picture excites would doubtless astonish, and perhaps disgust a foreigner, who, unused to such scenes, might censure the taste of the artist in the selection of his subject, but for our own parts we prefer the representation of a fight of this sort, which is purely national, to all the pictures of Waterloo which we yet have seen:—in fact, we have now no small authority for our preference, for, at a late public dinner, a gallant general, who has fought and bled for his country, declared that he owed all his success and reputation to the first black eye he received at Westminster; and, 'no less strange than true,' this remark was followed by a similar avowal from a British judge . . . On the whole, we hesitate not to pronounce this one of the very best pictures in the room."

It is thought that his own sons posed for some of the pupils. Mulready repaired this painting in 1860.

94 The Village Buffoon 1815–16 (Plate 121)
Canvas, $29\frac{1}{2} \times 24\frac{5}{8}$
London, Royal Academy of Arts
Exh. 1864 (47); Leeds 1868 (1174); R.A. 1872 (146); Philadelphia, *International Exhibition* 1876 (118); R.A. 1951–2 (326); Bournemouth 1957; Nottingham University, *Victorian Painting*, 1959 (53); Arts Council, *R.A. Diploma Pictures*, 1961–2 (27); *Treasures of the Royal Academy* 1963 (204); 1964 (10); Cork 1971 (82)
Related works A sketch appeared 1848 (LXXV) and 1864 (162)
Ref. Account Book 1814 "Dec. Comp[osition] . . . Village Buffoon P[ainted] 1816"; and 1815 "Village Buffoon 1/3 [?] done"; and 1816 "Diploma Picture"; Cole MS. "Diploma painted in 1817"; Farington, VIII, p. 96; Stephens, List
This was Mulready's Diploma Work for the Royal Academy.

95 William Mulready's Son unfinished *c.* 1818
Canvas, $18 \times 13\frac{1}{4}$
Location unknown
Exh. 1864 (104, Executors, "Painted about 1818")
This may be one of the oil sketches entitled "A Boy's Head" sold in the Artist's Sale (cat. nos. 181–2).

96 William Mulready's Son unfinished *c.* 1818
Canvas, $17\frac{1}{4} \times 14$
Location unknown
Exh. 1864 (105, Executors, "Painted about 1818")
This may be one of the oil sketches entitled "A Boy's Head" sold in the Artist's Sale (cat. nos 181–2).

179. *Lending a Bite* 1819. Oil on panel, 31×26. With Sotheby's Belgravia, 1976 (cat. 97)

97 Lending a Bite 1819 (Plate 179)
Panel, 31×26
Signed and dated W M 1819, lower left
With Sotheby's Belgravia, 29 June 1976 (63, illus. in color)
Exh. R.A. 1819 (143); 1848 (XVII); 1864 (listed between 48/49); R.A. 1889 (15)
Prov. Earl Grey; by 1864, Thomas Miller; by 1889, T. Horrocks Miller; Thomas Pitt Miller, his sale, Christie's, 26 April 1946 (92), bt Mitchell; M. Benjamin, bt in, Christie's, 10 June 1966 (161) and 11 Nov. 1966 (107); Sotheby's, Gleneagles Hotel, 29 Aug. 1969 (252), bt Wellington Sloane
Related works Pencil and white chalk drawing, Victoria and Albert Museum (6392), Plate 93, and pen and chalk drawing (hands), Victoria and Albert Museum (6390), illus. Rorimer 95, 97; pen and ink drawing (hands), Whitworth Art Gallery, University of Manchester (D. 52. 1895); several drawings appeared 1848 (CXLV . . .) and a sketch of boy's head, dated Aug. 1817 appeared 1864 (164);

see reworking of theme, *Giving a Bite* (cat. 139)
Ref. Account Book 1818 "Lending a Bite"; and 1819 "Nov 6 Earl Grey Lending a Bite 1/2 done in 1818 but entirely repainted 210"; Stephens, List and pp. 64, 85
Annals of the Fine Arts, 1819, p. 308: "Mulready, in comparison with Wilkie, exhibits less mind, and therefore is sooner forgotten; and we acknowledge we did forget one of his pictures, a few years since... In painting, that is in execution, we think him the first of his class in England, and cite this picture as a proof... one boy who has been successful enough to win an apple of a gambling old dame behind him, is lending a bite to his friend."

98 The Wolf and the Lamb Sketch *c.* 1819–20
Location unknown
Prov. Artist's Sale (492), bt Simpson
Related works Cat. 99

99 The Wolf and the Lamb 1820 (Color Plate III)
Panel, $23\frac{5}{8} \times 20\frac{1}{8}$
Signed and dated [W?] MULREADY 1820 on the brass plate attached to the gate-post
Her Majesty Queen Elizabeth II
Exh. R.A. 1820 (106); 1848 (XXXVII); 1855 (893); 1857 (361); Leeds 1868 (1170); Newcastle 1887 (854); 1964 (11)
Prov. George IV
Related Works Oil sketch (cat. 98); three drawings, Whitworth Art Gallery, University of Manchester (D. 98. 1895, D. 99. 1895, D. 102. 1895); pencil sketch, Collection Dudley Johnson; pen and ink sketch, Collection Kenneth A. Loht; several studies appeared 1848 (CXLVIII...) and 1864 (163, one dated 4.2/16); a copy of the two central characters belonged to Mrs Strange in 1957; aquafortis on steel by J. H. Robinson, dated 5 March 1828, published for the benefit of the Artists' Benevolent Fund; engravings by J. B. Neagle (Philadelphia), C. W. Sharpe, and Normand fils. A small replica in watercolor on ivory, exh. Colnaghi's, *John Linnell and his Circle*, 1973 (126) may be by Mulready but is more likely the work of an artist who reproduced oil paintings in miniature, e.g. H. P. Bone or G. Gray.
Ref. Account Book 1820 "Dec 16 His Majesty Wolf & Lamb 210"; for Cole Diaries, see Ch. III, n. 103; Millar, no. 970; for Redgrave *Memoir*, see Ch. III, n. 103; Stephens, List and pp. 64, 82, 84, 85, 88, 89
Examiner, 1820, pp. 316 and 397: "Mr. Mulready, in *The Wolf and the Lamb*, or a malignant and timid boy, wants a little force in the flesh, but he has a powerful contrast of character. Besides the beautiful finishing and firmness of hand corresponding with the painted earnestness of feeling in ... *The Wolf and the Lamb*, W. Mulready, R.A. has as complete a contrast of malevolence and mildness in two schoolboys as painting is capable of. The boy who threatens with fiend-like fierceness, to rent his rage on his pale and quivering companion, would have made chief flogger under the torturing system which Lord Castlereagh and his

coadjutors practised upon his countrymen in Ireland." This work suffered from the effects of asphaltum. Mulready repaired it and others restored it in the 19th century.

100 Portrait of Elizabeth Swinburne (1805–96) Sketch *c.* 1821–3 (Plate 162)
Millboard, $9\frac{1}{2} \times 8\frac{1}{2}$ (oval, $7\frac{3}{4} \times 6\frac{1}{2}$)
Capheaton Collection
Exh. 1864 (112)
Prov. Miss Julia Swinburne, by descent to present owner
Related works Mulready painted a watercolor (Plate 157) of Elizabeth in 1811 when she was a small child (Capheaton Collection), exh. 1848 (CIII) and 1964 (31).
Elizabeth Swinburne, later Mrs John William Bowden, was Sir J. E. Swinburne's youngest daughter. She may have been one of Mulready's pupils.

180. Sketch for *The Careless Messenger Detected* 1821. Oil on canvas, $10\frac{1}{4} \times 8\frac{1}{8}$ (relined, now $10\frac{1}{2} \times 8\frac{1}{2}$). City of Manchester Art Galleries (cat. 101)

101 The Careless Messenger Detected Sketch 1821 (Plate 180)
Canvas, $10\frac{1}{4} \times 8\frac{1}{8}$ (relined, now $10\frac{1}{2} \times 8\frac{1}{2}$)
Signed and dated W. Mulready 1821
City of Manchester Art Galleries (1920.524)
Exh. Glasgow 1901 (234, "The Careless Nurse"); 1964 (12)
Prov. John Pye, the engraver; Mr R. Colls; Charles Meigh, his sale, Christie's, 21 June 1850 (157), bt Doo (?);

Christie's, 5 June 1857 (146), bt Gambart; W. Holds-
worth, his sale, Christie's, 30 April 1881 (79), bt Agnew,
thence to Sir Charles Tennant; by 1890, Agnew, thence
to Dr Lloyd Roberts in 1894, his bequest to the museum,
1920
Related works Cat. 102
Ref. Account Book 1826 "Sk of Careless Messenger J Pye
21"; Cole MS. "there is a small finished oil sketch Mr.
Pye for 20 gns. afterwards disposed of to Mr. Colls who in
1846 asked 100 gs for it"; Stephens, Addit. List described
as "The Negligent Brother" and "The Careless Nurse"

102 The Careless Messenger Detected 1821
Panel, $30\frac{1}{2} \times 25\frac{1}{2}$
Location unknown
Exh. R.A. 1821 (134); 1848 (XXVIII); 1864 (50);
Newcastle 1887 (711)
Prov. Lambton family/Earl of Durham; Anderson &
Garland, N.Y. sale, property of the Earl of Durham, 18
April 1932 (50)
Related works Oil sketch (cat. 101); two pen and ink
drawings, Victoria and Albert Museum, illus. Rorimer
66–7; two pen and ink drawings contained in a letter from
Mulready to A. Cooper, dated 18 April 1821, Fitzwilliam
Museum, Cambridge (MS. 148–1949); several drawings
appeared 1848 (CXLV . . .), 1864 (167); watercolor
replica or study, signed and dated 1821, with Sotheby's,
5 April 1973 (156), bt Abbot & Holder; engraving "The
Negligent Boy" by De Mare
Ref. Account Book 1821 "Mr [?] Lambton Careless
Messenger 315" (Lady Louisa Lambton was his pupil.);
Rorimer, pp. 50–1; Stephens, List
Examiner, 1821, p. 395: "The background figures in 134,
The Careless Messenger detected, are rather too distinct for
their distance, and the surface of the inanimate objects bear
too close a resemblance as to finishing, surface, and strength
to the figures; they are therefore obtrusive, all having a
japan-like texture, but there is unusual beauty in the
pencilling of the flesh, and an approximation to life in the
angry aspect of the mother who conceals a stick behind her
to lay suddenly on her son, who is detected in playing
marbles, while his infant brother is laid down asleep . . . The
action of the figures is complete, and a bright and unusually
vigorous atmospheric light is spread over the picture."
Magazine of Fine Arts, 1821, p. 110: "Mr. Mulready still
indulges his predilection for the freaks of idle boys. We hope
he will henceforth fly at higher game, and consecrate his
talents to subjects productive of something better than a
momentary smile. 'The Careless Messenger detected' is
distinguished by great power and expression, and good
colouring."
Repository of the Arts, June 1821, p. 366: ". . . however, his
story is not, as it ought to be in a picture, strikingly
obvious."

103 Portrait of Miss Hotchkin 1822
Canvas, $13\frac{5}{8} \times 11\frac{5}{8}$

Location unknown
Exh. 1864 (53, representative of the late L. Hotchkin, Esq,
"Painted in 1822")

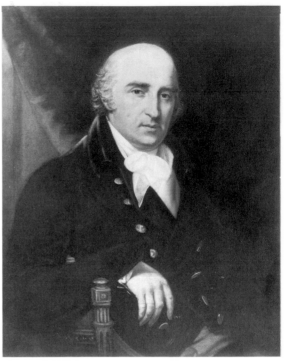

181. *Joseph Pitt c.* 1822–9. Oil on canvas, 30 × 25.
Cheltenham Art Gallery and Museum Service (cat. 104)

104 Portrait of Joseph Pitt (1759–1842) *c.* 1822–9
(Plate 181)
Canvas, 30 × 25
Cheltenham Borough Council Art Gallery and Museum
Service
Prov. . . . ; Miss G. Mayall of Compton, Abdale, Chelten-
ham, her gift to the museum, 1952
Ref. Cole MS. "Portraits—Joseph Pitt M.P."
A "Miss H. Pitt" was Mulready's pupil in 1822, 1823, 1825,
1827 and 1829. Presumably this portrait of Joseph Pitt (a
relative ?) was undertaken during this period. It is not in
Mulready's Account Book and was perhaps a gift to his
pupil. Mr Pitt was a senior partner in the banking firm of
Pitt, Gardner, Croome, Bowlby and Wood. He became a
Member of Parliament in 1812 for Cricklade and sat in five
successive Parliaments. He developed Pittsville Estate
which was laid out in 1824.

105 The Convalescent from Waterloo 1822 (Plate 98)
Panel, $24 \times 30\frac{1}{2}$
Victoria and Albert Museum, Jones Collection (506–1882)

Exh. R.A. 1822 (135); B.I. 1826 (51); Society of British Artists, Suffolk Street, 1834 (137); 1848 (XXXVI); Dublin, *International Exhibition*, 1853 (163); 1864 (51)

Prov. Lord Northwick, his sale, Phillips, Cheltenham, Thirlestane House, 29 July 1859 (386), bt H. Wallis; by 1864, John Jones

Related works Watercolor drawing was said to be with Mr E. G. Blythe in 1917; pencil and chalk study on panel, Victoria and Albert Museum (E. 4268–1915); pencil drawing of wrestling boys, signed and dated WM 12 July 1842, illus. Rorimer 69, 1864 (225). It is accompanied by a long inscription including the following: "I would willingly increase the proportion that this group bears to the rest of the composition. . .";engraving by George Doo, 1847 and J. & G. P. Nicholls, in *Art Journal* 1864. There is an engraved political cartoon based on this composition in the Capheaton Collection. Several sketches appeared 1864 (169); two outline drawings appeared Artist's Sale (327, 328), bt Brown

Ref. Account Book 1822 "Convalescent Lord Northwick Painted this year. not sold till 1826 £262.10"; and 1826 "Feb 10 Convalescent Ld Northwick 262.10"; James Smetham, the artist, praised it in a letter to Revd W. Knight, 1 April 1864, Pierpont Morgan Library; Dafforne, pp. 17–18; Redgrave, II, pp. 312–13; Rorimer, pp. 52–53; Stephens, List and pp. 64, 84–85, 91; for Cotman, see Ch. II, n. 78

Examiner, 1822, p. 301: "We are glad that the neat and powerful pencil of Mr. Mulready no longer moves in this morally and personally filthy region of *un*-polite art [low-life genre]; . . . [this] moves in our heart the springs of domestic delight; . . . The Artist's tact for expressing the kindly feelings is seen here to be as good as it has been for shewing the harsher ones; and the well-tinted flesh, the transparency, and the penciling, are worthy of his observance and display of mind and body."

New Monthly Magazine, June 1822, p. 256: "this is obviously inferior to most of his late works . . . the incident of the two children quarrelling, in the foreground, must be considered as totally out of place, since it evidently disturbs and interferes with the kind of interest intended to be called forth by the picture."

Repository of the Arts, June 1822, p. 354: "This picture looks hard and unfinished; but the sentiment of the figures is extremely pretty, and the action of the boys is good. In many parts of it is a pleasing example of Mr. Mulready's powers."

106 The Widow Sketch 1822

Panel, $5\frac{1}{8} \times 6\frac{1}{2}$

Private Collection

Exh. 1848 (LXIV, "Painted in 1822"); 1864 (52)

Prov. John Jeffries Stone, his sale, Christie's, 7 June 1880 (32), bt E. M. Stone

Related works Cat. 107

Ref. Cole MS. "Sketches in oil—Widow"

107 The Widow 1823 (Plate 124)

"So mourned the Dame of Ephesus her love"

Textual allusion: Petronius *Satyricon*

Canvas laid on panel, $27 \times 31\frac{1}{2}$

Signed and dated Wm. Mulready 1823, lower right (almost illegible)

Private Collection

Exh. R.A. 1824 (113); 1848 (XVIII); 1864 (listed between 53 and 54); Leeds 1868 (1165); Liverpool Art Club, October 1881 (66); Grosvenor Gallery 1888 (49)

Prov. George Knott, his sale, Christie's, 26 April 1845 (70), bt Hogarth; by 1864, Samuel Mendel; by 1865, Agnew thence to W. Holdsworth, his sale, Christie's, 30 April 1881 (80), bt Agnew, thence to Robert Rankin, his sale, Christie's 14 May 1898 (62), bt Childers; Lord Carysfort, by descent to present owner

Related works Oil sketch (cat. 106); drawing on panel, Victoria and Albert Museum (E. 4268–1915); six pen and ink and pencil drawings, Victoria and Albert Museum, illus. Rorimer 71–5, 238; an outline drawing on two sheets appeared Artist's Sale (324), bt Agnew

Ref. Account Book 1823 "Widow. not Exhibited"; and 1824 "Widow Exhi: Unsold."; and 1841 "Jul—Knott 315 [and] Widow Oct. 10 210" (Total payment: £525); for Cole Diary, see Ch. VI, n. 66; Cole MS. "purchased in 1842 by Mr. George Knott and sold after his death at Christie's April 26. 1845 for 400 guineas bt Mr. Hogarth No. 70"; praised by Wilkie in a letter to W. Allan, see Ch. III, n. 7; Tancred Borenius and Rev. J. V. Hodgson, *A Catalogue of the Pictures at Elton Hall in Huntingdonshire in the possession of Colonel Douglas James Proby*, London, 1924; Marcia R. Pointon, "William Mulready's 'The Widow': a 'subject unfit for pictorial representation'", *Burlington Magazine*, CXIX, 1977, 347–51; Rorimer, pp. 54–5; Stephens, List and p. 85; for *Blackwood's Magazine* and the *New Monthly Magazine*, see p. 169.

Examiner, 1824, p. 323: "The characters in this picture are painted with the artist's usual perspicuity and force, in the widow's assenting sheep's-eye glance at the wooer, his self-sufficient and assumed manner, the parent-forgetting frolicsomeness of the boys, the pensive recollectiveness of the daughter, and the prim but earnest fidelity of the old servant. The flesh colour and finishing are not less deserving of praise."

(F. G. Stephens) *Athenaeum*, 1886, p. 441: "'The Widow' is a complete Pre-Raphaelite picture, painted before even the most stringent Pre-Raphaelite Brother began to think out his principles, and it amply justifies Mulready's saying to the present writer that he 'long ago painted in that way,' i.e. long before 1848–9, the natal date of the Brotherhood."

108 The Travelling Druggist Sketch 1824 (Plate 182)

Canvas, $9\frac{3}{4} \times 7\frac{1}{2}$

Collection Mr C. B. J. Gledhill

Exh. 1848 (VI, "Painted in 1824"); 1864 (54)

Prov. Sir J. E. Swinburne, Bart.; Swinburne sale, Christie's, 4 June 1915 (59), bt Florence (?), Lady S.;

. . .; Christie's, 21 March 1969 (136), bt Gledhill
Related works Cat. 109
Ref. Cole MS. "Sketches in Oil—Druggist"; Stephens, Addit. List

182. Sketch for *The Travelling Druggist* 1824. Oil on canvas, $9\frac{3}{4} \times 7\frac{1}{2}$. Collection Mr C. B. J. Gledhill (cat. 108)

109 The Travelling Druggist 1825 (Plate 107)
Canvas laid on panel, $31\frac{1}{8} \times 26\frac{3}{8}$
Signed and dated 1825, lower left
Leeds, Harwood Gallery
Exh. R.A. 1825 (106); 1857 (363); 1864 (55); Manchester City Art Galleries 1908
Prov. Sir Matthew White Ridley; by 1857, John Chapman, by descent to Edward Chapman, Esq., his sale, Christie's, 21 Nov. 1924 (147), bt Mitchell . . .; Phillips, 22 March 1976 (58), bt Harwood Gallery
Related works Oil sketch (cat. 108); pen and ink drawing, Victoria and Albert Museum (6285), illus. Rorimer 70; pen and ink and wash drawing, British Museum (1864-5-14-8); a sepia sketch appeared 1864 (172)
Ref. Account Book 1825 "July 20 Sir M. W. Ridley. Druggist 315"; Redgrave, II, pp. 313–14; Rorimer, pp. 52–3; Stephens, List and pp. 85, 92–4.
Examiner, 1825, p. 385: "[It] is a picture that must universally please from its harmonious colour and its

contrasts of character; a stout, travelling Turk, and an anxious and delicate woman and her sick child, with a healthy one affectionately clinging to him."
Repository of the Arts, June 1825, p. 350: "A fine composition. . . The painting is in every respect beautiful; the details are highly wrought; and there is a clearness in the tints, and a careful execution, which cannot fail to be productive of the proper effect."
Times, 30 April 1825: "Mr. Mulready's Travelling Druggist displays great merit."

110 Portrait of Charles Legge *c*. 1825
Location unknown
Ref. Account Book 1825 "Nov 4 Countess of Dartmouth Portrait of Charles Legge 105"; Cole MS. "1828 Portrait of Charles Legge"
Legge is the Countess of Dartmouth's family name. There were teaching fees paid to Mulready under both names. This may be a portrait of Arthur Charles Legge (b. 1800), third son of the third Earl and Frances Aylesford, Countess of Dartmouth (who commissioned the portrait).
See also cat. 202.

111 Origin of a Painter 1826
Canvas, $31\frac{1}{8} \times 26\frac{1}{2}$
Location unknown
Exh. R.A. 1826 (120); 1848 (XXIV); 1864 (56)
Prov. Lady Swinburne, by descent to Miss J. Swinburne, her sale, Christie's, 8 July 1893 (51), bt O'Brien; 20 June 1896 (92), bt Tooth; T. M. McLean, his sale, Christie's, 30 Jan. 1909 (56), bt Sampson
Related works Chalk drawing, Victoria and Albert Museum (E. 1857–1910), illus. Rorimer 76, 1848 (CXL) and 1864 (174) (Plate 110); lithograph after the painting by Richard J. Lane, dated 1828
Ref. Account Book 1815 "Origin of a Painter P[ainted] 1826"; in 1826 "May 100 Oct 100 Origin of a Painter Ly Swinburne 200"; in 1827 "100 April 24 50 May 16 Lady Swinburne bal: of Origin 150" (total payment: £350); Rorimer, p. 56; R. Rosenblum, "The Origin of Painting: A Problem in the Iconography of Romantic Classicism", *Art Bulletin*, XXXIX, 1957, 279–90; Stephens, List
Repository of the Arts, June 1826, p. 361: "Mr. Mulready's picture does credit to his talents. A boy is tracing the shadow of his sleeping father on the wall, whilst his brothers and sisters are silently observing his performance. The expression of the boy is truly excellent; and the earnestness with which the girl holds the candle, to reflect the shadow for the pupil, is very ludicrous. The clearness of tint and the air of nature, which predominate in this picture, cannot be too highly praised."
Redgrave (II, p. 314) discussed its condition in 1866: "The picture has a faded look, as if the colour had passed away and left the brown ground: the whole appears dried up and starved, and the figures very poor and weak; the head of the young woman wants individuality, and is of a common class of idealization."

112 A Boy Firing a Cannon Sketch 1814–15 or *c.* 1827
Location unknown
Prov. Miss Julia Swinburne, her sale, Christie's, 8 July 1893
 (56), bt Green
Related works Cat. 113
Ref. See cat. 113, and Cole MS. "Sketches in oil—Cannon"

183. *A Boy Firing a Cannon* 1827. Oil on panel, 24⅞ × 33.
Location unknown (cat. 113)

113 A Boy Firing a Cannon 1827 (Plate 183)
Panel, 24⅞ × 33
Location unknown
Exh. R.A. 1827 (124); 1848 (XL); 1855 (897); 1862 (297);
 1864 (57)
Prov. Sir Robert Peel, sold with "Peel Heirlooms" at
 Robinson & F., 10 May 1900 (246), bt Dopson
Related works Oil sketch (cat. 112); three chalk drawings,
 Victoria and Albert Museum (6302–3, E. 2975–1910),
 illus. Rorimer 77–9, including a complete sketch of the
 composition (Plate 99) and a study of a girl and child, 1848
 (CXLI) and 1864 (184), Plate 100; a black and white chalk
 drawing of an interior of a herd's cottage, Mounces Know,
 British Museum 400492 (1886) 1864–5–141, served as a
 guide for the setting; several sketches appeared 1864 (144,
 185)
Ref. Account Book 1814 "Dec. Comp[osition] . . . Cannon
 P. 1827"; in 1815 "Cannon"; in 1827 "Oct 2 Right Hon.
 Robert Peel for Boy firing a Cannon 525"; a (draft) letter
 from Mulready to Peel, dated 28 Sept. 1827, Victoria and
 Albert Museum Library, conveys his desire to make
 corrections in the painting; Cole Diaries, 6 April 1845
 "He painted the Picture Sir R. Peel has in a short time. . .
 to enable him to build his Painting Room."; and again, 31
 May 1847 "In the Eg with Mulready saw his Boys firing."
 (Was Mulready repairing it?); Haydon (III, p. 201, 1
 June 1827) quoting Lord Egremont "People are talking of
 nothing but Mulready's little thing"; Redgrave, II,

p. 314; Rorimer, p. 57; Stephens, List and p. 5 ("painted
 in three weeks in 1827") and p. 64; William T. Whitley,
 Art in England 1821–1837, N.Y. and Cambridge, 1930,
 pp. 130–1
Examiner, 1827, p. 357: "A Boy firing a Cannon . . . shews a
very advanced knowledge of colour, light, and shade: these
in connection with the strong character of caution, surprise,
and curiosity, must equally gratify the scientific and the
untutored visitor. The colour is charmingly conducted from
the bright sky through mixed warm and grey, giving
splendour to the gradually obscured chiaroscuro of the
cottage. It has a delicious mellowness and truth. The
execution altogether, with the exception of a little feebleness
in the drapery, is masterly."
Repository of the Arts, June 1827, p. 352: "This little picture
is admirably painted; a boy is firing off his brass cannon, half
amazed himself at his prowess, and half terrifying the
equally silly bystanders. It possesses all the happy touches of
individual archness of character which Mr. Mulready's
pencil can so well depict, with the same felicitous power of
perfect finishing. The manner in which the light is
introduced through the door is admirable."

**114 Portrait of Frances Charlotte Talbot, Countess of
 Dartmouth** (d. 1823) 1827–8 (Plate 158)
Panel, 24¼ × 19⅞
Collection Lord Dartmouth
Exh. 1864 (50, "Portrait of the late Countess of
 Dartmouth—posthumous portrait, painted from a chalk
 sketch. Probably commenced about 1820 or 1821"); R.A.
 1886 (18)
Ref. Account Book 1827 "Lady Dartmouths Portrait
 Com^d"; and 1828 "Lady Dartmouth 108.2 Rec. Feb 6
 1829" and "Dec 16 Earl of Dartmouth 420"; Cole MS.
 "Posthumous portrait of Countess of Dartmouth" and
 "1828 Portrait of Lady Dartmouth"; Redgrave, II,
 p. 314; Stephens, Addit. List and p. 26
The setting is probably Sandwell Park, near West Brom-
wich, where the family was living at the time. The large
payment (£528.2.0) recorded in 1828 may have covered
other services performed by Mulready. A (draft) letter to
Lord Dartmouth (Victoria and Albert Museum Library)
discusses Mulready's assistance with the restoration of a
Reynolds painting in Lord Dartmouth's possession.

115 Interior of an English Cottage Sketch 1827
 (Plate 184)
Panel, 3⅞ × 2¾
Tate Gallery (1797)
Exh. 1848 (LXVI, "not received"); 1864 (58)
Prov. S. C. Hall (see note below); by 1848, Henry
 Vaughan, by whom bequeathed to the museum, 1900
Related works Cat. 116
Ref. Account Book 1827 "June 29 S. C. Hall for Sketch of
 Gamekeepers Wife 10.10"; Cole MS. "Sketches in oil—
 Interior H. Vaughan"
S. C. Hall wrote a description of *Interior of an English*

Cottage (cat. 116) to accompany an engraving by F. Engleheart (as "The Anxious Wife") for *The Amulet*, 1830, p. 84

184. Sketch for *Interior of an English Cottage* 1827. Oil on panel, $3\frac{7}{8} \times 2\frac{3}{4}$. Tate Gallery, London (cat. 115)

116 Interior of an English Cottage, or **The Gamekeeper's Wife** 1828 (Color Plate V)

Panel, $24\frac{1}{2} \times 19\frac{7}{8}$

Signed and dated William Mulready. 1828

Her Majesty Queen Elizabeth II

Exh. R.A. 1828 (127); 1848 (XXXIX); 1864 (59); Leeds 1868 (1167); R.A., *Kings' Pictures*, 1946–47 (488); R.A. 1951–2 (244)

Prov. George IV

Related works Oil sketch (cat. 115); chalk cartoon, Victoria and Albert Museum (6304), illus. Rorimer 80; pencil sketch of a child at her mother's knee and two pen and ink studies of cats, Whitworth Art Gallery, University of Manchester (D. 60. 1895, D. 75. 1895, D. 90b. 1895) may be related to this painting; engravings by C. Cousen as "The Home Expected", and by F. Engleheart as "The Anxious Wife" for *The Amulet*, 1830

Ref. Account Book 1828 "Oct. 30 His Majesty 315"; letter from W. Knighton on behalf of George IV to Sir Thomas Lawrence, dated 27 Oct. 1828, discusses the purchase and

names the price of 300 guineas (Lawrence correspondence, Royal Academy Library, 5/275); Millar, no. 971; Redgrave, II, pp. 314–16; Rorimer, pp. 58–9; Stephens, List and pp. 64, 100 (he mistakenly states that this painting was formerly in the collection of H. McConnel, Esq. and he was unaware of its location in the Royal Collection.)

Examiner, 1828, p. 308: "Mr. Mulready's *Interior of an English Cottage* is a rich mass of deep and bright sunset, chiaroscuro and colour" and p. 388: "[he] also imitates successfully Rembrandt's effects; but he adds good drawing. His *Interior of an English Cottage* is a luxuriant amber and ruby sunset, heightened by the strongly opposed shade of evening in the cottage."

Repository of the Arts, June 1828, p. 357: "A curious and in many respects an interesting picture, for the manner in which he has given a sunset, and the effect of fire-light within the cottage. But the deep streak of red is, after all, too thickly glaring for that picturesque effect in so limited a scene. In this little picture there is a greater display of the science of art than so unimportant a subject required."

117 Father and Child, or **Rustic Happiness** 1828–30 (Plate 113)

Panel, $8\frac{1}{2} \times 7\frac{1}{8}$

Signed and dated W Mulready 1828, lower center on the table

Collection Mrs Bridgid Hardwick

Exh. R.A. 1845 (145, "A Sketch, painted in 1830"); 1848 (IV); 1864 (65); Dublin Municipal Art Gallery, *Bodkin Collection*, 1962 (52)

Prov. C. Legge; Duchess of Gloucester; by 1864, Duke of Cambridge, his sale, Christie's, 11 June 1904 (29, "Rustic Happiness" and dated 1825), bt Permain; Barnet Lewis, Esq., his sale, Christie's, 3 March 1930 (199), bt Thomas Bodkin, by descent to present owner

Related works Pen and ink drawing inscribed "James Leckie and little Mary", formerly J. P. Heseltine Collection, and Paul Oppé Collection, illus. J. P. H., *John Varley and his Pupils W. Mulready, J. Linnell, and W. Hunt*, London, 1918, 10; a sepia study appeared 1864 (180), perhaps this drawing

Ref. Account Book 1830 "June 25. C Legge Father & Child 31.10"; Stephens, List

Examiner, 1845, p. 293: "The subject is simple, a boy playing with a child, with the figure of a woman in the background, probably the mother of the child. But the effect is striking; nay, considering the small size of the picture, astonishing. It is however *but* a sketch, painted (according to the Catalogue) in 1830."

W. M. Thackeray as M. A. Titmarsh in *Fraser's Magazine*, June 1845, p. 723: "There is a little Mulready, of which the colour blazes out like sapphires and rubies."

There is some discrepancy concerning the date of this painting. It was said to have been painted in 1830 in the R.A. 1845 catalogue; and in 1825 in the Christie's sale, 1904. But it is clearly dated 1828 on the panel.

118 Portrait of Mary Wright, Daughter of a Carpenter 1828 (Plate 165)
Panel, $9 \times 6\frac{3}{4}$
Victoria and Albert Museum, Sheepshanks Collection (F.A. 162)
Exh. 1864 (60, "Portrait of a little Girl, dated 1828"); South London Art Gallery, *Mid-Victorian Art, Draughtsmen & Dreamers*, 1971 (19)
Prov.; John Sheepshanks
Ref. South Kensington Museum (V & A) MS. Register of Pictures 1862–75: "as a return for some acts of kindness, presumably for the carpenter"
Mulready was remodelling his new residence in 1828, presumably employing Mary Wright's father, a carpenter. John Linnell also painted a "Mary Ann Wright" as a girl in 1832, sold Sotheby's, 26 March 1975 (65), illus., perhaps the same sitter. She resembles the girl in Mulready's painting but she looks nearly the same age, not four years older as would be indicated by the date of Linnell's portrait.

119 Portrait of Hook 1829
Location unknown
Ref. Account Book 1829 "July 22 Hooks Por: 40 Oct 1 Hooks Por: 40"
This may refer to a portrait of a lady exhibited in 1864 (63), cat. 120. Hook also appears as a pupil in Mulready's Account Book in 1829.

120 Portrait of a Lady unfinished 1829
Canvas, $35\frac{1}{2} \times 27\frac{1}{2}$
Location unknown
Exh. 1864 (63, "dated 1829", property of John Jeffries Stone) This painting did not appear in the sale of John Jeffries Stone's property (Christie's, 7 June 1880).

121 A Dog of Two Minds Sketch 1817
Panel or millboard, $9\frac{1}{4} \times 7\frac{3}{8}$
Location unknown
Exh. R.A. 1829 (104); 1848 (III, "Painted in 1817"); 1864 (48); Newcastle 1887 (840)
Prov. Sir J. E. Swinburne, Bart.; Swinburne sale, Christie's, 4 June 1915 (59), bt Florence (?), Lady S.
Related works Cat. 122; two sketches, dated Feb. 1816, appeared 1864 (163)
Ref. Cole MS. "Sketches in oil—Dog of two minds"; Stephens, Addit. List

122 A Dog of Two Minds 1829–30 (Plate 91)
Panel, $24\frac{3}{8} \times 20\frac{3}{8}$
Liverpool, Walker Art Gallery
Exh. R.A. 1830 (115); 1848 (XLVII); 1857 (358); 1864 (64); R.A. 1951–2 (258); Arts Council, *British Subject and Narrative Pictures 1800–1848*, 1955 (30); 1964 (15)
Prov. William Wells, his sale, Christie's, 10 May 1890 (66), bt Agnew, thence to George Holt, bequeathed by his daughter Emma Holt to the Corporation of Liverpool, 1945
Related works Oil sketch (cat. 121); two drawings appeared 1848 (CXLVIII...)
Ref. Account Book 1829 "Sk Dog of two 23 days 100 given"; and 1830 "Nov. 15. Wells. Dog. 262.10"; and possibly in 1815 "Effect of L & D of Dog."; Cunningham, *British Painters*, III, p. 275; Stephens, List and pp. 83, 94
Examiner, 1830, p. 403: "An indifferent subject, well painted, though a little hard".
Literary Gazette, 1830, p. 323: "The meaning of this picture is not easily to be discovered; and when discovered is far from pleasing. In point of execution, it is an admirable specimen of Mr. Mulready's talents."
New Monthly Magazine, June 1830, p. 244: "an exquisite sketch of comic life".

123 Puppies Heads 1829
Millboard, $7\frac{1}{2} \times 9\frac{1}{2}$
Signed and dated 1829
Location unknown
Exh. R.A. 1829 (311); 1848 (XLVI); 1864 (61)
Prov. Miss Julia Swinburne, her sale, Christie's, 8 July 1893 (49), bt Gooden
Ref. Account Book 1829 "Puppies heads partly 10 given"

124 Painting after Teniers c. 1829 (?)
Location unknown
Ref. Account Book 1829 "March 2 H G for Copy of Teniers 5"
"H G" may refer to Harriet Gouldsmith, his friend and pupil from the early years of his career.

125 Interior with figures, after Teniers c. 1829 (?)
Location unknown
Prov. John Jeffries Stone, his sale, Christie's, 7 June 1880 (29), bt Noseda
John Jeffries Stone was a friend of Mulready's, and he named a son, Edward Mulready Stone, after the artist. Mulready evidently gave him a number of early works. Stone also purchased several drawings at the Artist's Sale, including an "Interior of a cottage, after A. Ostade" (189). This painting may be related to cat. 124.

126 Returning from the Hustings 1829–30 (Plate 16)
Canvas, 10×8
Location unknown
Exh. R.A. 1830 (345); 1848 (VII, "Painted in 1829"); 1864 (62)
Prov. George Loddiges; by 1864, Conrad Loddiges
Related works Pencil drawing on tracing paper, Victoria and Albert Museum (6306), illus. Rorimer 81
Ref. Account Book 1829 "Return from Hustings 200 38 days 20 in 1830 given"; Rorimer, p. 60; Stephens, List and p. 85
In the Artist's Sale, the drawing in the Victoria and Albert

Museum was said to represent only a section of the painting (repeated by Rorimer). However, it corresponds to the photograph of the lost painting in the Witt Library. Perhaps the notation in the Artist's Sale was wrong.

127 Portrait of Col. Walter Sneyd of Keele, Sneyd, Tunstall (1762–1829) 1830

Location unknown

Ref. Account Book 1830 "Copy Col Sneyds por: fin Sep 15 R^d[received] in 31"; and 1831 "Sept 12 W Sneyd Copy 25"

Walter Sneyd was at one time a Lt. Colonel, Staffordshire Militia, an M.P. for Castle Rising and High Sheriff of Tunstall. He married the Hon. Louisa Bagot in 1786 and they had four daughters. The youngest, Elizabeth (d. 1869), was probably the "Miss Sneyd" or "E. M. Sneyd" who appeared as a pupil in Mulready's Account Book intermittently from 1815 until 1851. Mulready wrote to her in 1829, giving her very detailed advice concerning a painting which she submitted for his criticism (National Library of Scotland, Edinburgh), quoted in Rorimer (p. 11).

The entry in Mulready's Account Book is confusing. Did he make a copy of another artist's portrait of Col. Sneyd? Did he make a copy of an earlier (?) portrait of Sneyd by himself—a portrait which is not mentioned in his Account Book? The low fee paid for the work would suggest an oil sketch, or perhaps a drawing rather than an oil painting.

128 Cargill and Touchwood or Mr Peregrine Touchwood breaking in upon the Rev. Josiah Cargill 1831 (Plate 115)

Textual source: Sir Walter Scott's *St. Ronan's Well*
Panel, $20\frac{1}{4} \times 16\frac{1}{2}$
Yale Center for British Art, Paul Mellon Collection (1286)
Exh. R.A. 1832 (139); 1848 (XXXIII); 1857 (364); 1862 (302); 1864 (68)
Prov. Lady Swinburne; Miss Julia Swinburne; by 1889, Emma C. Robson (according to handwritten label on the panel); Christie's, 18 June 1892 (118), bt Hanson; Robert Rankin, his sale, Christie's, 14 May 1898 (109), bt Agnew, thence to Whitworth Institute, Manchester (listed in Manchester, Whitworth Institute, *Inventory of Pictures, Drawings, Engravings, Statuary and other objects in the Galleries of the Institute*, 1913, p. 5 (24, "Scene from St. Ronan's Well"—Scott, $20\frac{3}{4} \times 16\frac{1}{2}$ in.); ...; Longford Hall, Lancashire, sold by order of the Stretford Corporation, Christie's, 14 June 1968 (71), bt Gooden & Fox, thence to Mr and Mrs Paul Mellon, who presented it to the museum
Related works Pen and sepia wash drawing, Victoria and Albert Museum (6383), illus. Rorimer 84, probably 1864 (195); another pen and ink drawing appeared Artist's Sale (409), bt White; engraving by R. Graves, 1832
Ref. Account Book 1831 "Sep 5. Graves. Cargill & Touchwood Copy right 25"; and 1832 "Cargill and Touchwood Ly Swinburne Painted in 31. 157.10"; Rorimer, pp. 60–1; Stephens, List

The painting was exhibited in 1832 with the following quotation from Butler's *Hudibras* (also quoted by Scott):

> Twixt us the difference trims:-
> Using head instead of limbs,
> You have read what I have seen;
> Using limbs instead of head,
> I have seen what you have read;
> Which way does the balance lean?

Examiner, 1832, p. 421: "The secluded scholar is sufficiently pale and thin, but his face wants expression. The vulgar despiser of books, with his sleek and portly figure, ruddy countenance, self-satisfied air, and hands in his breeches pockets, is extremely well hit off."

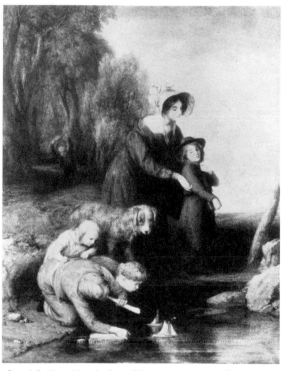

185. *A Sailing Match* 1831. Oil on panel, $24 \times 19\frac{3}{4}$. Location unknown (cat. 129)

129 A Sailing Match 1831 (Plate 185)

"Creeping like snail unwillingly to school"
Quotation: Shakespeare's *As You Like it*
Panel, $24 \times 19\frac{3}{4}$
Location unknown
Exh. R.A. 1831 (98); 1848 (XLIV); 1864 (66)
Prov. John Gibbons, Mrs Gibbons, sale of John Gibbons' property, Christie's, 29 Nov. 1912 (112), bt Sampson
Related works Cartoon and outline drawings, Victoria and Albert Museum (6322–23), illus. Rorimer 82 (cartoon); pen and ink drawing, Auckland Art Gallery (1956/2/11);

208

pen and ink drawing, Henry E. Huntington Art Gallery; pencil and chalk drawing, Whitworth Art Gallery, University of Manchester (D. 65. 1895); one drawing appeared 1864 (189); another outline drawing appeared Artist's Sale (329), bt Mylne; engraving by Charles Fox as "The Young Navigators" for *The Amulet*; smaller oil replica (cat. 137).
Ref. Account Book 1831 "Apr 13. & 21. 25. Gibbons . . . 210"; Mulready letters 1830–1, Collection Mrs E. Gibbons; Rorimer, pp. 60–1 quoting contemporary reviews; Redgrave, II, p. 316; Stephens, List and p. 94 where he identifies the young woman as Mrs Albert Varley, Mulready's nephew's wife; Waagen, *Treasures*, II, p. 304
Library of the Fine Arts, 1831, p. 424: "Can Mr. Mulready have an idea that his fame will be any way increased by such a picture as 98, 'A Sailing Match', with its muddy tones? and why, in the name of consistency, has he made the child passing the brook, so much like an old man? It is painful to contemplate such a picture 'after what we have seen' at this artist's hands."
New Monthly Magazine, July 1831, p. 314: "Mulready is always happy. He paints not only for the critic, but for those whose hearts warm towards what is natural and true."

130 The Forgotten Word 1832
Panel, $17\frac{1}{4} \times 13\frac{5}{8}$
Location unknown
Exh. R.A. 1832 (133); 1848 (XXXVIII); 1857 (355); 1864 (67)
Prov. Miss Julia Swinburne; . . .; Charles Storr Kennedy, his sale, Christie's, 6 July 1915 (77), bt Mitchell
Related works Chalk outline drawing appeared Artist's Sale (330), bt Mylne; engraving by C. Rolls for *The Amulet*, 1834 (Plate III)
Ref. Account Book 1832 " 'Forgotten Word' Miss Swinburne 60"; Dafforne, p. 23; Stephens, List, and p. 94 where he identifies the older girl as the wife of Mulready's nephew, Albert Varley; Cole (Diaries, 15 Dec. 1844) reports her death.
Dafforne's description of the painting differs significantly from the engraving: "Interior of a cottage, in which a girl, nursing an infant across her knees, is listening to a boy trying to repeat his lesson; but he has forgotten a word or some portion of his task, and stands mute and perplexed before his instructress, who evidently has no immediate intentions of helping him out in his difficulty: the stolid look of the little fellow is perfectly ludicrous."
Fraser's Magazine, July 1832, p. 719: "Nos. 133 [and 139] . . . are both very respectable productions, but not particularly striking . . . of the two, the first is decidedly the best."

131 Margaret of Anjou Throwing Away the Red Rose of Lancaster 1832
Textual source: Sir Walter Scott's *Anne of Geierstein*
Panel, $15\frac{5}{8} \times 13$
Location unknown

Exh. 1864 (70)
Prov. John Jeffries Stone, his sale, Christie's, 7 June 1880 (35), bt M.S.
Related works Crayon drawing, Victoria and Albert Museum (6562); a pen and ink drawing appeared in the Artist's Sale (275), bt Kimpton (?); engraving by R. Graves, 1833 (Plate 133)
Ref. Account Book 1832 "Aug 4 'Anne of Gerstein' D°[Graves Copyright] 25"

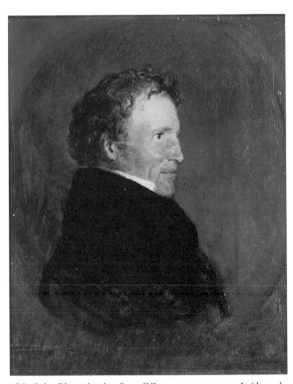

186. *John Sheepshanks* 1832. Oil on paper on panel, $6\frac{1}{2} \times 5\frac{1}{4}$. Victoria and Albert Museum, London (Crown Copyright) (cat. 132)

132 Portrait of John Sheepshanks (1787–1863)
Sketch 1832 (Plate 186)
Paper on panel, $6\frac{1}{2} \times 5\frac{1}{4}$
Victoria and Albert Museum, Sheepshanks Collection (F.A. 152)
Exh. 1848 (LXVIII, "Painted in 1832"); 1864 (69); Arts Council, *English Romantic Art*, 1947 (56); 1964 (16)
Prov. John Sheepshanks
Related works Probably a study for cat. 133
Ref. Account Book 1832 "a portrait of J. Sheepshanks"; Cole MS. under "Sketches in oil—Portraits J Sheepshanks"
John Sheepshanks was one of Mulready's most important patrons.

187. Engraving by H. T. Ryall after Mulready's *Alice Bridgenorth* 1833

188. Engraving by W. H. Mote after Mulready's *Edith Plantagenet* 1833

133 Interior, Portrait of John Sheepshanks (1787–1863) 1832–4 (Plate 159)
Panel, 20 × 15¾
Victoria and Albert Museum, Sheepshanks Collection (F.A. 142)
Exh. 1864 (71); R.A., *British Portraits*, 1956–7 (380); National Gallery of Ireland, etc., *Irish Portraits 1660–1860*, 1969–70 (108); Columbus, Columbus Gallery of Fine Arts, etc., *Aspects of Irish Art*, 1974 (39)
Prov. John Sheepshanks
Related works Two drawings, British Museum (1864-5-14-6, 7); four drawings, Victoria and Albert Museum (F.A. 75–78), illus. Rorimer 85–88, see Pl. 160; one drawing appeared 1848 (CXXXIX); several appeared 1864 (192, 193–194, 461)
Ref. Account Book 1832 "a portrait of J. Sheepshanks" (this may refer to cat. 132); 1833 "Mr Sheepshanks 'Interior' in progress 157.10"; and 1834 "Jan 15 Mr Sheepshanks Interior 14 days in '34 105"; Cole MS. "interior, with portrait of J Sheepshanks 1833"; Frank Davis, *Victorian Patrons of the Arts*, London, 1963; G. Reynolds, *Painters*

of the Victorian Scene, London, 1953, p. 50; Rorimer, pp. 62–64; Stephens, List and pp. 60, 101

134 Portrait of John Sheepshanks (1787–1863) *c.* 1832?
Location unknown
Prov. Rev. Thomas Sheepshanks of Harrogate, John Sheepshanks' nephew
Ref. "John Sheepshanks", *Dictionary of National Biography*, vol. 18, p. 9
This may be a drawing rather than an oil painting.

135 Alice Bridgenorth *c.* 1833
Textual source: Sir Walter Scott's *Peveril of the Peak*
Millboard, 9½ × 7½
Location unknown
Exh. 1864 (110)
Prov. Lady Swinburne; Miss Julia Swinburne
Related works Engraving by H. T. Ryall, 1833 (Plate 187)
Ref. Account Book 1833 "May 31 Ly Swinburne Alice & Edith 50" and "Martin Copyright Alice & Edith 10.10"; and 1834 "May 20 June 7 L Swinburne. Rec in error for

Alice & Edith 50"; Cole MS. "Heads—Alice & Edith Miss Swinburne"

The 1864 catalogue entry notes that Mulready brought only the head to completion. Seven designs for the illustration of *Peveril of the Peak* were exhibited in 1848 (CLXXX–CLXXXVI); Cole (Diaries, 2 July 1844) records Mulready at work on woodcuts for *Peveril of the Peak*.

136 Edith Plantagenet *c.* 1833
Textual source: Sir Walter Scott's *The Talisman*
Millboard, $9\frac{3}{4} \times 7\frac{3}{4}$
Location unknown
Exh. 1864 (111)
Prov. Lady Swinburne; Miss Julia Swinburne
Related works Engraving by W. H. Mote, 1833 (Plate 188)
Ref. see cat. 135
The 1864 catalogue entry notes that Mulready brought only the head to completion.

137 A Sailing Match 1833 (Plate 88)
Panel, $14 \times 12\frac{3}{4}$
Victoria and Albert Museum, Sheepshanks Collection (F.A. 147)
Exh. 1864 (72)
Prov. John Sheepshanks
Related works This is a reduced version of cat. 129. A note in the Account Book suggests that it was engraved by R. Graves.
Ref. Account Book 1832 "June 25 Boat race, small Graves Copyright 25"; and 1833 "Feb 18 Mr. Sheepshanks Small Boat Race 157. 10.0 *244.14*"; Stephens, List

138 The First Voyage 1833 (Plate 81)
Panel, $20\frac{1}{2} \times 25$
Bury Art Gallery (86)
Exh. R.A. 1833 (139); 1848 (XXX); 1864 (listed between 71 and 72); Manchester, *Art Treasures* 1878
Prov. Mr Edward R. Tunno, his sale, Christie's, 27 June 1863, bt Agnew, thence to Mr S. Mendel; by 1873, Agnew, thence to Thomas Wrigley, bequeathed to the museum, 1901
Related works Chalk drawing appeared R.A. 1849 and 1864 (263) and sepia sketch 1864 (196)
Ref. Account Book 1833 "July 19 Mr Tunno 'First Voyage' 262.10"; for Dafforne, see Ch. III, n. 26; Stephens, List and p. 79
New Monthly Magazine, 1833, Part II, p. 236: " 'First Voyage,' by Mulready, is a picture full of that quiet sentiment this artist knows so well how to pourtray; it is in excellent drawing, but rather monotonous in colour."
Examiner, 1849, p. 325 (commenting upon the chalk cartoon for the painting): "The astonishment of the baby voyager is unequalled in its way, except perhaps by the astonishment of the little girl in Hogarth's 'Enraged Musician.' "

139 Giving a Bite 1834 (Plate 94)
Panel, $20 \times 15\frac{1}{2}$
Signed and dated W Mulready 1834, lower left

Victoria and Albert Museum, Sheepshanks Collection (F.A. 140)
Exh. R.A. 1836 (117); 1848 (XLV); 1864 (73), Guildhall 1904 (92)
Prov. John Sheepshanks
Related works Five drawings (pen and ink, pencil, chalk), Victoria and Albert Museum (6390–94), illus. Rorimer 93–7 (95 & 97 may be studies for cat. 97); pen and ink drawing of hands, Whitworth Art Gallery, University of Manchester (D. 52. 1895); a watercolor, body color and pencil drawing of the composition, signed WM, Ulster Museum; a watercolor drawing of the composition employing a different color scheme from the finished oil, Eric W. Phipps Collection. The Victoria and Albert Museum also has a watercolor after Mulready's work (Dixon Bequest, 1190–1886), perhaps the same work sold at Christie's, 1863, then the property of E. Bicknell: "The Loan of a Bite", copy by S. P. Denning after the Sheepshanks Picture, watercolor. Engraving "Lending a Bite" by J. & G. P. Nicholls in *Art Journal*, 1864, and as "Giving a Bite" by W. Shenton for Finden's *Royal Gallery*. This painting is a variation of *Lending a Bite* (cat. 97).
Ref. Account Book 1834 "Sep 15 D°[Mr. Sheepshanks] Bite 262.10"; Rorimer, pp. 65–6 quoting contemporary reviews; Stephens, List and p. 83

140 The Toyseller Sketch *c.* 1835
Panel, $6\frac{3}{4} \times 8\frac{3}{4}$
Location unknown
Exh. 1864 (75)
Prov. Mrs Bacon
Related works Cat. 141; see also cat. 172
Ref. Account Book 1835 "July 29 Black in Chi[ldrens] Scn. [scene] to Mrs. Bacon…"; Cole MS. "a second [Toyseller] Mrs. Bacon"

141 The Toyseller 1835 (Plate 103)
Panel, $7\frac{1}{2} \times 9\frac{3}{4}$
Signed and dated W M 1835, lower right
Victoria and Albert Museum, Sheepshanks Collection (F.A. 149)
Exh. R.A. 1837 (74); 1848 (VIII); 1864 (76); 1964 (17)
Prov. R. Colls, an art dealer, probably sold the work to John Sheepshanks
Related works Mulready's last work was a nearly life-size version of this same theme (cat. 172). This small painting should be viewed as an oil sketch for the later, larger oil painting. He probably began preparation for the larger oil in 1836 with the "Outline of 'Black'. full size" (Account Book 1836) but dropped this work only to pick it up at the end of his career. See oil sketch for this painting (cat. 140).
Ref. Account Book 1835 "Aug 4 Colls. Black 25.4"; Cole MS. "Painted in 183 [*sic*] for Mr. R. Colls at the price of 25 Gs."; Stephens, List; Waagen, *Treasures*, II, p. 304

142 The Last In Sketch *c.* 1834–5 (Plate 189)
Panel, $8\frac{1}{4} \times 10\frac{1}{2}$

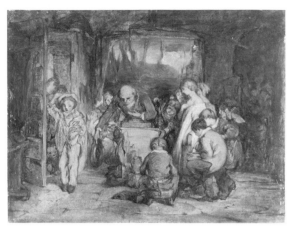

189. Sketch for *The Last In* *c.* 1834–5. Oil on panel, 8¼ × 10½. Collection Miss Judith G. Ledeboer (cat. 142)

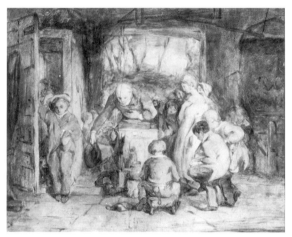

190. Sketch for *The Last In* *c.* 1834–5. Formerly oil on board, now canvas, 8 × 10. Pawsey & Payne, London

Collection Miss Judith G. Ledeboer
Prov. An oil sketch, 7¾ × 9¾ sold at Puttick's, 14 June 1915, bt Park, may be this painting (or cat. 143).
Although undocumented, this and the following oil sketch appear to be by Mulready. They accord with his practice in both size and manner.

143 The Last In Sketch *c.* 1834–5 (Plate 190)
Canvas, 8 × 10
London, Pawsey & Payne Ltd.
Prov. See cat. 142

This painting was originally on board; it has recently been transferred to canvas.

144 The Last In 1835 (Plate 87)
Panel, 24¾ × 30
Signed and dated W. M. 1835, lower left
Tate Gallery, Vernon Collection (393)
Exh. R.A. 1835 (105); 1864 (74); 1964 (14)
Prov. Robert Vernon
Related works Oil sketches (cat. nos. 142–3); two pen and ink drawings, one inscribed "Master Jack Lag, y/Innocent Master Jack", Victoria and Albert Museum (6400, 6403), illus. Rorimer 98–9; also two pen and ink and wash drawings (6168, 6170), which Rorimer neglected to associate with the painting; two pen and ink drawings, Whitworth Art Gallery, University of Manchester (D. 72. 1895, D. 74. 1895); a small pen and ink and wash drawing was with Colnaghi's, 1962 as "The Late Scholar"; a signed watercolor, possibly in another hand, with Agnew's, 1978; a red chalk cartoon appeared R.A. 1846, 1848 (L), 1864 (201), formerly J. E. Taylor Collection; several sketches appeared 1864 (139, 202); engraving by J. T. Smyth. There is an oil copy, 14 × 18, in an unknown hand in the possession of the executors of Revd James Gordon Robson.
Ref. Account Book 1834 "Sep 26 Sk[etch] Cartoon Last in Fin[ished] Tracing on Panel 31 Dec"; and 1835 "Nov 5 Vernon 'Last In' 420"; Rorimer, p. 67; Stephens, List and pp. 64, 83, 94 where he records that Mulready's nephew's wife, Mrs Albert Varley, posed for the tall girl on the right
Fraser's Magazine, July 1835, pp. 60–1: "there is a lack of that which art should add to nature, so as to render what is trivial as an incident valuable as a subject. In the picture itself, there is little either to captivate the eye or excite admiration."
New Monthly Magazine, 1835, Part II, p. 246: "It is humorously conceived, though a little confined in grouping, and admirably painted."

145 Open your Mouth and Shut your Eyes 1835–8 (Plate 130)
Panel, 12½ × 12
Victoria and Albert Museum, Sheepshanks Collection (F.A. 143)
Exh. R.A. 1839 (143); 1848 (XLVIII); 1864 (79)
Prov. John Sheepshanks
Related works Pen and ink drawing, signed and dated W M August 13, 18[3]8, Victoria and Albert Museum (E. 1798–1910), illus. Rorimer 39, appeared 1864 (195) with other drawings (132, 150, 171) including one dated 20.12, 1814
Ref. Account Book 1814 "Comps[compositions] . . . Open your mouth"; and in 1835 "July 27 'Open your Mouth' on Panel"; and 1838 "Oct 17 J Sh:[eepshanks] 78.15 'Open your Mouth' 157.10"; Rorimer, p. 36; Stephens,

List; for the *Art Union*, see p. 130, for the *Examiner*, see Ch. IV, n. 17

Blackwood's Magazine, Sept. 1839, p. 315: "The Sonnet and its Companion [*Open your Mouth...*] are very beautiful, by Mulready; somewhat too hot, but they are gems."

Literary Gazette, 1839, p. 316: "The first [*The Sonnet*] a beautiful pastoral, the second a boyish sport; both rendered interesting by their skillfull treatment and the rich and harmonious tone of colour under which they appear."

146 Self-Portrait unfinished *c.* 1835–40 (Plate 167)
Canvas, $8\frac{1}{2} \times 6\frac{5}{8}$
London, National Portrait Gallery (4450)
Prov. Mrs Horace Wyndham, direct descendant of the artist; Appleby Brothers, presented by Arthur Appleby to the museum, 1965
Ref. Cole MS. under "Portraits—2 of Self"

147 Brother and Sister, or **Pinch of the Ear** 1835–36 (Plate 127)
Panel, $12 \times 9\frac{3}{4}$
Signed and dated W Mulready 1836, lower right
Victoria and Albert Museum, Sheepshanks Collection (F.A. 144)
Exh. R.A. 1837 (61); 1848 (XLIX); 1855 (892); 1864 (77)
Prov. John Sheepshanks
Related works Pen and ink drawing, dated 17 July 1835, inscribed in another hand "by W. Mulready R.A." (Plate 129), Collection Leslie Parris; a watercolor was said to be in the possession of K. F. Ellis, 1904; two drawings appeared 1864 (132); an outline drawing appeared Artist's Sale (325), bt Brown; a note in the Account Book 1837 suggests that it was engraved for Finden; see later, larger treatment of the theme (cat. 170)
Ref. Account Book 1835 "July 18 'Ear' on Panel"; and 1836 "J. Sh[eepshanks] 152.10 'Ear' "; and 1837 "Mar 10 J Sh[eepshanks] 157.10 Brother and Sisters: 'Ear' [and] Finden. Copyright 'Ear' "; Dafforne, pp. 47 50; R. Liebreich, "Turner and Mulready On the effect of Certain Faults of Vision on Painting with Especial Reference to their Works", *Macmillan's Magazine*, XXV, 1872, 499–508; Redgrave, II, pp. 240–241; Stephens, List and pp. 64, 85, 101
Gentleman's Magazine VII, p. 629: "Surely he might give a little play to his imagination, and employ his talents on something rather more elevated than he has hitherto done."

148 Seven Ages of Man Sketch *c.* 1836–8
Location unknown
Prov. Artist's Sale (489), bt Pocock
Related works Cat. 149

149 Seven Ages of Man, or **All the World's a Stage** unfinished 1836–8 (Plate 132)
Textual source: Shakespeare's *As You Like It*
Canvas, $35\frac{1}{2} \times 45$

Victoria and Albert Museum, Sheepshanks Collection (F.A. 138)
Exh. R.A. 1838 (122); 1848 (XXVI); 1864 (78); Arts Council, *Romantic Movement*, 1959 (264); Bristol Cathedral, *Victorian Narrative Painting*, 1977
Prov. John Sheepshanks
Related works Oil sketch (cat. 148); pen and ink drawing, chalk drawing, Victoria and Albert Museum (6268, 6426), illus. Rorimer 100–1, 1864 (205); reverse drawing of composition in pencil and ink, Jupp Royal Academy Catalogues, VII, Royal Academy Library, 1864 (204); engraving by H. Bourne in *Art Journal*, 1874.
Ref. Account Book 1835 "Feb 7 First thought of 'Seven Ages' ... June 30 Arrang: ... July 11 Comd: by Sheepshanks to paint... Nov 17 traced... Dec 28 Block 'Seven Ages' del to Martin"; and 1836 "Ap:21 Martin Block 'Seven Ages' 15... Ap:21 J Sh[eepshanks] on acct of Seven Ages 310 ... Jan 7 Began the picture 'Seven Ages' outline"; in 1837 "Jan 31 J Sh[eepshanks] 100 on acct of Seven Ages"; in 1838 "Apr 10 'Seven Ages' sent RA back Aug 1 Retouched ... March 19-- J Sh[eepshanks] ... 'Seven Ages' 262.10"; in 1839 "Mar 15. [?] J Sh[eepshanks] 50 May 17 65 Balance for Seven Ages. 115" (Total payment: £787.10); Palmer, *Life*, pp. 62, 199; Redgrave, II, pp. 316–17; Rorimer, pp. 68–69 with contemporary opinions; for Ruskin, see Ch. IV, n. 1 and n. 30; Stephens, List and pp. 64, 83, 85, 100; for color reproduction, see Malcolm C. Salaman, *Shakespeare in Pictorial Art*, London, Paris, N.Y. 1916.
Frith, *Autobiography*, II, p. 55: (Letter from Douglas Cowper to Frith) "Mulready's 'All the World's a Stage' is a wonderful picture for contrast of character, in expression, color, & drawing also, it is one of the best in the exhibition."
W. M. Thackeray as M. A. Titmarsh, *Fraser's Magazine*, June 1838, p. 759: "King Mulready, I repeat, in double capitals; for, if this man has not the crowning picture of the exhibition, I am no better than a Dutchman. His picture represents the 'Seven Ages,' ... Not one of those figures but has a grace and soul of his own: no conventional copies of the stony antique; no distorted caricatures, like those of your 'classiques,' David, Girodet and Co.—but such expressions as a great poet would draw, who thinks profoundly and truly, and never forgets (he could not if he would) grace and beauty withall." (An engraving of Titmarsh placing the laurel-wreath on the brows of Mulready accompanied this praise.)
Illustrated London News, 25 July 1863, vol. 43, p. 93: "rather flimsy though elegant mannerisim of *The Seven Ages*".
Art Journal, 1864, p. 131 "it is far below the standard of his pictures from 'the Vicar of Wakefield' ".
The original design was drawn on wood as a frontispiece to the *Illustrations of Shakespeare's Seven Ages*, published by J. Van Voorst in 1840. The 1864 catalogue entry (78) contains a long and detailed description of each character in the painting. Mulready was probably inspired by contemporary stage productions for the background architecture. The

scenery for *As You Like It*, Drury Lane Theatre, 1842, engraved by Ellis after T. H. Shepherd, is quite like that employed by Mulready in this painting.

191. Study for *First Love c.* 1838. Pen, ink, watercolor and body color, 7½ × 6. Ashmolean Museum, Oxford

150 First Love 1838–9 (Plate 125)
Canvas, 30½ × 24½
Victoria and Albert Museum, Sheepshanks Collection (F.A. 141)
Exh. R.A. 1840 (133); 1848 (XXII), 1864 (81), Dublin, *International Exhibition*, 1865 (44)
Prov. John Sheepshanks
Related works Pen and ink, watercolor and body color drawing (Plate 191), Ashmolean Museum, 1848 (CLVIII) and 1864 (207); three drawings, Victoria and Albert Museum (6021, 6401, 6402), illus. Rorimer 102–4 and Plate 128; two pen and ink drawings (one of dogs), Whitworth Art Gallery, University of Manchester (D. 71. 1895, D. 73. 1895); an outline drawing appeared Artist's Sale (329), bt Mylne; engraving, *Illustrated London News*, 12 Feb. 1870
Ref. Account Book 1838 "July First Love . . . Nov 1 Chalk on the Canvas"; and 1839 "July 30 . . . on Acc. for First Love 428.15"; and 1840 "Jan 25 Apr 10 J Sh:[eepshanks] . . . balance for 'First Love' 70"; Cole MS. "painted for

the late Duke of Bedford but subject not approved.";
Rorimer, pp. 70–1; Stephens, List and pp. 64, 100–1; Waagen, *Treasures*, II, p. 303
Art Union, 1840, p. 74: " 'First Love' . . . is a delicious composition; a youth is whispering into the ear of as fair a maiden as was ever born of woman; she is too young to comprehend the meaning of the love-words that call the flush into her cheek and brow; the morning of their years and hopes is made to contrast happily with rich sunlight of a departing day; and just at the moment when some answer must be made, forth rushes from the cottage the girl's mother and a noisy boy, with a summons to the supper-table. It is a sweet story sweetly told; and negatives the assertion that a painter can preserve but one incident in a tale; what a volume of thought is produced by this single passage in a life!"
W. M. Thackeray as M. A. Titmarsh, *Fraser's Magazine*, June 1840, pp. 722, 726: "but dat bigture of First Loaf by Herr von Mulready ist wunder schon! . . . where in the whole works of modern artists will you find anything more exquisitely beautiful?"
Athenaeum, 10 June 1848, p. 584: "In 1839 Mr. Mulready proved again that he could invest a subject drawn from scenes of humble life with the attributes of the highest walks of his art. A poetic spirit breathes through his presentment of *First Love*."

151 The Sonnet 1839 (Color Plate IV)
Panel, 14 × 12
Victoria and Albert Museum, Sheepshanks Collection (F.A. 146)
Exh. R.A. 1839 (129); 1848 (LI); 1864 (80); Guildhall 1904 (89); Whitechapel 1905 (68); R.A. 1934 (559); Louvre 1938 (97); 1964 (18); Philadelphia Museum of Art 1968 (148); Sheffield, Mappin Art Gallery, *Victorian Paintings*, 1968 (10); Cork 1971 (83); Paris, Palais des Beaux-Arts, *La Peinture romantique anglaise et les préraphaelites*, 1972 (200)
Prov. John Sheepshanks
Related works Chalk cartoon, signed and dated 18[39?], National Gallery of Ireland (2950), appeared R.A. 1845, 1848 (LXX), 1864 (207); engraving by the Art Union of Ireland, 1840 and by J. C. Armytage. John Linnell, Jr made a lithograph from the *Sonnet* cartoon for subscribers to the National Gallery of British Art, 1848. A. E. Chalon, R.A. made a watercolor copy of *The Sonnet*, sold Sotheby's, 18 Oct 1961 (20), bt Maas.
Ref. Account Book 1839 "Jan 15. Feb 8.10. Cartoon of Sonnet" and "Mar 12 J Sh.[eepshanks] Sonnet 157.10"; *Art Union*, 1840, p. 164 quoting "Stanzas suggested by Mulready's picture 'The Sonnet', by J. G.G."; Dafforne, pp. 29–30; Robin Ironside and John Gere, *Pre-Raphaelite Painters*, London, 1948, p. 9; Redgrave, II, pp. 316–18, 321; Rorimer, p. 6; Stephens, List and pp. 64, 85, 95, 100; for *Blackwood's Magazine* and *Literary Gazette*, see cat. 145; for *Examiner*, Ch. IV, n. 17; see Ch. IV, n. 10 for addit. refs.

Art Union, 1839, p. 68: "A bit of true character that will tell with all who have been lovers. The youth is fiddling with his shoe-tye, but casting upwards a sly look, to ascertain what effect his lines produce upon the merry maid who reads them. His face is hidden, but we can guess his feelings, when he finds her placing her hand before her lips to suppress her laughter. It is admirably painted; but we venture to object to the lavish use of light-green to which the artist has, of late, resorted."

Art Union, 1839, p. 81: "... were it permitted to talk of living British artists, I might tell of a little picture called 'The Sonnet', of a spans breadth, which reminds the spectator of the magnificent genius of Michel Angelo in the Sistine Chapel."

152 Now Jump Sketch 1840 (Plate 82)
Panel, $6\frac{3}{4} \times 8\frac{1}{2}$
Location unknown
Exh. 1848 (LV, "A Sketch, Painted in 1840", property of Mrs Bacon); 1864 ("A Sketch—'Now Jump'", property of Mrs Bacon)
Prov. Mrs Bacon
Related works Chalk drawing entitled "The Bather, or Now Jump" appeared 1864 (209)
Ref. Cole MS. "Boy bathing—Mrs. Bacon" (this appears on the back of a page with works dated 1833–8), and again as "Child in bath—Mrs. Bacon"

153 The Artist's Study 1840
Panel, $15\frac{1}{2} \times 13\frac{1}{2}$
Location unknown
Exh. R.A. 1840 (99, "An Interior"); 1848 (XLI); 1864 (83)
Prov. Mrs Bacon
Related works Red Chalk and pencil cartoon, Fletcher Moss Museum, City of Manchester Art Galleries (1917.260), Color Plate VI, mentioned in Account Book 1853 "April 20 *Birchall* Artists Studio Drawing 262.10"; and Cole Diaries, 2 May 1852 "[Mulready] asked me to price his Cartoons—fixed £300 as price of the Artists Studio"; appeared 1864 (208) as did a pen and ink sketch (169)
Ref. Account Book 1840 "Oct 24 Mrs Bacon 'Artists Study' 110", and "March 2 Bacon 50 on Artists Study April 23 40 90"; and 1845 "Oct 17 Bacon balance of Artists Study 10.0.0" (Total payment: £210)
W. M. Thackeray as M. A. Titmarsh, *Fraser's Magazine*, June 1840, p. 728: "...is remarkable for exaggerated colour, ... The landscape seen from the window is beautifully solemn and very finely painted, in the clear bright manner of Van Dyck [Van Eyck?] and Cranach, and the early German School."

154 Train Up a Child in the Way He Should Go, and When He Is Old He Will Not Depart from It 1841 (Plate 101)
Quotation: Proverbs 22, 6
Panel, $25\frac{1}{2} \times 31$

Collection John A. Avery
Exh. R.A. 1841 (109); 1848 (XX); 1855 (895); 1857 (356); 1862 (303); 1864 (86); R.A. 1871 (260); Liverpool 1886 (742); Manchester, *Jubilee Exhibition*, 1887 (905, "Integrity"); Grosvenor Gallery 1888; Guildhall 1894 (91); Arts Council, *British Subject and Narrative Pictures*, 1953 (29); Arts Council, *Victorian Paintings*, 1962 (50); 1964 (19); R.A. 1968 (192); Paris, Palais des Beaux-arts, *La Peinture romantique anglaise et les préraphaelites*, 1972 (201)
Prov. Thomas Baring; Christie's, 8 June 1882, bt Agnew, thence to Ralph Brocklebank, his sale, Christie's, 29 April 1893 (95), bt Agnew for R. Brocklebank, his sale, Christie's, 7 July 1922 (67), bt Sampson; John Emsley, Esq., his sale, Sotheby's, 6 June 1945 (123), bt Mitchell; J. A. Avery, Esq.
Related works Pen and ink drawing, Victoria and Albert Museum (6384), Plate 102; a drawing sketch appeared R.A. 1848 and 1864 (255)
Ref. Account Book 1841 "Oct 29 Baring Lascars 450"; and 1851 "Feb 5 Baring for work on Lascars in 50 & 51 400"; and 1853 "June 16 T Baring retouching Lascars 200"; Thomas Baring's Account Book 1851 "Additional payment to W. Mulready for improving the Train up a child £400"; and in 1853 "I paid Mr. Mulready for restoration of the Lascars £200" (damaged as a result of fire, 1853, Baring residence, 41 Upper Grosvenor St.); Cole Diaries, 2 Jan. 1851 "at Mulreadys: Picture of Training a child gone at last to Mr Barings"; and 4 Dec. 1853 "[Mulready] Had nearly restored Lascars-damaged by Fire at Mr Barings"; Redgrave, *Memoir*, 10 April 1853 "Called on Mulready to see . . . 'Train up a Child' (which he spent many months in working on) after the injury it sustained in a fire at Mr. Thomas Baring's. I saw it after the accident, and it seemed in a fearful and hopeless state. It was stripped like tarnished silver, in dark metallic looking strips, where the hot steam had run down it. I knew that Mulready liked it to be seen thus, under as bad an aspect as possible, and that it will greatly please him, after the expressions of wonder at the hopelessness of its condition, to bring it round again." Redgrave, II, p. 319; G. Reynolds, *Victorian Painting*, London, 1966, pp. 12, 26; Rorimer, pp. 72–3 quoting contemporary opinions; Stephens, List and pp. 73, 82–3, 87–8 ("The artist's own opinion was that 'Train up a Child' was his masterpiece."), 95; Waagen, *Galleries*, p. 100; for the *Art Union*, see p. 102, for Gautier's remarks, see p. 102
Literary Gazette, 1841, p. 314: "He is about giving something to several dark-looking men, not unlike gipsies. The painting is full of merit; the two groups beautifully contrasted, and the person and looks of the child quite charming. But we cannot read the lesson; whether to inculcate charity, or what? The meaning escapes our penetration."
Stephens, *Fine Arts Quarterly Review*, 1863, p. 390: "The splendid group of Lascars is as fine as it is possible to conceive. Notice the terror of their dusky faces, their slow,

oriental motion of uncovering, and of imploring salutation and reverence, the arms silently outstretched to receive the half-affrighted boy's gift. Their strange eyes, motions, attitudes, and costumes are expressed so powerfully as to account for the terror of the child, and almost make us share it, thus giving force and tragic interest to the picture. Had the same powers of design been employed upon a mythological or tragic subject, the world would not have failed to see how grand they were."

This was retouched by the artist in 1850–1 and repaired after a fire in 1853.

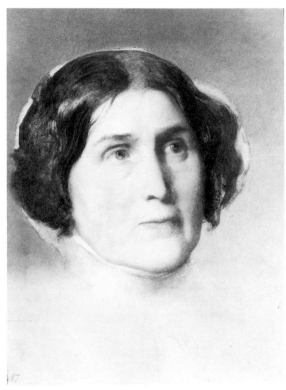

192. *Head of a Woman* 1840s. Oil on millboard, 16 × 12. Victoria and Albert Museum, London (Crown Copyright) (cat. 155)

155 Head of a Woman Sketch 1840s (Plate 192)
Millboard, 16 × 12
Victoria and Albert Museum (F.A. 243)
Exh. 1864 (108, "painted circa 1847")
Prov. Artist's Sale (487), bt Chaffers for the South Kensington Museum (now the Victoria and Albert Museum)
Perhaps this is Mulready's portrait of Mrs Leckie (cat. 156).

156 Portrait of Mrs. Leckie *c.* 1842 .
Location unknown
Related works Perhaps the unfinished female head (cat. 155)

is a study for this portrait or the portrait itself. For an earlier drawing of Mrs Leckie with Mulready's son Paul, see Plate 3.
Ref. Cole Diaries, 3 July 1842 "[Mulready's] fine lifelike portrait of Mrs. Leckie"; Cole MS. "Portrait of Mrs. Leckie"
For a discussion of Mrs Leckie, see Ch. I.

157 Crossing the Ford 1842 (Plate 126)
Panel, $23\frac{7}{8} \times 19\frac{3}{4}$
Tate Gallery, Vernon Collection (395)
Exh. R.A. 1842 (91, "The Ford"); 1864 (85); Nottingham University, *Victorian Painting*, 1959 (55); Arts Council, *Victorian Paintings*, 1962 (49); 1964 (20)
Prov. Robert Vernon
Related works Pen and ink drawing, Henry E. Huntington Art Gallery (68.39); chalk drawing, R.A. 1847, 1848 (V), and 1864 (222, where it was described as "the only drawing made for the picture of *Crossing the Ford*"), Dr Theodore Besterman Collection; a watercolor sketch of the composition was said to be in the collection of Mrs A. E. Fearnside, 1943; an engraving by Lumb Stocks in the *Art Journal*, 1852. A copy of this painting by George Gray on porcelain decorates a cabinet, designed by Gottfried Semper, exhibited at the Exhibition Universelle, Paris, 1855, now Victoria and Albert Museum (7248–1860), illus. Gillian Naylor, *The Arts & Crafts Movement*, London [1971], 8; an oil copy, $23\frac{1}{4} \times 19\frac{1}{4}$, of Mulready's painting by an unknown hand appeared Sotheby's, 10 Nov. 1965 (165), another oil copy, 24 × 20, probably not by the artist's hand appeared Sotheby's Belgravia, 16 Nov. 1976 (29, illus.).
Ref. Account Book 1842 "Oct 29 Vernon 260 Nov 19 115 Ford. 315"; J. Maas, *Victorian Painters*, London, 1969, p. 106; Redgrave, II, p. 318; Stephens, List and p. 89; W. M. Thackeray, "An Exhibition Gossip", *Ainsworth Magazine*, June 1842 (in *Critical Essays in Art*, 1904, p. 177)
Art Union, 1842, p. 121: "A main 'virtue' in the works of Mr. Mulready is that they tell their own story without the aid of descriptive title. . . . [*Crossing the Ford*] sustains the high reputation of its author; it is a work of surpassing beauty, grace, and excellence—one of the most valuable paintings ever produced in England."

158 The Whistonian Controversy 1843 (Plate 135)
Textual source: Oliver Goldsmith, *Vicar of Wakefield*
Panel, $24 \times 19\frac{1}{2}$
Private Collection
Exh. R.A. 1844 (128); 1848 (XXI); Royal Scottish Academy 1852 (200); 1855 (896); 1862 (300); 1864 (87); R.A. 1871 (146); Manchester, *Jubilee Exhibition*, 1887 (906); Guildhall 1904 (118); Winchester College & Southampton Art Gallery 1955 (43); 1964 (21)
Prov. Thomas Baring, by descent to current owner
Related works The painting was derived from Mulready's illustration, engraved by John Thompson, for Goldsmith's *Vicar of Wakefield*, published by J. Van

Voorst, London, 1843; engraving by S. Sly.

Ref. Account Book 1843 "Oct 14 Baring Dispute 350"; and 1846 "July 24 Baring 300"; (in payment for this and *Haymaking*) Baring MS. Catalogue "Mu.[lready] fixed £600 for the pair of Controv. & this [*Haymaking*; *Burchell and Sophia*] I pd. in all £1000"; Cole Diaries, 5 Oct. 1843 "Called on Mulready & his Wilmot & Vicar of Wakefield just finished wh: is for Mr T. Baring"; for B. R. Haydon's remarks, see Ch. IV, n. 49; Redgrave, II, pp. 247, 318; Stephens, List and pp. 64, 87, 89

Art Union, 1844, p. 156: "The excellence of this picture is that of the very highest order of the genre class. . . . On the whole it may be pronounced the best work of this year's production. It cannot fail to augment a reputation already high, if not the highest."

W. M. Thackeray as M. A. Titmarsh, *Fraser's Magazine*, June 1844, p. 706: "I believe this to be one of the finest cabinet pictures in the world. . . [the color is] brilliant, rich, astonishingly luminous, and intense. The pictures of Van Eyck are not more brilliant in tone than this magnificent combination of blazing reds, browns, and purples."

159 The Intercepted Billet 1844 (Plate 140)

Panel, 10 × 8¼

Victoria and Albert Museum, Sheepshanks Collection (F.A. 150)

Exh. R.A. 1844 (145); 1848 (XLIII); 1864 (88)

Prov. John Sheepshanks

Related works Chalk drawing, Victoria and Albert Museum (6139), illus. Rorimer 215; engraving of the principal figure by W. Shelton for *The Amulet*

Ref. Cole Diaries "11 Feb 1844 Called on . . . Mulready who said his price for his Bouquet wd be 200 gns" (But in fact, it was a gift to Sheepshanks.); Rorimer, p. 117; Stephens, List

Art Union, 1844, p. 156: "A small picture composed of two heads,—one that of an Italian noble of the palmy days of Venetian bravoism; the other that of his servant, who has just delivered to him a bouquet and a billet, intended for any hands rather than his. He clenches the flowers, and his eye is fixed in a muttered vow of vengeance. The style of the story is lucid and emphatic."

This painting grew as the artist worked on it. The catalogue entry (1864) explains: "The centre part of the picture is on panel, screwed into a zinc trough, and the edges filled in with cement of isinglass and whiting, and then prepared for painting, so as to give the Artist room to carry out an idea that had grown under his hands."

160 Measuring for Heights Sketch 1844

Textual source: Oliver Goldsmith, *Vicar of Wakefield*

Paper, 4¾ × 3¾

Location unknown

Exh. 1848 (LXI, "Painted in 1844"); 1864 (91)

Prov. Artist's Sale (428), bt Grundy; George Fox, his sale, Christie's, 12 May 1877 (134), bt in; Sir Bruce M. Seton, his sale, Christie's, 4 March 1912 (275), bt Permain

Related works This sketch was probably based on

193. Engraving by John Thompson after Mulready's design *Measuring for Heights*

Mulready's illustration, engraved by John Thompson, of the same subject (Plate 193) for J. Van Voorst's 1843 edition of Goldsmith's *Vicar of Wakefield*; a pen and ink drawing appeared Artist's Sale (334), bt Agnew

Ref. Account Book 1861 under "A Form for what may never come not an Estimate"—"Llewllyn (?)—oil of V of W 400"; Stephens, Addit. List

161 The Elopement Sketch 1844

Textual source: Oliver Goldsmith, *Vicar of Wakefield*

Paper, 4¾ × 3⅞

Location unknown

Exh. 1848 (LXII, "Painted in 1844"); 1864 (92)

Prov. Artist's Sale (429), bt Burton

Related works This sketch was probably based on Mulready's illustration, engraved by John Thompson, of the same subject for J. Van Voorst's 1843 edition of Goldsmith's *Vicar of Wakefield*; pen and sepia wash drawing, Victoria and Albert Museum (6571), 1864 (220), Plate 139

Ref. Account Book 1861 (see cat. 160); Stephens, Addit. List

162 Choosing the Wedding Gown Sketch 1844

Textual source: Oliver Goldsmith, *Vicar of Wakefield*

Paper, 4¼ × 3¾

Location unknown

Exh. 1848 (LIX, "Painted in 1844"); 1864 (89)

Prov. Artist's Sale (426), bt Agnew; Henry McConnel, his
sale, Christie's, 27 March 1886 (39), bt Agnew, thence to
J. Worthington, by descent to Mrs A. M. Worthington,
her sale, J. & H. Drew, 30 June 1939, bt Agnew, thence to
Sir H. Walpole
Related works Cat. 163
Ref. Account Book 1861 (see cat. 160)

163 Choosing the Wedding Gown 1845 (Color
Plate VII)
Textual source: Oliver Goldsmith, *Vicar of Wakefield*
Panel, 21 × 17¾
Victoria and Albert Museum, Sheepshanks Collection (F.A.
145)
Exh. R.A. 1846 (140); 1848 (XXXI); 1855 (889); 1864 (93);
Guildhall 1904 (88); Arts Council, *Great Victorian
Pictures*, 1978 (39)
Prov. John Sheepshanks
Related works Oil sketch (cat. 162); this painting was based
on Mulready's illustration, engraved by John Thompson
for J. Van Voorst's 1843 edition of Goldsmith's *Vicar of
Wakefield*; red chalk and pencil cartoon, Private Col-
lection, R.A. 1844, 1848 (LXIX), 1864 (229), Plate 136; a
chalk sketch appeared 1864 (219); a pen and ink drawing
appeared Artist's Sale (431), bt Agnew; and a small
watercolor was said to be in the collection of Albert
Millard, 1968; engravings by W. J. Linton, J. and G. P.
Nicholls in *Art Journal*, 1864, W. L. Thomas in *London
Society*, 1866, F. Heath in *Art Journal*, 1869; chromo-
lithograph by V. Brooks; mezzotint by George Sanders
Ref. Account Book 1844 "J Sh[eepshanks] . . . on Acc: of
Wedding Gown 250"; in 1845 "J Sh[eepshanks] . . .
balance for Wedding Gown 275" (Stephens, p. 95 n.
claims Mulready received 1000 gns.); Cole Diaries "16
Feb 1845 . . . [Mulready] shd me his painting of the
Wedding Gown just begun with the Spaniel painted—";
and "9 March 1845 Called on Mulready—He had just
finished the hands of the Vicar in the Wedding Gown'';
and "21 March 1845 Called on Mulready. he at Wedding
Gown: just done the Vicars dress"; and "15 June 1845
Called on Mulready: He had nearly finished the Ladys
Yellow gown of the Wedding Gown:"; and "24 August
1845 Called on Mulready: He had painted Mrs. Primrose
face. it looked petite—His son, myself & himself did not
like it. others did very much"; and "14 December 1845
. . . went afterwards to see Sheepshanks' Collect:
Mulready's Wedding Gown there"; and (re: restoration
of the painting over a decade later) "Nov 1 1857 . . . At
Mulreadys . . . told him of his Wedding Gown cracking";
and "Nov 6 1859 Called on Mulready who showed how
the spittle & finger marks of the Public had damaged his
Wedding Gown"; and "18 December 1859 . . . With
Hennie [Cole's daughter] to call on Mulready who had
just repaired the Wedding Gown"; see also Ch. VI, n. 58
for Prince Albert's request for a copy of this painting; *Art
Union*, June 1846, p. 175; *Athenaeum*, 16 May 1846;
Gautier, pp. 27–29; for B. R. Haydon's remarks, see

Ch. IV, n. 59; for *Illustrated London News*, see p. 144,
Redgrave, II, pp. 243, 318–19; G. Reynolds, *Victorian
Painting*, London, 1966, p. 14; Ruskin, *Works*, IV, p. 336
and XIV, pp. 300–1; Stephens, List and pp. 64, 82,
95–7. For a more extensive listing of Victorian references,
including liberal quotations therefrom, see Arts Council,
Great Victorian Pictures, 1978 (39).
Examiner, 1846, p. 293: "Perhaps the gem of the collection,
the 'belle of the season', is Mr. Mulready's 'Choosing the
Wedding Gown.' It is a work which English artists might
send anywhere, saying 'This is a production of our
school.' . . . 'Choosing the Wedding Gown' is such a picture
as we could conceive one of the first Dutch masters painting,
had he lived all his life amid English society of our day. . .
'The Choice of a Wedding Gown' is a subject which admits
of the artist indulging in the deepest luxury of colour
without appearing unnatural. The richness of the stuffs in
the foreground, the harmonising browns of the counter, the
equally rich pure blue in which both are set, are real: only
expressed to ordinary eyes as intensely as the painter himself
feels them. This is art: the power of reproducing in words,
tones, outlines, or colours, any object whatever as it appears
to the poet-artist. In so far as colour and form are concerned,
this work need not fear comparison with the best Dutch
painting of the same class. In nice discrimination of
character—the solemn insinuating mercer and his shrewd
comely spouse—it is equal to any of them; and in the
delicate sentiment impressed on bride and bridegroom it is
superior."
W. M. Thackeray, *Morning Chronicle*, 5 May 1846 (in
Contributions to the Morning Chronicle, edited by Gordon N.
Ray, University of Illinois Press, Urbana, 1955, p. 144): "If
the works of Gerard Douw and Micris fetch enormous
prices now, some future Sir Robert Peel will one day pay
down a family's handsome maintenance for the possession of
this admirable picture. For colour and finish it may rank by
any cabinet picture of any master. It does not create pleasure
merely, but astonishment. . . . A blaze of fireworks is not
more intensely brilliant: it must illuminate the whole room
at night, when everybody is gone, and flare out like a
chemist's bottle—one is obliged to resort to extravagancies
and caricatures in merely attempting to give an idea of its
astounding power and brilliancy. Such a picture as this
ought to be sent abroad, for the credit of the country, and to
show what English artists can do."

164 Haymaking Sketch 1844
Textual source: Oliver Goldsmith, *Vicar of Wakefield*
Paper, 4¼ × 3¾
Location unknown
Exh. 1848 (LX, "Painted in 1844"), 1864 (90)
Prov. Artist's Sale (427), bt Agnew; Henry McConnell, his
sale, Christie's, 27 March 1886 (40), bt Agnew, thence to
J. Worthington, by descent to Mrs A. M. Worthington,
her sale, J. & H. Drew, 30 June 1939, bt Agnew, thence to
Sir H. Walpole

Related works Cat. 165; Thomas Agnew & Son, Ltd has a photograph of this painting in their archives
Ref. Account Book 1861 (see cat. 160); Stephens, Addit. List

165 Haymaking: Burchell and Sophia 1846–7 (Plate 137)
Textual source: Oliver Goldsmith, *Vicar of Wakefield*
Panel, 24 × 19½
Private Collection
Exh. R.A. 1847 (134); 1848 (XIX); Royal Scottish Academy 1852 (57); 1857 (362); 1862 (299); Manchester, *Jubilee Exhibition*, 1887 (907); Guildhall 1897 (102); Guildhall 1904 (125); Winchester College and Southampton Art Gallery 1955 (44); 1964 (22); Ottawa, National Gallery, *Paintings and Drawings by Victorian Artists*, 1965 (100); R.A. 1968 (195)
Prov. Thomas Baring, by descent to current owner
Related works Oil sketch (cat. 164); this painting was based on Mulready's illustration, engraved by John Thompson, for J. Van Voorst's 1843 edition of Goldsmith's *Vicar of Wakefield*; pen and sepia drawing, British Museum (1864-5-14), probably 1864 (182), Plate 138.
Ref. Account Book 1846 "July 24 Baring 300 [in payment for this and *Whistonian Controversy*]"; and 1847 "June 29 Baring 'Birchall & Sophia' 350"; MS. Catalogue of the Baring Collection "Mu.[lready] fixed £600 for the pair of Controv. [*Whistonian Controversy*] & this I pd. in all £1000"; Cole Diaries "March 1, 1846 Called on Mulready at work on Haymaking first time I saw the picture on the easel"; and 2 June, 1846 "With [David?] Cox to Mulreadys: He remarked that the drawing of the Haymakers was so perfect that [?] was the absolute creation"; *Illustrated London News*, 8 May 1847, p. 296; and 25 July 1863, p. 93; Redgrave, II, pp. 243, 319; Ruskin, *Works*, IV, p. 336 and XIV, p. 300; Stephens, List and pp. 64, 82; Waagen, *Treasures*, II, p. 189
Examiner, 1847, p. 293: " 'Sophia and Burchell' is bright colour, forming the center of as bright a landscape. The hayfield on the declivity of a hill, with the hanging grove in the background, are the ideal of an unpretending English landscape. The manly vigour of the poor gentleman, and the modest entire affection of Sophia, are exquisitely conceived. The uneasy backward glance of the good vicar, the unsuspicious repose of his wife, the somewhat listless loneliness of Olivia, and the tumbling of the two boys among the hay, are Goldsmith all over."
Ruskin, *Works*, XII, p. 364: "[It was] above his powers . . . the character of Sir William Thornhill being utterly missed."

166 The Butt—Shooting a Cherry *c.* 1822, taken up again 1847 (Plate 106)
Canvas (lined), 15¼ × 18
Victoria and Albert Museum, Sheepshanks Collection (F.A. 148)
Exh. R.A. 1848 (160); 1855 (891); 1864 (95); Arts Council, *English Romantic Art*, 1947 (55); 1964 (23)

Prov. John Sheepshanks
Related works Watercolor sketch of the composition, Glasgow Art Gallery (catalogued as "Open your Mouth and Shut your Eyes"); chalk drawing, Victoria and Albert Museum (6303), illus. Rorimer 106, probably 1864 (256); engravings by H. Bourne in *Art Journal*, 1869 and W. Thomas in *Illustrated London News*, 1869
Ref. Account Book 1847 "J Sh[eepshanks] . . . 'The Butt' [Long series of payments from February through December] 315"; and 1848 "Feb 6 J Sheepshanks balance for 'The Butt.' 210"; Cole Diaries, 15 Aug. 1847 "To Mulready's painting the butchers dog"; Cole MS. "The Butt—his own"; Cunningham, *Lives*, III, p. 278; Gautier, pp. 26–7; Redgrave, II, p. 319; Rorimer, pp. 74–5 quoting contemporary remarks; Ruskin, *Works*, IV, p. 336; Stephens, List and pp. 64, 82–3, 85, 87, 89, 97–101 and p. 6: "retained for not less than twenty-five years".
Art Union, 1848, p. 168: "There are in this picture qualities which Masaccio and his most distinguished followers did possess; and others for which they strove a life time,— qualities which we heartily wish had been bestowed upon another subject."
Examiner, 1848, p. 293: "For power and richness of colour this picture is marvellous. It lights the room all round it. . . The unobtrusively felicitous arrangement; the smallest details, even to the shape and colour of the hands of the "butt"; the play of the sunshine on the wall beneath the trees; everything combines to make perfect this masterpiece of art."
New Monthly Magazine, 1848 Part II, p. 230: ". . . one of the gems of the exhibition. If you see a very little picture, with a very large crowd assembled to see it, you may be pretty sure it is by Mulready."
Stephens reports how John Linnell found the canvas with a sketch upon it, long neglected in Mulready's studio; he encouraged Mulready to take it up again after a twenty-five years' hiatus.

167 Women Bathing, or The Bathers 1848–49 (Plate 148)
Millboard, 18 × 14
Dublin, The Hugh Lane Municipal Gallery of Modern Art (14237), on permanent loan to the National Gallery of Ireland
Exh. R.A. 1849 (135); 1864 (97); Manchester, *Art Treasures*, 1878; Grosvenor Gallery 1888 (115)
Prov. Thomas Baring; by 1878, Agnew, thence to E. C. Potter, his sale, Christie's, 22 March 1884 (37), bt Thomas Woolner, R.A., his sale, Christie's, 18 May 1895 (107), bt Vokins; Fairfax Murray, who presented the painting to the Municipal Gallery of Modern Art, Dublin, 1910
Related works Chalk drawing of an academic nude, signed W M July 8, 1848, St. Louis Art Museum (38: 1972)
Ref. Account Book 1849 "April 27 Baring Bathers 840"; Cole Diaries "12 Nov 1848 At Mulreadys. began his bathers"; for *Art Union*, see Ch. V, n. 18; Bodkin, *Dublin*

Magazine, p. 424; Stephens, List and pp. 87, 99; Waagen, *Galleries*, p. 100

Examiner, 1849, p. 325: "In truth, his 'Women Bathing' is little more than a graceful academical study. And yet in the clear delicate tints of his flesh, and in the exquisite keeping of his landscape and sky, there is perhaps as strong an evidence of his mastery over all the resources of colour, as in any of his richest and most striking productions."

Fraser's Magazine, July 1849, p. 76: "Mulready offers only two pictures, neither of them calculated to sustain, much less to advance, his reputation."

168 Blackheath Park 1851–2 (Plate 70)

Panel, $13\frac{1}{2} \times 24$

Victoria and Albert Museum, Sheepshanks Collection (F.A. 137)

Exh. R.A. 1852 (96); 1855 (890); 1864 (98); Guildhall 1904 (99); 1964 (26); Sheffield, Mappin Art Gallery, *Victorian Painting*, 1968 (162); Colnaghi's, *John Linnell and his Circle*, 1973 (129)

Prov. John Sheepshanks

Related works Pen and sepia wash drawing, Victoria and Albert Museum (E. 1800–1910) illus. Rorimer 107, 1864 (448) and another (272); also possibly cat. 205

Ref. Account Book 1851 "J Sheepshanks as below [calculations], Blackheath Pk. 150"; and 1852 "J. Sheepshanks balance for Blackheath Park 112.10"; Cole Diaries "17 August 1851 . . . Called on Mulready at work at Landscape of Blackheath. Sheepshanks there"; for the *Art Journal*, 1852, see p. 74; *Art Journal*, 1855, p. 282; Dafforne pp. 46–7 quoting French reviews; for Gautier, see p. 73; Horsley, p. 50; Redgrave, II, p. 309; Redgrave, *Memoir*, p. 92; Rorimer, pp. 76–7; Stephens, List and pp. 59–60; A. Staley, *The Pre-Raphaelite Landscape*, p. 172

Athenaeum, 1852, p. 519: ". . . a refreshing *green* bit of nature".

Examiner, 1852, p. 277: "Mr. Mulready [shows] only a bit of a landscape from one of the London suburbs, marvellous but small"; and p. 294: "Mulready's small picture . . . is perfect of its kind."

Art Journal, 1856, p. 78 (quoting M. Maxime Du Camp on British Art, Exhibition Universelle, Paris, 1855) "In landscape . . . Mr. Mulready is not fortunate. His 'Blackheath Park' all dry and crude, reminds one of a large agate stone, on which a mockery of vegetable life is traced. There is neither greatness nor reality in it; it is cold, poor, and without scope."

169 Bathers Surprised, or The Bathers, or The Nymph
c. 1852–3 (Plate 149)

Panel, $23\frac{1}{4} \times 17\frac{1}{2}$

National Gallery of Ireland (611)

Exh. 1855 (894, "Les Baigneuses"); 1857 (357, "The Bathers"); 1862 (301, "The Bathers"); 1864 (96, where it is incorrectly identified as the painting exhibited R.A. 1849); Manchester, *Art Treasures*, 1878; Guildhall, *Loan*

Collection of pictures and drawings by J. M. W. Turner and a selection of pictures by some of his contemporaries, 1899 (196); Guildhall 1904 (90); 1964 (25); R.A. 1968 (191); Columbus and Toledo, Ohio, etc., *Aspects of Irish Art*, 1974 (40); Bordeaux, Galerie des Beaux Arts, *Peinture Britannique; de Gainsborough a Bacon*, 1977 (124)

Prov. Thomas Baring; by 1878, Agnew, thence to E. C. Potter, his sale, Christie's, 22 March 1884 (38), bt Agnew; by 1899, Octavius E. Coope, his sale, Christie's, 6 May 1910 (24), bt Sir Hugh Lane, from whom purchased by the museum, 1911

Related works Chalk drawing, entitled *The Nymph*, National Gallery of Ireland (2913), 1864 (260); academic nude, signed with initials, dated 1853, with Christie's, 20 July 1976 (173) seems to be the same model for the central figure, as is the academic nude, Tate Gallery, illus. Heleniak, Part iii, p. 616; an ink and wash drawing of *Diana and Actaeon*, Cecil Higgins Art Gallery (Plate 152) and a pen and ink drawing of *Diana Transforming Actaeon into a Stag*, Victoria and Albert Museum (6264) are probably related to this painting.

Ref. Account Book 1852 "Aug 23 T Baring for Nymph 300", and 1853 "Dec 5 [?] Baring for Nymph 700" (total payment: £1000); Cole Diaries "22 August 1852 . . . Called on Mulready saw his bather front view a most lovely work met Thackeray & Leech & sent them to see:"; *Art Journal*, 1855, pp. 282–3; Bodkin, *Dublin Magazine*, p. 424; for Frith's remarks, see Ch. V, n. 8; Redgrave, II, p. 319; G. Reynolds, *Victorian Painting*, London, 1966, p. 26 where he mistakenly believes this to have been exhibited R.A. 1849; Stephens, List and pp. 87, 89, 99, 101; for Waagen, see Ch. V. n. 23.

Dafforne (p. 46) quoting the Paris *Moniteur*, 1855; "This is not the ivory of which Vanderwerf carves out his goddesses and nymphs; much less is it the deep amber with which Titian gives the rich bloom to his Venus, his mistress, and his courtesans—rather might we compare it to the blanched silver with which Correggio has modelled the torso of Antiope; but better than all that, it is the fairest skin of that swan's nest which floats upon the sea—a skin of that fine stuff which alone was worn by mother Eve before she sinned. Nothing is wanting to make it a perfect *chef-d'oeuvre* but a little of that style whereof Greece and Italy have monopolized the secret."

Redgrave, Memoir, p. 92 (10 April, 1853): " 'The Bathers,' upon which Mulready is now at work, is a monument of the same love and labour. Who but he could model the form and make it so complete? It is part of the same mind that produced Mr. Sheepshanks landscape [*Blackheath Park*, cat. 168], but I have my doubts if such art is worth its cost, and if it is not sometimes labour without perfecting."

Revue des Deux Mondes, quoted in the *Art Journal*, 1855, pp. 282–3: "The young girl in the foreground is drawn in a very defective style . . . Neither the torso nor limbs indicate a serious study of nature. It is of the class pretty well, but no more. To do justice to such a subject it would have been necessary to have studied the model for a considerable time

before proceeding to copy it. Mons. Mulready has not embarassed himself by such discretion."

170 The Young Brother, or Brother and Sister
completed 1857 (Plate 151)

Canvas, 30½ × 24¾

Tate Gallery, Vernon Collection (396)

Exh. R.A. 1857 (24); 1864 (99); 1964 (24)

Prov. This work was commissioned by Robert Vernon (1774–1849) but was not finished until eight years after his death. Mulready was paid by the executors of Vernon's will in 1857.

Related works This is an enlarged version with some variations of *Brother and Sister* (cat. 147); engraving by R. C. Bell; an enamel miniature after this painting by G. Gray appeared R.A. 1859 (707); see sketch or possibly copy by another hand (cat. 204)

Ref. Account Book 1857 "April 8 Vernon 'Young Brother' 1050"; Cole Diaries, 17 Feb. 1856 "Mulreadys. At work on Pinching the Ear 'large',", and 15 March 1857 "To Mulreadys with children & Thackerays—His picture of brother & sister finished:-," and 22 March 1857 "With RR [Richard Redgrave] to Mulreadys He wished to keep his copyright of Mr. Vernon's picture"; Cunningham, *Lives*, III, p. 278; R. Liebreich, "Turner and Mulready On the Effect of Certain Faults of Vision on Painting, with Especial Reference to their Works", *Macmillan's Magazine*, XXV, 1872, 499–508; *Literary Gazette*, 1857, p. 449; J. Maas, *Victorian Painters*, London 1969, p. 107; Stephens, List and pp. 64, 89

Examiner, 1857, p. 278: "A sister holds him, and an elder brother tickles him lovingly behind the ear. His gesture and expression are delightful."

Ruskin, *Works*, XIV, p. 100: "Without exception, the least interesting piece of good painting I have ever seen in my life"; and p. 222: ". . . succeeds in using more skill in painting Nothing than any other painter ever spent before on that subject".

171 The Lesson, or Just as the Twig is bent the Tree's inclined 1859 (Plate 114)

Quotation: Pope, *Moral Essays* Ep. I, 1.150

Panel, 17½ × 13½ (within oval frame)

Victoria and Albert Museum, Sheepshanks Collection (F.A. 236)

Exh. R.A. 1859 (167); 1862 (298); 1864 (100); Nottingham University, *Victorian Painting*, 1959 (52)

Prov. John Sheepshanks

Related works Twelve pen and ink drawings, Victoria and Albert Museum, illus. Rorimer 167–78 (Plate 23), 1864 (476); a chalk cartoon appeared R.A. 1858 (see Ref.), 1864 (308); and a study for the head of the mother appeared 1864 (309); an outline drawing appeared Artist's Sale (332), bt Milbank

Ref. Account Book 1857 "YM car: Dᵒ[Young Mother cartoon: worked on]"; and 1858 "Car[toon]: Y M work

[Young Mother]"; and 1859 "May 2 Birchall for Young Mother. Cartoon 315"; Cole Diaries, 13 March 1859 "Saw his [Mulready's] last 6 months drawing his mother & child", and 18 September 1859 "After dinner with them to Mulready's—at work finishing the Mother & Child—"; *Art Journal*, 1859, p. 164; Palgrave, p. 23; Redgrave, II, p. 319; Rorimer, pp. 104–6; Ruskin, *Works*, XIV, pp. 221–2; Stephens, List and pp. 4, 89, 100–1

Examiner, 1859, p. 277: "Mr. Mulready is a contributor of a delightful bit of colouring, a mother with a rather large boy on her knee in naked prayer. The art of the painter has disdained his nightclothes."

172 The Toyseller unfinished *c.* 1857–63 (Color Plate VIII)

Canvas, 44 × 56

National Gallery of Ireland (387)

Exh. R.A. 1862 (73); 1864 (101); R.A. 1968 (217)

Prov. Artist's Sale (506), bt Agnew for Charles P. Matthews, his sale, Christie's, 6 June 1891 (94), bt Doyle for the museum

Related works Chalk drawing (Head of a Negro), signed and dated "R.A. 12 March 1858 WM", Mr and Mrs Vincent E. Butler, 1864 (297), (Plate 104); another "Negro in black chalk" appeared in the Artist's Sale (305), bt White; eight pen and ink drawings, Victoria and Albert Museum, Rorimer 167–74 (many illus.), probably 1864 (342, 349, 354); see smaller, earlier version (cat. 141)

Ref. Account Book 1836 "Jan Outline of 'Black', full size"; and 1857 "Black worked on"; and 1858 "June [?] 30 Work on Black . . .", and 1861 under the heading "A Form for what may never come Not an Estimate": "T Baring Black 2100"; Michael Mulready, Diary Notes, Tate Gallery MS. 7216.31 (July 1863), ". . . a letter from Mr Baring about his Picture of the Toyseller" (Thomas Baring never purchased the painting). Cole mentions Mulready's progress on the work quite often in his Diaries, for example "13 March 1859 [Mulready at work on] his large picture of The Black"; or on 4 Jan. 1863 "His [Mulready's] large picture of the Toyseller still on hand"; *Athenaeum*, 1 Feb. 1862, p. 159 and 3 May 1862, p. 601; Redgrave, II, p. 319; Rorimer, pp. 102–3; Stephens, List and pp. 64, 81, 89 and 101 (where he reports that Russell Ward, son of E. M. Ward, R.A., modelled for the child)

Examiner, 1862, p. 279: "With fair, soft, brilliant flesh, that looks as if a touch would dimple it, a child in a fair nurse's arms, and partly rested on her yellow shawl, averts its eyes from the face of *A Toyseller*, in red vest, because he is black, although he sounds a tempting rattle and looks innocent enough. The sentiment is pleasant and well expressed but as a delightful study of human form and of the artistic, but unaffected management of colour, this picture by Mr. Mulready is not to be surpassed."

Mulready's Account Book suggests that this large painting was intended for his patron Thomas Baring, which is confirmed by the brief note in Michael Mulready's Diary

Notes (see Refs.). Baring did not take the opportunity to buy it in the Artist's Sale; perhaps he objected to its unfinished condition.

173 Landscape Sketch
Location unknown
Prov. Artist's Sale (496), bt C. Russell

174 Still-life with Bottle Sketch
Location unknown
Prov. Artist's Sale (491), bt Agnew, thence to W. P. Frith

175 Vegetables and a Bottle Sketch
Location unknown
Prov. Artist's Sale (491), bt Agnew, thence to W. P. Frith

176 A Turk's Head Sketch
Location unknown
Prov. Artist's Sale (488), bt Mylne

177–8 (2) Imitation(s) of Ostade Sketches
Location unknown
Prov. Artist's Sale (493), bt H. White

179 Old Man's Head Sketch
Location unknown
Prov. Artist's Sale (497), bt Agnew; see also cat. nos. 193, 203

180 Group of Children Sketch
Small
Location unknown
Prov. Artist's Sale (490), bt Bicknell
This may be the oil sketch which was recently sold at Christie's, 16 July 1976 (55). See cat. 183.

181 A Boy's Head Sketch
Location unknown
Prov. Artist's Sale (485), bt Cox

182 A Boy's Head Sketch
Location unknown
Prov. Artist's Sale (486), bt Cox

183 The Young Pugilists Sketch (Plate 194)
Board, 6 × 8½
Signed with initials
With Christie's, 16 July 1976 (55)
Prov. . . . ; Sotheby's Belgravia, 23 April 1974 (62)
This may be the oil sketch, *Group of Children* (cat. 180), sold in the Artist's Sale (490). Perhaps it is an oil sketch for *Boys Playing Cricket*, 1810 (cat. 63, now lost). One of the central characters leans on his bat while a schoolmaster and dame sort out the participants of a fight, a scene reminiscent of *The Fight Interrupted*, 1816 (cat. 93).

194. *The Young Pugilists* Oil on board, 6 × 8½. With Christie's, 1976 (cat. 183)

184 A Girl in a Landscape
Location unknown
Prov. John Jeffries Stone, his sale, Christie's, 7 June 1880 (34), bt Joy (?)
For Mr Stone, see cat. 125.

185 Cottage Interior
Location unknown
Prov. John Jeffries Stone, his sale, Christie's, 7 June 1880 (41), bt M.S.
For Mr Stone, see cat. 125.

186 Children Gathering Fruit
Location unknown
Prov. John Jeffries Stone, his sale, Christie's, 7 June 1880 (42), bt Restill
For Mr Stone, see cat. 125. A pen and ink drawing of boys climbing a tree and gathering fruit, collection of Lorenz Eitner, may be a study for this lost painting.

PAINTINGS BY WILLIAM MULREADY AND OTHERS

Mulready assisted Robert Ker Porter (1777–1842) with the following panoramas:

187 The Battle of Alexandria 1802
Canvas panorama, 22′ × 135′
Location unknown (probably destroyed)
Exh. The Lyceum, May 1802
Related works Sketch for a battle scene, pen and ink drawing, Victoria and Albert Museum (6002), illus. Rorimer 308, may be related to Mulready's work on Ker Porter's panoramas; the British Museum holds the advertising broadsheet designed by Ker Porter which incorporates sketches from the panorama.
Ref. For Robert Ker Porter's Diary, 1802, collection of Mr

Rodney Searight, see Ch. I, n. 161; M. Ancketill, *Rediscovery of Sir Robert Ker Porter (1777–1842)*, scheduled for publication London, 1980.

188 The Battle of Lodi 1802
Canvas panorama, 22′ × 135′
Location unknown (probably destroyed)
Exh. The Lyceum, January 1803
Related works and ref. see cat. 187

189 The Battle of Agincourt 1804–5
Canvas panorama, in three parts 23′ × 56′, 23′ × 24′, 23′ × 20′
Destroyed in World War II
Exh. Egyptian Hall, Mansion House, London, *c.* 1808–11; Guildhall *c.* 1823 and thereafter it was brought out for two weeks every three or four years until 1850; Guildhall 1866 and again 1880
Prov. Presented by Robert Ker Porter to the Corporation of London in 1808; it was sold by the Corporation of London in 1886 (*Athenaeum*, 16 Oct. 1886).
Ref. Account Book 1805 "Assisted Rob Ker Porter in his Battle of Agincourt. he never paid me."; Cole (Diaries, 1 Jan. 1844) reported how Mulready was still smarting at this non-payment years later; M. Ancketill, *Rediscovery of Sir Robert Ker Porter (1777–1842)*, scheduled for publication London, 1980
Building News, 1 Oct, 1880, p. 397: "Last week a monster painting was exposed to view at the Guildhall, after having lain in an out-of-the-way corner of the Mansion House for many years. Occasionally, it is stated, the picture had been used as a screen at the Mansion House . . . the condition of the picture, only about 60 years old, is disgraceful. The large fragment shows the battle between the French and English armies; it is crowded with spirited figures of soldiers in the thick of battle; some have fallen under the flight of arrows, and others are fighting with vigour. One of the smaller pieces on the left is particularly noticeable for the bold scenery, with a castle situated on an eminence, and a well-painted group of horsemen in the foreground in deadly contest. The painting of the other portions exhibit a winding river among fertile meadows, and hills in the distance, with figures in the foreground. One section shows the retreat of the French army, and the other an advancing column of the English passing through a wooded country."

W. Mulready, Harriet Gouldsmith
190 A Cottage *c.* 1806–11
Location unknown
Prov. . . .; by 1839, Robert Vernon, sold Christie's, *c.* 1849
Ref. Vernon Heath, *Vernon Heath's Recollections*, London, etc., 1892, p. 347
Harriet Gouldsmith was Mulready's friend and pupil in 1806. For a discussion of her, see Ch. I.

Harriet Gouldsmith, W. Mulready, John Linnell
191 Landscape with Cottage and Figures *c.* 1806–11
Location unknown
Prov. John Jeffries Stone, his sale, Christie's, 7 June 1880 (43), bt Vokins

John Linnell was Mulready's close friend and near pupil in the early years of the century. Harriet Gouldsmith was Mulready's pupil in 1806 and was also acquainted with John Linnell. For a discussion of their friendship, see Ch. I. John Jeffries Stone was a friend of Mulready's and the artist evidently gave him a number of paintings.

PAINTINGS ATTRIBUTED TO MULREADY

192 Boy with a Dog
Canvas, 25 × 20
Private Collection of J. H. Appleby, Jersey
Prov. Mrs Horace Wyndham (née Ethel Mulready), William Mulready's great-grand-daughter
Family tradition assigns this portrait to Mulready, although it could be by one of his sons. The subject has not been identified.

195. *The Artist's Father* (?) Oil on panel, 6½ × 5. Courtesy of the National Gallery of Ireland, Dublin (cat. 193)

193 Portrait of the Artist's Father (?) (Plate 195)
Panel, 6½ × 5
National Gallery of Ireland (616)
Prov. . . .; Sir W. Thornley Stoker, his sale, Dublin 1910, bt by the museum

This may be an early oil sketch by Mulready. There is some resemblance between this man's face and that of Mulready's father who modelled for the schoolmaster in *Idle Boys* and *The Fight Interrupted*. But the resemblance is not conclusive. Perhaps this is *Old Man's Head* (cat. 179).

196. The Lock Gate Oil on millboard, $12\frac{1}{8} \times 9\frac{7}{8}$. Yale Center for British Art, Paul Mellon Collection (cat. 194)

194 The Lock Gate (Plate 196)

Millboard, $12\frac{1}{8} \times 9\frac{7}{8}$
Yale Center for British Art, Paul Mellon Collection (2034)
Inscription on back: "Sketch from Nature by W. Mulready", and on handwritten label: "This charming bit of painting by W. Mulready was bought by Mr. Wyatt of Oxford at Mulready's Sale and exchanged by him with W. Delamotte, artist. From his son Philip Delamotte it passed to me Geo. Gaskoin." No Wyatt is listed as a buyer at the Artist's Sale (although an agent could have acted on his behalf) but more importantly, "W. Delamotte, the artist" died in 1863, a year before the Artist's Sale. Clearly the label is not to be trusted. If it is by Mulready this painting is much slicker, much glossier than any of his known open-air oil sketches (*c.* 1806) and it features a shade of near violet not to be found in any of his early landscapes.

195 Landscape with Farmhouse

Canvas, $19\frac{5}{8} \times 26\frac{1}{4}$
Cork, Crawford Municipal Art Gallery (70)

Exh. Leicester, *One Hundred Years of British Landscape Painting*, 1956; Dublin Municipal Art Gallery, *Bodkin Collection*, 1962 (53)
Prov....; Thomas Bodkin
This landscape has been attributed to Mulready with good reason. The dry, crisp application of paint, the precise rendering of the foreground pond with vegetation and ducks, the leaden sky and the placement of the substantial farm buildings parallel to the surface of the painting all suggest Mulready. However, it is rather large for a Mulready painting in this vein, and one does miss human activity, a common ingredient in Mulready's early landscapes *c.* 1807–10 which it most nearly resembles.

196 The Village

$15\frac{3}{8} \times 12\frac{9}{16}$
Location unknown
Prov....; Warneck Collection, sold Hotel Drouot, Paris, May 1905 (17)
Known only by an engraving (Witt Library), this village street scene appears to be by Mulready. The near cottage at the right is very similar to *An Old Cottage, St. Albans*, and the sloping pebble-strewn road is much like that in *An Old Gable*. One would however expect to see some human figures in a Mulready cottage scene.

197 A Snow Scene

Panel, $12 \times 17\frac{3}{4}$
Tate Gallery (1038)
Exh. R.A. 1876 (20)
Prov....; (?) Christie's, 25 March 1865, bt Marshall; by 1876, W. Fuller Maitland, from whom purchased by the muscum in 1878
Ref. Stephens, Addit. List; Redgrave (II, p. 247) mentions a painting entitled "Village Gossips" which may refer to this work; for color reproduction, see *Illustrated London News*, Christmas No., 20 Nov. 1940
There are no sketches of snow scenes in Mulready's many landscape drawings. However the slate-grey sky and the sturdy peasants gossiping in the foreground are very reminiscent of Mulready's early landscapes. Perhaps it is *A Conversation* which appears in Mulready's Account Book in 1809 & 1810 (cat. 58). Another "Snowy Village Scene," 15×18, signed on panel, was sold 11 May 1978 (330) by Henry Spencer, Retford, but I was unable to examine the painting.

198 Rustic Charity

Millboard, 12×10
Signed W. MULREADY, lower left
Southport, Atkinson Art Gallery
Prov....; bequeathed to the Gallery by Mr Bell in 1929
In style this painting is closest to Mulready's early landscapes *c.* 1807–10. However, the cottage seems weakly drawn and at the same time too slickly delineated for a Mulready cottage scene. Moreover, the signature written in large capitals is unusually obtrusive. Mulready's signature

was often cleverly concealed or painted in subtle tones to blend with the background. Today they are often barely visible. The theme itself was extremely popular. William Collins' version of *Rustic Charity*, R.A. 1834 (112) comes closest to this example. It too features three small children on the left offering sustenance to a seated elderly vagrant on the right.

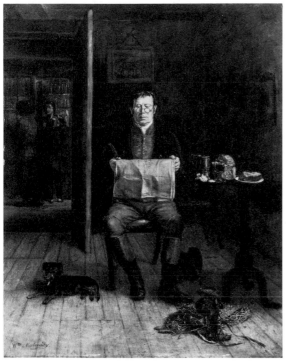

197. *Squire in a Tavern* Oil on panel, $20\frac{7}{8} \times 16\frac{15}{16}$. Courtesy of the National Gallery of Ireland, Dublin (cat. 199)

199 Squire in a Tavern (Plate 197)
Panel, $20\frac{7}{8} \times 16\frac{15}{16}$
Signed Wm Mulready, lower left
National Gallery of Ireland (1382)
Prov. . . .; Monsignor John K. Ryan, gift to the museum 1958
This may be an undocumented work by Mulready. It is reminiscent of Mulready's early somber Dutch-like interiors *The Rattle* and *A Carpenter's Shop and Kitchen*, both of 1808. But these works are more skillfully, more finely painted than the panel under consideration. If it is by Mulready, its weak drawing and perspectival problems suggest a date earlier than the above two paintings. But in many respects this painting comes closest to another work attributed to Mulready which exhibits the same faults: *The Letter*, 20 × 24, bearing a signature and dated 1843 (with M. Newman Ltd 1970). This painting depicts a similar interior

with a central figure reading a letter surrounded by his family; a postman leaves through a rear door at the left. It is certainly not by Mulready who in 1843 was at the height of his powers. Perhaps *Squire in a Tavern* is not an early work by Mulready but a later panel by the unknown artist who painted *The Letter*.

200 The Farrier's Shop, or The Forge, or The Blacksmith Shop (Plate 198)
Canvas, $16\frac{1}{8} \times 20\frac{1}{2}$
Cambridge, Fitzwilliam Museum (952)
Prov. Mrs Gibbons, Mrs B. Gibbons, her sale Christie's, 5 May 1883 (27, "The Smithy"), bt Agnew, thence to A. D. Jardine who returned it to Agnew in 1885, bt T. Woolner, R.A.; Joseph Prior, by whom bequeathed to the museum in 1919
Exh. Grosvenor Gallery 1888 (114); Paris, Palais des Beaux-arts, *La Peinture romantique anglaise et les préraphaelites*, 1972 (199); Colnaghi's, *John Linnell and his Circle*, 1973 (123); Hazlitt, Gooden & Fox, *Landscapes from the Fitzwilliam*, 1974 (36)
Ref. Stephens, Addit. List.
This has been accepted as unquestionably a Mulready painting although it is neither signed nor dated, was not exhibited during his lifetime nor at the memorial exhibition in 1864 and cannot be identified with any work listed in the Artist's Sale or in his Account Book. Since Mr John Gibbons (died 1851) collected works reliably associated with Mulready, this painting, the property of Mrs Gibbons (and presumably purchased sometime after 1864 since the work was not included in the memorial exhibition, South Kensington Museum which received Mrs Gibbons' full cooperation) has assumed the same aura of authenticity. In fact, its color is fresher and brighter than his other known early works and the paint application, while too precise by Mulready's standards in the depiction of leaves, is rather soupy in the roof of the shop and in the right foreground

198. *The Farrier's Shop* Oil on canvas, $16\frac{1}{8} \times 20\frac{1}{2}$. Fitzwilliam Museum, Cambridge (cat. 200)

area and not as dry in the rendering of stonework as is true of Mulready's landscapes of the early teens (*The Mall, Kensington Gravel Pits* and *Near the Mall*) which it most nearly resembles. Unless or until a securely documented Mulready landscape appears which exhibits these traits, the attribution of this painting should remain in some doubt.

201 Country Fish Hawker
Panel, 11 × 14
Collection Mr and Mrs J. Ambron
Prov. . . .; by 1870, Rodgett Collection; James Price, his sale, Christie's, 15 June 1895 (22), bt Currie; . . .; Christie's, 8–9 Nov. 1973 (68), bt Unicorn Gallery Ltd, thence to private collection; by 1976, Unicorn Gallery Ltd, thence to present owners
This may be an early oil sketch by Mulready for a painting never undertaken by the artist. In composition it most closely resembles *The Village Buffoon* of 1815–16 and *The Travelling Druggist* of 1825 (especially the oil sketch). However, this panel is rather large for one of Mulready's oil sketches and the woman's sharply defined features seem out of place in Mulready's oeuvre.

199. *Interior* Oil on copper, 24 × 20. Lord Dartmouth (cat. 202)

202 Interior (Plate 199)
Copper, 24 × 20
Collection Lord Dartmouth
This charming scene of a small boy seated at a table eating while his dog looks on, has been ascribed traditionally to Mulready by its owners (successive Earls of Dartmouth). But this attribution is troubling. Mulready painted portraits of Frances Charlotte Talbot, Countess of Dartmouth (cat. 114), 1827–8 and Charles Legge (cat. 110), *c.* 1825 and since this painting is one of two paintings ascribed to Mulready in the possession of the Legge/Dartmouth family

(the other being the very fine portrait of Fanny Talbot, pl. 158) one might imagine that this would be the latter portrait. But this painting exhibits very weak drawing, inaccurate perspective and is painted on copper (a support which Mulready is not known ever to have used). Moreover, the boy's features are barely visible, which makes one wonder if it would have been labelled a "Portrait of Charles Legge" as the 1825 painting was described in contemporary accounts. The matter is complicated by the fact that "Charles Legge" has not been identified. Frances Aylesford, Countess of Dartmouth commissioned the portrait in 1825 and the only Charles in her immediate family was her third son Arthur Charles Legge (b. 1800) who would have been 25 at the time of the commission (not a young boy as is the figure in this painting). Perhaps this painting under consideration is the work of one of Mulready's pupils in the Legge/Dartmouth family, painted under his tutelage, perhaps even with his help. Both Frances Aylesford and Frances Talbot, Dowager Countess and Countess of Dartmouth took lessons from Mulready, as did other members of the Legge/Dartmouth family. This could account for its weak execution and its stylistic dependence upon Mulready.

203 An Old Man at a Gate
Panel, 8 × 6⅞
With Phillips Auctioneers, London 1978
Prov. . . .; Geoffrey Hutchinson; Lord Ilford
This appears to be an oil sketch by Mulready (*c.* 1820s). Perhaps it is an *Old Man's Head* (cat. 179).

204 The Young Brother Sketch (?)
Canvas, 30 × 24
London, Somerville & Simpson Ltd
Prov. . . .; Christie's, 29 September 1977 (41, "Family Affection"), bt Somerville & Simpson Ltd
This undocumented painting appears to be an unfinished study for *The Young Brother* in the Tate Gallery (cat. 170). In support of this attribution, the painting resembles Mulready's late works and it is painted on a stretcher supplied by Charles Roberson, 51 Long Acre, the source for two of Mulready's canvases from the 1840s (cat. nos. 155, 167). But it is a problematic work.
While Mulready occasionally produced oil sketches for his finished oils, they were always much smaller and decidedly less detailed than the finished painting. Yet this oil is approximately the same size, and although unfinished in parts, considerably more detailed than any documented oil sketch by the artist. Mulready also did more than one version of a theme on occasion, but the paintings were never the same size, and the compositions were generally varied (as for example in the two documented versions of this subject: cat. nos. 147, 170). However, one factor might account for the appearance of this uncharacteristic work in Mulready's late oeuvre. Mulready received a commission to paint the Tate Gallery's canvas from Robert Vernon before he died in 1849; the painting was not completed until 1857,

200. *Young Girl with a Basket of Eggs* Oil on canvas, 30 × 24⅞. Ulster Museum, Belfast (cat. 206)

an unusually long time even by Mulready's standards. Was this canvas under consideration a false start—put aside by the artist because of some difficulty? Certainly the figure on the right and the foliage above him are unsatisfactory. But again, this was not his practice. He was more likely to take up the same canvas, scrape it down and repaint it (see for example cat. 166). The only other oil sketches or replicas of a Mulready painting which are the same size as the original but not in the artist's hand (see cat. 157) were also based on a Mulready painting in the Vernon Collection, which suggests that the Vernon paintings were available for full-scale copying at one time (a practice which is no longer allowed). This painting may be an uncharacteristic oil sketch by Mulready or perhaps a very skillful early copy by an unknown hand.

205 The Pool
Canvas, 20 × 24
Victoria and Albert Museum, Townshend Bequest (1839–69)
Exh. Cork 1971 (85)
Prov. By 1854 or 1856, Chauncey Hare Townshend, his bequest to the Museum
Ref. Waagen, *Galleries*, p. 178
This painting does not resemble Mulready's early landscapes (pre-1814) nor does it resemble his one late landscape

Blackheath Park (cat. 168). Had it not been discussed as early as 1857 in Waagen's study, one would doubt its attribution to Mulready. And since it fits so uneasily into his landscape ouevre, one should retain some uncertainty over the identification. The feathery touch of the brush suggests a study or sketch (although by Mulready's standards, it would be rather large for that). If by Mulready, perhaps it was done about the same time Mulready painted *Blackheath Park* (*c.* 1851), showing the pond from another angle.

206 Young Girl with a Basket of Eggs (Plate 200)
Canvas, 30 × 24⅞
Signed W Mulready., lower left
Ulster Museum
Prov. . . .; A. Thompson, from whom purchased by the museum 1962
Aspects of this painting are very close to Mulready's late painting *The Lesson*. The treatment of the trees, especially the leaves, with their dry, crumbly effect is remarkably similar. But certain elements are jarring and inconsistent with Mulready's production, even in a late work where one might expect a falling off in skill. The folds in the woman's dress are unusually harsh, scarcely suggesting a soft, pliant material. The dog is weakly drawn, far removed from the living, breathing animals contained in *The Butt—Shooting a Cherry* or *Giving a Bite*. Perhaps it is the work of his less skillful son, William Mulready, Jr, who painted in his father's style.

227

Notes

NOTE TO PREFACE

1. Sir Henry Cole, Diaries, 12 Nov. 1848, Victoria and Albert Museum Library.

NOTE TO INTRODUCTION

1. John Ruskin, *The Works of John Ruskin*, eds. E. T. Cook, and Alexander Wedderburn, London 1903–12, XII, p. 364; hereafter cited as Ruskin, *Works*.

NOTES TO CHAPTER 1

1. Mulready's name appears frequently in William Godwin's MS Diary in 1805 (Bodleian Library, Oxford University; microfilm, Duke University Library). There are references to meetings and discussions with Mulready beginning 15 March 1805. The biography is first mentioned on 15 July 1805; the preface is noted on 15 September 1805. This Diary was brought to my attention by William Pressly.

2. Sir Henry Cole's Diaries, Victoria and Albert Museum Library. Hereafter cited as Cole's Diaries. Sensitive perhaps to his humble origins, Mulready at first shied away from the thought of republishing the work, believing that "it would still do him harm" (3 Feb. 1843). However, by 1847 he changed his mind and agreed to a reprinting (12 Dec. 1847). The reprinting was not undertaken until 1885, long after his death.

3. Tate Gallery, MS. 7216.30. Purchased by them at Sotheby's, 28 March 1972, 438.

4. There was no central repository for the registration of births in Ireland until 1864. The Roman Catholic Cathedral, Ennis, County Clare, has no baptismal records before 1843. The baptismal registers for the Anglican parish of Drumcliff (including Ennis) were not preserved before 1841. Without primary material one must rely on the birthdate of 1 April 1786 cited by William Godwin and by F. G. Stephens (*Masterpieces of Mulready*, London, 1867, later revised with additional material: *Memorials of William Mulready, R.A.*, London, 1890; hereafter cited as Stephens, *Memorials*). Godwin had direct access to the youthful Mulready and Stephens conferred with Mulready's immediate family when writing his biography shortly after Mulready's death. 30 April 1786, sometimes cited as his birthdate in nineteenth-century accounts, should be discounted. (See, for example, Samuel Redgrave, *Dictionary of Artists of the English School*, London, 1874, pp. 287–8.)

5. Stephens, *Memorials*, p. 9; and Richard Redgrave, *Richard Redgrave: A Memoir compiled from his Diary by F. M. Redgrave*, London, 1891, p. 278: "[Mulready's father] was very violent, was very fond of pugilists, and a great master of the noble science himself. This I know to be true, and that he trained up his son to the same love . . . [he] was very hot-tempered." Hereafter cited as Redgrave, *Memoir*.

6. E. R. Firestone, "John Linnell, English Artist: Works, Patrons and Dealers", Ph.D Dissertation, The University of Wisconsin, 1971, p. 29, note 39. Hereafter cited as Firestone.

7. Stephens, *Memorials*, p. 19.

8. An oil portrait at the National Gallery of Ireland is entitled *The Artist's Father* (Plate 195), and attributed to Mulready. There is a resemblance between this alert, forceful face and the old man featured in Mulready's paintings; but the resemblance is not conclusive.

9. William Mulready's manuscript notes on his family background, Tate Gallery, MS. 7216. 30.

10. Firestone, p. 35, pl. 9.

11. "Mrs Mulready gave me a letter with money which I returned and it was offered again but I refused." Linnell's Journals, annotated by A. H. Palmer. The Linnell Trust, made available to me by the kindness of Joan Linnell Burton.

12. William Godwin (pseud. Theophilus Marcliffe), *The Looking Glass . . .* , London, 1805. Hereafter cited as Godwin, *Looking Glass*.

13. Cole's Diaries 18 Aug. 1850.

14. For a history of the Irish in England, see J. A. Jackson, *The Irish in Britain*, London and Cleveland, 1963.

15. In view of this situation it is interesting to note that Mulready's important future patron Sir John E. Swinburne, Bart. felt obliged to relinquish Catholicism in order

to participate in public life. In a letter to Sir Robert Murray Keith, dated 30 July 1786 (Additional MS. 35537 ff. 42–3. British Library), he explained: "It was absurd to sacrifice my consideration in my own country, my prospects in life, to condemn myself to eternal insignificance by oblivion, for Tenets I did not believe, & ceremonies I never practised." Just two months later he was recalled from Europe to stand for a Parliamentary seat. Additional MS. 35537, f. 132, British Library.

16. Julia Swinburne's Greek grammar book, Victoria and Albert Museum Library. Mulready drawings in the Whitworth Art Gallery, University of Manchester are particularly rich in Greek jottings.

17. Dated 10 Feb 1812, Victoria and Albert Museum Library. His friend John Linnell received French lessons in exchange for drawing instruction in 1811.

18. Allan Cunningham, *The Life of Sir David Wilkie; with His Journals, Tours, and Critical Remarks on Works of Art; and a Selection of his Correspondence*, London, 1843, I, pp. 35–6. Hereafter cited as Cunningham, *Wilkie*.

19. Godwin, *Looking Glass*, p. 79; and Stephens, *Memorials*, p. 20. Mulready's parents contacted a Mr Neill and a Mr Baynes briefly, before approaching Mr Corbet. Stephens suggests that Baynes was James Baynes, a drawing master, and an exhibitor at the Royal Academy and in Suffolk Street from 1796 to 1837, and "in all likelihood [he] accompanied John Varley and George Arnauld, A.R.A. during that pedestrian tour in North Wales . . ."

20. There is an illustration of Banks' initial rejection of Mulready in J. T. Smith, *Nollekens and his Times*, ed. Wilfred Whitten, 2 vols., London, 1920 (first published 1828); see II.

21. Banks himself was not particularly reliant on preparatory drawings for his sculpture; he worked instead with increasingly developed clay models (C. F. Bell, *Annals of Thomas Banks, Sculptor, Royal Academician*, Cambridge, 1938, p. 7).

22. John Varley attended a drawing school *c*. 1794 at 12 Furnival's Inn Court and later assisted at 15 or 16 Furnival's Inn Court (Alfred T. Story, *James Holmes and John Varley*, London, 1894, pp. 206–7; hereafter cited as Story, *Varley*). But according to Joseph Farington, Mulready "called on Banks at 15—Banks brot. Him to me—obliged to get His living did anything in art & studied at Academy—not pupil to any . . ." Diary, 16 October 1815, Royal Library, Windsor Castle (Microfilm typescript, New York Public Library).

23. Stephens, *Memorials*, pp. 22–3. Mulready related this tale of Gothic foliage to Stephens who later suspected that Mulready meant Gothic statues, since a number of fifteenth-century figures removed from the London Guildhall entered Banks' possession some years after 1789, in which year the Guildhall was restored by George Dance the Younger.

24. Sidney C. Hutchison, "The Royal Academy Schools 1768–1830", *Walpole Society*, XXXVIII, 1960–2, 159.

25. Reference is made to Banks' methods in a letter of 1 March 1830 from his daughter Mrs Forster to Allan Cunningham: "he always recommended industry and persevering application, without which no great end could be attained . . ." Quoted in Bell, p. 6. Samuel Smiles (*Self Help*, 1958, [first published 1859], p. 173) also records Thomas Banks' motto as "Industry and Perseverance". He goes on to describe the importance of this motto for his pupil Mulready; discussed by Paul Usherwood, "The Painting of William Mulready, R.A., 1786–1863", M.A. Thesis, Courtauld Institute of Art, University of London, 1971. Of course, hard work was generally considered to be a principal virtue in nineteenth-century England.

26. It was dated 1800 in the catalogue of the exhibition following Mulready's death (London, Science and Art Department, South Kensington Museum, *A Catalogue of the Pictures, Drawings sketches, etc. of the late William Mulready, Esq., R.A.*, 1864, 115; hereafter cited as South Kensington Exhibition). There is some confusion with regard to Mulready's admission to the Schools. Did his admission on 23 Oct 1800 constitute permission to attend the Life Academy or to draw after antique casts? If the former, this drawing should be dated October; if the latter, the drawing should be dated soon after his admission to draw after antique casts and before the end of the year.

27. Kathryn M. Heleniak, "William Mulready, R.A. (1786–1863) and the Society of Arts", Part i, *Journal of the Royal Society of Arts*, July, 1976, pp. 465–9. Stephens incorrectly dated the Silver Pallet Award to 1802/3; other authors subsequently repeated the error.

28. Hutchison, *Walpole Society*, p. 159.

29. Joseph Farington, *The Farington Diary*, ed. James Greig, London, 1922–28, IV, p. 215. Hereafter cited as Farington.

30. She exhibited landscapes at the Royal Academy, the British Institution, and the Old Watercolour Society between 1811 and 1819 under the name Mrs Mulready and possibly again in 1828 at the Royal Academy under the name Eliza R. Mulready. The titles of the works (e.g., *Cottages, A Cottage, A Village Church*) suggest a similarity to her brother's and Mulready's landscape themes. The Witt Library has an engraving of St. John's Church, Chester dated 1801, after a drawing by E. Varley for Britton's *Beauties of England and Wales*.

31. Elizabeth Mulready's mother was a descendant of General Fleetwood, Lord Deputy of Ireland, who married Cromwell's daughter Bridget. Her father was believed to have been a tutor to the Earl of Stanhope (Story, *Varley*, p. 200). Her own brothers also rose to prominence as artists: John (1778–1842), Cornelius (1781–1873), and William (*c*. 1785–1856). Cornelius also distinguished himself in the realm of invention (See M. Pidgley, "Cornelius Varley, Cotman and the Telegraphic Telescope", *Burlington Magazine*, CXIV, 1972, 781–6).

32. A drawing by Mulready in the Henry E. Huntington Art Gallery is identified as Elizabeth Varley (59.55.954). It is a very candid study of a young woman with somewhat irregular features and an almost contemptuous expression.

Since the hair-style dates the drawing to the mid-nineteenth century when Elizabeth was an elderly woman, it can scarcely be a portrait of her. It remains an unidentified study.

33. Stephens, *Memorials*, p. 42. Mr Albert Varley, John Varley's eldest son, had the miniature in his possession. It is now lost.

34. James Dafforne, *Art Journal*, 1864, p. 131.

35. An investigation of local parish records did not disclose the wedding date for Elizabeth Varley and William Mulready or the baptisms of the four sons. The couple evidently separated in 1808 but as late as 19 Sept. 1809 they were both William Godwin's supper guests. William Godwin's Diary, Bodleian Library, Oxford University; microfilm, Duke University.

36. Stephens, *Memorials*, p. 73.

37. Michael Mulready's Diary Notes following his father's death, Tate Gallery, MS. 7216.31.

38. Cole's Diaries, 2 Oct. 1863: "M. Mulready willing to assist with details of father's life. I told him I should not enter into his family particulars." At this time Cole was attempting to find someone to undertake the writing of Mulready's life. Also, letter from Michael Mulready to Cole, dated 9 July 1863: "for family reasons the Funeral will be as quiet as proper respect for his memory will permit." (Victoria and Albert Museum Library) Such concerns with privacy were central to Victorian biographers; for discussion see A. O. J. Cockshut, *Truth to Life: The Art of Biography in the Nineteenth Century*, N.Y., 1974.

39. Story, *Varley*, p. 241.

40. Redgrave, *Memoir*, p. 278. Farington (VIII, p. 56, 12 Feb. 1816) gives additional support to this view: "[Mulready] appeared to me to be of a very *nervous habit*, and He spoke of His suffering much in His professional practise from this irritability."

41. Both manuscripts are held in the Victoria and Albert Museum Library. Mulready's statement is undated but was probably drawn up in response to his wife's letter. It was once attached to the formal letters of separation which have since disappeared. Elizabeth Mulready mentions Mulready's address as Linden Grove in her letter, a residence he took up in 1828 (The lease commencing 25 March 1828 is now held in the Tate Gallery, 7216.28). She also suggests that their separation took place about twenty years before, thus placing the date of the letter and Mulready's statement about 1828–30.

42. In the light of this prose one is scarcely surprised to discover that Mrs Mulready wrote "dramas" in later life, as revealed in a letter to Mulready, dated 7 April 1860, Victoria and Albert Museum Library.

43. Autobiographical Notes (MS) written in 1863, The Linnell Trust.

44. Alfred T. Story, *The Life of John Linnell*, London, 1892, I, p. 45; hereafter cited as Story, *Linnell*. Stephens believes that the design was engraved and circulated ("John Linnell, Painter and Engraver", Part II, *Art Journal*, 1882, p. 295). Linnell himself explained that he "soon became the

companion of Mulready more than of any other person whatever" (Autobiographical Notes).

45. Also related by Story, *Linnell*, I, pp. 59–60. Mulready's Account Book, 1808 supports this conclusion: "July with Linnell to Chatham. 3 or 4 carefull sketches. one in oil D. Wilkie" (Victoria and Albert Museum Library, hereafter cited as Account Book). None of these works can now be identified. Two black and white chalk studies "made in 1808 Chatham" were exhibited in the exhibition of Mulready's works at the Society of Arts, 1848, CXXXVI and CLXIV; hereafter cited as the Society of Arts Exhibition. The Mulready Executors' Sale, Christie's, 28, 29, 30 April 1864, hereafter cited as Artist's Sale, lists the following two works: no. 208, Exterior of a cottage at Chatham (pen & ink), signed and dated 21 July 1808; and no. 245, Cottage at Chatham (chalk), signed 1808.

46. Speculation concerning Mulready's private life (based on Elizabeth Mulready's letter) was raised recently by a modern writer, Brian Reade, in *Sexual Heretics . . .*, London, 1970, p. 16, where he inaccurately places their separation in 1828. This reference was kindly brought to my attention by Peter Ferriday.

47. Mulready's Account Book lists Miss H. Gouldsmith as a pupil in 1806 and 1807. Her name is cited again under 1809 & 10 when he evidently gave her one of his paintings: "Gravel Pit given to Gouldsmith". A portrait of "H. G." listed in 1814 may also refer to her. David Wilkie mentions Miss Gouldsmith in relation to Mulready in his Journal of 1808: "5th Oct. 1808 . . . Mr. and Miss Goldsmith came with Mulready"; quoted in Cunningham, *Wilkie*, I, p. 200. Miss Gouldsmith exhibited at the Royal Academy, the British Institution, and the Society of Painters in Oil and Water-Colours, specializing in landscapes much in Mulready's early vein (See Col. M. H. Grant, *A Chronological History of the Old English Landscape Painters (in Oil) from the XVIth Century to the XIXth Century*, 2 vols., London, 1926, Pl. 217). Her works were frequently praised in contemporary exhibition reviews, including an exhibition of 30 of her paintings in a Pall Mall gallery in 1830 (*Examiner* 1830, p. 356). She was also represented in the collection of Mulready's patron, Sir John Swinburne—a purchase probably undertaken at the advice of Mulready, his friend and her tutor (See Christie's, Property of Sir John E. Swinburne, 15 June 1861, 115). A work painted jointly by Mulready and Gouldsmith was in the collection of Robert Vernon (cat. 190). See Ch. VI. Another was painted by Mulready, Linnell and Gouldsmith (cat. 191).

48. Linnell's Journal, 1811 and discussed in Firestone, p. 27.

49. Anne Isabella (or Annabella) Milbanke is listed in Mulready's Account Book in 1811 for 19 lessons. A flattering letter describing Mulready's beneficial influence not only on her artistic progress but on her general character as well, is held in the Victoria and Albert Museum Library (discussed in Ch. VI). Another letter, held in the Beinecke Rare Books Collection, Yale University, in an unknown hand on behalf of Lady Byron (watermark 1830), refers to

Mulready at this time as one of Lady Byron's "oldest friends". It accompanied an enclosure (now lost) of a very private nature. This was kindly brought to my attention by Josephine Gear. Lady Byron is also probably the "Ly Bn" to whom Mulready refers in his Account Book 1826, under "Abstract of Expenditure": "pd [paid] Ly Bn old debt fees [?] MMM 20"; which suggests that Mulready had borrowed twenty pounds from her some time in the past.

50. Percy Shelley's cousin by marriage, Lady Shelley (née Frances Winckley), wife of Sir John Shelley (1772–1852) appears in Mulready's Account Book in 1813 for 22 lessons.

51. Farington, VIII, p. 56, 12 Feb. 1816.

52. Farington, VIII, p. 56, 12 Feb. 1816: "[Mulready] alluded to the report which had been circulated to the prejudice of his moral character." The unedited, unpublished Diary (Royal Library, Windsor Castle, consulted by the gracious permission of Her Majesty Queen Elizabeth II) contains two additional references to these rumors (24 Jan. 1816 and 10 Feb. 1816). Microfilm typescript, New York Public Library. A good appearance, all-round respectability, and a pleasant personality were certainly important criteria in the considerations of the Academy, and Farington's Diary is rich in material to support this fact. Farington reports a conversation with a fellow Academician concerning the forthcoming elections for 1817, in which R. R. Reinagle is suggested; but "He has disagreeable self-conceit and is believed to be connected with criticizing newspapers. Chantrey ... is so circumstanced in His profession that He wd. make a good appearance to the Public ... a plain man, of good sense, and shewing nothing to create apprehension of His being disagreeable in the Society" (VIII, p. 98, 11 Nov. 1816). The Academy's far from artistic assessment of future members was also reiterated by Mulready himself when he advised Linnell that "it would be better for him and for his chances of preferment if he made himself a little more of the courtier, and paid more attention to his dress, general appearance, etc. Then pointing to a spot of mud upon his cloak, he said, 'That is what stood in the way of your election more than anything else. ...'" (Story, *Linnell*, I, pp. 131–2).

53. Account Book.

54. Letter from Samuel Palmer to George Gurney, dated Oct. '80, Victoria and Albert Museum Library.

55. Joseph Farington's Diary (Royal Library, Windsor Castle), 25 Jan. 1816. Microfilm typescript, New York Public Library.

56. Linnell (Autobiographical Notes) reported the "pleasant little parties ... got up by Mr. M. [where he] soon learned to join in the rounds and glees and we were certainly full of enjoyment though our fare was so very simple". Mulready was a frequent guest at William Godwin's dinner parties or simple suppers from 1803–10 (Godwin's Diary, Bodleian Library, Oxford University; microfilm, Duke University).

57. Stephens (*Memorials*, p. 2) quotes Samuel Palmer recalling that Mulready could reduce friends to "convulsions of laughter, on & off, during an evening, one of the party falling upon the carpet & rolling". Stephens ("Linnell", Part I, *Art Journal*, 1882, p. 264) also records an incident where Mulready and Linnell carried a third friend, William Henry Hunt, on their shoulders feigning death, in order to open a path in a crowded street. Richard Redgrave described Mulready's skillful table tricks at a Royal Academy dinner in his memoirs (*Memoir*, pp. 257–8). Mulready was capable of more subtle humor too, as evidenced in his tongue-in-cheek letter to Henry Cole concerning his award following the international exhibition in Paris, 1855, discussed in Ch. I, note 181.

58. Story, *Linnell*, I, pp. 138–9.

59. Letter to Boner, dated 19 July 1833, quoted in *John Constable Correspondence*, ed. R. B. Becket, Suffolk Records Society, 1967, V, p. 164.

60. William Holman Hunt, *Pre-Raphaelitism and the Pre-Raphaelite Brotherhood*, London, 1905, I, pp. 95–6.

61. She is always addressed as Mrs Leckie, and her husband is never mentioned in contemporary accounts, although a daughter, Mary Mulready Leckie, named after the artist, appears from time to time. Linnell refers to "Miss Lecky" calling with a message from Mulready in his Journal on 8 March 1842; Cole (Diaries, 3 July 1842) "saw also the Lady herself [Mrs Leckie] & her daughter"—undoubtedly the same Mary Mulready Leckie who exhibited at the Royal Academy between 1842 and 1844 as an honorary contributor. However, a Mulready painting entitled *Father and Child* exhibited at the Royal Academy in 1845 (dated 1828) may feature Mrs Leckie's husband. A preparatory pen and ink drawing, once in the J. P. Heseltine collection, is inscribed "James Leckie and little Mary", reproduced in J. P. H. [eseltine], *John Varley and his Pupils W. Mulready, J. Linnell, and W. Hunt*, London, 1918, fig. 10. Conceivably James Leckie, a boyish figure who looks more brotherly than fatherly could be the husband of Mrs Leckie.

62. Elizabeth Mulready refers to those "who have lodged with or been imployed by Mrs. Lekie" in her letter of 1828–30 to Mulready.

63. Letter from John Hatton to Mulready, dated 10 Nov. 1835, Victoria and Albert Museum Library. A brief account of this lively composer can be found in the *Dictionary of National Biography*.

64. See, for example, Cole's Diaries, 21 March 1844 and 28 March 1844.

65. Tate Gallery, MS. 7216.31.

66. Diaries, 19 April 1864.

67. In 1810 a father's rights were so absolute that a court could not even guarantee a mother access to her children. Even with the enactment of the Children's Custody Act of 1839, a father's rights were only slightly restricted. Courts were then given discretionary power to place young children with their mothers. For further discussion, see Ivy Pinchbeck and Margaret Hewitt, *Children in English Society*, London and Toronto, 1973, II, Chapter XIII: The Rights and Duties of Parents.

68. Farington, VIII, p. 56, 12 Feb. 1816.

69. A letter to Mulready from his neighbor Mr F. D. Schau (?)

dated 16 June 1826, describes the unruly behavior of his sons (Victoria and Albert Museum Library). Elizabeth Mulready also makes reference to their reputation—"the scorn of everyone"—in her letter of 1828–30.

70. His sons exhibited at the Royal Academy and also at the British Institution. See Algernon Graves, *The Royal Academy of Arts: A Complete Dictionary of Contributors and their works from its foundation in 1769 to 1904*, London, 8 vols., 1905–06; and Algernon Graves, *The British Institution 1806–1867: A Complete Dictionary of Contributors and their works from the foundation of the Institution*, London, 1908. The two works by William, Jr in the Sheepshanks Collection at the Victoria and Albert Museum and two small studies by Michael in the same museum reveal a strong stylistic dependence on their father. See Introduction to the catalogue.

71. Story, *Varley*, p. 238.

72. Conversation with John Harrison, Mulready's great-great-great-grandson, descendant of Paul Augustus Mulready.

73. Several letters between John Linnell, Sr and William Mulready, Jr (and his wife) confirm these transactions of the mid-1840s. Due to William Jr's unreliable character, Mulready evidently attached conditions to his regular contributions which Linnell struggled to uphold, including some proof of his son's labor and his personal appearance for the funds. His son squandered the money and, despite Mulready's allowance, was imprisoned for debt *c*. 1844. These letters are in the Linnell Trust.

74. Victoria and Albert Museum Library.

75. A manuscript note in the Anderdon set of Royal Academy exhibition catalogues, now held at the Royal Academy Library (folio 22/183) remarks upon Mulready's death, and mentions "the affliction of unsettled reason in one of his sons and [how] only the day preceding his death he had signed a certificate authorizing his removal to a lunatic asylum". Michael Mulready's Diary Notes following his father's death relate his difficulty in finding an appropriate asylum for Paul. However, Paul recovered his sanity, before dying in 1864 following an operation necessitated by an injury sustained as a spectator at a cricket match—an injury said to have been predicted by his uncle John Varley at Paul's birth sixty years before. Varley was famous for his belief and practice of astrology; see, for example, his publication on the subject, *Treatise on Zodiacal Physiognomy*, London, 1828. Elizabeth Mulready reminded her son of this prediction in his sixtieth year, not long before his death. See her letter to Paul, reproduced in Adrian Bury, *John Varley of the 'Old Society,'* Leigh-on-Sea, 1947, p. 53.

76. Elizabeth Robinson Mulready died on 16 July 1864 at 80 years of age in the presence of one William Mulready, possibly her son, but more likely her grandson, William Henry Mulready, a bachelor son of William Mulready, Jr (Certificate of Death). Elizabeth was in debt when Mulready died the preceding year according to Michael Mulready's Diary Notes, but Mulready's will provided that she be taken care of by their sons, Paul Augustus and

Michael, out of the estate bequeathed to them. See also Ch. I, note 133. A letter from Elizabeth to Mulready, dated 26 November 1855, Victoria and Albert Museum Library, congratulating him on his award following the exhibition of his works at the Exposition Universelle in Paris that same year, suggests that her once antagonistic feelings toward her husband had mellowed over the years.

77. Michael Mulready dictated that "for family reasons the Funeral will be as quiet as proper respect for his memory will permit", letter to Henry Cole, dated 9 July, 1863, Victoria and Albert Museum Library. A manuscript note contained in the Anderdon set of Royal Academy exhibition catalogues, Royal Academy Library (folio 22/183), written in 1863, remarks upon the unusually unpretentious burial: "Mulready was buried in the Cemetery of Kensal Green attended by two of his Sons [Michael & John]. Only 2 of the 40 R.A.s attended and they to their honor Volunteers let their names be recorded S. A. Hart & J. S. Cooper there were two Associates, one being Mr. O'Neal [G. B. O'Neill]. What a picture of grand humility! Look back at the 'Pomposa Funetra' of Reynolds, West, Lawrence & Turner—to say nothing of old Nollekins!" Cole gives a slightly different account in his Diary: "13 July 1863 Office: With Redgrave to Mulreadys funeral at Kensal Green: attended by Creswick, Hart, Foley only as Academicians—buried near to Sir Wm. Molesworths grave—". Redgrave also left a report (*Memoir*, p. 273). Shortly after Mulready's death a stunning neo-Gothic memorial designed by Godfrey Sykes was placed over his grave. It features a nearly life-size effigy of the artist.

78. David Wilkie, A. W. Callcott, John Linnell, Thomas Webster—to name but a few—all lived in this neighborhood for a time. Mulready's lease is held in the Tate Gallery, 72.1626. Additional designs for his home and garden are reproduced in the catalogue prepared by Anne Rorimer: Victoria and Albert Museum, *Drawings by William Mulready*, London, 1972, 468–74; hereafter cited as Rorimer. The pen and ink studies of furniture, and the quite spare interior scene reproduced in Rorimer, 90–91, probably relate to Mulready's home rather than (as Rorimer suggests) to the home of his patron, John Sheepshanks. The furniture in Mulready's home is mentioned in his Account Book and enumerated in a bill presented by Toplis, dated 1831–3, Victoria and Albert Museum Library.

79. See, for example, James Dafforne, *Pictures by William Mulready, R.A.*, London [1872], p. 4 and Richard and Samuel Redgrave, *A Century of Painters of the English School*, London, 1866, II, p. 323.

80. Cole's Diaries, 13 June 1854.

81. Cole's Diaries, 25 April 1845; 19 May 1846; 16 March 1847.

82. Cole's Diaries, 13 June 1854.

83. Cole's Diaries, 27 March 1847.

84. Cole's Diaries, 7 Dec. 1845; 15 Feb. 1848; 10 June 1849; 14 Oct. 1860.

85. Cunningham, *Wilkie*, I, p. 172, quoted from Wilkie's Journal, entry for 11 May 1808; William Powell Frith (*My*

Autobiography and Reminiscences, London, 1887–8, I, pp. 195–6) reports that Mulready was "so intimate [with Wilkie] as to be a constant guest. . . ." See also a formal dinner invitation from Wilkie to Mulready, undated, Victoria and Albert Museum Library.

86. Letter to Mulready from William Collins, undated but watermarked 1821, Victoria and Albert Museum Library. The diary of Mrs William Collins for 1835 frequently mentions Mulready as a guest at their home as well (Victoria and Albert Museum Library). Later, John Linnell may have been responsible for introducing Mulready to the American landscapist Jasper F. Cropsey, who resided in England from 1856 until 1863. An invitation from Linnell to Cropsey, dated 30 June 1857, urges Cropsey to "bring Mr. Mulready, by hook, or by crook or by train"; as quoted in W. S. Talbot, "Jasper F. Cropsey 1823–1900," Ph.D. Dissertation, New York University, 1972, I, p. 120.

87. It has been suggested that William Blake engraved Mulready's illustrations for Charles and Mary Lamb's well-known *Tales from Shakespeare*, a children's book first published by William Godwin in 1807 (see Ch. II, note 5). Mulready certainly provided the illustrations (Account Book, 1806), but there is no evidence to suggest that Blake ever worked for Godwin or encountered Mulready at this stage. More likely, the style of the illustrations, a diluted neo-classicism not unlike that of Richard Westall or Thomas Stothard, and at times reminiscent of Blake, generated the rumor of his supposed connection with the work. Mulready probably met Blake through John Linnell or John Varley *c.* 1818–19, about the time that Varley encouraged Blake in his drawing of visionary heads. The notebook containing these drawings was in Mulready's possession at his death, and was sold in the Artist's Sale, 86. (A facsimile reproduction of the Blake-Varley Sketchbook of 1819 was published in London, 1969 with an introduction and notes by Martin Butlin.) Despite his ownership of this book and the enthusiastic admiration of his friends Varley and Linnell (who employed Blake to execute the Book of Job engravings, 1823–5; and the illustrations to Dante's Divine Comedy, 1824–7, left incomplete at Blake's death), Mulready did not appreciate Blake's mysterious power. Cole recorded that Mulready "roundly & severely criticized Blake" (Diaries, 26 Feb. 1843). Undoubtedly Blake's ethereal approach was antipathetic to Mulready, who valued an attachment to the visible world.

Samuel Palmer came to know Mulready, Linnell, and Blake in the 1820s. His admiration for Mulready and his association with the above artists is recorded in A. H. Palmer, *The Life and Letters of Samuel Palmer*, London, 1892; and in *The Letters of Samuel Palmer*, ed. Raymond Lister, Oxford, 1974.

88. Jack Lindsay, *J. M. W. Turner: A Critical Biography*, London, 1966, p. 241. Mulready also participated with Turner in activities of the Academy Club as described by A. J. Finberg in *The Life of J. M. W. Turner, R.A.*, 2nd ed., Oxford, 1961, p. 259. A letter from Turner to Mulready in the Victoria and Albert Museum Library records Turner's admiration for Mulready's art: "to collect works of [such] merit . . . is the first act (I do sincerely hope) of a good disposition towards modern Art. . . ." The letter is undated but postmarked 18 Ju 1824. In his postscript, Turner inquires as to "the size of the Pictures of the Wolf and the Lamb [*The Wolf and the Lamb*, R.A. 1820] with the Price you wish for it"—perhaps a reference to an engraving after the work sponsored by the Artists' Annuity and Benevolent Fund.

89. Ruskin, *Works*, IV, p. 357.

90. See a letter to Sir John E. Swinburne, dated 23 Jan. 1830, Victoria and Albert Museum Library. Mulready recalls a recent dinner with Lawrence, an evening which lasted "till a quarter past twelve at night", not long before his unexpected death.

91. See letters from Elizabeth Eastlake to Mulready, dated 8 Jan. 1853 and 2 Jan. 1863, Victoria and Albert Museum Library; the latter letter mentions Mulready's "annual dinner visit" to the Eastlakes.

92. Frith, *Autobiography*, I, p. 179; and a letter from Frith to Mulready inviting him to dinner, dated 29 April 1853. Frith also visited Mulready at his home as is indicated by two draft invitations by Mulready, dated 11 April 1857 and 11 July 1860. All correspondence in the Victoria and Albert Museum Library.

93. Letter from John Constable to Mulready, undated but watermarked 1836, Victoria and Albert Museum Library asking Mulready's forgiveness for being exceedingly remiss in not having notified Mulready of his landscape lectures, then insisting that Mulready attend some with him on a future day—"We opened a Mummy there last night. . ." The full text is quoted in *John Constable: Further Documents & Correspondence*, eds. Leslie Parris, Conal Shields and Ian Fleming Williams, London and Ipswich, 1975, pp. 259–60.

94. Letter from Michael Faraday to Mulready, dated 14 March 1829, Victoria and Albert Museum Library. Mulready was also acquainted with the great Victorian engineer Isambard Kingdom Brunel. See letter to Brunel from Mulready, dated 14 Dec. 1847, Bodleian Library, Oxford University, MS. Autogr. c. 6. fol. 65.

95. John Linnell described such evenings to James Dafforne (Mulready's obituary, *Art Journal*, 1863, p. 181): "41, Skinner Street [Godwin's House] . . . a house I never pass without thinking of the evening parties in that fine first-floor room overlooking Snow Hill, and where Mr. Mulready and I were frequently visitors". The MS. copy of Linnell's letter to Dafforne including this recollection is held by the Linnell Trust. Mulready is mentioned as a frequent—at times almost daily—guest of William Godwin from 1803 until 1810, during which time Godwin also received frequent visits from Coleridge, Wordsworth, C. Lamb and Hazlitt. Godwin's Diary, Bodleian Library, Oxford University; microfilm, Duke University. For additional light on this milieu, see H. N. Brailsford, *Shelley, Godwin and their Circle*, N.Y. and London, 1913, and C. Kegan Paul, *William Godwin: His Friends and Contemporaries*, 2 vols. London, 1876.

96. Cole's Diaries, 21 June 1840. Thackerary held a high opinion of Mulready's artistic ability, as recorded by Cole (2 Nov. 1850): "Thackeray agreed Mulready drew as well as any of the old masters." As an art critic writing under the pseudonym Michael Angelo Titmarsh in the late 1830s and early 1840s, Thackeray gave Mulready high praise, even naming him "King Mulready" for the "crowning picture of the exhibition" (R.A. 1838, *Seven Ages of Man; Fraser's Magazine*, June 1838, p. 759). The same issue includes an amusing engraving of Titmarsh placing the laurel wreath on Mulready's brow.

97. Letter to Mulready from A. C. Cope, dated 4 Nov. 1852, Victoria and Albert Museum Library: "we are going to have a little children's party, & some fun, if you should be walking this way, & would look in upon us, I needn't say how glad we should be. . . ."

98. The complimentary tickets are now held in the Victoria and Albert Museum Library, dated 1841 and 1842. However, these may have been distributed to all Royal Academicians, as a letter to the Editor in the *Art Union* may suggest (1841, p. 38). Mulready also received free season tickets from Mr. Arnold in 1827, and Mr. and Mrs. Charles Mathews in 1839 (Victoria and Albert Museum Library). Godwin, *Looking Glass* . . . (p. 67) describes Mulready waiting at the stage door as a boy.

99. Story, *Linnell*, I, p. 55; and Cunningham, *Wilkie*, I, (his Journal mentions frequent trips to the theater).

100. Account Book, 1826, under Abstract of Expenditure: "Theatre & Exhibitions: 3 pounds, 14 shillings, 7 pence."

101. Stephens, *Memorials*, p. 49.

102. Kellow Chesney, *The Victorian Underworld*, N.Y., 1972, pp. 267–8.

103. Esmé Wingfield-Stratford, *The Earnest Victorians*, N.Y., 1930, p. 4. One might also recall here Theodore Géricault's lithographs of London street boxing in the early 1820s. According to F. G. Stephens, Mulready contributed the illustrations to Pierce Egan's *Boxiana: Sketches of Antient and Modern Pugilism*, London, G. Smeeton, 1812 which includes an engraving depicting the famous Cribb/ Molineux match. Of the nineteen illustrations, one is assigned to T. L. Busby, and one to the Cruickshank brothers; the remainder have no artist's name attached to them. There is no record of payment in Mulready's Account Book for these illustrations; perhaps Mulready did them out of friendship and admiration for Egan, the sports journalist. A note in his Account Book 1812 confirms that they were acquainted for he lists a "Portrait of Egan" without any payment recorded (i.e. a gift). Marcia Pointon discusses these illustrations in an article which treats the broader question of artists' interest in the boxing world in early 19th century England; see "Painters and Pugilism in early nineteenth century England",*Gazette des Beaux-Arts*, October 1978, pp. 131–9.

104. *Byron*, London, Victoria and Albert Museum, 1974, Section I, the "Byron Screen".

105. Story, *Varley*, p. 234; Stephens (*Memorials*, p. 66) confirms this.

106. William T. Whitley, *Art in England, 1800–1820*, Cambridge, 1928, p. 86. Whitley refers here to a tradition that Mulready as an R.A. student took on the porter and model Sam Strowger, who evidently provoked the students. Whitley claims there is no proof to the story. Linnell in his Autobiographical Notes identifies the porter as "Little Sam not Sam Strowger . . . a pugilist [who] was drunk and very abusive and threatened some [R.A.] students. M took up their defence and offered to fight the porter who very wisely declined the contest and succombed". Bury (*Varley*, p. 27) reports that Mulready was said to have fought the Somers Town Champion in a room at the Rose and Crown, Bayswater with the contest continued all night ending in a draw with Mulready "confined to his bed for several days after the event". See also Stephens, *Memorials*, p. 57.

107. Autobiographical Notes.

108. Story, *Varley*, pp. 236–9.

109. Linnell (Autobiographical Notes) described Mulready as "a strong active man of five feet ten inches high".

110. Redgrave (*Memoir*, p. 273) mentions Mulready's "long standing heart disease arising from rheumatic fever". The Anderdon set of Royal Academy exhibition catalogues, Royal Academy Library, contains a copy of a letter written by A. W. Callcott to Phillips on 30 Jan. 1817 concerning Mulready's ill health, referring to Mulready's bout of rheumatic fever: "Poor Mulready in point of suffering is better, exhibits some small power now over the extremities, but the fever still continues to prey upon him, & he is most miserably lowered. I hope & trust he will get over it, but I dread the result—". See also Farington's Diary, 10 Feb. 1817.

111. Stephens, *Memorials*, p. 67; and Frith, *Autobiography*, III, p. 228: "[Mulready] always took great interest in street fights when opponents were equally matched. I saw him one day with an intense expression of interest on his face, looking from the street into a small alley which ran at right angles with it; and when I reached him I saw the cause of his interest in the form of two boys who were pummelling one another, displaying what he called true British pluck." A pen and ink drawing in the Victoria and Albert Museum captures just such a street fight (no. 6633).

112. His interest in fisticuffs did not carry over into an interest in actual war. He avoided conscription into the British army. Mulready paid for a substitute in 1826 (Tate Gallery, MS. 7216.14; Account Book, 1826: "Militia sub. 3.5.6."); but at this late date it was probably for his son William Jr. The one oil painting which makes reference to the war, *The Convalescent from Waterloo*, R.A. 1822, avoids all suggestion of blood, battle, and glory, depicting instead the pathetic after-effects of the war: the wounded seeking comfort from their families.

113. Both J. C. Horsley (*Recollections of a Royal Academician . . .*, London, 1903, pp. 117–18) and Frith (*Autobiography*, I, pp. 180–3) describe Mulready's encounter with a robber whom he fought and chased, only to lose him; but he drew his likeness and presented it to the police who in turn caught him. Mulready's evidence helped convict the

man. Horsley's MS. recollection of Mulready is in the collection of his great-granddaughter Miss R. Strode.

114. Story, *Linnell*, I, p. 263; and Stephens, *Memorials*, p. 85.

115. Mulready's fascination with criminals and his special appreciation for children were not uncommon in the Victorian period. The general occurrence of such interests is discussed in Mario Praz, *The Romantic Agony*, London, 1933, p. 415.

116. Letter from Mulready to Sir John Edward Swinburne, Bart., dated 11 and 16 Jan. 1824, Swinburne (Capheaton) MSS., Northumberland Record Office, Newcastle-upon-Tyne, ZSW 627.

117. Frith (*Autobiography*, I, p. 183) reports that Mulready actually assisted at this trial, explaining: "A portion of Weare's skull had been broken by Thurtell's pistol into several small pieces, which the surgeon, who was giving evidence, vainly tried to piece together, so as to fit them into that part of the skull that had escaped fracture. Seeing the surgeon's nervousness . . . Mulready offered his services; and on the back of his sketch book he fitted together the pieces of bone 'as you would a puzzle' —" One doubts this story, wondering why Mulready would hold back such information in the extensive report sent to his patron Swinburne. This trial is discussed at length in J. C. Reid, *Bucks and Bruisers: Pierce Egan and Regency England*, London, 1971 and in Pointon, *Gazette des Beaux Arts*.

118. Bell, p. 147.

119. Letter to Mulready from M. Gilbertson, dated 21 October 1824, Victoria and Albert Museum Library.

120. Frith, *Autobiography*, I, p. 183.

121. Another reproduced Rorimer, 203. This pair created a terrific stir when they murdered her lover. Their hanging was conducted before a jovial mob whose levity was indignantly criticized by Charles Dickens in *The Times* See John Morley, *Death, Heaven and the Victorians*, London, 1971, illustrations 15–16 with contemporary broadsheets dealing with the Mannings.

122. Redgrave, *Memoir*, p. 122; and Stephens, *Memorials*, p. 74.

123. Report of the National Gallery Site Commission (Parliamentary Papers 1857, Sess. 2, C. 2261 XXIV.1.) pp. 49–56; and Report of the Commissioners on the position of the Royal Academy in relation to the Fine Arts (Parliamentary Papers 1863 C. 3205 XXVII.1.) pp. 190–99; hereafter cited as Royal Academy Commission.

124. Stephens (*Memorials*, p. 53) reports how Mulready once said: "I remember the time when I had a wife, four children, nothing to do, and was six hundred pounds in debt!" Linnell's Journal for 1811 confirms this state of affairs. Mulready is cited as a frequent borrower. A note in Mulready's Account Book 1811 also supports this statement: "Dbt after 6 years struggle £450 and more".

125. 1815–17, 1820–2, 1824–6, 1828–30.

126. In a letter to Sir John E. Swinburne, 11 and 16 January 1824, Swinburne (Capheaton) MSS., Northumberland Record Office, Newcastle-upon-Tyne, ZSW 627,

Mulready discussed the contract with Mssr. Hurst & Robinson & Co: "they engage to pay, upon the day that I shall be satisfied with a Proof of the Plate, 800 guineas, to our Treasurer for the payment of the Engraver; & further, on the same day to pay into the hands of the Treasurer of the Artists Fund the sum of one thousand pounds to be applied to the purpose of that Institution". Mulready also subscribed to the print along with others. Stephens believed that Mulready gave the copyright of his print to the Society. John Pye in a series of letters to Stephens (Bodleian Library, Oxford University MS. DON d. 116) disputed this. In 1825 Mulready also supplied 10 gns. to the Society's next print publication, after H. Howard's picture *The Pleiades* (Tate Gallery MS. 7216.12), and according to his Account Book 1828 he also "Lent on account of Pleiades [£] 50".

127. Payment for the seal appears in Mulready's Account Book 1834 (£94.10). The drawing was originally in the possession of Sir John E. Swinburne who became a very liberal benefactor of the Fund. He discussed his participation in a letter to Leigh Hunt, dated 3 May 1814, Additional MS 38108 f. 187, British Library. See Ch. VI, note 14. John Pye described his participation and the Society in general in his *Patronage of British Art*, London, 1845; illustrated with engravings after portrait drawings of members by Mulready. Another preparatory drawing for the seal was exhibited at the Society of Arts Exhibition, CXXXVII, then the property of the medalist William Wyon, Esq., R.A. A small pen and ink study for the right hand section of the seal is in the Whitworth Art Gallery, University of Manchester (D.63.1895).

128. Account Book, 1828: "Lent on account J. Varley 8.6"; in 1826: "Lent George Lardner £20"; in 1827 there were no loans, but a number of cash gifts. Mulready's Account Book lists his expenditures in 1826, 1827 and 1828; in the other years he records his receipts only. One might also mention here his assistance to relatives when they arrived from Ireland, as noted in his papers in the Tate Gallery; and his donations to models in destitute condition, as reported by Stephens (*Memorials*, p. 67).

129. Account Book, 1828: "10/- to Baptists, Easter off. £1 Common Charity £2.15.6." He was also a subscriber to the Acts of Mercy in 1830, see Additional MS. 39791 f. 51, British Library. As late as 1863, the year of his death, Mulready donated a watercolor drawing of *The Disobedient Prophet* to an exhibition at the British Artist's Gallery to benefit the Lancashire Operatives (cotton workers), see unsigned letter, Tate Gallery, MS. 7216.8; and a letter from Lady Elizabeth Eastlake to Mulready, dated 2 Jan. 1863, Victoria and Albert Museum Library.

130. Mulready always identified himself as a Roman Catholic, a member of the "old faith" (Redgrave, *Memoir*, p. 273). Cole (Diaries, 31 Aug. 1846) reported that Mulready "declined to be godfather [of Cole's child] because he was a 'roman Catholic'." However, Mulready was buried in the Protestant section of the Kensal Green Cemetery following an Anglican funeral service, which greatly surprised his friends. It is quite likely that he was not

an active member of his church—that is, a yearly communicant—and thus was not entitled to a Catholic burial. Had he known, Mulready probably would not have objected to this Protestant burial, since, as Redgrave explained, "he loved charity in such matters", being a "hater of the new school of perverts", the latter referring to the zealots of the Oxford Movement, recent converts to Catholicism who relished ritual. (See also Ch. I, note 129 for his donation to the Baptists.) Apparently Mulready once contemplated doing a painting entitled "Church and Dissent" which, if completed, would have discomfited the clergy, according to the intended buyer, Henry McConnel. Though a drawing (now lost) was done, the painting was never completed. See letter to Mulready from Henry McConnel, dated 7 Sept. 1860, Victoria and Albert Museum Library. A small drawing of a bishop and others now in the possession of Mr William Fischelis may be related to this proposed painting.

131. Letter to Mulready from John L. Hatton, dated 14 Oct. 1838, Victoria and Albert Museum Library. Perhaps Mulready's drawing of a young man gazing at musical folios while languidly reclining on a couch, signed and dated 1827, (Pl. 15) should be identified as the musician John Hatton. An earlier letter of 1835 (see Ch. I, note 132) indicates that he and Mulready were close friends moving in similar circles. The drawing has been incorrectly identified as a self-portrait. But it depicts a young man, hardly a 41-year-old artist; and if the musical folios may be taken as a clue it may portray the musician John Hatton.

132. Letter to Mulready from John L. Hatton, dated 10 Nov. 1835, Victoria and Albert Museum Library. Cole (Diaries, 30 March 1845) also records another sad solicitation to Mulready: "Called on Mulready who showed me a letter written by Jawell [?] begging money before his Transportation."

133. Handwritten notes in the Tate Gallery papers state that Mulready left £11,208 cash, and the Artist's Sale realized approximately £3,875. There may have been additional funds—bank annuities, land—that were not included in these sums. Mulready himself made calculations concerning his possible estate sometime after making his will (dated 2 April 1860), predicting an estate of about £16,500. He then admitted: "If the whole of the personalty should not amount to £17,000 by the time it falls in the hands of Executors it will be distressing to me: . . . If the personalty should amount to £18,000 it shd and perhaps would content me £20,000 wd be ample all further speculations and estimates are useless." (Tate Gallery, MS. 7216.32). These speculations are attached to a codicil to his will giving his wife a sum of money outright which would provide an income of seventy pounds a year, rather than leaving her completely at the disposition of her sons as the will outlined. However, this codicil may not have become official for one finds no record of it having been proven as was the original will.

134. Godwin's Diary, Bodleian Library, Oxford University, 1805–1811; microfilm, Duke University.

135. Earl Grey Papers, University of Durham, Department of Palaeography and Diplomatic, and see Ch. VI.

136. Richard Redgrave, *On the Gift of the Sheepshanks Collection with a View to the Formation of a National Gallery of British Art*, London, 1857; and Henry Cole, *Fifty Years of Public Life*, London, 1884, I, p. 325.

137. Cole planned the exhibition at the Society of Arts in 1848. For additional discussion, see Kathryn M. Heleniak, "William Mulready, R.A. (1786–1863) and the Society of Arts", Part ii, *Journal of the Royal Society of Arts*, August, 1976, pp. 558–62. He was also the driving force behind the exhibition held after Mulready's death in 1864 at the South Kensington Museum, now the Victoria and Albert Museum.

138. See T. M. Wears, *The History of the Mulready Envelope*, London, 1886; Edward B. Evans, *A Description of the Mulready Envelope, and of various imitations and caricatures of its design; with an account of other illustrated envelopes of 1840 and following years*, London, 1891; reprinted with a new forward by Eric Allen, London, 1970; George W. Smith, "Mulready and the Work of West, Heath and Leech", *Philatelic Journal of Great Britain*, LXXXI, 1971, no. 4; and "Mulready and the Work of John Flaxman", *Philatelic Journal of Great Britain*, LXXXIII, 1973, no. 1. Sir Henry Cole also discusses it at length in *Fifty Years*, I, pp. 62–4, reproduced on p. 64. The charming design of Brittannia sending out messengers to the corners of the world was greeted with stinging criticism and comical caricatures. George W. Smith has suggested that the envelope was criticized for political reasons; the Tories wished to attack the Whigs for sponsoring postal reform. But this can scarcely account for the widespread derision which greeted the work.

139. In 1847 Mulready agreed to contribute to "Summerly's Art Manufactures", Cole's scheme (under the pseudonym Felix Summerly) to "revive the good old practice connecting the best art with familiar objects in daily use" (Cole, *Fifty Years*, I, p. 108). This project is discussed in Shirley Bury's article "Felix Summerly's Art Manufactures", *Apollo*, LXXV, 1967, 28–33; see also a pamphlet with the Cole material at the Victoria and Albert Museum Library entitled *Art-Manufactures. Collected by Felix Summerly, Shewing the Union of Fine Art with Manufacture*, 6th ed., December 1847, p. 2: "In Preparation . . . The Hayfield, after the Picture by W. Mulready, R.A., exhibited at the Royal Academy in 1847. Painted on a porcelain vase." Cole's Diary for 1847 (23 Aug.) reveals that Copeland's was to have produced the vase with the financial risk undertaken by Mulready (if he agreed). With that stipulation one wonders if it was ever actually produced. There is no example in the Victoria and Albert Museum (which does have samples of other Summerly products). However, I have seen a pottery milk jug adorned with the Mulready painting (Collection Mrs Bridgid Hardwick). This may be the Summerly product translated into another material, not an uncommon occurrence, as Bury explains in the above article.

140. Geraldine Pelles, *Art, Artists and Society: Origins of a Modern Dilemma. Painting in England and France 1750–1850*, Englewood Cliffs, N.J., 1963.

141. Whitley, p. 191.

142. Letter to Mulready from David Wilkie, dated 4 Dec. 1813, Victoria and Albert Museum Library. Farington (Diary, 7 April 1813) also reports how Wilkie had encouraged Mulready by hanging one of his paintings in a prominent location in the R.A. exhibition of 1813.

143. According to Whitley (p. 251 and p. 254), in the November elections for Associate Mulready carried the first election by an overwhelming majority: twenty-three votes to one each for John Jackson and John Sanders. The vote for full Academician in February was much closer. Mulready defeated A. E. Chalon by only one vote, Chalon having served in the junior rank of Associate for four years since 1812 to Mulready's mere three months.

144. Mulready declined to serve in two other positions in the Academy: Keeper of Paintings, and Professor of Painting. Discussed in two letters to Mulready from George Jones, R.A., dated 4 March 1840, and 21 Oct. 1847, Victoria and Albert Museum Library.

145. Whitley, p. 271; Sidney C. Hutchison, *The History of the Royal Academy 1768–1968*, London, 1968, p. 95.

146. Frith, *Autobiography*, I, pp. 229–30.

147. With reference to the portraits of Sir Thomas and Lady Baring; Firestone, p. 75.

148. Horsley, p. 50. In his Sketchbook, Victoria and Albert Museum Library, Mulready records his view on criticism: "Let your own picture have all the benefit of your own and all criticism. Let others have all the praise you can honestly bestow, and *more*." Hereafter cited as Sketchbook. In practice, his honesty frequently necessitated his candid, often critical assessment of others' works if solicited. W. P. Frith (*Autobiography*, I, pp. 253–4) requested Mulready's criticism of his painting *Life at the Seaside*, R.A. 1854 (Ramsgate Sands), much to his subsequent regret, for although he "knew him to be a severe, but not an ill-natured critic" he was nevertheless devastated by Mulready's critical comments on the painting.

149. Farington, V, p. 172, 24 May 1809: "The prices demanded by some of the Young men for their pictures is extravagant even to be ridiculous. Douglas for 'The Reposo' 3 figures 300 guineas. —Mulready, for a Carpenter's Shop 300 guineas." This opinion was supported by a collector, as reported by Wilkie in his Journal (Cunningham, *Wilkie*, I, p. 227): "[28 Feb. 1809], Had a call from Mr. Gouldsmith, junior, who asked me to dine with him on Monday, and paint him a picture, the price of which he fixed at 50 guineas; he regretted that Mulready had asked so much for his picture as 300 guineas."

150. Farington, VIII, p. 177, 16 May 1818: "Smirke spoke of the consequence of young men being admitted into the Academy Council & of the sudden self importance manifest in them. He particularly noticed in the two last admitted— M[ulready] & J[oseph]."

151. *Morning Chronicle*, 16 May 1833, recorded in the Whitley Papers, British Museum.

152. Whitley, p. 148. They were abolished briefly in 1852 on Mulready's motion; although they were later reintroduced for all exhibitors, not for members only as had been the case before Mulready's motion.

153. Account Book, 1853. For his instruction of private pupils, see Ch. VI.

154. Even in 1853 when Mulready supplemented his own duty by taking on Cope's and Dyce's attendances as well, he collected only £70 for his R.A. visits out of a total yearly income of £1050 (Account Book, 1853).

155. Redgrave, *Memoir*, p. 178. For further discussion on his Life Studies, see Ch. V.

156. Mulready, William Dyce and Daniel Maclise were asked to submit designs for the Turner prize as reported in the Royal Academy Council Minutes, 5 June 1858.

157. Mulready's medal design is interleafed with the Jupp Royal Academy exhibition catalogues, vol. VII, Royal Academy Library. Maclise's winning design is reproduced in the exhibition catalogue prepared by Richard Ormond and John Turpin, *Daniel Maclise 1806–1870*, London, National Portrait Gallery and Dublin, National Gallery of Ireland, 1972, 127.

158. Royal Academy Commission.

159. Cole (Diaries, 1 Jan. 1860) reported "Walked to Mulreadys—talked of his allegiance to the Academy remaining until he resigned." In fact, he died before he could resign. Mulready was not blind to the Academy's faults. On another occasion he remarked to Cole that its merits just balanced its faults (Diaries, 1 April 1849).

160. Redgrave, *Memoir*, p. 273.

161. Unfortunately, these works are lost, although at least one of them, the *Battle of Agincourt*, survived in a tattered state well into the nineteenth century, surfacing from time to time in exhibitions at the Mansion House, London (Stephens, *Memorials*, pp. 26–31). Samuel Redgrave (*Dictionary*, pp. 287–8) claimed that Mulready assisted with Ker Porter's *Battle of Seringapatam* (1800) at a time when Mulready was barely fourteen. Linnell in his Autobiographical Notes (written in 1863) also mentioned Mulready's employment on this panorama although Linnell did not meet Mulready until *c.* 1804, several years after its completion. Stephens for various reasons, including Mulready's age in 1800, rejected this suggestion and opted for the *Battle of Agincourt* only. Jane Ker Porter, Robert's sister, told Thomas F. Dibdin that "No artist had seen the painting of Seringapatam during its progress"; as reported in Thomas F. Dibdin, *Reminiscences of a Literary Life*, London, 1836, II, pp. 143–7. This would seem to eliminate the possibility of any assistance unless Mulready's youth made him unworthy of the title artist.

While there is no evidence to support Mulready's participation in the preparation of the Seringapatam panorama, there is proof of his assistance with three others. Mulready's own Account Book in 1805 (the year it begins) supports Stephens' contention that Mulready worked on the *Battle of Agincourt*: "Assisted Robt Ker Porter in his

Battle of Agincourt. he never paid me." Robert Ker Porter's Diary (made available to me by the generosity of its owner, Mr Rodney Searight) cited Mulready's assistance on two additional panoramas: "25 January 1802. Began my large picture assisted by Mr. Page, to whom I pay 6 guineas per week, and Mr Mulready 1 per week." (This refers to the *Battle of Alexandria* completed 3 May 1802 and exhibited at the Lyceum the same day.) "Oct. 6 [1802] Squared my canvas and Mr Mulready began the outline." (This refers to the *Battle of Lodi* which opened at the Lyceum in January 1803.) Mulready confirmed this in a letter of 1855: "in 1802 we [John Cawse & Mulready] were employed together on a panoramic picture . . .", (draft) letter from Mulready to the President and Council of the Artists' General Benevolent Institution on behalf of John Cawse dated 29 May 1855, Victoria and Albert Museum Library. Mr M. D. Ancketill, who is currently preparing an extensive biography of Robert Ker Porter, kindly directed my attention to the Ker Porter Diary and the Dibdin reference. He believes that Ker Porter engaged Mulready no earlier than 1802, when Mulready is first mentioned in Ker Porter's Diary.

162. Cole's Diaries: "25 January 1843 . . . [Mulready] told me of Flaxmans congratulating him on the designs of the Queen of Hearts in the Streets taking off his hat." The British Library contains a number of children's books whose illustrations are attributed to Mulready including: Charles Lamb, *The King & Queen of Hearts: with the rogueries of the knave who stole the Queen's pies*, Printed for M. J. Godwin at the Juvenile Library, 1809. A barely legible scribble in Mulready's Account Book 1806, includes "15 Queen of Hearts" (indicating the 15 engravings that illustrate this work) along with several other notations concerning his illustration of children's books. The New York Public Library owns Mulready's preparatory drawings for William Roscoe's *The Butterfly's Ball and the Grasshopper's Feast*, 1807 (see Pl. 20). The Pierpont Morgan Library has the original drawings used to illustrate Dr Goldsmith's *Elegy on that Glory of her Sex, Mrs. Mary Blaize*, published 1808 by L. Harris and attributed to Mulready. The latter publication is not among those specifically listed in Mulready's Account Book.

163. The Artist's Sale featured an extensive collection of prints collected during Mulready's lifetime, for example: 19. After Dutch Painters, by Lewis—11; 37. The Luxembourg Gallery—25; 57. After Old Masters—29; 58. Twenty-three, by Lucas van Leyden; 61. St. Jerome & c., by Dürer—7; 71. Rubens landscapes—15.

164. Wilkie's Journal (Cunningham, *Wilkie*, I) records the numerous collections which were available for artists' viewing as early as the first decade of the nineteenth century. Mulready, a close friend, was well aware of them, too. For example, an undated informal note from J. L. (John Linnell), Tate Gallery, MS. 7216.10 refers to such a collection: "Well worth seeing, some additions to the collection very curious, *one exquisite* I will accompany you some day if you please."

165. Charles Aders was a wealthy merchant who collected early German works. His wife opened their home on Euston Square to literary and artistic figures including Coleridge, Charles Lamb, Crabb Robinson, Samuel Rodgers, John Flaxman, William Blake and John Linnell, to name but a few. (See M. K. Joseph, "Charles Aders, A Biographical Note", *Auckland University College Bulletin*, no. 43, 1953, 6ff.) A letter of the 1820s from William Collins to John Linnell establishes Mulready's presence at their home: "Will it suit your convenience to go with me on Saturday next at half-past one to see the collection of German pictures in Euston Square? . . . I have written to Mulready to request he will call here at the hour above mentioned." (Story, *Linnell*, I, p. 281).

166. These manuscript calculations are now held in the Tate Gallery (MS. 7216.16). Unfortunately, Mulready's final computation is not clear.

167. Although prints were of course available, and French paintings were occasionally exhibited publicly in London, Mulready also had access to the collection of his patron Thomas Baring, who was one of the few English patrons to combine a collection of old masters (primarily Dutch and Flemish) with modern French and English paintings.

168. Royal Academy Commission.

169. The *Art Journal* (1855, pp. 282–283) reported quite extensively on the French press reviews quoting several, repeated in Dafforne, *Mulready*, pp. 44–5; and F. G. Stephens, "William Mulready, R.A.", *Fine Arts Quarterly Review*, I, 1863, p. 392.

170. A (draft) letter from Mulready to Sir Henry Cole, dated 14 Sept. 1855, Victoria and Albert Museum Library. Beginning in 1854 there were annual exhibitions of French paintings at a dealer's in London. The *Art Journal* review (1855, p. 194) of the second annual exhibition discussed paintings by Ingres, Horace Vernet, Paul Delaroche, Ary Scheffer, Meissonier, and Rosa Bonheur.

171. Sketchbook.

172. Royal Academy Commission.

173. Mulready used a magnifying glass to study objects before depicting them.

174. Royal Academy Commission.

175. Sketchbook.

176. As quoted in Linda Nochlin, *Realism and Tradition in Art, 1848–1900* (Sources & Documents in the History of Art, ed. H. W. Janson), Englewood Cliffs, N.J., 1966, p. 54. Thoré also reacted favorably to Mulready's works.

177. Mulready summarized his feelings in his testimony to the Commissioners in 1863 (Royal Academy Commission): "at this moment we may be threatened with a taste which has hardly respect enough for the antique . . . it looks too much to deviations from beautiful forms and to irregularities. There is now too great an indifference to beauty." (This is perhaps a reference to Pre-Raphaelite painting, a school which he generally supported.)

178. For study purposes, Mulready insisted on the examination and depiction of common non-aesthetic objects—such as potatoes—for the sake of truth, "to cut away the adventitious aid of association"; as quoted by Samuel Palmer in his description of Mulready's methods in

a letter to Mr P. G. Hamerton, dated February 1874; cited in Palmer, *Life*, p. 346.

179. Amy Woolner, *Thomas Woolner, R.A. Sculptor and Poet: His Life and Letters*, London, 1917, p. 164.

180. Stephens (*Memorials*, pp. 113–14) lists Mulready's entries in the international exhibitions including the nine works for the Exposition Universelle in 1855. They are also cited here in the respective catalogue entries.

181. This honor was not as welcome as might be imagined. Such titles were not recognized in Great Britain and acceptance of foreign decorations was discouraged though not forbidden. Richard Redgrave (*Memoir*, p. 145) and Cole (*Fifty Years*, I, pp. 222–3), both members of England's Executive Committee for the Paris exhibition and like Mulready recipients of French decorations, record the diplomatic turmoil created by the presentation of these honors. In addition, Stephens (*Fine Arts Quarterly Review*, 1863, p. 392) asserts that Mulready "would have received the gold medal for English exhibitors, if the French critics had had their way. The English laymen awarded it to Sir E. Landseer." The *Art Journal* (1856, p. 18) also discusses the controversy over the awarding of medals to English artists. Evidently Cole believed that the award would be unacceptable to Mulready. An amusing letter to Cole (draft letter, dated 4 Nov. 1855, Victoria and Albert Museum Library) records Mulready's wry response to Cole's machinations on his behalf: "perhaps you will tell me in a whisper why you thought that a five franc piece, or a medal of that value would not have been very acceptable to me? or did you fear that a five franc medal might neutralize the honor spontaneously conferred upon me by a hundred franc artists and thousands of franc people—".

NOTES TO CHAPTER II

1. William Gilpin, *Three Essays: On Picturesque Beauty; On Picturesque Travel; and on Sketching Landscape*, London, 1792; and Uvedale Price, *An Essay on the Picturesque, As Compared with the Sublime and the Beautiful, and on the Use of Studying Pictures, for the Purpose of Improving Real Landscape*, London, 1794. For an extensive discussion of the picturesque, consult: Christopher Hussey, *The Picturesque; Studies in a Point of View*, London and New York, 1927.

2. Varley may have been introduced to Mulready by their mutual acquaintance Robert Ker Porter, like Varley an active member of watercolor societies. Perhaps when Ker Porter employed Mulready as his assistant on panoramas in 1802 (see Ch. I) he encouraged him to pursue landscape under the tutelage of Varley.

3. *Crypt in Kirkstall Abbey*, 392; *West Front Entrance of Kirkstall Abbey*, 411; and *Cottage at Knaresborough*, 507.

4. Account Book, 1808: *Supper at Emmaus* and two versions of *Endymion*. His Account Book records that the Endymion paintings were rejected by the Hoare family—a rejection which may have helped to turn Mulready away from history painting.

5. Mulready's illustrations to Charles and Mary Lamb's children's book, *Tales from Shakespeare*, 2 vols., London, 1807, published by M. J. (William) Godwin, consist of a compendium of watered-down neo-classical compositions, perhaps best compared with Richard Westall's productions. Their superficial resemblance to William Blake's work encouraged an earlier belief that they were by Blake or at least engraved by him. They are certainly Mulready's designs; this is confirmed by a brief note in his Account Book, 1806. Geoffrey Keynes (*Bibliography of William Blake*, N.Y., 1921, p. 195) also dismissed the suggestion that they were engraved by Blake. Interestingly the plates were omitted in the second edition (1809) where a prefatory note explained that they were found to be more suitable for young ladies rather than for children as originally intended. They were brought back for the edition of 1810 and subsequent editions. Charles Lamb was displeased with the illustrations, as revealed in a letter to Wordsworth asking him to excuse the designs, explaining that Godwin "left the choice of subjects to the bad baby [the second Mrs Godwin] who from mischief—(I suppose) has chosen one from damn'd beastly vulgarity (vide Merch. Venice) where no atom of authority was in the tale to justify it—to another has given a name which exists not in the tale, Nic. Bottom, & which she thought would be funny, though in this I suspect *his* hand, . . . & one of Hamlet, & Grave digg. a scene which is not hinted at in the story, & you might as well have put King Canute the Great reproving his courtiers—the rest are Giants & Giantesses . . . begging you to tear out the cuts & give them to Johnny, as Mrs. Godwin's fancy". Charles Lamb to William Wordsworth, 29 Jan. 1807 in *The Letters of Charles and Mary Anne Lamb*, ed. Edwin W. Marrs, Jr, 2 vols., Ithaca and London, 1976, II, p. 256.

6. This theme was undertaken later by Mulready's contemporaries James Northcote, William Hilton, James Ward and John Linnell. His first tutor, the Scotsman John Graham, also painted a work with this title.

7. There is some doubt concerning this. The Redgraves (*A Century*, p. 229) suggest that Mulready was incapable of such figure painting in 1804, which Stephens refutes in his *Memorials* (pp. 44–45). Mulready's Account Book cites a "comp[osition]: Dis. Prophet" in 1838 (there is no Account Book for 1804) which suggests that he worked on the theme much later—or perhaps returned to it. The signed watercolor to which Stephens referred was exhibited at the Society of Arts (CLXI), at the Society of British Artists, Suffolk Street in 1863 in aid of the Lancashire Operatives where it was purchased by William Bowman, Bart. and at the South Kensington Exhibition (385). It appeared in Bowman's sale, Christie's, 24 March 1893 (175), bt. Murray.

8. See T. S. R. Boase, "Shipwrecks in English Romantic Painting", *Journal of the Warburg and Courtauld Institutes*, XXII, 1959, 332–46. In England, J. H. Fuseli, Benjamin West, Philip James de Loutherbourg, J. M. W. Turner, John Martin, and Francis Danby painted "The Deluge". The subject was immensely popular in France as well. For

specific examples and a general discussion of the theme, see the exhibition catalogue, *French Painting 1774–1830: The Age of Revolution*, Paris, Grand Palais; Detroit Institute of Arts; New York, Metropolitan Museum of Art; 1974–75, 26 concerning Henri-Pierre Danloux's version at the Salon of 1802.

9. Fuseli was Professor of Painting at the Academy from 1799 until his death. See, for example, the reclining woman with head thrown back in several versions of *The Nightmare*, or his drawing of *Eriphyle*, dated 1810 (reproduced *Johann Heinrich Füssli 1774–1825*, Paris, Musée du Petit Palais, 1975, 42), whose raised shoulder and knee more nearly resemble the sketch after Mulready's composition.

10. Numerous drawings attest to his continued interest in historical themes. Such drawings were exhibited in the Society of Arts and the South Kensington Museum and subsequently sold in the Artist's Sale. The South Kensington Museum (Victoria and Albert Museum) purchased several. See, for example, Rorimer, 309 (*Adam and Eve*) and 325 (*Death of Absalum*, which would have made a marvelous Romantic painting reminiscent of Horace Vernet's treatment of Mazeppa, which was exhibited in 1828 at Mr Hobday's Gallery of Modern Works, French and English). Mulready's Account Book, 1838, also contains two scribbles detailing historical themes: "May comp. Dis. Prophet" and "June Flight into Egypt". The plans for decorating the new Palace of Westminster in the 1840s renewed Mulready's interest in historical themes. As Henry Cole reported (Diaries, 12 May 1844) "[Mulready] was quite decided against having anything to do with the Frescoes at Westr unless as a 'Journeyman' [i.e. if another artist would actually carry out his design] but that he intended to paint one or two privately". Daniel Maclise offered his services to Mulready but nothing came of it. Several drawings of armour and historical costume in 1844 (Victoria and Albert Museum, discussed by Cole in his Diaries, 18/19 August 1844) are the only physical record of Mulready's interest in this vast decorating scheme. His painting *The Intercepted Billet*, *c.* 1844 (Pl. 140), a costume piece, can be loosely linked to Mulready's historical preoccupations at the time.

11. A pencil drawing of a cottage, inscribed "Kirkstall", signed and dated 22 July 1803 is interwoven with the folios of the Jupp Royal Academy exhibition catalogues, Royal Academy Library, vol. VII, back of folio 137 and 138 (previously South Kensington Exhibition, 117, and Artist's Sale, 181). Another pencil drawing entitled *Principal Entrance to Kirkstall Abbey*, signed and dated 21 July 1803, was exhibited in the South Kensington Exhibition, 116. Both testify to his presence in Yorkshire in the summer of 1803. A drawing of Kirkstall Abbey by John Varley dated 1803, City of Stoke-on-Trent Art Gallery, places Varley in Yorkshire at the same time.

12. Mulready may have made several sketching excursions to Yorkshire. Two additional drawings exhibited at the South Kensington Exhibition were also based on a Yorkshire tour in the summer of 1804, since they are both signed and dated 1804: *Fountains Abbey*, 120; and *Knaresborough Castle*, 119. Both of these drawings were then in the possession of the Misses Kaye, as well as *A Church*, 118, signed and dated 1804, which was probably a Yorkshire monument as well. Two additional pencil drawings in the same exhibition (both under 117) could indicate excursions to Yorkshire in the summers of 1805 and 1806: *Porch, Upton*, signed and dated 26 July 1805; and *Font, East Cray*, dated 28 June 1806. (There are several Uptons in England, including one in Yorkshire; Cray exists in both Wales and Yorkshire.)

13. Victoria and Albert Museum Library.

14. In fact, *The Crypt in Kirkstall Abbey*, which was exhibited at the Royal Academy, may very well have been a watercolor. Its position in the Academy's exhibition would suggest a watercolor rather than an oil painting. The oil exhibited in 1864 after Mulready's death may be another painting altogether.

15. Julia Swinburne (1795–1893) was Sir John E. Swinburne's eldest daughter, and the sister of Frances Swinburne (1799–1821). Both were Mulready's students after 1811. Julia Swinburne evidently made a copy of Mulready's watercolor which appeared in the Isabel Swinburne Sale, Christie's, 26 May 1894, 117, under the name of the artist, Julia Swinburne, (*Copy of the Church Door by W. Mulready, R.A.*). Conceivably the small painting of the Church Door behind Frances Swinburne in her self-portrait could be Julia's copy, rather than the Mulready original.

16. Evidently this drawing never left Mulready's possession during his lifetime. According to the British Museum records, this work was purchased at the Artist's Sale in May 1864 (actually 28–30 April 1864). Unfortunately, an examination of the sale catalogue, including a section expressly devoted to watercolor drawings, discloses no drawing which can be identified with it.

The location of *The Porch of St. Margaret's, York* was listed as unknown in the South Kensington Exhibition which preceded the Artist's Sale by one month (March 1864). The Executors, Paul Augustus and Michael Mulready, cooperated with the exhibition, lending works which were subsequently sold in the Artist's Sale. It is just possible that the watercolor purchased by the British Museum (but not identified by title at the Artist's Sale) went unrecognized by the Executors as the work once exhibited at the Royal Academy, and was therefore not exhibited as such in the South Kensington Exhibition.

17. A contemporary description of Kirkstall Abbey (not of Wordsworthian caliber) well conveys this attitude:

> After a few paces farther . . . [we] unexpectedly burst on the sight of the tranquil and pensive beauty of the desolate Monastery, as it reposes in the lap of pastoral luxuriance. . . . [After surveying] the mouldering magnificence of the religious pile . . . can [one] avoid a salutory conviction of the vanity of all earthly solicitude, or of the unworthiness of a Temple, built by hands for

the service of an enduring Providence! (Anon., *Kirkstall Abbey*, Longman & Co., London and Hernaman, Leeds, 1827.)

Surprisingly, this description accompanies an engraving after a drawing by Mulready of the Chapter House, Kirkstall Abbey, which, while more conventional than his alarmingly direct Porch doors, nevertheless retains an emphasis upon the strength of the architectural wall structure, minimizing its decrepit state and avoiding any reference to the pastoral surroundings of the medieval ruin.

18. A pencil drawing of St Peter's Well, York Minster (Plate 169), the subject of a lost oil painting exhibited at the Royal Academy in 1806, suggests that Mulready treated an interior scene in much the same way.

19. A preparatory pencil drawing, signed and dated 27 July 1803 (with Sotheby's, 22 Dec. 1977 (98/i), probably done on the spot, actually includes three figures: a workman repairing the porch roof and a couple chatting in the foreground.

20. See, for example, Thomas Girtin's watercolor of Kirkstall Abbey, signed and dated 1800, British Museum, reproduced in the exhibition catalogue: *Romantic Art in Britain, Paintings and Drawings 1760–1860*, Philadelphia Museum of Art, Detroit Institute of Arts, 1968, 114.

21. In fact, Varley was most famous for panoramic watercolor views, not these close-up views of individual monuments. Surprisingly, one does not encounter similar signed and dated panoramic views by Mulready. The Witt Library, London has a photograph after one such work attributed to Mulready originally from the collection of Sir Michael Sadler, a collection now housed in the Cooper Art Gallery, Barnsley, Yorkshire. But on what basis was it attributed? It is neither signed nor dated. Nor does it compare with other known works by Mulready. The Cooper Art Gallery has no watercolor now assigned to Mulready from the Sadler collection. Perhaps it has since been reassigned. Of course, numerous watercolors now given to Varley should perhaps be attributed to Mulready; but since Mulready frequently signed his early works, if such panoramic views existed one would expect to encounter at least one or two such signed works in English public collections.

22. These drawings are not strictly watercolors. They employ pen and, in the case of the Victoria and Albert Museum example, pencil as well, to detail certain architectural elements. Nevertheless, large forms are produced by watercolor washes alone, removing the works from the category of drawings merely filled in with watercolor which prevailed before late eighteenth-century innovations. While Mulready was certainly aware of the accomplishments of the Cozens and of Thomas Girtin (through Varley, if not on his own), he evidently did not participate in the copying of such works at Dr Thomas Monro's. Varley had worked at Dr Monro's as had Cotman and more importantly, Mulready's companions John Linnell and William Henry Hunt (*c*. 1805). Yet no mention is made of Mulready's attendance there; nor did any of his drawings appear in the Monro Sale,

Christie's 1833. Interestingly, Mulready did have a pupil, Mstr. H. Monro in 1805, just possibly Monro's son Henry, who later exhibited works at the Royal Academy.

23. Apparently these oil sketches were never publicly exhibited by Mulready, but several became part of a public collection in 1857 when John Sheepshanks donated his paintings to the nation, and several were subsequently included in the 1864 exhibition at the South Kensington Museum. It seems they were never purchased from the artist, but were probably a gift from Mulready to his generous and appreciative patron years after they were painted. An exception to this may be *A Gravel Pit* (Cat. 34); see Ch. II, n. 87.

24. Clearly open-air oil painting fulfilled the needs of a number of British artists at this early date, a situation which has received little attention from art historians, who dwell principally on Constable's oil sketches, the later Pre-Raphaelites, and of course the French Impressionists. An exhibition organized by John Gage entitled *A Decade of Naturalism 1810–1820*, Norwich, Castle Museum and London, Victoria and Albert Museum, 1969–70, focused on Constable's open-air paintings but briefly cited the earlier development in the late eighteenth century (for example, the oil sketches of the Welsh artist Thomas Jones) and the first decade of the nineteenth century (including Varley's circle). There was also an exhibition of Thomas Jones' work at the National Museum of Wales in 1970, catalogue by John Jacobs. The exhibition *Landscape in Britain 1750–1850*, London, Tate Gallery, 1973 refers to this development in a few entries. See no. 38, nos. 94–6. Hereafter cited as *Landscape in Britain*.

25. Story, *Linnell*, I, p. 25. In his Autobiographical Notes, Linnell explained that Varley's pupils "were constantly drawing from nature".

26. London, P. & D. Colnaghi & Co., Ltd., *A Loan Exhibition of Drawings, Watercolours, and Paintings by John Linnell and his Circle*, 1973, contains illustrations of Hunt's and Linnell's oil sketches.

27. *Landscape in Britain*, no. 237.

28. Graham Reynolds, *Turner*, N.Y. [1969], p. 71, illus. 57; Finberg, p. 137; and London, Tate Gallery, *Turner 1775–1851*, 1975, 135–41, 143–6. John Gage places them slightly later.

29. *Constable Correspondence*, II, p. 32 and London, Tate Gallery, *Constable, Paintings, Watercolours and Drawings*, 1976.

30. *Preraphaelite Diaries and Letters*, ed. W. M. Rossetti, London, 1900, pp. 125, 134, 142–3.

31. Notation on an undated drawing, Whitworth Art Gallery, University of Manchester.

32. Mulready's Sketchbook has a page devoted to a list of botanical terms which reveals at least his glancing familiarity with the science. Popular magazines dealing with botanical matters proliferated in the nineteenth century, and Mulready may have gleaned his knowledge from this source. His own garden plans in the late 1820s reveal a keen

interest in the plant world, although the proposed garden never materialized. His friend John Sheepshanks was an amateur botanist and had a plant named after him.

33. Cole's Diaries, 3 July 1844: Mulready was "very indignant that his designs shd be sd to be like A Durers". At about this time Cole was preparing a new publication of Dürer's wood engravings. John Ruskin also compared Mulready with Dürer when commenting upon Mulready's painting of animals (*Works*, IV, p. 336). Despite the indignation recorded by Cole, Mulready collected Dürer's prints (Artist's Sale, 61).

34. See, for example, Edward Munch's imprisoning forests (*The Voice*, Boston, Museum of Fine Arts).

35. All are briefly noted under the respective entries for each artist in *Landscape in Britain*. See also E. H. Gombrich, *Art and Illusion*, 2nd ed., Princeton, N.J., 1972.

36. Kurt Badt, *John Constable's Clouds*, London, 1950. He also discusses the relationship between Romanticism and science. Louis Hawes in "Constable's Sky Sketches", *Journal of the Warburg and Courtauld Institutes*, XXXII, 1969, 344–65 questions the supposed significance of Luke Howard's influence on Constable's "skying".

37. Whitworth Art Gallery, University of Manchester (D.104. 1895).

38. Jane Austen, *Sense and Sensibility*, Penguin, 1973 (first published 1811), p. 121.

39. George Dawe, *The Life of George Morland*, London, 1904 (first published 1807). On occasion Mulready's early works were collected by the same patrons: T. S. Leader, Alexander Davison, and Mr Harris of Garrard Street. Cited by Dawe, pp. 88, 120, 122. Mulready's Account Book discloses the same buyers.

40. Linnell's Autobiographical Notes.

41. See Ch. II, note 39.

42. Dawe, p. 111.

43. For example, in 1808 alone, David Wilkie recorded his visits to Henry Hope's Collection, Lord Stafford's Gallery, the Angerstein Collection, Lansdowne Collection, Sir George Beaumont's Collection, Lord Radstock's Collection, Lord Grosvenor's Collection, Lord Audley's Collection and the collection of Sir Francis Bourgeois, to cite but a few (Cunningham, *Wilkie*, I).

44. Letter from William Blake to Richard Phillips, dated 1 June 1806; quoted in *The Letters of William Blake*, ed. Geoffrey Keynes, Cambridge, Mass., 1968, p. 123.

45. The Arts Council of Great Britain in 1971 devoted an exhibition, *The Shock of Recognition*, to examining some aspects of the relationship between the English and Dutch landscape schools, with particular emphasis given to Thomas Gainsborough, John Constable, John Crome and J. M. W. Turner, though it was by no means restricted to those artists.

46. For example, "11th [May 1808] Called on Mr. Wells [a dealer] to return to him the Ostade he lent me; looked at some new pictures he had lately got; called on Mulready on my way home." Or, on the next day, he "took home Ridley Colborne's Ostade and Teniers" (Cunningham, *Wilkie*, I,

p. 172). A few months later, he "Called on Mr. Wells and saw, among other pictures, a very fine one by Ostade, which he was so kind as to promise to lend me" (12 Dec. 1808, Cunningham, *Wilkie*, I, p. 213). These are just a few examples of many that could be cited. See also Ch. II, note 43 for his visits to private collections.

47. Journal, 29 Dec. 1808 (Cunningham, *Wilkie*, I, p. 215): "went and looked at some of the old pictures collected by Sir Francis Bourgeois, and like them much".

48. See, for example, D. Teniers the Elder, *A Road near a Cottage* (49), and *A Cottage* (52); C. Dusart, *An Old Building* (39); D. Teniers the Younger, *A Chaff-Cutter* (142).

49. Asher Wertheimer, *The Hope Collection of Pictures of the Dutch and Flemish Schools*, London, 1898.

50. Account Book, 1807. Wilkie recorded his visit to the Hope Collection in 1808 (Cunningham, *Wilkie*, I, p. 209; Journal, 21 Nov. 1808): "Accompanied Seguier to Henry Hope's, where we staid some time, examining the pictures in the two rooms upstairs, in which I found some things which will be of use to me. . . ." For Thomas Hope, see David Watkin, *Thomas Hope and the Neo-Classical Idea*, London, 1968 (which neglects to mention his patronage of Mulready). A catalogue of Thomas Hope's English painting collection is recorded in *Annals of the Fine Arts*, IV, 1819, 93–7.

51. Sheepshanks sold his enormous collection of prints and drawings to the British Museum in 1836.

52. Oliver Millar, *The Later Georgian Pictures in the Collection of her Majesty the Queen*, 2 vols., London, 1969.

53. Sir Joshua Reynolds, *Discourses on Art*, introduction by Robert R. Wark, London, 1966, pp. 98–9.

54. Allan Cunningham (*The Cabinet Gallery of Pictures by the First Masters . . .*, London, 1836, II, pp. 88–91) frequently cites Reynolds' "high commendations of the Dutch School". Beginning in 1815, the Painting School of the Royal Academy often borrowed paintings from the Dulwich Picture Gallery for copying by students. A "Teniers Copy" in Mulready's Account Book, 1829, should probably be linked to his supervision in the Painting School that same year, since we know that he took pride in working alongside students.

55. This clarity is reminiscent of Joseph Wright of Derby's landscapes, for example, *The Old Man and Death*, exhibited 1774. Wright's have a grayer tonality, Mulready's more golden.

56. Letter from Constable to C. R. Leslie, dated 17 Dec. 1832; quoted in *Constable Correspondence*, III, p. 85.

57. J. L. Roget, *A History of the Old Water-Colour Society*, London, 1891, I, p. 390, quoting J. J. Jenkins' manuscript account of William Henry Hunt. For an account of William Henry Hunt's career, see F. G. Stephens, "William Henry Hunt", *Old Water-Colour Society's Club*, XII, 1935, 17–50. This was reprinted with some additions from *Fraser's Magazine*, October 1865, pp. 525–36.

58. That such drawings would appeal to an engraver is not surprising, since their tonal variations resemble fine engraved prints. Mulready probably met Wilson Lowry

through Varley, an acquaintance of Lowry's from about 1802. Varley's second wife was Wilson Lowry's daughter.

59. Two additional pencil cottages were sold to "Hobson" and "Harris" in 1805. This type of drawing generally sold for one guinea, whereas his oils sold for five guineas.

60. Mulready was certainly acquainted with Paul Sandby Munn as early as 1803, when they both attended a meeting of the Sketching Society, a watercolor society dominated by John Sell Cotman. Mulready was never an official member of the Sketching Society; however, he was recorded as a visitor to one of their sessions, as evidenced by the following inscription on a Cotman drawing, dated 4 Nov. 1803: "J. S. Cotman, president, J. Varley: T. Webster: T. Powell: J. Hayward: P. S. Munn. Visitors, Stevens and Mulready." The subject for the evening was taken from Ossian: "We came to the Hall of the Kings, where it rose in the midst of the rocks." Unfortunately, Mulready's contribution to Ossianic iconography is lost. The above is quoted in S. D. Kitson, *The Life of J. S. Cotman*, London, 1937, p. 34. The Sketching Society was the subject of an exhibition at the Victoria and Albert Museum in 1971, organized by Jean Hamilton.

61. See, for example, Meindert Hobbema's *Wooded Landscape*, Fitzwilliam Museum, Cambridge (cited by John Smith, *A Catalogue Raisonné of the Works of the Most Eminent Dutch, Flemish, and French Painters . . .*, London, 1835, VI, p. 141, no. 82). His master Jacob van Ruisdael provided numerous other examples incorporating similar elements—many in English collections.

62. South Kensington Exhibition, 34, and repeated by Stephens, *Memorials*, p. 61, where he adds that the painting is "noteworthy in showing the house in Robinson's Row where Mulready lived".

63. *The Leaping Horse* (Sketch), 1824–5, Victoria and Albert Museum; *The Leaping Horse*, R.A. 1825, Royal Academy of Arts.

64. This was not a new practice. Old masters employed this economical corrective method. In 1807, Sir George Beaumont discussed this with Wilkie in reference to Rembrandt: "wherever he had failed, he has cut out the paper, and inserted a fresh piece . . .", as quoted by Cunningham, *Wilkie*, I, p. 154. Mulready eliminated the "cutting out" step, merely pasting the correction over the faulty area. He evidently used this technique as early as 1804 when he pasted a child onto his Kirkstall Abbey watercolor (Plate 27).

65. *Kensington Gravel Pits*, painted in 1812, exhibited 1813, reproduced *Landscape in Britain*, 245 (a work also exhibiting astonishing clarity).

66. In manuscript notes certainly later than the works now under consideration, Mulready refers to a proposed painting as "a sort of De Hooge-like treatment of the scene . . ." (Victoria and Albert Museum, 6500). De Hooch's works were known. In 1820 Mulready's friend David Wilkie cites a "De Hooge" copy as being "of the greatest use" when "painting in my background" (to *The Chelsea Pensioners . . .*, 1822; Cunningham, *Wilkie*, II, p. 45). There were two

de Hooch's in Robert Peel's collection (Peel was also Mulready's patron), and John Linnell owned a De Hooch painting, *A Courtyard, with cavaliers and ladies at a repast*, sold by his descendants at Christie's, 15 March 1918, 137—a work that probably came into his possession in his later, prosperous years, although it reflected his youthful taste for carefully rendered scenes. This 1918 sale also included numerous early German works including those by Lucas Van Leyden. The excessive clarity which enters Mulready's scenes, particularly *Near the Mall*, may be the result of his contact with Van Leyden's works or with the prints after such paintings. The Artist's Sale following Mulready's death contained 23 engravings by Lucas Van Leyden (58). Linnell is said to have encountered Dürer's works in 1811 and perhaps Van Leyden's works as well (which were in turn dependent on Dürer). (See Firestone, p. 37). He would have shared his discovery with his close friend Mulready. At a later date Linnell certainly encouraged the young Samuel Palmer to emulate Van Leyden, confirmed by a note in Palmer's notebook of 1823/4: "Look for Van Leydenish qualities in real landscape, and look hard, long and continually." (Quoted in Palmer, *Life*, p. 14). If Mulready was not yet familiar with such early German works when executing his Mall paintings, his own naturalism would have prepared him to appreciate their works when he encountered them afterwards.

67. Cornelius Varley's watercolors on occasion compare favorably with Mulready's oils. This was true of his brief sketches as compared with Mulready's *plein-air* oils and is also true of his cityscapes. A watercolor inscribed "Mill Bank Thames C. Varley" (Tate Gallery) is very similar to Mulready's *The Mall . . .* in its disposition of architectural elements. Cornelius Varley was not primarily a painter, but rather a scientist who indulged in painting, having been trained by his brother John Varley. Perhaps his empirical, orderly mind carried over into his artistic vision of the world an orderly, organizing facility, which was also evident in the work of his brother-in-law Mulready. One wonders if Mulready employed his invention, the telegraphic telescope, to achieve this orderly perspectival effect. For a discussion of this invention, see M. Pidgley, "Cornelius Varley, Cotman and the Telegraphic Telescope", *Burlington Magazine*, CXIV, 1972, pp. 781–6; and Martin Butlin, "Blake, The Varleys, and the Patent Graphic Telescope", in *William Blake, Essays in Honour of Sir Geoffrey Keynes*, eds. Paley & Phillips, Oxford, 1973. Or perhaps Mulready employed the old-fashioned camera obscura. His friend Linnell purchased one in 1811 (Linnell's Journal, 1811).

68. See, for example, *The Village Buffoon*, 1815–16; *Lending a Bite*, 1819; *A Careless Messenger Detected*, 1821; and *A Dog of Two Minds*, 1829. The only other painting using this backdrop is *The Butt—Shooting a Cherry* of 1847, but this was begun more than twenty years before.

69. Sketchbook.

70. A painting by Poussin from the Bourgeois Collection, *A Roman Road* (Dulwich Picture Gallery) manifests a similarly deep, orderly recession accompanied by simple,

geometric architectural elements; although here the architectural elements are less prominent than in Mulready's Mall scenes.

71. For Bertin (1775–1842), see, for example, the two small landscapes in the exhibition *The Age of NeoClassicism*, London, Royal Academy of Arts, 1972, 27 and 28. For Louis-Auguste Gérard (1782–1862), see the landscape included in the exhibition *Landscapes from the Fitzwilliam*, London, Hazlitt, Gooden and Fox, 1974, 27, pl. 24 (*Landscape with a Bridge*). A small painting recently exhibited in the exhibition *French Painting 1774–1830: The Age of Revolution*, Paris, Grand Palais, etc., 1974–5, by Antoine-Pierre Mongin (1761/2–1827) provides another case in point: *Curiosity* (132), a freshly observed scene imbued with a classicizing order; even the introduction of the amusing incident is similar to Mulready's works.

72. Mulready's teacher John Varley produced rustic cottages, sometimes quite like Mulready's, in the watercolor medium. See, for example, *Old Cottage Near Watford*, signed and dated 1809, reproduced Bury, *Varley*, pl. 37. Although Linnell's early finished oils reveal the same minute rendering found in Mulready's exhibited works, he was not much taken with cottage scenes. However, he exhibited *A Cottage Door*, British Institution, 1809 (now lost) and the Tate Gallery has an oil study of rooftops by Linnell. Unfortunately, the many cottage scenes exhibited at the Royal Academy up to 1810 by a number of little-known artists are unavailable for comparison today.

73. One painting is in Sir Edmund Bacon's Collection (however, some experts have suggested an attribution to Miles or J. J. Cotman rather than to John Sell Cotman); the other passed through a sale at Sotheby's, 19 July 1972, 108, where it was purchased by P. & D. Colnaghi & Co. Ltd. (Plate 49). The dating for these two oils is uncertain Colnaghi's believed the latter work to be early, a product of Cotman's first period painting in oil, *c.* 1807–10. However, a drawing entitled *An Old Cottage at St. Albans* was exhibited at the Norwich Society of Artists in 1824 (48) leading others to date the oils to the later period. Miklos Rajnai, the Castle Museum, Norwich concurs with this later date. A similar oil painting, *Old Houses at Gorleston*, appeared in the exhibition *Landscape in Britain* (265) where the catalogue suggests an early date, perhaps soon after Cotman took up oil painting late in 1806.

Some of Cotman's oil landscape sketches can also be remarkably close to Mulready's Hampstead Heath paintings. See, for example, *Mousehold Heath*, Tate Gallery, and *Silver Birches*, Castle Museum, Norwich.

74. See, for example, Thomas Girtin's pencil drawing, *St. Albans, The Abbey Gate-House*, *c.* 1800–01, reproduced Thomas Girtin and David Loshak, *The Art of Thomas Girtin*, London, 1954, 415; Cornelius Varley's watercolor and pencil drawing, *St. Albans Hertfordshire*, reproduced *Drawings and Watercolours by Cornelius Varley*, London, P. & D. Colnaghi & Co. Ltd., 1973, 115. In his MS. Autobiography Cornelius Varley claimed that the idea of originating the Old Watercolour Society occurred to him

while visiting St Albans.

The Royal Academy exhibitions also displayed numerous works featuring St Albans subjects. Two examples which parallel the titles of Mulready's St Albans oils are in 1804 (372), *View of St. Albans* by J. H. Miller; and in 1808 (48), *Cottages at St. Albans, Herts.* by G. Shepherd.

75. For example, the pencil drawing inscribed "St. Albans, Hertfordshire Cotman 2306", Castle Museum, Norwich.

76. Kitson, pp. 120–1. Cotman announced the completion of his first oil painting in a letter to Dawson Turner, dated 15 Oct. 1806. Cotman's oil paintings are confined to two periods: the first *c.* 1807–1810, and the second beginning *c.* 1820.

77. For example, his pencil and wash drawing, *A Half-Timbered House by a Lake*, signed and dated 1800, reproduced Christie's 7 March 1972, 30.

78. They certainly knew each other by 1803 when, as mentioned earlier, Mulready was a guest at a Sketching Society meeting of 4 Nov. 1803 with Cotman presiding. Later, Cotman and Mulready were again directly linked in a Cotman note to Dawson Turner, dated 21 June 1822 (Kitson, p. 34), where Cotman commented favorably on Mulready's painting at the Royal Academy exhibition *Convalescent from Waterloo*.

79. Cotman lived with Paul Sandby Munn from 1802 to 1804.

80. Derek and Timothy Clifford (*John Crome*, Greenwich, Conn., 1968, Appendix F, pp. 270–1) acknowledge the similarity of their work, suggesting that some works now attributed to Crome were perhaps the early work of Mulready, without specifying any particular paintings. Nor do they suggest any influence on either side.

81. An anonymous critic quoted in Whitley, p. 104. Crome's friend Augustus W. Callcott was also Mulready's friend, and may have directed Crome's attention to his work.

82. *An Old Cottage, St. Albans* was sold to Lady B. Proctor for £6 in 1806; by 1807 Mulready's prices varied from £9 to £31 for similar scenes. Thomas Hope paid £21 and £31 for his cottage scenes purchased that year. (Account Book, 1806, 1807). According to Kitson (p. 117), Dawson Turner purchased at least five of Crome's cottage paintings, paying an average of three pounds apiece.

83. Clifford, p. 100.

84. For example, *View of Blofield, near Norwich*, Birmingham City Art Gallery; or *Blacksmith's Shop Near Hingham, Norfolk*, R.A. 1808, Philadelphia Museum of Art (Plate 64). Mulready's one open-air oil sketch including a cottage (*Cottages on the Coast* Plate 170), signed and dated 1806, is decidedly closer to Crome than his studio oils. In fact, there is reason to believe that Mulready "corrected" the cottages toward regular outlines in his studio oils. For example, the houses featured in an early sketch for the painting *View of St. Albans*, illus. Rorimer 50, are markedly more slanted than those displayed in the more detailed, presumably later, pencil drawing of the same buildings in Plate 53.

85. For example, *St. Martins Gate, Norwich*, *c.* 1808–12,

Castle Museum, Norwich, or *Old Houses at Norwich*, Yale Center for British Art, Paul Mellon Collection, Pl. 65.

86. One might also mention that the dimensions of Crome's paintings are usually significantly greater than Mulready's.

87. When exhibited at the R.A. in 1848 it was described as "Painted from nature in 1807 or 1808". Although *A Gravel Pit* was perhaps begun as an open-air painting depicting a specific site, its studied appearance suggests that it was completed in the studio; and in both color and manner it resembles Mulready's studio landscapes of the same period. But it is just possible that this painting was one of Mulready's "careful sketches", a term which he used to describe a lost oil of Chatham, 1808 (cat. 44), presumably a more detailed open-air painting. If this decidedly finished *Gravel Pit* was painted completely out-of-doors it would mark an important step in the development of *plein-air* painting.

Such scenes were frequently exhibited at the Royal Academy: *The Gravel Pit*, A. W. Callcott (1803, 164); *View near Kensington Gravel Pits*, Miss B. Clutton (1803, 590); *The Sand-Pit*, J. Ward (1811, 107); *Gravel Pits: a study from Nature*, J. Linnell (1823, 623) to cite a few—and most importantly Sir Francis Bourgeois' version exhibited in 1807 (14), *Children at Play near a Sand-Pit*, which perhaps inspired Mulready.

Such subjects lost their appeal by the time Mulready exhibited his painting in 1848, when the critic of the *Art Union* (1848, p. 167) declared: "The subject is perhaps as deficient of attraction as can well be imagined; but, in the hands of a master of effect, which it appears the artist was at even this early period, there is nothing that cannot be chastened into the beautiful, however remote it may be from agreeable association."

88. Ruskin recognized the sublimity of this view, the "bank so low, so familiar, so sublime!" (*Works*, IV, p. 337).

89. Mulready's one landscape exercise in Rembrandtesque chiaroscuro is quite close to Turner's painting of approximately the same date, *Sketch of a Bank with Gipsies* (Tate Gallery). Exhibited at Turner's Gallery in 1809, it also features a steep bank with the lower area in deep shadows. Two cows replace Mulready's children on the edge. For a discussion of Turner's painting, see John Gage, "Turner and the Picturesque", *Burlington Magazine*, CVII, 1965, 79; and *Landscape in Britain*, 205.

90. A number of artists dealt with the theme of children bathing. George Morland and John Crome featured boys bathing in a river or pond (Morland, *Boys Bathing*, illus. *Connoisseur*, Dec. 1911; Crome, *The Poringland Oak*, c. 1815–16, Tate Gallery, illus. Clifford, 107). The Royal Academy exhibitions cite several others, for example *A Landscape: Children Bathing*, R. Cooper (1803, 363); *Boys Bathing*, J. J. Chalon (1810, 302); *Boys Bathing: A Morning Scene*, W. Collins, Jun. (1810, 313). The latter artist produced a number of paintings showing children by the sea after 1816, for example, *Seaford, Sussex*, 1844, Victoria and Albert Museum. S. Woodforde preceded him with such seashore themes (R.A. 1813, 174: *Scene on the Sea-shore: Children Dividing their Shells*). In a rare scene by Benjamin West entire families are shown occupied with the serious business of bathing in *The Bathing Place at Ramsgate*, c. 1788, Yale Center for British Art, Paul Mellon Collection.

91. William Dyce, *Pegwell Bay Kent*, 1859–60, Tate Gallery, illus. Maas, p. 237; and William P. Frith, *Life at the Seaside* (Ramsgate Sands), R.A. 1854, Her Majesty the Queen, illus. Maas, p. 118.

92. As Uvedale Price explained in his *Essay on the Picturesque* (1794): "In our own species, objects merely picturesque are to be found among the wandering tribes of gypsies and beggars." Mulready's contribution to this picturesque theme is one of very many examples. Gainsborough depicted gypsies (*Woody Landscape with Gypsies*, Tate Gallery); Francis Wheatley and George Morland painted several versions of the theme and according to his biographer George Dawe (p. 104), Morland "often lived with them for several days together". David Cox (R.A. 1808, 457: *Gypsies, from Nature*), John Crome and James Ward (examples of which were in Gillott's Collection, Christie's, 26 April 1872, 200, and 27 April, 241), David Wilkie (oil sketch, Victoria and Albert Museum), and even John Constable (*Dedham Vale*, R.A. 1828) all contributed to the iconography.

In George Eliot's novel *The Mill on the Floss*, first published in 1860 but looking back to the early years of the century, the young protagonist, Maggie Tulliver, seeks freedom from her oppressive world by running away to the local gypsies: "when she was miserable it seemed to her the only way of escaping opprobrium, and being entirely in harmony with circumstances would be to live in a little brown tent on the commons; the Gypsies, she considered would gladly receive her . . . [and be] her refuge from all the blighting obloquy that had pursued her in civilized life" (Signet Classic, N.Y. and Scarborough, Ontario, 1965, Chapter 11). For Maggie Tulliver and society at large (including the art world), gypsies represented untrammeled human nature, free from the restrictions of society. They were a mysterious force in the comfortable English countryside. For a more extended discussion of this subject, see John R. Reed, *Victorian Conventions*, n.p., 1975, Chapter 14: Gypsies.

93. Review of the Mulready Exhibition at the Society of Arts, *The Athenaeum*, 10 June 1848, p. 584.

94. William Collins and Francis Danby also painted the theme. There can at times be a striking parallel between William Collins' early rustic scenes incorporating children and Mulready's own. For example, Collins' *Minnow Catchers*, Bury Art Gallery, is remarkably free of the saccharine quality that generally saturates his rustic children's scenes, and could quite easily be placed in Mulready's oeuvre. The robust children, the finely wrought treestump and foreground foliage, the distant cart-horse are remarkably similar to Mulready's early landscapes. Was Mulready's friend Collins influenced on occasion by Mulready's style? Francis Danby's early landscapes (c. 1820), painted with a minute precision and inhabited by rustic children, also recall Mulready's early landscapes. (See

Eric Adams, *Francis Danby: Varieties of Poetic Landscape*, New Haven & London, 1973). But it seems unlikely that Danby, painting these landscapes in his native Bristol, was directly influenced by Mulready's early and far from visible works.

95. Redgrave, *Memoir*, pp. 91–2. Mulready's early landscapes were cautiously but sometimes thinly painted. The commercial drying oils that he then employed encouraged the disintegration of some surfaces. Mulready discussed this in his testimony before the National Gallery Site Commission in 1857. He often had to retouch these paintings.

96. Cole's Diaries, 5 May 1844: "Called on Mulready who speaking of his two small landscapes painted in 1811 & 12 said they were thought too bad for Exhibition."

97. Augustus Callcott (1779–1844) arranged for the commission of these paintings, a point confirmed in Cole's Diaries (26 December 1845): "[Sheepshanks] told me that Mulreadys little Landscapes of the Mall had been painted for Mr. Horsley but rejected by Callcott." This particular wording is significant since Horsley had already purchased one of Mulready's rustic scenes as recorded in Mulready's Account Book, 1809 & 10 ("Heston", or *Boys Playing Cricket*). Callcott's disapproval of the Mall paintings may have soured them for Mr Horsley.

Despite Callcott's rejection of these works he may have influenced Mulready's early style. Callcott was a friend of John Varley's; they had both participated in the Sketching Society. Callcott met Mulready early on in Mulready's career; they later shared the same patrons: Sir John Swinburne and Lord Grey as well as Mr Horsley. After Mulready moved to Kensington Gravel Pits in 1809 they were neighbors. Elected an Academician in 1810 he would have provided a slightly older role model for Mulready. Although very successful during his lifetime, considered Turner's rival and knighted by Queen Victoria, Callcott is little known today. (He was not even included in the Tate Gallery exhibition *Landscape in Britain 1750–1850*, 1973.) As a result, it is difficult to define his style. However, a small early painting of a rustic cottage by Callcott in the Royal Collection, Osborne House, indicates a broader, more painterly execution than Mulready's (not surprising in light of his criticism of Mulready's highly detailed Mall paintings). David Brown is currently preparing a Ph.D. thesis (Leicester University) on Callcott entitled: Life and Works of Sir A. W. Callcott, R.A. 1779–1884. For a limited discussion of his career, see R. and S. Redgrave, *A Century*, II, Chapter XI.

98. The *Art Union* critic (R.A. review, 1844, p. 161) describing *The Mall, Kensington Gravel Pits* wrote: "it has that solid appearance of reality which can only be communicated to a work by accurate study of the locale itself. It is distinguished by great breadth, yet there is a singularly nice finish only apparent on a close examination of the picture." After noting the appearance of its pendant, *Near the Mall*, the critic continued: "Both are gems of rare value." Or again when both were exhibited at the Society of Arts in 1848: "simple in subject but so extraordinary in execution and feeling, as to place them at once on a level with the very best productions of the kind that have ever been seen" (*Art Union*, 1848, p. 208). Such early scenes were also coveted by patrons. John Gibbons collected several, feeling no doubt that they accorded with his taste as described to W. P. Frith: "Just let me mention . . . that I *love finish*, even to the *minutest details* (Frith, *Autobiography*, II, p. 145, in a letter dated 7 Oct. 1843).

99. As well as having been exhibited in 1844, the Mall paintings reappeared along with other early landscapes in the comprehensive exhibition at the Society of Arts, opening 1 June 1848, closing probably in mid-August. This Mulready exhibition may have attracted the attention of William Holman Hunt and D. G. Rossetti, who were meeting during the summer of 1848 just prior to the formation of the Pre-Raphaelite Brotherhood the following autumn. One finds no direct mention of their having visited the show.

100. Mulready comforted the Pre-Raphaelites when they were abused by the critics, citing the rejection of his own early works, and explaining: "never mind what they say, go on; what is good in your views will outlive this squabble; it was the same when I was young" (Stephens, *Fine Arts Quarterly Review*, 1863, p. 392). F. G. Stephens wrote a major study on Mulready's art and life; William Holman Hunt commented favorably on his art (see Ch. II, note 105).

101. T. Gautier, *Les beaux-arts en Europe*, Paris, 1855, p. 30.

102. Story, *Linnell*, II, p. 224. By 1856, Mulready's close friend Henry Cole had taken up photography.

103. Artist's Sale, 28 and 65. These specifically cite Photographs of Landscapes. There were several other categories as well. Photograph Portraits of Artists, Figures and "from Pictures and Drawings". Another member of John Varley's original student group, William Henry Hunt, also collected photographs; his album of photographs was sold at Sotheby's, 2 July 1962, 275. Photography seems to have held a special appeal for those artists who early in the century had attempted to record nature in all its detail on canvas or paper.

104. *Art Journal*, 1852, p. 167.

105. Ford Madox Hueffer, *Ford Madox Brown, A Record of his Life and Work*, London, N.Y., and Bombay, 1896, p. 77; letter from Brown to Lowes Dickenson in Rome, 1851. William Holman Hunt also recorded his admiration for Mulready (Hunt, I, p. 49) and described how he looked forward to attending the Royal Academy Schools when Mulready was a Visitor. Evidently Mulready reciprocated this admiration, for Hunt recorded that "models who posed to him told me that he always inquired as to what I was doing at home, adding 'ah! you'll see, he will do something one day.'" (Hunt, I, p. 96).

106. Allen Staley (*The Pre-Raphaelite Landscape*, Oxford, 1973, p. 172) draws attention to this fact.

107. The color in Mulready's work was bright, as was true of Pre-Raphaelite painting, but then his work had featured

brilliant color since the 1830s, influencing the young Pre-Raphaelites, not the other way around. In any case, this particular work, while bright, is nevertheless quite saccharine in its color scheme with tender autumn shades competing with a brighter yellow-green; whereas the Pre-Raphaelite color while bright was also harsh, not pretty or sweet.

Notes to Chapter III

1. For example, Joshua Reynolds' *Lady Mary Leslie*, 1764 or Thomas Gainsborough's *The Girl with Pigs*, *c.* 1782. For the first and most basic discussion of Reynolds' and Gainsborough's portraits of children, see Edgar Wind, "Humanitätsidee und heroisiertes Porträt in der englischen Kultur des 18 Jahrhunderts", *England und die Antike*, Vorträge der Bibliothek Warburg 1930–1, Leipzig and Berlin, 1932, pp. 156–229.

2. See, for example, W. R. Bigg's *The Romps*, 1795, Leeds City Art Gallery, illus. *Connoisseur*, Nov. 1955, showing small girls knocking over a table and spilling ink while playing; or Francis Wheatley's *The School Door*, stipple engraving by G. Keating, 1798, showing a child crying before a school door, or George Morland's *Juvenile Navigators*, collection of Maj. R. Macdonald-Buchanan, and engraved by W. Ward, 1789.

3. South Kensington Exhibition, 33.

4. For Greuze's works, see Anita Brookner, *Greuze, the Rise and Fall of an Eighteenth-Century Phenomenon*, Greenwich, Conn., [1972].

5. Rorimer (p. 8) cites the engraving by Adriaen van Ostade, *The Desired Doll*, 1679, but any number of Dutch and Flemish paintings or prints show similar scenes.

6. Cunningham, *Wilkie*, I, p. 172. For the full quotation, see Ch. II, note 46. Mulready and Wilkie are recorded as having had supper with William Godwin on 8 Aug. 1806, 10 Oct. 1806, and 21 Nov. 1806 (Godwin's Diary, Bodleian Library, Oxford University; microfilm, Duke University).

7. There are numerous references to their continued friendship beyond the early references in Godwin's Diary and Wilkie's Journal. The letter describing Wilkie's efforts to facilitate Mulready's election to the Royal Academy has been cited earlier (Ch. I). Mulready also modelled in 1814 for the figure of Duncan Gray in Wilkie's painting of the same title (see also Ch. III, note 9). When the painting was engraved in 1827 by F. Engleheart, Wilkie wrote to his brother from France: "My friend Mulready has had by this time some practice in this way. Could you get him to look at it with Engleheart?" (quoted in Cunningham, *Wilkie*, II, pp. 44–5). In 1824 Wilkie, writing to his friend William Allan, commented favorably on Mulready's painting *The Widow*, then on exhibit at the Royal Academy (MS. letter, with Sotheby's, 23 Oct. 1967, 610). In 1838 in a letter to William Collins, Wilkie cited his friend Mulready's opinion with regard to Turner's forthcoming resignation as Professor of Perspective at the Academy (quoted in Finberg,

p. 369).

8. When genre painting in nineteenth-century England is discussed, Wilkie is considered the leader with all subsequent genre painters following in his wake. R. and S. Redgrave (*A Century*, II, p. 247) de-emphasize Mulready's actual dependence on Wilkie, stating simply that "Mulready's first subjects were evidently chosen in emulation of Wilkie, who preceded him by a year or two in public favour." Stephens quite often compares Mulready to Wilkie suggesting that "Doubtless the success of Wilkie spurred Mulready to exercise to the utmost his own indomitable energy, industry and cultivated powers." (*Memorials*, p. 51). Mulready's other biographer, James Dafforne (*Mulready*, p. 7) denies any influence—surely a mistake. Later general histories mention Mulready in the same breath with Wilkie but, as Graham Reynolds points out in his valuable study *Painters of the Victorian Scene* (London, 1953, p. 8), Mulready was "in no sense a slavish imitator of Wilkie, and the influence of the Scottish artist over the English one [in fact, Irish] was confined to suggesting to him a new range of subject matter".

9. Farington, VIII, p. 56, 12 Feb. 1816: "Wilkie, He [Mulready] sd., was His most confidential friend in professional matters." Wilkie lent Mulready materials on occasion as is revealed in a letter from Wilkie to Mulready, Victoria and Albert Museum Library. Though undated, it was written *c.* 1814 when Mulready was serving as Wilkie's model for *Duncan Gray*. Mulready also collected proof engravings after Wilkie's early paintings. Three appeared in the Artist's Sale (*The Rent Day*, *The Errand Boy*, and *The Cut Finger*).

10. Benjamin Robert Haydon, *Diary*, ed. Willard Bissell Pope, Cambridge, Mass., 1960–3, III, p. 519, 1–8 June 1831.

11. Haydon, *Diary*, III, p. 100, 14 May 1826.

12. In a letter from A. Cooper to Mulready, dated 10 Feb. 1818, Victoria and Albert Museum Library, Cooper described his conversation with a collector inquiring about Mulready's works: "I told him you did not wish to enter into competition with Wilkie nor did he wish you should upon consideration."

13. One should mention here that Mulready first did simple scenes from daily life, often incorporating children, in his illustrations for William Godwin's children's books. See, for example, "The Boys and the Frogs" (Plate 19) and "The Good Natured Man and the Adder" in Edward Baldwin's (pseud. for W. Godwin) *Fables, Ancient and Modern. Adapted for the Use of Children from Three to Eight Years of Age*, 2 vols., London, 1805. Thus, Mulready's own early illustrations may have encouraged him to redirect his painting to genre subjects—even if Wilkie's professional success provided the immediate stimulus for the change.

14. For example, John J. Angerstein commented upon the Hogarthian character of *Village Politicians* at the Royal Academy dinner of 1806 (reported in Cunningham, *Wilkie*, I, p. 115).

15. Margaret Greaves, *Sir George Beaumont*, London, 1966, p. 82. Not everyone was willing to accept such comparisons. The critic for *The Champion* (1816) decried them, pointing out the absence of any moral instruction in Wilkie's works, an element so prominent and praiseworthy in Hogarth's (Wilkie Press Cuttings, Victoria and Albert Museum Library).

16. See, for example, Rembrandt's Holy Family paintings of the 1640s at the Louvre, Paris, the Hermitage Museum, Leningrad, and the Gemaldegalerie, Kassel.

17. See, for example, *A Cottage Interior*, 1793, Victoria and Albert Museum (Plate 74), or *Cottage Interior, at Lexden, Essex*, 1802, illus. *Connoisseur*, May 1926.

18. For Mulready's own reference to De Hooch see Ch. II, note 66.

19. Wilkie's Journal, 9 May 1808, quoted in Cunningham, *Wilkie*, I, p. 172. The Witt Library has a brief pencil sketch for the three figures, in reverse, with slightly different poses, inscribed and dated 1807. This does not necessarily predate Mulready's work on *The Rattle*. *The Rattle* was begun in 1807 (Account Book) and his oil and pencil sketches preceded the finished oil. As Mulready was known to take great care with his compositions, his preparatory sketches undoubtedly took up some considerable time in 1807.

20. For a discussion of this, see H. Carter, *The English Temperance Movement: A Study in Objectives*, London, 1933; and Brian Harrison, *Drink and the Victorians: the Temperance Question in England 1815–1872*, London, 1971.

21. *Ackermann's Repository of Arts, Literature, Commerce*, June 1809, I, p. 490. Surprisingly, Wilkie did treat a similar theme shortly after in *Village Festival*, Tate Gallery, which includes a public drinking house; the center of the composition is taken up with a family urging a drunken father home. This group seems to have been inspired by the figures in Mulready's painting of 1809.

22. "Punch", the popular street entertainment, became quite popular with British nineteenth-century artists, allowing them to depict a wide range of people—children and adults, rich and poor. B. R. Haydon and A. B. Houghton's paintings of this theme are in the Tate Gallery.

23. Wilkie's *Village Festival* and *Blind Man's Buff* display his early characteristically long, horizontal compositions filled with lively, often comical figures.

24. The sunflower is traditionally associated with the life-giving energy of the sun, as for example, in Philipp Otto Runge's painting of the *Hulsenbeck Children* of 1805–6. Like Mulready's *Toyseller*, it brings together children with a sunflower. But in Runge's earlier work the child reaches out to grab the sunflower's leaf, fusing its life with the energy of the plant; in Mulready's painting the apprehensive child draws away from the encroaching sunflower, the burgeoning, vitalistic force of the natural world. A portrait by Hogarth of the *MacKinnon Children*, c. 1742, National Gallery of Dublin (illustrated in Ronald Paulson, *Hogarth: His Life, Art, and Times*, New Haven and London, 1971) features two small children beside a large sunflower. A butterfly rests on the sunflower symbolizing "fleeting time,

lost beauty, and lost innocence" (Paulson, I, p. 459). The underlying sense of uncertainty, of transience, is similar to the feeling suggested by Mulready's painting. One wonders if Mulready was familiar with Hogarth's work.

25. For example, Benjamin R. Haydon's *The First Start in Life* or *Take Care, my Darling*, 1832; David Wilkie's *First Earring*, 1835; W. C. Marshall's *The First Step* (sculpture), R.A. 1847. Frank Stone exhibited a painting of the same title, *The First Voyage*, R.A. 1859, engraved by F. Heath. Like Mulready's version, it exudes a sober, somber spirit. But here the voyage is a genuine voyage, not a play scene. The youth stands on a dock surrounded by solicitous women who bid him goodbye as he is about to join his fisherman father in a nearby boat.

26. For example, George Smith's *The Launch*, R.A. 1853 (an engraving after the painting is interleafed with the Jupp Royal Academy exhibition catalogues, R.A. Library). Here a group of mirthful children watch a child moving downstream in a tub. Thomas Webster also painted the theme. His *Children in a Tub* is cited by Ralph N. James in *Painters and their Works*, London, 1883, III, p. 270. Mulready's biographer James Dafforne (*Mulready*, p. 25) must have had these jollier examples in mind when he described Mulready's *First Voyage* (completely ignoring its somber spirit): "Young urchins have placed a child in a washing tub, which they are guiding down a shallow stream with the greatest glee."

27. See Lorenz Eitner, "The Open Window and the Storm-Tossed Boat; an Essay in the Iconography of Romanticism", *Art Bulletin*, XXXVII, 1955, 281–90. In the light of this theme, it is interesting to note that Mulready owned a print after one of Thomas Cole's paintings from the *Voyage of Life* series; sold in the Artist's Sale, 9.

28. Mulready's *Idle Boys* is quite similar to Jan Steen's *A Village School*, National Gallery of Ireland, Dublin (Plate 86), a painting which went through a sale in London in 1815; it is cited in John Smith's *A Catalogue Raisonné of the Works of the Most Eminent Dutch, Flemish, and French Painters . . .*, London, 1829–37, IV, pp. 7–8.

29. This view was fostered by the Evangelicals. Their religious principles sanctified the harsh oppression of children—an oppression forcefully illustrated by Mrs Sherwood's highly successful book for children, *The History of the Fairchild Family, or the Child's Manual, being a collection of Stories calculated to show the importance and effects of a religious education*, first published in 1818 with subsequent parts published in 1842 and 1847. But Mulready's paintings do not display the heavy-handed, condemnatory stance of the Evangelical. One can generally smile at his juvenile malefactors without harboring fears for their everlasting damnation.

30. London, Kenwood House, Iveagh Bequest; illustrated in Paris, Petit Palais, *La peinture romantique et les pré-raphaelites*, 1972, 125. Mulready owned Lane's Studies after Gainsborough which appeared in the Artist's Sale (34).

31. Engravings after Hogarth's *Marriage à la Mode* series were in Mulready's collection at the time of his death

(Artist's Sale, 38).

32. Several of Mulready's animal drawings were sold in the Artist's Sale following his death, many of which are now held in the Whitworth Art Gallery, University of Manchester. Mulready also owned several prints after Edwin Landseer's animal paintings (Artist's Sale, 13). Ruskin favorably compared Mulready's animals to Dürer's. See also Ch. II, note 33.

33. Portraits of fine horses had been quite common in the eighteenth century, most notably those by George Stubbs. But lowlier animals received the attention of artists as well, for example H. B. Chalon's *Portrait of a Maltese Ass*, R.A.1803 (200); Edwin Landseer's *Portrait of a Donkey*, R.A. 1818 (44); or H. C. Slous' *Portrait of a Favourite Cat*, R.A. 1818 (45).

34. R.A. exhibitions were filled with such scenes, for example J. Downman, *Girl Feeding Rabbits*, R.A. 1803 (133); Sir F. Bourgeois, *Young Cottagers Feeding Poultry*, R.A. 1805 (133); T. Clarke, *A Girl Feeding a Kitten*, R.A.1807 (116); J. Fussell, *The Pet Lamb*, R.A. 1829 (118). Mulready himself produced a drawing of a sleeping child and lamb for a Dalziel wood engraving.

35. Illustrated in T. S. R. Boase, *English Art 1800–1870*, Oxford, 1959, 64a.

36. This is also true of Collins' *Children Feeding Rabbits*, 1834 and his *Children Playing with Puppies*, R.A. 1812 (147), the latter showing a nurturing bitch and a group of children playing with her brood.

37. While British artists did produce heroic death scenes (for example, *The Death of Nelson* by Benjamin West, William Bromley, Turner, T. Stothard and Daniel Maclise), battle scenes (for example, the innumerable naval battle paintings exhibited at the Royal Academy during the first decade of the century by P. J. de Loutherbourg, N. Pocock and S. Drummond, as well as the numerous renditions later of the Battle of Waterloo), or scenes glorifying a living hero (for example, William Hilton's *Triumphal Entry of His Grace the Duke of Wellington into Madrid in 1812* or James Ward's enormous canvas *Triumph of the Duke of Wellington*, 1815–21), they seemed more inclined to paint domestic responses to war. Mulready himself had stated that "Civilian life had as many stirring incidents in it as one at Sea or in the army & more touching too" (Cole's Diaries, 5 May 1849), and here he translates a war theme into a touching civilian domestic drama.

Pathetic scenes of soldiers' and sailors' "returns" were quite popular with English artists in the late eighteenth and early nineteenth centuries (for example, James Ward's *The Wounded Soldier*, engraved in mezzotint by J. R. Smith, 1803, illus. Sacheverell Sitwell, *Narrative Pictures*, London, N.Y., 1969 [reprint of 1936 edition], no. 77, reappearing with the Crimean War (Sir Joseph Noel Paton, *Home! Return from the Crimea*, 1856, illus. Hilary Beck, *Victorian Engravings*, London, 1973, no. 32). The ordinary disabled soldier, the anonymous fighting man who bore the brunt of battle, struck a particularly poignant note for the British public. Mulready may have been immediately inspired to

take up the theme after viewing a sketch exhibited at the Royal Academy the preceding year (R.A. 1821, 122) by his friend George Jones, representing disabled soldiers in a cabaret at Waterloo, a few days after the battle.

38. Cunningham, *Wilkie*, I, pp. 218–19.

39. July 1816, p. 542.

40. *Art Union*, 1839, pp. 69–70 (discussing Webster's *Foot Ball*, R.A. 1839).

41. Thomas Arnold was the reforming headmaster of Rugby from 1829 until his death in 1842. His philosophy is embodied in the well-known novel *Tom Brown's School Days* (1858) by his pupil Thomas Hughes. Tom Brown explains the essence of the philosophy in the following lines: "After all, what would life be without fighting? ... From the cradle to the grave, fighting, rightly understood, is the business, the real highest, honestest, business of every son of man." Quoted in Asa Briggs, *Victorian People*, rev. ed., Chicago, 1970, p. 150. In his discussion of Hughes, Briggs explains that "the science of fisticuffs was a necessary prelude to the science of government, in London as much as at Rugby" (p. 163).

42. See Ch. I, note 111.

43. The motif of children playing with toy boats was a popular theme with British artists, which is not too surprising in view of the nation's geography and the superiority of the British naval fleet. George Morland, David Wilkie, William Collins, Francis Danby and Thomas Webster all painted such scenes.

44. Edward Bulwer Lytton, *England and the English*, University of Chicago reprint (first published 1833), London & Chicago, 1970, p. 34.

45. David Owen, *English Philanthropy 1660–1960*, Cambridge, Mass., 1964 and Brian Harrison, "Philanthropy and the Victorians", *Victorian Studies*, IX, 1966, 353–374. See also Clarence R. Decker, *The Victorian Conscience*, N.Y., 1952.

46. Poverty and crime were closely linked in a number of studies during the period. Henry Mayhew expressed it most succinctly in his famous study *London Labour and the London Poor* ..., 4 vols., 1849–62: "That vagrancy is the nursery of crime, and that the habitual tramps are first the beggars, then the thieves, and, finally, the convicts of the country, the evidence of all parties goes to prove ... The vagrants form one of the most restless, discontented, vicious, and dangerous elements of society. ... These constitute ... the main source from which the criminals are continually recruited and augmented." Quoted in J. J. Tobias, *Urban Crime in Victorian England*, N.Y., 1972 (first published as *Crime and Industrial Society in the 19th Century*, 1967), p. 73. Tobias cites a number of nineteenth-century studies dealing with this problem including H. Brandon, ed., *Poverty, Medicity, and Crime* ..., 1839; T. Archer, *The Pauper, the Thief, and the Convict* ..., 1865.

The fear that the wandering pedlar or "packman" could generate is reflected in a passage from George Eliot's *The Mill on the Floss* (first published 1860), Signet Classic, 1965, p. 331: "'Mr. Glegg, Mr. Glegg,' said a severe voice

from the open parlour window, 'pray are you coming in to tea or are you going to stand talking with packmen till you get murdered in the open daylight? . . . Murdered—yes— it isn't many 'sizes ago since a packman murdered a young woman in a lonely place, and stole her thimble, and threw her body into a ditch.'"

47. Mulready may have been inspired to employ this particular proverb by the appearance of a sculpture exhibited with the same title in the Royal Academy exhibition of 1838 (1268, *Maternal instruction*; a bas-relief "Train up a child in the way he should go, and when he is old he will not depart from it." T. Earle). Later, W. C. T. Dobson (R.A. 1860, 234) and Thomas Faed (R.A. 1863, 213) also used the proverb as the inspiration for paintings.

Clearly the proverb guided and soothed parents of the day including Mulready's friend and fellow artist Samuel Palmer, who paraphrased the proverb in a letter to a friend when discussing parental responsibility: "we have the blessed assurance and promise that a child brought up in the way he should go will not depart from it when old" (Palmer, *Life*, p. 181).

48. Lascars, or Indian sailors, were probably the most common class of Indian men seen in England and the term may have been applied to all poor Indians then visible in England. In Mulready's drawings at the Victoria and Albert Museum one finds examples of other exotic people who attracted his attention including Turks (illus. Rorimer, 197 and 296), tattooed savages (illus. Rorimer, 327) and a sketch of a Chinaman selling fireworks to children (illus. Rorimer, 328). His design for Rowland Hill's Penny Post envelope (1840) also contained people from different continents and may have suggested the Indian theme for *Train Up a Child*. . . .

49. See also the painting entitled *Rustic Charity* (cat. 198) attributed to Mulready.

50. G. D. Bearce discusses this point quite extensively in his excellent study *British Attitudes Toward India 1784–1858*, London & N.Y., 1961 as does C. Bolt in her broader study *Victorian Attitudes to Race*, London, 1971.

51. 4 March 1871, quoted in Bolt, p. 166. Bearce cites a number of other earlier examples of such characterizations including James Mill's description of Muslim India seen in the same critical light as Hindu India (*History of British India*, first published, 1817): "the same insincerity, mendacity, and perfidy; the same indifference to the feelings of others; the same prostitution and venality, are conspicuous in both" (Bearce, pp. 74–75).

52. Robert Southey's long narrative poem, *The Curse of Kehama* (first published 1810) contains descriptions of Indian widow-burning and other human sacrifices, as does William Ward's *Account of the Writings, Religion and Manners of the Hindoos*, 4 vols., Serampore, 1811. Widow-burning was also the subject of two paintings by W. F. Witherington, exhibited at the Royal Academy in 1820 (298 and 397). J. Atkinson exhibited a painting treating another Hindu ceremony, *The Cherak Pooja* (R.A. 1831, 187).

53. *The Oriental Annual, or Scenes in India*, 1838, pp. 131–2: "The incoherent mixture of fanaticism, mortification, and sensuality, in the same person is perhaps nowhere in the world so remarkable as in Hindostan . . . It is notorious that these monsters [Hindu holymen] frequently seduce from their conjugal fidelity the most beautiful women they meet with. . ."

54. *Les beaux-arts en Europe*, Paris, 1855, p. 29.

55. Quoted in M. Dorothy George, *London Life in the Eighteenth Century*, Harmondsworth, Middlesex, 1965, p. 144 (first published 1925).

56. Chesney, p. 221 and Henry Mayhew, *London Labour and the London Poor*, London, 1861, III, p. 406. The Houseless Poor Society during the winter of 1848–9 sheltered among others 53 from Germany, 8068 from Ireland, 12 from Africa, 25 from the West Indies but only 19 from the East Indies. In 1857 the Strangers Home for Asiatics, Africans and South Sea Islanders was opened in London. A very successful Indian beggar is also cited in J. T. Smith, *Vagabondiana or Mendicant Wanderers through the Streets of London*, 1817.

57. R. and S. Redgrave, *A Century*, II, p. 319.

58. *Art Union*, 1841, p. 77. Dr. Gustav F. Waagen when viewing the painting in Thomas Baring's collection mistook the Lascars for gypsies (*Galleries and Cabinets of Art in Great Britain . . .*, London, 1857, p. 100).

59. Portraits of Indians were quite common in the late eighteenth and in the nineteenth centuries and Mulready himself may have contributed some examples. His Account Book (1805) lists "Two Portraits of Indian Women". Of course, these may have been American Indians rather than Indians from the subcontinent. Mulready was acquainted with William Daniell, nephew of Thomas Daniell, both of whom gained fame for their views of India (Undated letter from William Daniell to Mulready, Victoria and Albert Museum Library). William Daniell contributed designs to the *Oriental Annual* to which Mulready subscribed. Mulready also owned copies of Charles Grant's *Oriental Heads; a series of miscellaneous rough sketches of Oriental heads* [1844 etc.]. Both appeared in the Artist's Sale. For a survey of artists producing scenes from India see Mildred Archer, *British Drawings in the India Office Library*, 2 vols., London, 1969.

60. For a discussion of the noble savage, see H. N. Fairchild, *The Noble Savage*, N.Y., 1928; and Robert Rosenblum, "The Dawn of British Romantic Painting 1760–1780", in P. Hughes and D. Williams, eds., *The Varied Pattern: Studies in the 18th Century*, Toronto, 1971, pp. 189–210.

61. Edinburgh Castle, and illustrated in Boase, *English Art*, 57. However, its critical reception would not have encouraged Mulready to follow suit. The *Art Union* (1839, p. 67) "lament[ed] the expenditure of so much time to so little purpose, by an artist whose every scrap of covered paper is of value". Mulready may have treated this theme himself if he helped R. Ker Porter with his panorama *Seringapatam* in 1800. See Ch. I, n. 161.

62. A painting by the little-known artist Phoebus (?) Levin entitled *The Dancing Platform at Cremorne Gardens*, 1864 also includes Indians (although rather inconspicuously) on English soil, as entertainers at Cremorne Gardens (illus. Maas, p. 118). Graham Reynolds in discussing *Train Up a Child . . .* (*Victorian Painting*, London, 1966, p. 12) also called to mind the Indian jugglers in Wilkie Collins' novel *The Moonstone* (1868).

63. For an excellent discussion of these views, see Philip D. Curtin, *The Image of Africa; British Ideas and Action, 1780–1850*, 2 vols., London, 1964 (1973 printing) and Kenneth Little, *Negroes in Britain, a study of racial relations in English Society*, rev. ed., London and Boston, 1972 (first published 1948), especially Part 2: The Historical and Cultural Context of Racial Relations in Britain. See also James Walvin, *The Black Presence, a Documentary History of the Negro in England 1555–1860*, N.Y., 1972, especially Ch. 6, "Black Caricature", and James Walvin, *Black and White, The Negro and English Society 1555–1945*, London 1973.

64. Both are reprinted in Walvin, *Black Presence*, Ch. 6.

65. John Sutherland, "Thackeray as Victorian Racialist", *Essays in Criticism*, XX, October 1970, 441–5; and Charles Dickens, "The Black Man", *All the Year Round*, N.S., vol. 13, 6 March 1875, p. 492.

66. Bolt, p. 227 and Curtin, II, Ch. 15 "The Racists". Rev. Richard Watson reported as early as 1824 that the two enemies of racial equality were the planters and the scientists, "the minute philosophers, who take the gauge of intellectual capacity from the disposition of the bones of the head, and link mortality and the contour of the countenance; men who measure mind by the rule and compass; and estimate capacity for knowledge and salvation by a scale of inches and the acuteness of angles". (Quoted in Curtin, I, p. 242).

67. Bolt, p. xi.

68. Bolt, p. x.

69. Chesney, p. 201. *Uncle Tom's Cabin* was first published in book form in 1852. According to Eva Beatrice Dykes (*The Negro in English Romantic Thought*, Washington, 1942, pp. 149–50) Stowe received letters of praise from Prince Albert, Lord Carlisle and the Earl of Shaftesbury and dramatizations of *Uncle Tom's Cabin* were leading attractions at two London theaters.

70. Quoted in Little, pp. 217–18. Eva B. Dykes (p. 140) also discusses how the novelist Maria Edgeworth felt obliged to change the marriage of a black man to a white woman in the novel *Belinda* since so many people were scandalized by the idea.

71. The best example of Hogarth's bold approach can be seen in *Noon*, an engraving from the series *Four Times of Day*, 1738, which includes an incident of a black man fondling the breast of a white woman while kissing her cheek, causing her to spill her dish; she does not object, nor does the surrounding crowd (illus. in Joseph Burke and Colin Caldwell, *Hogarth: the Complete Engravings*, London, 1968, Pl. 178). Its sensuousness could still be appreciated without

being condemned as late as 1814 when the *Examiner* (p. 399) described "the plump, ripe, florid, luscious look of the Servant wench embraced by a greasy rascal of an Othello, with her pye-dish tottering like her virtue".

72. *The Lute Player*, R.A. 1838, Tate Gallery. This traditional view of the black as exotic, decorative servant continued in the nineteenth century, and one could cite innumerable examples in England including C. R. Leslie's *Sancho and the Duchess*, c. 1844, Tate Gallery, or David Wilkie's *Josephine and the Fortune Teller*, 1837, National Gallery of Scotland. Two pen and ink drawings of a black servant girl in a low, revealing dress by Mulready at the Victoria and Albert Museum (illus. Rorimer, 230, 232) suggest that he too may have contemplated employing this traditional subject.

Mulready's illustrations for children's books included two other images of blacks in E. Baldwin's (pseud. for W. Godwin) *Fables Ancient and Modern . . .*, 2 vols., London, 1805: the title page showing a dignified black conversing with two small children, and an illustration for "Washing the Blackamoor White", a tale in which the black man is portrayed sympathetically. If Mulready illustrated *Pierce Egan's Boxiana . . .*, London, 1812 (Ch. I, note 103) he also produced three portraits of black boxers: two of the famous Molineux and one of Richmond.

73. See David V. Erdman, "Blake's Vision of Slavery", *Journal of the Warburg and Courtauld Institutes*, XV, 1952, 242–52; and Dawe, *Morland*, p. 38. Two Morland paintings, *Slave Trade* and *African Hospitality*, came up for sale at Christie's, 30 June 1969, 61.

74. *Art Union*, 1840, p. 75.

75. *Uncle Tom and his Wife for Sale*, R.A. 1857 (345).

76. Liverpool, Walker Art Gallery; an engraving based on the work is reproduced in Beck, no. 24.

77. A black was shown in a far from sympathetic light in H. Pidding's painting, *Massa out and Sambo merry dry*, Society of British Artists, 1828 as described in the *New Monthly Magazine*, 1828, p. 206: "the expression of the negro face, and the cellar key by his side, tell the whole tale of his master's absence and Sambo's roguery very admirably".

78. A replica of the left-hand portion of this painting signed and dated W. Mulready 1854, but not by the artist, was sold at Sotheby's Belgravia, 16 Nov. 1976 (212).

79. One should also mention here a work by William Parrot exhibited at the Royal Academy in 1851 (150) under the title "The Nigger Boat-Builder", now in the Brighton Art Gallery as "The Negro Boat Builder". Like Mulready's *Toyseller*, it depicts a black in the English countryside — specifically, Brighton Beach. Also, black minstrels or whites in black face appear as rather insignificant figures in the background of W. P. Frith's *Life at the Seaside*, R.A. 1854, illus. Maas, p. 118. Henry Mayhew (*London Labour and the London Poor*, III, p. 190) discusses the rarity of blacks in London after the mid-nineteenth century, and the occasional appearance of American black minstrels or more

frequently Englishmen wearing black face working as street singers.

80. Discussed in Pinchbeck, Ch. XIV: Children as Wage Earners in Early Industrialism.

81. For over one hundred years commission upon commission reported on the appalling conditions of their employment. Lord Shaftesbury, who had been involved in the nineteenth-century struggles to improve the conditions for young children employed in factories and mines, also agitated on behalf of chimney sweeps. It was not, however, until 1875 that an Act of Parliament was passed prohibiting the use of children as chimney sweeps.

82. William Blake, "The Chimney Sweeper", from *Songs of Innocence*, 1789; Charles Lamb, "The Praise of Chimney-Sweeps", in *Essays of Elia*, N.Y., 1931, p. 153; Charles Dickens, *Oliver Twist*, first published 1838.

83. A painting entitled *The Chimney Sweep* (Central Art Gallery, Wolverhampton) by F. D. Hardy, exhibited at the Royal Academy in 1862 (108), shows a somewhat similar confrontation between children. Here several children peer into a fireplace observing the labor of the chimney sweep, showing some fear but even greater curiosity.

84. The Whitworth Art Gallery, University of Manchester has a series of handwritten notes by Mulready (two pages are dated 1822) containing his brief descriptions and sketches of working men's (and boys') costumes with particular emphasis given to the color of their costumes and their suitability for pictures. He discusses blacksmiths, brewers, bakers, fishermen, watermen, messengers, fishmongers, oilmen, cheesemongers, greengrocers, carpenters, porters, and helpers in stableyards—as well as their assistants—to cite a few, thus composing a veritable encyclopedia of working "types". At one point he concludes that "West Countrymen, Navigators, Canal Bargemen & Fishermen wear the best costumes for Pictures." Not surprisingly, Mulready's viewers readily recognized the working types in his paintings by their traditional working clothes.

85. Charles Dickens worked this theme effectively a number of times, most poignantly with Little Nell in *The Old Curiosity Shop* (1840) and Paul Dombey in *Dombey & Son* (1846). The theme was also extremely popular in painting and sculpture. The popularity of the ballad "Babes in the Wood", a story of two children left to die in the forest, reflects this obsession. Perhaps the most famous version is Richard Redgrave's painting exhibited at the Royal Academy in 1860, and now held in the Forbes Collection; but it is by no means an isolated example.

86. The painting is quite similar to Rembrandt's *Jewish Merchant*, National Gallery, London, which was in Lord Beaumont's collection by 1797. Mary Webster discusses the long history of the theme of the itinerant pedlar in her study *Francis Wheatley*, London, 1970.

87. "Of Queens' Gardens", *Sesame and Lilies*, in *Works*, XVIII, pp. 116–45. See also Walter E. Houghton, *The Victorian Frame of Mind*, New Haven, 1957, Ch. 13: Love: Home, Sweet Home; Ralph Dutton, *The Victorian Home*, London, 1954.

88. Mulready's friend David Wilkie attempted to dispel this myth in his painting, *Distraining for Rent*, 1815; but as A. Raimbach, Wilkie's principal engraver, later explained: "[while] Distraining for Rent has been generally acknowledged to be one of Wilkie's most admirable works . . . objection was [made] to the subject; as too sadly real, in one point of consideration, and as being liable to a political interpretation in others. Some persons, it is said, spoke of it as a 'factious subject.'" (*Memoirs and Recollections of Abraham Raimbach*, ed. M. T. S. Raimbach, London, 1843, p. 163). Hardly a reception guaranteed to encourage other artists to follow suit.

An art critic for the *Art Journal* later criticized the discrepancy between happy rural families portrayed in painting (with specific reference to Thomas Webster's painting *Good Night*, R.A. 1846) and the real condition of the rustic laborer and his family, once a freeholder but now "almost among the extinct races, a victim to the Moloch of wealth. . ." The critic refrained from continuing in this line, fearing that he would get "too political" (1855, p. 295).

89. The prison-like atmosphere of school was perpetuated not only in literature but in painting as well. Children's reluctance to enter the oppressive, "unnatural" atmosphere of school was a popular subject with artists. For example, "The Truant" was the title of a number of paintings exhibited at the Royal Academy in the nineteenth century. And several artists including Mulready (*A Sailing Match*) subtitled their paintings with the appropriate quotation from Shakespeare: "The school-boy . . . creeping, like snail, unwillingly to school" (*As You Like It*) to express this sentiment (G. Clint, R.A. 1803, 207; H. Thomson, R.A. 1807, 226; and C. W. Cope, R.A. 1852, 205). But perhaps Thomas Webster caught the nature of the idea most completely in his "before and after" paintings exhibited at the Royal Academy in 1836 (along with Mulready's *Last In*): *Going into School* (316) and *Coming out of School* (334) where the children drag themselves mournfully to school in the former and burst forth joyfully in the latter.

90. For a discussion of this theme including Mulready's painting, see Robert Rosenblum, "The Origin of Painting: A Problem in the Iconography of Romantic Classicism", *Art Bulletin*, XXXIX, 1957, 279–90.

91. This scene may have been inspired by Wilkie's painting *The Rabbit on the Wall*, R.A. 1816, where four members of a family occupy a darkened cottage interior, entertained by the father who playfully casts shadows on the wall. Mulready's first preparatory studies were begun in 1815 when Wilkie was working on this painting.

92. This fascination with the boyhood of famous artists can be seen in the following paintings exhibited at the Royal Academy: *Benjamin West's First Efforts in Art* by E. M. Ward and C. Compton, R.A. 1849, 303 and 344 respectively; *Opie, When a Boy Reproved by his Mother for Painting his Father's Portrait on Sunday* by J. Absolon, R.A. 1853, 157; and, of course, William Dyce's famous painting *Titian Preparing to Make his First Essay in Colouring*, R.A. 1857, 107. This trend was merely part of a larger interest in

the imagined formative years of important Biblical, historical or mythological figures. See Ernst Kris and Otto Kurz, *Die Legende von Künstler; ein geschichtlicher Versuch*, Vienna, 1934 (Translated as *Legend, Myth and Magic in the Image of the Artist*, New Haven and London, 1979).

93. William Collins' painting *The Morning Lesson*, 1834 may have been inspired by Mulready's work. Here a young mother sits in profile outside her cottage door reading to her small children from a book upon her lap.

94. Henry Cole produced a number of children's books in the 1840s under his pseudonym Felix Summerly, entitling the series "Summerly's Home Treasury". A number of artists contributed illustrations to these books including C. W. Cope, John C. Horsley, and Richard Redgrave, as well as Mulready. Discussed in Cole, *Fifty Years*, I, pp. 101–2 and II, pp. 161–2.

95. Cole's Diaries, 1 Jan. 1844: "Called on Mulready, who sd he wd do something for the Home Treasury but thought Jack the Giant Killer wd not suit him." Another note in Cole's Diary (18 Feb. 1844) suggests the seriousness with which Mulready undertook such work: "He [Mulready] sd an artist was judged of by his works most seen & that therefore he shd take as much pains with an illustr: for a childs book as one of his pictures:".

96. Mulready prepared the drawing on zinc plate himself as recorded in Cole's Diaries, 1 March 1844 and in a letter from Mulready to Cole, dated 1 June 1844; both Victoria and Albert Museum Library. Mulready presented the zinc plate to Lady Cole, from whom it passed into the collection of the Victoria and Albert Museum. Five preparatory drawings are held in the museum (6438–6442), illus. Rorimer 111–15. Prototypes for the mother/child group can be seen in Raphael's drawing *Madonna teaching the Infant Jesus*, Duke of Devonshire, Chatsworth; and in J. H. Fuseli's *Young Milton instructed by his Mother*, Basle, Hotel Euler and another version, Liverpool, Walker Art Gallery.

97. The theme was treated in painting most notably by Richard Redgrave in his *Poor Teacher*, R.A. 1843 and *The Governess*, R.A. 1845; the latter exhibited with the following sad commentary: "She sees no kind domestic visage here." Two female artists, Miss R. Solomon and Emily Osborn, also exhibited paintings on this theme (R.A. 1854 and 1860 respectively), each accompanying their paintings with morose poetry describing the unhappy situation of their central characters.

98. This emphasis upon religious ritual—bible reading and prayer—unites Mulready's work with much religious painting in the late eighteenth and the nineteenth centuries, when ritual supplanted religious history as the focal point of religious painting. Thomas Webster's *Children at Prayer*, 1835, Victoria and Albert Museum; David Wilkie's *Grace before Meat*, 1839, Birmingham City Art Gallery; and C. W. Cope's *Prayer Time*, R.A. 1860 (?), Harris Museum and Art Gallery, Preston are similar paintings in this vein by Mulready's acquaintances.

99. City of Manchester Art Galleries, illus. in the catalogue *William Holman Hunt*, introduction and catalogue by Mary Bennett, Walker Art Gallery, Liverpool, 1969, Pl. 37. Hunt explained that the shepherd was one "who is neglecting his real duty of guarding the sheep.... He was the type of muddle-headed pastors, who, instead of performing their services to the flock—which is in constant peril—discuss vain questions of no value to any human soul. . ." For a brief discussion of the religious situation during this period, see G. Kitson Clark, *The Making of Victorian England*, Cambridge, Mass., 1962, Ch. VI: The religion of the people. See also Owen Chadwick, *The Victorian Church*, London, 1966.

100. See Ch. I, note 130.

101. Manuscript notes, Whitworth Art Gallery, University of Manchester (D.121g. 1895).

102. See Boase, *English Art*, p. 171, quoting a criticism in *Fraser's Magazine*, 1831. See also the reviews of the Royal Academy exhibitions in *Art Union*, 1840, p. 94 and *The Athenaeum*, 1842, p. 482 for additional examples. Stylistic considerations may also have turned Mulready's attention away from childhood scenes. See Ch. IV and Ch. VI.

103. Redgrave (*Memoir*, p. 169) reported how the painting was a great favorite with George IV "and that when it came back to Mulready to be looked over, the whole bottom of the frame was a mass of wax, which had dropped from the candle when the King, from time to time, stood before it explaining the story". It may have been a particular favorite with Queen Victoria as well, for Henry Cole (Diaries, 22 July 1843) noted its location in the Queen's private sitting room at Windsor in 1843.

104. The City of Manchester Art Galleries, Fletcher Moss Museum has a number of Hunt's watercolors of rustic youths.

105. See R. and S. Redgrave, *A Century*, Ch. XXI; and "Thomas Webster, R.A." (Part of a series: British Artists—Their Style and Character), *Art Journal*, 1855, pp. 293–6.

106. See Wolverhampton, Central Art Gallery and Laing Art Gallery, Newcastle-upon-Tyne, *The Cranbrook Colony*, 1977 which includes several illustrations.

107. However, unlike Mulready's oeuvre, Dickensian social commentary occasionally surfaced in the works of these artists. Thomas Webster painted Dotheboy's Hall (R.A. 1848, 135), a scene of a harsh, oppressive Yorkshire school detailed in Dickens' *Nicholas Nickleby* (1839). F. D. Hardy's *The Chimney Sweep*, R.A. 1862 (see Ch. III, note 83) focuses on the deplorable working conditions of poor children. And Mulready's own grandson, Augustus E. Mulready (c. 1840–after 1903), who associated with these artists (especially J. C. Horsley) in the latter decades of the century, often explored the theme of poverty-stricken street children, with maudlin effect. Despite the easy sentimentality of his paintings they occasionally capture the hard edge of the late nineteenth-century urban scene.

108. This threatening vulnerability can, however, bring to mind Charles Dickens' children or Charlotte Bronte's young Jane Eyre—children buffeted by uncontrollable forces, helpless, and courted by death. Peter Coveney explores this literary trend in his perceptive study *The Image*

of *Childhood*, rev. ed., Harmondsworth, 1967. Two recent publications also touch upon this literary development: David Grylls, *Guardians and Angels: Parents and Children in Nineteenth Century Literature*, London and Boston, 1978 and R. Pattison, *The Child Figure in English Literature*, Athens, Georgia, c. 1978. Sad children with maudlin expressions (inspired by Murillo) were present in English painting from Gainsborough on through A. E. Mulready. Millais' paintings of the 1850s (*Autumn Leaves, Blind Girl, Sir Isumbras at the Ford*) present a good mid-nineteenth-century example. Startled and frightened children became more prevalent late in the century (see for example, Millais' *Little Miss Muffet* or *The Princes in the Tower*, 1878). Mulready's frightened children were an unusual manifestation in the early and mid-nineteenth century.

NOTES TO CHAPTER IV

1. John Varley modelled for the suitor. The placement of the woman with her suitor to her right is reminiscent of David Wilkie's primmer courtship painting, *Duncan Gray* of 1814, Victoria and Albert Museum. Mulready posed for the suitor in Wilkie's painting. The ostrich egg in *The Widow* is mysterious. Is it a symbol of death or of absent friends? A similar globe appears (with other appurtenances of death) in Hogarth's series *Marriage à la Mode* (III), where the count, seated in a pose much like Mulready's suitor is visiting the quarters of the quack and bawd. For a perceptive discussion of this painting, see also Marcia Pointon, "William Mulready's 'The Widow': a subject 'unfit for pictorial representation'", *Burlington Magazine*, CXIX, 1977, 347–51. Here Pointon borrows Ruskin's phrase to describe the unsavoury subject of *The Widow*. Ruskin actually employed these words to criticize Mulready's *The Seven Ages of Man* not on moral grounds but rather because the theme did not lend itself to pictorial representation.

2. Mulready appended a phrase alluding to Petronius' *Satyricon*, a rather scandalous source, to elucidate this painting: "So mourned the Dame of Ephesus her love". The Dame of Ephesus, while mourning her husband at his tomb, was seduced by a soldier in the cemetery. Dr Pointon suggests that an interpretation of the ancient story by Pindar was probably the immediate source for Mulready. Mulready's irreverent tone was criticized in the press and apparently discouraged buyers. See Chapter VI. The comical courtship of the rich widow was not Mulready's private preserve. It was a traditional theme, as can be seen for example in a work depicting a similar subject, attributed to Mieris, in the Hope Collection. C. M. Westmacott (*British Galleries of Painting and Sculpture . . .*, London, 1824, p. 238) described it as "An exquisite work, full of humour, and rich in all the highest excellencies of art." The Hope Collection (and this painting) was readily available for Mulready's inspection. Slightly later, Punch's amusing comments on the courtship of rich widows were drawn together in *The Natural History of Courtship by Punch*, Philadelphia, 1844, ch. XII. Richard Redgrave also treated

the theme of the young widow's remarriage but without comical overtones in his painting *Throwing Off Her Weeds*, 1846, Victoria and Albert Museum.

3. J. M. W. Turner, John Linnell, W. F. Witherington, William Collins, David Cox, and Samuel Palmer all painted this subject, along with innumerable lesser known nineteenth-century artists.

4. A painting by G. E. Hicks and a sculpture by J. Hancock exhibited at the Royal Academy in 1856 (nos. 231 and 1255 respectively) employed lines from Longellow's poem *Maidenhood* to suggest the same meaning: "Standing with reluctant feet where the brook and river meet, Womanhood and childhood fleet." Patricia Meyer Spacks explores the theme of adolescence in Victorian literature in "Us or Them", *The Hudson Review*, XXXI, Spring 1978, 34–52.

5. *Art Union*, 1839, p. 68.

6. Illustrated in Timothy Hilton, *The Pre-Raphaelites*, London, 1970, no. 38.

7. Illustrated Christie's, 26 July 1974, 201, pl. 20.

8. Ronald Pearsall, *The Worm in the Bud; the world of Victorian sexuality*, N.Y., 1969, p. 91.

9. Pearsall (p. 290) quotes from a report of the London Society for the Protection of Young Females (1835): "It has been proved that 400 individuals procure a livelihood by trepanning females from eleven to fifteen years of age for the purpose of prostitution."

10. The *Art Union* first noted this dependence upon Michelangelo in its review of the Royal Academy exhibition of 1839 (p. 81). Arnold Wilson drew a specific comparison with the Prophet Jeremiah in his catalogue for the 1964 Mulready exhibition in Bristol. Shortly after painting *The Sonnet* Mulready made extensive calculations to determine the number of hours employed by Michelangelo in painting the Sistine Chapel (Tate Gallery MS. 7216.16).

11. Not unlike Joshua Reynolds' use of Michelangeloesque forms for his portrait of *Sarah Siddons as the Tragic Muse*, R.A. 1784, Henry E. Huntingdon Library and Art Gallery.

12. One questions the likelihood of an English country lad being able to write his own name, let alone a poem—not to speak of the likelihood of his sweetheart being able to read his sonnet. In 1845 33% of the male population and 49% of the female population of Great Britain were reported to be illiterate. See *Early Victorian England, 1830–1865*, ed. G. M. Young, London, N.Y., Toronto, 1934, II, p. 3.

13. The painting was not identified as a courtship scene in one of the earliest catalogues (1867) for the Sheepshanks Collection, South Kensington Museum. There it is described as "Interior—baker's man waits while a female examines his accounts." One might mention here the possible influence of George Richmond's painting *The Eve of Separation*, R.A. 1830, illustrated in William Gaunt, *The Restless Century: Painting in Britain 1800–1900*, London, 1972, Pl. 39. The lovers in Mulready's design for *The Seven Ages of Man* (Pl. 132) may also have suggested the theme.

14. Illustrated Maas, p. 114.

15. *April Love*, 1855–6, illustrated Hilton, no. 69; and *The Long Engagement*, 1853–9, illustrated Staley, Pl. 1b.

16. See Ch. III, note 99.

17. *Examiner*, 1839, p. 486.

18. Farington, VIII, p. 56, 12 Feb. 1816.

19. In both of these studies the color of the clothing differs from that chosen for the final paintings.

20. Cole reported in his Diary (25 Aug. 1850) that Mulready "wd speak to Field to exhibit colours" at the International Exhibition of 1851. Mulready cited Field in his Sketchbook and subscribed to Field's *Outlines of Analogical Philosophy*, 1839 (2 vols.).

21. Manuscript notes, 1822 (Whitworth Art Gallery, University of Manchester, D.121e. 1895): "Bl. Verdites in water & glue was used in drapery by Titian"; and "Pale broken Blue. like some of the lightish purplish, slatey blues of Ostade, Van Dyck, Rubens, Murillio."

22. Mulready urged the Trustees of the National Gallery to clean Paul Veronese's *The Consecration of St. Nicholas*. In a letter of 2 July 1852 (Copy of letter, William Mure of Caldwell's correspondence, MS. 4952, f. 252, Scottish National Library, Edinburgh) Mulready complained: "Two years ago I spoke to Col. Thwaites about the bad state of the Varnish on the Paul Veronese — It is now still worse — certainly not in a fit condition for students to make copies in colour —."

23. Samuel Palmer, *The Letters of Samuel Palmer*, ed. Raymond Lister, Oxford, 1974, II, p. 890, a note from Samuel Palmer to Philip Gilbert Hamerton, dated 1873. One wonders if the development of Mulready's bright palette in the 1830s could be attributed to the influence of early Flemish masters. Their white grounds, their brilliant pigments, their high finish may have attracted Mulready's attention. Having visited the Ader's collection, he was certainly aware of their manner. By the 1840s, such influence is quite likely. See p. 143 for discussion. Palmer's own work shows this Flemish influence in the 1820s.

24. John Gage, *Colour in Turner*, London, 1969, p. 20. This is a very good source for the discussion of color theory in early nineteenth-century England. A lecture in 1872 by R. Liebreich, ophthalmic surgeon and lecturer at St Thomas's Hospital, attributed Mulready's and Turner's bright color to faulty eyesight. See R. Liebreich, "Turner and Mulready. On the Effect of Certain Faults of Vision on Painting, with Especial Reference to their Works", *Macmillan's Magazine*, XXV, 1872, 499–508.

25. Correspondence between David Wilkie and William Collins during Wilkie's sojourn in Europe in the 1820s reveals their mutual dislike for the "flowery gaudiness" at the Royal Academy exhibitions. See their many letters in Cunningham, *Wilkie*; and Wilkie Collins, *Memoirs of the Life of William Collins, Esq., R.A., with Selections from his Journals and Correspondence*, 2 vols., London, 1848.

26. Turner looked to Rembrandt's example at approximately the same time.

27. John Linnell's paintings of this period also display this mottled effect.

28. Sketchbook.

29. Published in 1840 with original drawings on wood by Mulready, C. R. Leslie, John Constable, David Wilkie, William Collins, A. E. Chalon, A. Cooper, A. W. Callcott, Edwin Landseer and William Hilton.

30. Ruskin (*Works*, XII, p. 364) rightly observed: "this subject cannot be painted. In the written passage, the thoughts are progressive and connected; in the picture they must be co-existent, and yet separate; nor can all the characters of the ages be rendered in painting at all . . ." Others also attempted the theme: S. De Wilde (R.A. 1815), D. Maclise (R.A. 1848) and C. W. Cope (sold Christie's, 14 March 1969, 106); even one in sculpture by William Behnes (R.A. 1830); the crowded, circular design is retained in an engraving after the relief in the Jupp Royal Academy exhibition catalogues, Royal Academy of Arts Library. Mulready turned to Shakespeare again in a watercolor (now lost) of Caliban, Trinculo and Stephano led by Ariel.

31. Sketchbook.

32. *Discourses on Art*, introduction by Robert R. Wark, London (Collier Books), 1966, p. 23.

33. Sketchbook.

34. Sketchbook.

35. Mulready illustrated a number of works (besides the childrens' books early in his career), including Sir Walter Scott's Waverly Novels (1833, 1846); John Pye's *Patronage of British Art*, 1845; Felix Summerly's (pseud. Henry Cole) *Mother's Primer*, 1844; Oliver Goldsmith's *Vicar of Wakefield*, 1843; James Grant's poems: "Madonna Pia" and "The Pale Student", 1847; Thomas Moore's *Irish Melodies*, 1856; and, according to F. G. Stephens, Pierce Egan's *Boxiana*, 1812, etc. He also contributed illustrations to an edition of Thomas Gray's *Elegy*, 1834; Van Voorst's *Seven Ages of Shakespeare*, 1840; an edition of poems by T. J. Judkin and the Moxon edition of Alfred, Lord Tennyson's poems of 1857, made famous by the illustrations of Rossetti, W. Holman Hunt and Millais. For Mulready's opinion on the importance of his work as an illustrator, see Ch. III, note 95.

36. Etty's version, R.A. 1827, illustrated in Dennis Farr, *William Etty* (London, 1958), pl. 26; Turner's version, 1837, illustrated Reynolds, *Turner*, no. 152. It is also reminiscent of Antoine-Jean Gros' *Sappho at Leucadia*, 1801, illustrated Paris, Grand Palais etc., *French Painting 1774–1830: The Age of Revolution*, 1974–75, 87.

37. Paul Usherwood also observed this in his M.A. Thesis, "The Painting of William Mulready, R.A. 1786–1863", Courtauld Institute of Art, University of London, 1971. I had come to the same conclusion independently.

38. G. S. Rousseau, ed., Goldsmith, *The Critical Heritage*, London and Boston, 1974, discusses the 19th century interpretation of this novel — its "warm-hearted simplicity" (p. 293).

39. Rousseau, pp. 272–6.

40. *Athenaeum* [H. Cole], 21 Jan. 1843, p. 165; *The Examiner*, 11 Feb. 1843, p. 84. Van Voorst's reissue in 1855 included a number of other favorable press reviews.

41. Illustrated in the 1880 edition of *The Vicar of Wakefield*, published by Scribner and Welford, N.Y. This reproduction was brought to my attention by Jennifer Lattin.

42. *Fitting Out Moses for the Fair*, no. 223.

43. Maclise: *Olivia and Sophia fitting out Moses for the fair*, R.A. 1838, 277 and *Hunt the slipper at neighbor Flamborough's—unexpected visit of the ladies*, R.A. 1841, 313 (Maclise also exhibited another in 1850, 56: *The gross of green spectacles*); Redgrave: *Olivia's Return to her Parents*, R.A. 1839, 505, and *The Vicar of Wakefield finding his lost daughter at the inn*, R.A. 1841, 498; Frith: *A Scene from the Vicar of Wakefield (Measuring Heights)*, R.A. 1842, 454 and *The Squire describing some passages in his town life*, R.A. 1844, 491; Leslie: *Scene from the Vicar of Wakefield—"Virtue, my dear Lady Blarney, virtue is worth any price; but where is that to be found?"*, R.A. 1843, 164.

44. *Art Union*, 1844, p. 168.

45. *Art Union*, 1844, p. 166.

46. Frith, *Autobiography*, I, p. 96: "Thackeray, who was the critic in Fraser of that day, declined to give the name of either Gil Blas or the Vicar in full, but always wrote of the latter as the 'V–r of W–d,' and warned us that if our servile conduct was persevered in, he would never look at pictures of either of those distinguished individuals, much less write about them."

47. T. E. Plint of Leeds, an important patron of the Pre-Raphaelites, requested a *Vicar of Wakefield* subject or a subject from Scott, having admired Mulready's illustrations for both, in a letter of 17 Nov. 1853, Victoria and Albert Museum Library. No Mulready paintings appeared in Plint's collection when it was sold.

48. George and Edward Dalziel, *The Brothers Dalziel: A Record of Fifty Years' Work 1840–1890*, London, 1901, p. 28.

49. Haydon, *Diary*, V, pp. 360–1, 7 May 1844: "There is a picture at the Academy which is as great an Epoch in the color of our Domestic School as was Wilkie's Blind Fiddler in Composition—by Mulready—Nestorian Controversy"; or again, p. 372, 27 June 1844: "I spent the morning at the Exhibition & narrowly scrutinized every picture ... Mulready's Westonian Controversy is exquisite."

50. Mulready seems to have drawn hands compulsively, as reported by Redgrave in his Diary, 11 Nov. 1857 (*Memoir*, p. 178): "'I used,' he [Mulready] said, 'to draw rapidly in pen-and-ink, but I have lost some of my power. I used to be able to draw half a dozen hands carefully and correctly in one hour. Now I find I can't do that. I must restore that power; I must get it up again,' This at seventy-three!" See Plate 24.

51. *Vicar of Wakefield*, Signet Classic, 1961, Ch. 1, p. 9. This edition is cited hereafter.

52. This beautiful cartoon was rightly praised when it appeared in the R.A. exhibition, 1844 by the *Art Union*'s critic (1844, p. 168): "rarely do we see such power and originality brought to bear upon the reiterated themes here exhibited. The value of this gem is not to be reckoned by gold".

53. See Henry Cole's record of Mulready's slow progress in the catalogue entry for the painting.

54. A note in Cole's Diary (4 Sept. 1841) records Mulready's

thoughts on this method: Mulready "talked chiefly about Fresco painting which he said did not produce rapid & spontaneous effects, because though it required rapid executions—that was merely a facsimile of a well digested design". Fresco painting was then much discussed because of its proposed use for the decoration of the new Palace of Westminster. See T. S. R. Boase, "The Decoration of the New Palace of Westminster, 1841–1863", *Journal of the Warburg and Courtauld Institutes*, XVII, 1954, 319–58.

55. *Memorials*, p. 5.

56. Ruskin (*Works*, IV, p. 336) commenting upon the spaniel in the foreground remarked "Albert Dürer is indeed the only rival who might be suggested . . . [although] Dürer was less true and less delicate in hue."

57. Thackeray compared Mulready's *Whistonian Controversy* to the pictures of Van Eyck (*Fraser's Magazine*, June 1844, p. 706).

58. Cunningham (*Cabinet Gallery*, II, p. 126) mentions that Van Mieris was fond of painting mercers exhibiting their silks and satins to fastidious ladies. See also Van Mieris' *A Cavalier in a Shop*, signed and dated 1660, illustrated *Catalogue of Vienna Gallery*, 1907, opposite p. 313.

59. B. R. Haydon, (*Diary*, V, p. 537, 4 May 1846) noted this condition in his Diary: "I am returned from the Academy and as usual after being *the* finest it turns out to be *the* average. Mulready's stippling is hideously apparent."

60. 10 Oct. 1846 (p. 233). The description accompanies a wood engraving of the painting. The Pre-Raphaelites' later disdain for "sloshy" painting was nurtured in this milieu.

61. Ch. 6, p. 31.

62. Sheepshanks Collection, Victoria and Albert Museum. Since Mulready began work on his illustrations in 1841 it is just possible that Frith's work may have derived from Mulready's preparatory drawings (if Frith had access to them in Mulready's studio).

63. Ch. 17, p. 84.

64. The composition derives in part from one of Mulready's illustrations for the *Vicar of Wakefield*.

65. This may have been inspired by seventeenth-century Dutch or Flemish scenes where doctors or chemists give potions to women.

66. See, for example, Ford Madox Brown's *Take Your Son, Sir!* c. 1857, illustrated Hilton, no. 110; and J. E. Millais' drawing, *Retribution*, 1854, illustrated Hilton, no. 100.

67. See, for example, William Lindsay Windus' *Too Late*, 1859, or P. H. Calderon's *Broken Vows*, 1858, in Raymond Lister, *Victorian Narrative Paintings*, New York, 1966, pp. 80–1 and pp. 116–17.

68. Scenes reminiscent of Rembrandt's etching *The Bedstead*, 1646, illustrated in Edward Lucie-Smith, *Eroticism in Western Art*, New York and Washington, 1972, no. 189.

69. Sketchbook. That this was true can be seen from the overwhelmingly positive public reception given to Hiram Power's "covertly exciting" semi-nude statue *The Greek Slave* when it was exhibited in London at the Great Exhibition of 1851.

NOTES TO CHAPTER V

1. See Ch. I for a discussion of his role as a Visitor.

2. Royal Academy Commission.

3. Along with several others, C. L. Eastlake, then President of the Royal Academy, expressed his admiration for Mulready's teaching skills to the Royal Academy Commission (1863): "I consider him [Mulready] the best and most judicious teacher the Academy has ever had, in my recollection. I consider him the best judge of the merits of drawing in this country..." The South Kensington Museum (later to be the Victoria and Albert Museum) obtained several academic nudes for student instruction, a number of which were translated into lithographs to be used in art schools throughout the country (as reported in the *Art Journal*, 1859, p. 100).

4. Royal Academy Commission.

5. Stephens (*Memorials*, pp. 101–2) describes Mulready's technique and reports that Mulready took up this method in 1840 at the suggestion of his son Michael. This is confirmed by a note in Cole's Diary (18 Aug. 1863): "M. Mulready sd his father first used Black & Red Chalk at his suggestion."

6. For additional illustrations, and some contemporary references, see Rorimer, "Academic Studies".

7. Mulready drew alongside a number of younger artists at the Kensington Life Academy, including William Holman Hunt. Thomas Bodkin identified two drawings of the same model by Mulready and Hunt ("Two English Drawings", *Miscellanea Leo van Puyvelde*, Brussels, 1949, pp. 250–3) without fully commenting upon their remarkably different approaches. While Hunt's drawing is harsh and cold, affording no flattery to the model, Mulready's is soft, delicate and idealized—a distinction which Hunt recognized: "He [Mulready] was cramped by a taste for Dresden-china prettiness, and the uncourageous desire—then well-nigh universal—to win applause for beauty." (Hunt I, p. 49). A drawing of a male nude by Mulready (Victoria and Albert Museum, 6583) forms another link with Hunt and the Kensington Life Academy; it is inscribed "Kensington Life Academy 24 Dec 1858 W H Hunt placed the model WM." At about the same time a fellow Pre-Raphaelite, the sculptor Thomas Woolner, praised Mulready's Academic Studies displayed in the Art Treasures Exhibition, Manchester, 1857: "Mulreadys from the life marvelous, the best I ever saw". Letter to W. M. Rossetti, dated 2 Aug. 1857; quoted in Woolner, p. 135.

8. Mulready's nude drawings and Bather paintings were a source of pride to certain English painters who were sensitive to charges that the English could not draw and who believed that Mulready's works were a refutation of this charge. W. P. Frith wrote a letter to Mulready (watermark 1853, Victoria and Albert Museum Library) requesting permission to introduce a "foreign artist who is wishful to see the best specimens of English painting. he *does not expect* to see what I & all who have seen it think one of the finest eg. of either English or any other painting—a certain lady bather—now in your room & mind *I don't take the liberty of*

asking such a thing but I only say if you were to show it then you *would do us all credit*."

9. For example, William Frost, a follower of William Etty, gained his Associate membership in the Royal Academy after exhibiting a painting of this theme in 1846. It later entered Lord Northwick's collection. Illustrated in Christopher Wood, *Dictionary of Victorian Painters*, Woodbridge, Suffolk, 1971.

10. A scene where Musidora's young lover, Damon, discovers her bathing, as seen, for example, in works by the following artists: W. Kennedy, R.A. 1844, 564; J. Thomas (sculpture), R.A. 1849, 1340; J. Legrew, R.A. 1850, 1309.

11. Dennis Farr in *William Etty* (London, 1958) details Etty's financial success in the 1840s—thanks to a few select patrons, particularly Joseph Gillott, the Birmingham pen manufacturer, and more significantly dealers. Moreover, Mulready began his first Bather painting in the autumn of 1848 when Mulready's friend Henry Cole began his preparation for the William Etty exhibition to be held at the Society of Arts the following summer (Cole's Diary: 12 Nov. and 8 Dec. 1848). William Gaunt and F. Gordon Roe (*Etty and the Nude*, Leigh-on-Sea, Essex, 1943) identify an Etty Female Nude (Pl. 31) as having been in Mulready's collection. While Mulready owned an engraving after Etty's painting *Mercy Interceding for the Vanquished* (Artist's Sale, 3), no Etty painting appeared in the Artist's Sale following his death.

12. 1830, p. 323.

13. Loose manuscript notes, Victoria and Albert Museum Library. The reputation of female models was certainly low. The dearth of suitable paying occupations for women forced some to model, often against their own wishes, as a last resort to keep them from even less reputable pursuits. In a letter to Mulready, Landseer recommended a woman for modelling, specifying that "perhaps an *honest penny* may be put in her way". Far from expressing any lascivious intentions Landseer underlined her artistic value: "There is much good about her shapes and *color*—... I really think you may like to look at her forms." Letter dated 26 March (probably late 1850s or 1860s), Victoria and Albert Museum Library. W. P. Frith (*Autobiography*, I, pp. 58–9) recounted the shame of a young woman forced by financial hardship to pose for him fully clothed.

14. *Fraser's Magazine*, June 1839, p. 745. S. C. Hall, editor of the *Art Journal*, refers to this prevalent attitude to nude forms in his *Retrospect of a Long Life: from 1815 to 1883*, N.Y., 1883, p. 196: "In the days to which I go back it was not unusual, at stately mansions, to cover up statues on reception nights; I can call to mind one case in which each statue of marble was gifted with an apron."

15. *Works*, XXIII, p. 18.

16. *Works*, XXII, p. 235.

17. The correspondence is quoted in Rorimer, p. 33. This correspondence reveals Mulready's hope that the Queen's interest and approval would encourage artists to pursue the study of nudes and legitimize it in the eyes of the public: "May I be forgiven for expressing a hope that Her Majesty's

favour towards this drawing of mine may ultimately prove a stimulant to students in an element of Art, that might, if ardently pursued in Academies, and discreetly used in pictures, help to maintain the strength and credit of our schools." Draft letter to Col. C. B. Phipps, the Queen's intermediary in this transaction, dated 22 July 1854, Victoria and Albert Museum Library. Ironically the model's expression and pose in the drawing selected by the artist for Queen Victoria seem to embody the society's anxiety in the face of the naked human form. Generally Mulready was reluctant to part with his academic nudes, fearing that they were appreciated for the wrong reasons.

18. *Art Journal*, 1849, p. 168: "We admire a well-painted back, but this picture will not be so highly appreciated as those of the Primrose family" (in *The Vicar of Wakefield*).

19. The St Louis Art Museum has a chalk and pencil Life Study (38: 1972), signed with initials and dated 1848, depicting the same female model used in *Women Bathing*.

20. It was included in the *Catalogue of the Bridgewater Collection of Pictures, belonging to the Earl of Ellesmere at Bridgewater House, Cleveland Square, St. James's.*, 1851 (19). Mulready received teaching fees in 1849 and 1850 from "Ellesmere" probably the Earl of Ellesmere. As a teacher to members of the Ellesmere family Mulready may have had special access to this collection.

21. Arnold Wilson (Bristol, *William Mulready*, 1964) has suggested quite plausibly that at least one of the background figures depends upon Michelangelo's *Battle of Cascina*.

22. Mulready treated the subject of Diana and Actaeon in two drawings: one now in the Victoria and Albert Museum (6264), and the other in the Cecil Higgins Art Gallery. Cole probably referred to one of these in his Diary (26 June 1853): "Called on Mulready. showed his Sketch for Actaeon—".

23. The stippled shadows were noted by G. F. Waagen when he viewed the painting in Thomas Baring's collection. See Waagen, *Galleries and Cabinets of Art in Great Britain . . .*, London, 1857, p. 100.

24. One thinks of Ingres' *Turkish Bath*, 1862, Paris, Louvre or Courbet's *Sleep*, 1866, Paris, Petit Palais. Mulready could produce sensuous female nudes in his drawings. A pen and ink sketch, dated 1833 (Whitworth Art Gallery, University of Manchester D.77. 1895) shows a curvaceous Eve-like figure with symbolic animals—a goat and rabbits.

25. Dafforne (*Mulready*, p. 46) quotes two French reviews: a favorable response in the *Moniteur* and unfavorable criticism in the *Revue des Deux Mondes*; originally quoted in the *Art Journal* 1855, pp. 282–3, see cat. 169.

26. Cole's Diaries contain several references to this composition, entitled "The Lizards". It was sold at the Artist's Sale (343), bought by Farrer, thence to Agnew's who in turn sold it to R. Heugh. He gave it to the Royal Scottish Academy in 1864; it was presented to the National Gallery of Scotland in 1910. Mulready also produced a composition of partially nude female figures ("Sea Fairies") as an illustration for the Moxon edition of Tennyson's Poems published in 1857.

NOTES TO CHAPTER VI

1. This phenomenon is discussed by Francis Haskell in *Rediscoveries in Art, some aspects of taste, fashion and collecting in England and France*, delivered under the auspices of New York University, Institute of Fine Arts, Ithaca, N.Y., [1976].

2. The full title is *Rhymes on Art; or The remonstrances of a painter; in two parts, with notes, and a preface, including strictures on the state of the arts, criticism, patronage and public taste.* Wilkie mentioned reading this book in his Journal (20 May 1809). See Cunningham, *Wilkie*, I, p. 237.

3. Stephens, *Memorials*, p. 53. Linnell's Journal for 1811 confirms this. Mulready is cited as a frequent borrower.

4. Thomas Hope purchased two rustic scenes by Mulready (cat. nos. 23, 32); possibly the two paintings without ascriptions described by C. M. Westmacott in his *British Galleries of Painting and Sculpture . . .*, London, 1824, p. 218: "small architectural subject[s], View[s] of an English Village". David Watkin (*Thomas Hope and the Neo-Classical Idea*, London, 1968) describes Hope's extensive collecting activities, although he fails to mention his patronage of Mulready.

5. Mr Henderson, identified as a dentist in Cole's MS. See cat. nos. 22, 31.

6. Mr T. Welsh, identified by Stephens (*Memorials*, p. 62) as a "singing-master of reputation". See cat. nos. 53, 60, 64.

7. Alexander Davison. See cat. nos. 56–7. See also Ch. II, note 38.

8. For example, Lady Beauchamp Proctor and Lady Acheson mentioned in Mulready's Account Book in 1806. See cat. nos. 13, 14.

9. However, one of Mulready's paintings (cat. 61) was purchased by Thomas Lister Parker, an antiquarian, cousin to Sir John Leicester, and a patron of British art in his own right.

10. See Margaret Greaves, *Sir George Beaumont*, London, 1966; John Young, *A Catalogue of Pictures by British Artists in the Possession of Sir John Fleming Leicester, Bart. . . .*, London, 1821; and John Young, *A Catalogue of the Celebrated Collection of Pictures of the late John Julius Angerstein, Esq. . . .*, London, 1823. For further discussion of the patronage of British art in the early nineteenth century see Frank Herrmann, *The English as Collectors*, N.Y., 1972; Josephine Gear, *Masters or Servants?: A study of selected English painters and their patrons of the late eighteenth and early nineteenth centuries*, N.Y., 1977; and Trevor Fawcett, *The Rise of English Provincial Art, Artists, Patrons and Institutions outside London, 1800–1830*, Oxford, 1974.

11. An article in the *Art Union*, 1839 (pp. 58–9) describes a portion of Swinburne's collection housed in his London residence. It also describes Swinburne's formative role as an early patron of British art: "Sir John Swinburne was among the earliest patrons of British Art. He advanced its interests when it was not so much a fashion to do as it has become in our day."

12. See the sales of his property and the property of his descendants: Christie's, 15 June 1861, 8 July 1893, 20 June 1896, 4 and 12 June 1915, and 26 May 1916.

13. Letter to Leigh Hunt, dated 3 May 1814, Additional MS. 38108, f. 188, British Library: "I have seen your friend Haydon frequently lately he is, he says, much better, of the Nature of the complaint in his eyes, I am not sufficiently apprized to form a judgment, but I cannot *view* it without considerable anxiety. His Picture is getting on very well indeed, I think it a work of very superior genius."

14. Swinburne was an active contributor to the Artists' Benevolent Fund which he discusses in a letter to Leigh Hunt, dated 3 May 1814, Additional MS. 38108, f. 187, British Library; "nothing evinces the active benevolence of this country more than the support afforded to Charitable Institutions at this moment, when there is not an individual who does not severely feel the extraordinary pressure of the times".

15. Letter to Lord Grey, dated 15 Sept. 1811, Earl Grey Papers, University of Durham, Department of Palaeography and Diplomatic: "Poor Thompson the Painter is I fear relapsing I had a very indifferent account of him last night." See Ch. VI, note 13.

16. Letter to Lord Grey, dated 11 June 1820, Earl Grey Papers, University of Durham, Department of Palaeography and Diplomatic.

17. According to Mulready's Account Book, Lady Swinburne and Sir John's eldest daughter, Julia purchased some of these works.

18. Farington, VIII, p. 40, 13 Oct. 1815.

19. Letters to Sir John Swinburne, dated 23 and 26 Jan. 1830, Victoria and Albert Museum Library.

20. Many visits are documented in Cole's Diaries. See Ch. I, note 84.

21. Mulready evidently invested three thousand pounds with Sir John Swinburne and two others. Draft document, Tate Gallery 7216.28.

22. Cole's Diaries, 14 Oct. 1860: "with Marian [Cole's wife] to see Mulready who detailed his visit to Capheaton & Sir J. Swinburnes death at 99".

23. Julia (1795–1893), Emelia Elizabeth (1798–1882) who married Sir George Henry Ward, Frances (1799–1821), and Elizabeth (1805–96) who married John William Bowden. Mulready's Account Book records payment for lessons during 1811–27. In a letter from Sir John to his friend Leigh Hunt, dated 19 July 1852, Additional MS. 38110, f. 391, British Library, he refers to Julia as "a very competent judge [of painting] having attained no common skill in painting, under the long & able instruction of my valuable friend Mulready".

24. Stephens, *Memorials*, p. 4. A critic for the *Morning Chronicle*, 14 June 1830, complained that Mulready was "too much occupied as a drawing master to paint pictures that maintain his former reputation". Recorded in the Whitley Papers, British Museum.

25. This was true up until the late 1820s. For example, in 1816, the year of his election to the Royal Academy,

Mulready received £290.19 for his teaching (representing 277 lessons) while selling only one painting for £157.10. This can be explained by two factors: his genuine love of teaching and his unusually low production of paintings. David Wilkie encouraged Mulready to continue private instruction after he achieved success, explaining: "it has often occurred to me that Artists who are in full employment and who have had the greatest experience and success in their lives might by devoting a small portion of time to teaching derive a considerable advantage from it themselves and produce through the medium of their pupils a greater influence upon the public taste than can be done by them as individuals in any other way". Letter to Mulready, dated 9 June (no year), Victoria and Albert Museum Library.

26. In this context, it is interesting to note that the Society of Arts offered prizes in the early nineteenth century for the drawings of the "Nobility and Gentry" to encourage their future patronage of the arts.

27. Mulready drew the same classical cast (Rorimer, illus. 38) and undoubtedly recommended it for their study.

28. Mulready wrote friendly personal notes to his student Miss Newdigate, congratulating her upon her betrothal and marriage. Kindly brought to my attention by her descendant Richard Bridgeman.

29. A letter to an unidentified student, signed WM. and dated Sept. 1847, Collection of Mr and Mrs Cyril Fry. Rorimer (p. 11) quotes a similar letter from Mulready, dated 20 January 1829 to his pupil of many years Miss Sneyd (Scottish National Library, Edinburgh), in which he encourages her to send her painting to the Royal Academy exhibition.

30. Quoted in I. B. O'Malley, *Florence Nightingale 1820–1856, A Study of Her Life down to the end of the Crimean War*, London, 1931, p. 73. This reference was kindly brought to my attention by Sibella Bonham Carter. The Bonham Carter name appears in Mulready's Account Book for teaching lessons in 1837, 1838, and 1841.

31. The Nightingale name appears in Mulready's Account Book for five lessons in 1844. A reference in O'Malley's book (p. 75) suggests that Florence's older sister was an amateur artist and hence probably Mulready's student: "Parthe was better off, she had her drawing book."

32. Undated letter to Mulready (probably *c.* 1811–12), Victoria and Albert Museum Library. She studied with Mulready in 1811. She was still corresponding with him in 1830. See Ch. I, note 49. Another letter from the father of one of Mulready's male students also testifies to his benevolent influence: "Your counsels have been to him of more value than I can describe. And I can trace their consequence not only in art, but in conduct. He has received from you encouragement which has gone a good way to substitute rational confidence in what he is to be for a very irrational amount of confidence in what he was . . . his obligations to you . . . are of a kind which he never will fully appreciate till he has seen many more years go past him." Letter from Alec Morgan (?), dated 13 Sept. 1861, Victoria and Albert Museum Library.

33. See Ch. I, notes 47 and 48. Miss Gouldsmith assisted Mulready on more than one occasion. See cat. nos 190, 191.

34. See Christie's, Sir J. E. Swinburne's Property, 15 June 1861, 118: "P. Nasmyth, A Woody Landscape ... This charming work was selected for Sir John Swinburne by Mr. Mulready."

35. Christie's, Sir J. E. Swinburne's Property, 15 June 1861, 115: "Harriet Goldsmith, a landscape, with a cottage and figures." Mulready may also have encouraged his patron John Sheepshanks to buy the painting of his pupil Miss Sneyd. In his letter to her (Ch. VI, note 29) he mentions having brought it out to Blackheath, perhaps to Sheepshanks' residence there, where it was admired. However, no Sneyd painting appears in Sheepshanks' collection.

36. Sir John encouraged Lord Grey to take up the leadership of moderate reform, while expressing his own support for the Whig principles of "more extended suffrage, more frequent Parliaments, & the doing away [with] rotten Boroughs". Letter to Lord Grey, dated 20 Dec. 1822, Earl Grey Papers, University of Durham, Department of Palaeography and Diplomatic.

37. For a description of his collection, see Mrs A. Jameson, *Companion to the most celebrated Private Galleries of Art in London*, London, 1844; Sir Walter Armstrong, *The Peel Collection and the Dutch School of Painting*, London, 1904; and J. Mordaunt Crook, "Sir Robert Peel: Patron of the Arts", *History Today*, XVI, 1966, 3–11.

38. Mulready was introduced to Peel in 1825 by William Collins, R.A. whose own politics were decidedly conservative.

39. Dafforne, *Mulready*, p. 52.

40. John Linnell found the unfinished canvas in Mulready's studio years after it had been put aside and urged him to take it up again. See Stephens, *Memorials*, p. 99.

41. John Gibbons, an ironmaster from Staffordshire, purchased one painting directly from Mulready: *A Sailing Match*, 1831. He then went on to collect a number of Mulready's early landscapes. See Christie's, Mrs. B. Gibbons 3 May 1883; John Gibbons Property, 26 May 1894 and 29 Nov. 1912. Gibbons' patronage is discussed in Frith, *Autobiography*, II, Ch. 10 including a few brief references to Mulready. See also Ch. II, note 98.

42. Cole's Diaries, 6 April 1845.

43. Haskell discusses Baring in his study (Ch. 4).

44. Baring also purchased drawings from Mulready including his cartoon for *Choosing the Wedding Gown*.

45. Richard Redgrave, who prepared the first catalogue for the Sheepshanks collection, described only one painting, *The Intercepted Billet*, as a gift "Presented to Mr. Sheepshanks by the Artist". Mulready's early open-air oil sketches were also probably gifts to Sheepshanks as were some preparatory oil sketches. A printed catalogue of John Sheepshanks' collection dated *c.* 1850 (Victoria and Albert Museum Library) does not include these landscape sketches nor other oil sketches by Mulready that were part of Sheepshanks' gift to the nation in 1857. It may be that they were not considered important enough to be catalogued, or

it may be that Mulready gave them to Sheepshanks later in the 1850s when it was quite certain that they would be given to the nation. No transactions of this nature appear in Mulready's Account Book.

46. A description of Vernon's collection in the *Art Union* (1839, p. 19) lists "an early Landscape by Mulready", possibly the painting described as "Cottage" by "Mulready and Miss Goldsmith" included in Vernon's gift to the nation (*Vernon Heath's Recollections*, p. 347). No such painting is listed in the Vernon collection at the Tate Gallery. It was probably the landscape sold by Vernon for £32 at Christie's in 1849, before his collection became the nation's property. Vernon Heath describes his uncle's pruning in *Vernon Heath's Recollections*, p. 2. See cat. 190.

47. See Gerald Reitlinger, *The Economics of Taste: The Rise & Fall of Picture Prices 1760–1960*, London, 1961. Mulready's *Barber's Shop* was sold to its original owner, Lord Ducie, in 1811 for £84. When it was lent to the Art Treasures Exhibition in Manchester in 1857 the current owner, R. Hemmings, reported that he had paid £1400 for the work. Letter from John C. Deane to the officials in charge of the exhibition, dated 22 Dec. 1856, describing R. Hemmings' collection after examining it for possible inclusion of paintings in the Art Treasures Exhibition. Archives of the Royal Manchester Institution, City of Manchester Library.

48. The transactions concerning Vernon's gift are described in Heath, *Vernon Heath's Recollections*. See also S. C. Hall, *The Vernon Gallery*, 3 vols., London, 1854. For Sheepshanks, see Richard Redgrave, *On the Gift of the Sheepshanks Collection with a View to the Formation of a National Gallery of British Art*, London, 1857.

49. See Vernon Heath, p. 18 and Heleniak, "William Mulready, R.A. (1786–1863) and the Society of Arts", Part ii, *Journal of the Royal Society of Arts*, August 1976, pp. 558–62.

50. For a few years in the late nineteenth century they were temporarily housed in the same building, though kept distinct, before the Vernon Collection moved to the National Gallery, and then to the Tate Gallery.

51. Vernon favored W. Etty, T. Stothard, A. W. Callcott; Sheepshanks favored Mulready, C. R. Leslie, and E. Landseer.

52. G. F. Waagen, *Treasures of Art in Great Britain ...*, London, 1854, II, pp. 299–307.

53. He bought *First Love* after it was evidently rejected by the Duke of Bedford (Cole MS.).

54. 1837, 1838, 1839, and possibly 1834. Account Book.

55. Letter to Mulready from A. Cooper, dated 10 Feb. 1818, Victoria and Albert Museum Library.

56. Two letters to Mulready from J. Fairey, dated 12 Nov. 1852 and 21 Feb. 1853, Victoria and Albert Museum Library.

57. Letter to Mulready from T. E. Plint, dated 17 Nov. 1853, Victoria and Albert Museum Library.

58. Henry Cole noted this twice in his Diary. On 1 June 1846: "At Mulreadys—He showed me letter from Mr.

Anson [Prince Albert's Secretary] asking him to make a copy of the Wedding Gown for Pr: Alb: He declined on the ground that as a copy it would be unworthy the Princes Collection"; and 14 March 1864: "Queen, P. Alfred & Helena visited Mulready Ex: She recollected Mulreadys refusal to make a copy of the Wedding Gown." Mulready avoided exact duplication of his paintings although he did return to themes, changing details, scale, or style.

59. See Ch. I, note 149.

60. Discussed in Reitlinger, pp. 85–6 and Gear, pp. 266–8.

61. Mulready's painting can be seen in R. Huskisson's painting *Lord Northwick's Picture Gallery at Thirlestaine House, c.* 1846, illustrated in the exhibition catalogue *The Pursuit of Happiness: A View of Life in Georgian England,* Yale Center for British Art, 1977, 87.

62. It was bought in for £714 at Christie's, 12 May 1838. It was subsequently sold after his death in 1859 for £1,239. He originally paid only £262.10 for the painting in 1826.

63. July 1824, p. 109. It was also noted that the painting "occupies the place of honour, over the fireplace in the great room, that has been of late years allotted to Wilkie's principal productions". Wilkie admired it. See his praise in a letter to William Allan (Ch. III, note 7).

64. May 1824, p. 567.

65. Peter Ferriday, "The Victorian Art Market", Part I, *Country Life,* 9 June 1966, p. 1457, records an episode concerning George Knott's patronage. Knott enquired about Maclise's painting, *The Play Scene in Hamlet,* but was unfamiliar with Shakespeare's play. When the story was explained, he quite naturally refused to buy the painting.

66. Cole's *Diaries,* 26 April 1845: "Went to Sale of Mr. Knotts pictures of modern artists most of which sold for high prices except Mulready's Widow bought for 500 guineas sold for 400."

67. Peter Ferriday, "The Victorian Art Market: The Profits of Painting", Part II, *Country Life,* 16 June 1966, pp. 1576–8.

68. Dated 4 Jan. 1859, quoted in Firestone, p. 143. Linnell denied this.

69. His evidence before the National Gallery Site Commission underlines his position: "I am not sure that a painter has a right, except in experiments, to use pigments which he knows are short-lived. I do not think he has a right to use such pigments in a picture that he knows the purchaser expects to last ... it is a question of morality with the painter."

70. Mulready sold a pencil drawing in 1805 to "Harris"—possibly the dealer Harris, then active in London; in 1811 Mulready sold *Kitchen Fire* to "Smith", perhaps the dealer John Smith, author of *A Catalogue Raisonné of the Works of the Most Eminent Dutch, Flemish, and French Painters . . .,* London, 1829–37. The painting shortly after entered Ridley Colborne's collection. And in 1835 he sold a sketch to "Colls", probably the dealer R. Colls.

71. Forgeries were a problem. Artists and owners were often anxious to protect their works from copyists. Mulready allowed his works to be exhibited at the Art Treasures Exhibition in Manchester, 1857 only if they could "be secured from being copied". Letter to Mulready from the officials of the exhibition, dated 23 Aug. 1856, Archives of the Royal Manchester Institution, City of Manchester Library.

72. Actions encouraged by Samuel Carter Hall, editor of the *Art Union* (later *Art Journal*). As he explained (*Retrospect of a Long Life . . .,* N.Y., 1883, p. 197): "I made manifest the policy of buying only such pictures as could be readily identified—certified by the artists who were living." Hall urged buyers to beware of old master forgeries, and also encouraged caution with regard to modern paintings.

73. Letter to Mulready from George Crump, dated 3 March 1852, Victoria and Albert Museum Library.

74. Letter to Mulready from Henry McConnel, dated 7 Sept. 1860, Victoria and Albert Museum Library.

75. See Ch. I, note 133.

76. See Ch. I.

77. Mulready provided a number of profile portraits to illustrate John Pye's *Patronage of British Art,* London, 1845. Some of the original drawings are illustrated in Rorimer, 179–92. See Pls. 13, 154. Some additional drawings—portraits or heads—are also illustrated in Rorimer, 193–240.

78. See, for example, two portraits by Quinten Metsys, illustrated in Charles D. Cuttler, *Northern Painting from Pucelle to Breugel,* N.Y., Chicago . . ., 1968, figs. 565–6.

79. Fuseli copied Fanny Swinburne's self-portrait. See Gert Schiff, *Johann Heinrich Füssli 1741–1825,* Zurich and Munich, 1973, II, no. 1686, kindly brought to my attention by the author.

80. The portrait recalls Gerard Terborch's portrait of *Helena van der Schalcke,* 1644, illustrated in S. J. Gudlaugsson, *Gerard Ter Borch,* The Hague, 1959, Pl. 30.

81. The most important of which is the red and black chalk drawing, *c.* 1840, Royal Academy, Pl. 166. A small pencil self-portrait head in profile ($2\frac{3}{4} \times 1\frac{3}{4}$ in) was sold at Christie's, 20 July 1976, 174/4. For a listing of portraits of Mulready by other artists, see Richard Ormond, *Early Victorian Portraits,* 2 vols., London, 1973. Mulready was the only contemporary artist to be included in the series of life-size mosaic portraits that decorate the South Court of the Victoria and Albert Museum (then the South Kensington Museum). He is in the company of Cimabue, Leonardo, Raphael, Michelangelo, Inigo Jones and Christopher Wren. The portrait was painted by F. B. Barwell and the mosaic executed by Minton, Hollins & Co. This was kindly brought to my attention by John F. Physick, Assistant Keeper, Victoria and Albert Museum.

82. Mulready also appeared in *A Carpenter's Shop and Kitchen,* 1808, and in *The Music Lesson,* 1809. His Account Book, 1813 records another self-portrait (now lost): "1 of self nearly done".

83. Letter to Mr L. R. Valpy, n.d., quoted in Palmer, *Life,* p. 399.

Select Bibliography

A number of works cited where relevant in the text are not included in this bibliography.

IMPORTANT MANUSCRIPT MATERIAL:

William Mulready's Account Book (1805–*c.* 1861), Sketchbook (used over a number of years; it contains two dated comments Sept. 1834, May 1844 and a loose sheet 1859), correspondence and personal papers, Victoria and Albert Museum Library

William Mulready's correspondence, notes and personal papers, Tate Gallery

Michael Mulready's Diary Notes with Mulready material, Tate Gallery

Sir Henry Cole's Diaries, Victoria and Albert Museum Library

Cole MS. Catalogue (A manuscript catalogue listing Mulready's paintings; along with notes on their location, their condition, their appearance in exhibitions; thought to be in Henry Cole's hand, probably assembled in preparation for the Mulready exhibition at the Society of Arts, 1848. Later notes added in another hand, initialled R.R. [Richard Redgrave?]), Victoria and Albert Museum Library

Joseph Farington's Diary, Royal Library, Windsor Castle, consulted with the gracious permission of Her Majesty Queen Elizabeth II

William Godwin's Diary, Bodleian Library, Oxford University

John Linnell's Autobiographical Notes 1863 and Journals (annotated by A. H. Palmer), The Linnell Trust

PRINCIPAL PUBLISHED SOURCES FOR MULREADY:

This tabulation is by no means comprehensive. It is meant to be a useful gathering of the essential publications on Mulready's art. More ephemeral articles, often based on information contained in the following publications, are not cited here. The art historical works in the subsequent bibliographical category (BACKGROUND) frequently make reference to Mulready or to his work, as numerous notes in the text suggest.

Artist's Sale, see Christie, Manson & Woods . . .

Bodkin, Thomas, "Two English Drawings", *Miscellanea Leo van Puyvelde*, Brussels, 1949, pp. 250–3

Bodkin, Thomas, "William Mulready, R.A.", *Dublin Magazine*, I, 1923, 420–9

Bristol, City Art Gallery, *William Mulready*, [1964], prepared by Arnold Wilson

Christie, Manson & Woods, *Catalogue of the whole of the remaining Drawings, Sketches in Oil, Chalks, and Pen and Ink of William Mulready, R.A., deceased . . .*, April 28, 29, 30, 1864 (Artist's Sale)

Dafforne, James [Mulready's Obituary], *Art Journal*, 1863, p. 181

Dafforne, James, *Pictures by William Mulready, R.A.*, London, [1872]

Evans, Edward B., *A Description of the Mulready Envelope, and of various imitations and caricatures of its design; with an account of other illustrated envelopes of 1840 and following years*, London, 1891; reprinted with a new foreword by Eric Allen, London, 1970

Feuillet de Conches, Felix S., "Mulready: Peintre de Genre, de L'Academie Royale", *L'Artiste*, XLX, 1883, 235–55

Godwin, William (pseudonym: Theophilus Marcliffe), *The Looking Glass a True History of the Early Years of an Artist; Calculated to awaken the Emulation of Young Persons of Both Sexes, in the Pursuit of every laudable Attainment: particularly in the cultivation of the Fine Arts*, London, 1805

Grigson, G., "The Drawings of William Mulready", *Image*, I, 1949, 3–14

Heleniak, Kathryn Moore, "William Mulready, R.A. (1786–1863) and the Society of Arts", *Journal of the Royal Society of Arts*, Parts i–iii, July, August and September, 1976

Liebreich, R., "Turner and Mulready On the Effect of Certain Faults of Vision on Painting, with Especial Reference to their Works", *Macmillan's Magazine*, XXV, 1872, 499–508

London, Science and Art Department, South Kensington Museum, *A Catalogue of the Pictures, Drawings, sketches, etc. of the late William Mulready, Esq., R.A.*, 1864

London, Society of Arts, *A Catalogue of the Pictures, Drawings, sketches, etc. of William Mulready, R.A. Selected for exhibition at the Society of Arts, Adelphi, London: in aid of the formation of a National Gallery of British Art, 1848*, 1848

London, Victoria and Albert Museum, *Drawings by William Mulready*, 1972, prepared by Anne Rorimer

"Mulready, the English Genre Painter", *Appleton's Journal of Literature, Science & Art*, XXXVII, 1869, 513–15

National Gallery Site Commission (Parliamentary Papers 1857, Sess. 2, C. 2261, XXIV.1.), pp. 49–56

Pointon, Marcia, "William Mulready's 'The Widow': a subject 'unfit for pictorial representation'", *Burlington Magazine*, CXIX, 1977, 347–51

Redgrave, Richard and Samuel, *A Century of Painters of the English School*, 2 vols., London, 1866, and revised with additional material, 1890 Quotations are taken from the 1866 edition.

Report of the Commissioners on the position of the Royal Academy in relation to the Fine Arts (Parliamentary Papers 1863, C. 3205, XXVII.1.), pp. 190–9

Rorimer, see London, Victoria and Albert Museum, *Drawings* . . .

Royal Academy Commission, see Report of the Commissioners . . .

Smith, George W., "Mulready and the Work of John Flaxman", *Philatelic Journal of Great Britain*, LXXXIII, 1973, no. 1

Smith, George W., "Mulready and the Work of West, Heath and Leech", *Philatelic Journal of Great Britain*, LXXXI, 1971, no. 4

Society of Arts, see London, Society of Arts, *A Catalogue* . . .

South Kensington Museum, see London, Science and Art Department, South Kensington Museum, *A Catalogue* . . .

Stephens, Frederic G., *Masterpieces of Mulready*, London, 1867

Stephens, Frederic G., *Memorials of William Mulready, R.A.*, London, 1890

Stephens, Frederic G., "William Mulready, R.A.", *Fine Arts Quarterly Review*, I, 1863, 381–92

Wears, T. M., *The History of the Mulready Envelope*, London, 1886

Wilson, Arnold, "Drawings by William Mulready, R.A. 1786–1863", *The Connoisseur*, November, 1964

BACKGROUND—HISTORICAL AND ART HISTORICAL:
An Account of all the pictures exhibited in the rooms of The British Institution from 1813 to 1823 belonging to the Nobility and Gentry of England: with remarks critical and explanatory, London, 1824

Adams, Eric, *Francis Danby: Varieties of Poetic Landscape*, New Haven & London, 1973

Anderdon Royal Academy exhibition catalogues (printed and manuscript material), Royal Academy of Arts Library

Ariès, Philippe, *Centuries of Childhood*, N.Y., 1962

Bearce, G. D., *British Attitudes Toward India 1784–1858*, London & N.Y., 1961

Beck, Hilary, *Victorian Engravings*, London, 1973

Bell, C. F., *Annals of Thomas Banks, Sculptor, Royal Academician*, Cambridge, 1938

Blake, William, *The Letters of William Blake*, ed. Geoffrey Keynes, Cambridge, Mass., 1968

Boase, T. S. R., *English Art 1800–1870*, Oxford, 1959

Bolt, Christine, *Victorian Attitudes to Race*, London, 1971

Bristol, City Art Gallery, *The Bristol School of Artists; Francis Danby and Painting in Bristol 1810–1840*, 1973, catalogue by Francis Greenacre

Buchanan, William, *Memoirs of Painting, with a chronological History of the Importation of Pictures by the Great Masters into England since the French Revolution*, 2 vols., London, 1824

Bury, Adrian, *John Varley of the 'Old Society'*, Leigh-on-Sea, 1947

Bury, Shirley, "Felix Summerly's Art Manufactures", *Apollo*, LXXV, 1967, 28–33

Butlin, Martin, "Blake, The Varleys, and the Patent Graphic Telescope", in *William Blake, Essays in Honour of Sir Geoffrey Keynes*, eds. Paley & Phillips, Oxford, 1973

Chesney, Kellow, *The Victorian Underworld*, N.Y., 1972

Clifford, Derek and Timothy, *John Crome*, Greenwich, Conn., 1968

Cole, Sir Henry, *Fifty Years of Public Life*, 2 vols., London, 1884

Collins, W. Wilkie, *Memoirs of the Life of William Collins., Esq., R.A., with selections from his Journals and Correspondence*, 2 vols., London, 1848

Constable, John, *John Constable Correspondence*, ed. R. B. Becket, 6 vols., London & Ipswich, 1962–8

Constable, John, *John Constable: Further Documents and Correspondence*, eds. Leslie Parris, Conal Shields and Ian Fleming-Williams, London & Ipswich, 1975

Cork, Crawford Municipal Art Gallery, *Irish Art in the 19th Century*, 1971, introduction by Cyril Barret, S.J.

Coveney, Peter, *The Image of Childhood*, rev. ed., Harmondsworth, Middlesex, England, 1967

Cunningham, Allan, *The Cabinet Gallery of Pictures by the First Masters of The English and Foreign Schools in seventy-three Line Engravings; with biographical and critical dissertations*, 2 vols., London, 1836

Cunningham, Allan, *The Life of Sir David Wilkie; with His Journals, Tours, and Critical Remarks on Works of Art; and a Selection of his Correspondence*, 3 vols., London, 1843

Cunningham, Allan, *The Lives of the most Eminent British Painters*, rev. ed. Mrs Charles Heaton, 3 vols., London, 1879–80

Curtin, Philip D., *The Image of Africa; British Ideas and Action, 1780–1850*, 2 vols., Madison, Wisconsin and London, 1964 (1973 printing)

Davis, Frank, *Victorian Patrons of the Arts*, London, 1963

Dawe, George, *The Life of George Morland*, ed. J. J. Foster, London, 1904 (first published 1807)

Dictionary of National Biography, eds. Sir Leslie Stephen and Sir Sidney Lee, 22 vols., London, 1885–1901

Dublin, Municipal Gallery of Modern Art, *Bodkin Irish Collection*, 1962

Dykes, Eva B., *The Negro in English Romantic Thought*, Washington, 1942

Fairchild, H. N., *The Noble Savage; a Study in Romantic Naturalism*, N.Y., 1928

Farington, Joseph, *The Farington Diary*, ed. James Greig, 8 vols., London, 1922–8

Farr, Dennis, *William Etty*, [London, 1958]

Fawcett, Trevor, *The Rise of English Provincial Art, Artists, Patrons and Institutions outside London, 1800–1830*, Oxford, 1974

Ferriday, Peter, "The Victorian Art Market", *Country Life*, Part I, 9 June, 1966, pp. 1456–8 and Part II, 16 June, 1966, pp. 1576–8

Finberg, A. J., *The Life of J. M. W. Turner, R.A.*, 2nd ed., Oxford, 1961

Firestone, Evan R., "John Linnell, English Artist: Works, Patrons and Dealers", Ph.D. Dissertation, The University of Wisconsin, 1971

Fredeman, W. E., *The P.R.B. Journal*, Oxford, 1975

Frith, William Powell, *My Autobiography and Reminiscences*, 3 vols., London, 1887–8

Gage, John, *Colour in Turner*, London, 1969

Gaunt, William and F. Gordon Roe, *Etty and the Nude*, Leigh-on-Sea, 1943

Gautier, T., *Les beaux-arts en Europe*, Paris, 1855

Gear, Josephine, *Masters or Servants?: A Study of selected English painters and their patrons of the late eighteenth and early nineteenth centuries*, N.Y., 1977

George, Eric, *The Life and Death of Benjamin Robert Haydon, Historical Painter, 1786–1846*, 2nd ed., ed. Dorothy George, Oxford, 1967

George, M. Dorothy, *London Life in the Eighteenth Century*, Harmondsworth, Middlesex, 1965

Gilpin, William, *Three Essays: On Picturesque Beauty; On Picturesque Travel; and on Sketching Landscape*, London, 1792

Girtin, Thomas and David Loshak, *The Art of Thomas Girtin*, London, 1954

Gordon, Catherine, "The Illustration of Sir Walter Scott: Nineteenth-Century Enthusiasm and Adaptation", *Journal of the Warburg and Courtauld Institutes*, XXXIV, 1971, 297–317

Grant, Col. Maurice Harold, *A Chronological History of the Old English Landscape Painters (in Oil) from the XVIth Century to the XIXth Century*, 2 vols., London, 1926

Grant, Col. Maurice Harold, *A Dictionary of British Landscape Painters from the 16th C. to the early 20th C.*, Leigh-on-Sea, 1952, reprinted with supplement, 1970

Graves, Algernon, *The British Institution 1806–1867: A Complete Dictionary of Contributors and their works from the foundation of the Institution*, London, 1908

Graves, Algernon, *A Century of Loan Exhibitions 1813–1912*, London 1913–15 (reprinted in 3 vols., Bath, 1970)

Graves, Algernon, *Dictionary of Artists who have exhibited Works in the Principal London Exhibitions from 1760 to 1893*, 3rd ed., N.Y., 1901

Graves, Algernon, *The Royal Academy of Arts: A Complete Dictionary of Contributors and their work from its foundation in 1769 to 1904*, London, 8 vols., 1905–6

Greaves, Margaret, *Sir George Beaumont*, London, 1966

Grigson, Geoffrey, " 'Gordale Scar' to the Pre-Raphaelites", *Listener*, XXXIX, 1 Jan., 1948, 24–5

Hall, Samuel C., *Retrospect of a Long Life: from 1815 to 1883*, N.Y., 1883

Hall, Samuel C., *The Vernon Gallery*, 3 vols., London, 1854

Hardie, Martin, *Water Colour Painting in Britain*, II, III, London, 1967–8

Haskell, Francis, *Rediscoveries in Art, some aspects of taste, fashion and collecting in England and France*, Ithaca, N.Y., [1976]

Haydon, Benjamin Robert, *Correspondence and Table Talk, with a Memoir by his Son, Frederick Wordsworth Haydon*, 2 vols., London, 1876

Haydon, Benjamin Robert, *Diary*, ed. Willard Bissell Pope, 5 vols., Cambridge, Mass., 1960–3

Heath, Vernon, *Vernon Heath's Recollections*, London, Paris, Melbourne, 1892

Herrmann, Frank, *The English as Collectors*, N.Y., 1972

H.[eseltine], J. P., *John Varley and his Pupils W. Mulready, J. Linnell, and W. Hunt*, London, 1918

Hilton, Timothy, *The Pre-Raphaelites*, London, 1970

Horsley, J. C., *Recollections of a Royal Academician*, ed. Mrs Edmund Phelps, London, 1903

Houghton, Walter E., *The Victorian Frame of Mind 1830–1870*, New Haven, 1957

Hueffer, Ford Madox, *Ford Madox Brown, A record of his life and work*, London, N.Y., and Bombay, 1896

Hunt, William Holman, *Pre-Raphaelitism and the Pre-Raphaelite Brotherhood*, 2 vols., London, 1905

Hussey, Christopher, *The Picturesque; Studies in a Point of View*, London and New York, 1927

Hutchison, Sidney C., *The History of the Royal Academy 1768–1968*, London, 1968

Hutchison, Sidney C., "The Royal Academy Schools, 1768–1830", *Walpole Society*, XXXVIII, 1960–2, 123–191

Jameson, Mrs. A., *Companion to the most celebrated Private Galleries of Art in London*, London, 1844

Joseph, M. K., "Charles Aders, A Biographical Note", *Auckland University College Bulletin*, no. 43, 1953, 6 ff.

Jupp Royal Academy exhibition catalogues (printed and manuscript material), Royal Academy of Arts Library

Kitson, S. D., *The Life of J. S. Cotman*, London, 1937

Kris, Ernst and Otto Kurz, *Die Legende von Künstler; ein geschichtlicher Versuch*, Vienna, 1934 (Translated as *Legend, Myth and Magic in the Image of the Artist*, New Haven and London, 1979.)

Leicester, Leicester Museums and Art Gallery, *A Hundred Years of British Landscape Painting 1750–1850*, 1956

Leslie, Charles Robert, *Autobiographical Recollections of the Life of C. R. Leslie*, ed. Tom Taylor, 2 vols., London, 1860

Lindsay, Jack, *J. M. W. Turner: A Critical Biography*, London, 1966

Lister, Raymond, *Victorian Narrative Paintings*, N.Y., 1966

Little, Kenneth, *Negroes in Britain: a study of racial relations in English Society*, rev. ed., London and Boston, 1972

Liverpool, Walker Art Gallery, *William Holman Hunt*, 1969, prepared by Mary Bennett

London, Arts Council of Great Britain, *Romantic Movement*, 1959

London, National Portrait Gallery and National Gallery of Ireland, Dublin, *Daniel Maclise 1806–1870*, 1972, prepared by Richard Ormond and John Turpin

London, P. & D. Colnaghi & Co. Ltd, *Drawings and Watercolours by Cornelius Varley*, 1973

London, P. & D. Colnaghi & Co. Ltd, *A Loan Exhibition of Drawings, Watercolours, and Paintings by John Linnell and his Circle*, 1973

London, Royal Academy of Arts, *Commemorative Catalogue of the Exhibition of British Art*, 1934

London, Royal Academy of Arts, *The First Hundred Years of the Royal Academy, 1769–1868*, 1951

London, Tate Gallery, *Constable . . .*, 1976

London, Tate Gallery, *Landscape in Britain 1750–1850*, 1973

London, Tate Gallery, *Turner 1775–1851*, 1975

Lugt, F. *Répertoire des Catalogues de Ventes Publiques intéressant l'art ou la curiosité*, 3 vols., The Hague, 1938, 1953, 1964

Lytton, Edward Bulwer, *England and the English*, London & Chicago, 1970 (first published 1833)

Maas, Jeremy, *Victorian Painters*, London, 1969

Marcus, Steven, *The Other Victorians: A study of Sexuality and Pornography in Mid-Nineteenth Century England*, London, 1966

Mayhew, Henry, *London Labour and the London Poor*, 4 vols., London, 1861

Millar, Oliver, *The Later Georgian Pictures in the Collection of Her Majesty the Queen*, 2 vols., London, 1969

Monkhouse, W. Cosmo, *Masterpieces of English Art*, London, 1869

Morley, John, *Death, Heaven and the Victorians*, London, 1971

Muir, Percy, *English Children's Books 1600–1900*, 2nd ed., N.Y. & Washington, 1969

Northcote, J., *Conversations with James Ward on Art and Artists*, ed. E. Fletcher, London, 1901

Norwich, Castle Museum and Victoria and Albert Museum, London, *A Decade of Naturalism 1810–1820*, 1969–70, prepared by John Gage

O'Malley, I. B., *Florence Nightingale 1820–1856, A Study of Her Life down to the end of the Crimean War*, London, 1931

Oppé, A. Paul, "Art", in *Early Victorian England, 1830–1865*, ed. G. M. Young, 2 vols., London, N.Y., Toronto, 1934

Ormond, Richard, *Early Victorian Portraits*, 2 vols., London, 1973

Palgrave, Francis Turner, *Essays on Art*, N.Y., 1867

Palgrave, Francis Turner, *Gems of English Art*, London 1869

Palmer, A. H., *The Life and Letters of Samuel Palmer*, London, 1892

Palmer, Samuel, *The Letters of Samuel Palmer*, ed. Raymond Lister, Oxford, 1974

Paris, Grand Palais, Detroit Institute of Arts, New York, Metropolitan Museum of Art, *French Painting 1774–1830: The Age of Revolution*, 1974–5

Paris, Petit Palais, *La peinture romantique anglaise et les préraphaélites*, 1972

Pearsall, Ronald, *The Worm in the Bud; the world of Victorian sexuality*, N.Y., 1969

Pelles, Geraldine, *Art, Artists and Society: Origins of a Modern Dilemma. Painting in England and France 1750–1850*, Englewood Cliffs, N.J., 1963

Philadelphia, Philadelphia Museum of Art, Detroit Institute of Arts, *Romantic Art in Britain, Paintings and Drawings 1760–1860*, 1968, prepared by Frederick Cummings and Allen Staley, with an essay by Robert Rosenblum

Pidgley, M., "Cornelius Varley, Cotman and the Telegraphic Telescope", *Burlington Magazine*, CXIV, 1972, 781–6

Pinchbeck, Ivy and Margaret Hewitt, *Children in English Society, from the Eighteenth Century to the Children's Act 1948*, London and Toronto, 1973

Pointon, Marcia, "Painters and Pugilism in Early Nineteenth-Century England", *Gazette des Beaux-Arts*, XCII, 1978, 131–140

Praz, Mario, *The Romantic Agony*, London, 1933

Price, Uvedale, *An Essay on the Picturesque, As Compared with the Sublime and the Beautiful, and on the Use of Studying Pictures, for the Purpose of Improving Real Landscape*, London, 1794

Pye, John, *Patronage of British Art*, London, 1845

Raimbach, Abraham, *Memoirs and Recollections of Abraham Raimbach*, ed. M. T. S. Raimbach, London, 1843

Redford, George, *Art Sales: A History of Sales of Pictures & Other Works of Art with Notices of the Collections sold, Names of Owners, Titles of Pictures, Prices & Purchasers*, 2 vols., London, 1888

Redgrave, Richard, *On the Gift of the Sheepshanks Collection with a View to the Formation of a National Gallery of British Art*, London, 1857

Redgrave, Richard, *Richard Redgrave: A Memoir compiled from his Diary by F. M. Redgrave*, London, 1891

Redgrave, Samuel, *A Dictionary of Artists of the English School*, London, 1874

Reed, John, *Victorian Conventions*, n.p., 1975

Reitlinger, Gerald, *The Economics of Taste: The Rise & Fall of Picture Prices 1760–1960*, London, 1961

Reynolds, Graham, *Constable the Natural Painter*, N.Y., n.d.

Reynolds, Graham, *Painters of the Victorian Scene*, London, 1953

Reynolds, Graham, *Turner*, N.Y., [1969]

Reynolds, Graham, *Victorian Painting*, London, 1966

Reynolds, Sir Joshua, *Discourses on Art*, introduction by Robert Wark (Collier Books), London, 1966

Roget, John Lewis, *A History of the 'Old Water-Colour Society' now the Royal Society of Painters in Water Colours*, 2 vols., London, 1891

Rosenblum, Robert, "The Dawn of British Romantic Painting 1760–1780", in P. Hughes and D. Williams, eds., *The Varied Pattern: Studies in the 18th Century*, Toronto, 1971, pp. 189–210

Rosenblum, Robert, "The Origin of Painting: A Problem in the Iconography of Romantic Classicism", *Art Bulletin*, XXXIX, 1957, 279–90

Rossetti, William M., ed., *Preraphaelite Diaries and Letters*, London, 1900

Rousseau, G. S., ed., *Goldsmith, The Critical Heritage*, London and Boston, 1974

Ruskin, John, *The Works of John Ruskin*, eds. E. T. Cook, and Alexander Wedderburn, 39 vols., London, 1903–12

Shee, Sir Martin Archer, *Rhymes on Art; or The remonstrances of a painter; in two parts, with notes, and a preface, including strictures on the state of the arts, criticism, patronage and public taste*, London, 1805

Sitwell, Sacheverell, *Narrative Pictures*, London, N.Y., 1969 (reprint of 1936 edition)

Smith, J. T., *Nollekens and his Times*, ed. Wilfred Whitten, 2 vols., London, 1920 (first published 1828)

Smith, John, *A Catalogue Raisonné of the Works of the Most Eminent Dutch, Flemish, and French Painters . . .*, 8 vols., London, 1829–37, supp. 1842

Staley, Allen, *The Pre-Raphaelite Landscape*, Oxford, 1973

Steegman, John, *Consort of Taste 1830–1870*, London, 1950

Steegman, John, *The Rule of Taste, from George I to George IV*, London, 1936

Stephens, Frederic G., "The Aims, Studies, and Progress of John Linnell, Painter and Engraver", *Art Journal*, 1883, pp. 37–40

Stephens, Frederic G., "John Linnell, Painter and Engraver", Part I, *Art Journal*, 1882, pp. 261–4; and Part II, *Art Journal*, 1882, pp. 293–6

Stephens, Frederic G., "William Henry Hunt", *Old Water-Colour Society's Club*, XII, 1935, 17–50 (This is a reprint with some additions from *Fraser's Magazine*, October 1865, pp. 525–36.)

Story, Alfred T., *James Holmes and John Varley*, London, 1894

Story, Alfred T., *The Life of John Linnell*, 2 vols., London, 1892

Thackeray, W. M., *The Works of William Makepeace Thackeray*, XXV (Miscellaneous essays, sketches and reviews), London, 1886

"Thomas Webster, R.A.", *Art Journal*, 1855, pp. 293–6

Thoré, T. (pseud. W. Bürger), *Tresors d'art en Angleterre*, Bruxelles, 1860

Tobias, J. J., *Urban Crime in Victorian England*, N.Y., 1972

Varley, John, *A Treatise on the Principles of Landscape Design, with General Observations and Instructions to Young Artists, illustrated with sixteen highly Finished Views*, London, published in 3 parts, 1816–18

Waagen, Gustav F., *Galleries and Cabinets of art in Great Britain: Being an account of more than forty collections of paintings, drawings, sculptures, mss., etc. visited in 1854 and 1856, and now for*

the first time described, London, 1857

Waagen, Gustav F., *Treasures of art in Great Britain: being an account of the chief collections of paintings, drawings, sculptures, illuminated mss., etc.*, 3 vols., London, 1854

Ward, Mrs E. M., *Reminiscences*, ed. E. O'Donnell, London, 1911

Walvin, James, *Black and White: The Negro and English Society 1555–1945*, London, 1973

Walvin, James, *The Black Presence, a Documentary History of the Negro in England 1555–1860*, N.Y., 1972

Watkin, David, *Thomas Hope and the Neo-Classical Idea*, London, 1968

Welsford, R., *Men of Mark 'twixt Tyne and Tweed*, 2 vols., Newcastle, 1895

Westmacott, C. M., *British Galleries of Painting & Sculpture, comprising a general historical & critical Catalogue, with separate Notices of every Work of Fine Art in the Principal Collections*, London, 1824

Whitley Papers, British Museum

Whitley, William T., *Art in England, 1800–1820*, Cambridge, 1928

Wingfield-Stratford, Esmé, *The Earnest Victorians*, N.Y., 1930

Wolverhampton, Central Art Gallery and Laing Art Gallery, Newcastle, *The Cranbrook Colony*, 1977, prepared by Andrew Greg

Wood, Christopher, *Dictionary of Victorian Painters*, Woodbridge, Suffolk, 1971

Woodward, John, "Painting and Sculpture", in *The Early Victorian Period, 1830–1860*, Connoisseur Guides, 1958

Woolner, Amy, *Thomas Woolner, R.A., Sculptor and Poet: His Life and Letters*, London, 1917

Young, G. M., ed., *Early Victorian England, 1830–1865*, 2 vols., London, N.Y., Toronto, 1934

Index